Praise fo

All the Way

"As a lover of both homes and words, I am personally grateful that a certain 1913 Tudor mansion in Akron, Ohio, was allowed to slide into crumbling, moldy decay. The sad state of this once-grand home gave hyperactive journalist David Giffels something to do with his energy— restore the home over a period of ten-plus years—and provided him with the material to pen this truly wonderful book. . . . The author's insight is so great and so full of heart and cheer that he may make readers want a little more of this driven nature in their own lives. . . . [A] soulful, funny tale." —*Los Angeles Times*

"Curl up in a hammock with David Giffels's *All the Way Home*. . . . Find out how a war with vermin turned into a battle of the bands." —*Chicago Tribune*

"[A] sweet and funny book. . . . The story of the Giffels and the falling-down house is as romantic as they come, tied up with not just the love of a house, but the love of a city." —*New York Times*

"What David Giffels makes you believe in *All the Way Home: Building a Family in a Falling-Down House* is that an abandoned villa in Akron, Ohio, could be tantalizingly within reach, and that you might be insane enough to want to jump in and fix it. . . . The story's best moments are when he first encounters, and falls in love with, the rusting hulk that will become his home. . . . High jinks follow, with a crew of colorful sub-contractors, some discoveries both scary (termites) and mind-bogglingly wonderful (a metal box of Depression-era cash). . . . [Giffels has a] brisk tone, full of brio and self-deprecation." —*Atlanta Journal-Constitution*

"The details of ruin are delicious. . . . *All the Way Home* is not only a chronicle of this renovation but also an homage to Akron, Ohio, and an affirmation of his place in it." —*Washington Post Book World*

"A delight. . . . How the Giffels come to buy this 'absurd, stupendous place' for just $65,000 is a suspenseful story in itself. . . . It's a pleasure to follow the author around the side and across the only working threshold. . . . His memoir turns into a coming-of-age story, flecked with Dave Eggers–like bravado."
—*Cleveland Plain Dealer*

"[A] fantastic summer read. . . . Engrossing. . . . Giffels recounts his battle—against rodents, unbridled wisteria, and other unpleasant surprises—to make a decrepit Gatsby-esque mansion livable."
—*O, the Oprah Magazine, at Home*

"David Giffels offers a poignant yet hilarious account of his experience as a new husband, would-be father, and obsessed home fixer-upper."
—*Parade*

"[The book] everyone should be talking about. It's an old story, this memoir. But Giffels breathes new life into the convention." —*GQ*

"You know that old ramshackle house you love so much . . . the one you're thinking about saving yourself if no one else does? Well, before you go ahead and do something crazy, be sure and read David Giffels's excellent book."
—*This Old House Magazine*

"*All the Way Home* is technically the story of a man against a house—but it's also the story of a man against nature, a man against himself, and a man against his own perception of what makes life meaningful. David Giffels is a diplomatic combination of George Bailey, Henry Rollins, and Bob Vila, and he knows what he's doing."
—Chuck Klosterman, author of *Sex, Drugs, and Cocoa Puffs*

"This book captures the true, hilarious heart of the eternal, primal struggle: Man vs. House. Along the way lies the terror of fatherhood and collapsing floors and squirrels, and with each David Giffels earns his laughs the hard way: by living them.
—Larry Doyle, author of *I Love You, Beth Cooper*

"*All the Way Home* does for a dilapidated white whale of a mansion in Akron, Ohio, what J. R. Moehringer's *The Tender Bar* did for a Long

Island saloon. In detailing how he forged a home for himself and his family—and literally discovered a buried treasure along the way—David Giffels explores the meaning of family and fatherhood, punk and power tools, struggle and squirrels. This is one of the most beautiful, genuine, and absurdly likable memoirs you will ever read."

—Michael Weinreb, author of *Game of Kings: A Year Among the Oddballs and Geniuses Who Make Up America's Top High School Chess Team*

"*All the Way Home* is an eloquent and very funny paean to fatherhood and family set in a crumbling framework of anemic plaster and rogue plumbing. Giffels paints an endearing, thoroughly enjoyable picture of a husband and father who sets out to redefine 'fixer-upper.' It's David meets Do-It-Yourself Goliath, documented with the charm and humor of a man as comfortable with words as he is a Sawzall."

—Brian Sack, author of *In the Event of My Untimely Demise*

"Part *This Old House*, very little *Father Knows Best*, very enjoyably written."

—Dan Moulthrop, NPR's *The Sound of Ideas*

"It was an epic, resolute campaign against ancient wood, copper, mortar, and linoleum; against soil, grout, and glue; against mice, raccoons, and squirrels. Walls spoke secrets, joists told tales. . . . Reconstructing that grand old dwelling was a life-changing event and, perforce, a fount of comedy. As he doggedly stripped accretions of paint from door hinges, Giffels uncovered layers of heartfelt meaning. . . . An entertaining . . . affecting memoir of making a home."

—*Kirkus Reviews*

"A funny, painful, engaging cautionary tale; warmly recommended."

—*Library Journal*

"*All the Way Home* is far more than the story of an old house; it is the beautifully written story of a family struggling to overcome not only termites and dry rot, but unexpected tragedy as well. At times laugh-out-loud funny, at times tearfully poignant, *All the Way Home* is a compelling, deeply rewarding journey through a family, a house, and a home."

—*BookPage*

Greg Milo

About the Author

DAVID GIFFELS is an assistant professor of English at the University of Akron, where he teaches creative nonfiction. A former columnist for the *Akron Beacon Journal* and a contributing commentator on NPR, he has received numerous journalism awards, including a top honor from the National Society of Newspaper Columnists in 2008. A former writer for MTV's *Beavis and Butt-Head*, his writing has appeared in the *New York Times Magazine*, *Redbook*, *This Old House Magazine*, and many other publications. He lives in Akron, Ohio, with his wife and two children.

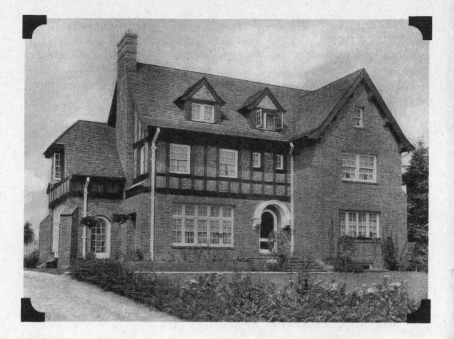

All the Way Home

[Building a Family in a Falling-Down House]

DAVID GIFFELS

HARPER

NEW YORK · LONDON · TORONTO · SYDNEY

HARPER

A hardcover edition of this book was published in 2008
by William Morrow, an imprint of HarperCollins Publishers.

HarperCollins books may be purchased for educational, business, or sales
promotional use. For information please write: Special Markets Department,
HarperCollins Publishers, 10 East 53rd Street,
New York, NY 10022.

FIRST HARPER PAPERBACK PUBLISHED 2009.

Designed by Kate Nichols
Blueprints on pages vi–ix by Thomas E. Giffels

The Library of Congress has catalogued the hardcover edition as follows:

Giffels, David.
 All the way home : building a family in a falling-down house / David Giffels.
 p. cm.
 ISBN 978-0-06-136286-6
 1. Dwellings—Remodeling. I. Title.
TH4816.G54 2008
643'.7092—dc22 2007039267

ISBN 978-0-06-136287-3 (pbk.)

09 10 11 12 13 OV/RRD 10 9 8 7 6 5 4 3 2 1

[For Gina,

who endures and

endures]

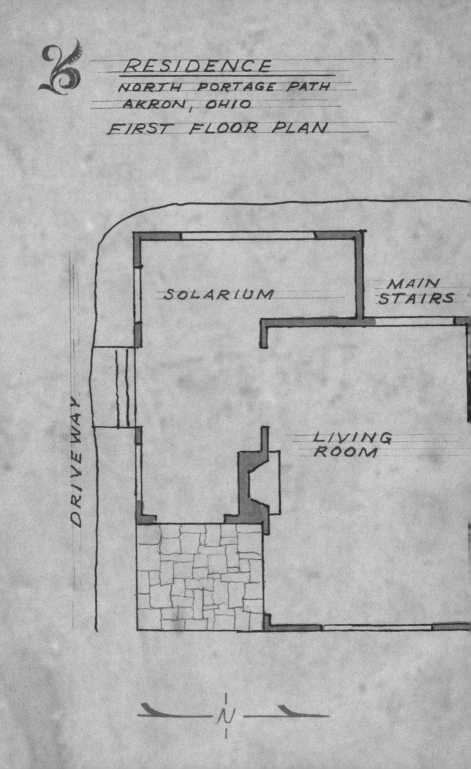

RESIDENCE

NORTH PORTAGE PATH

AKRON, OHIO

FIRST FLOOR PLAN

SOLARIUM

MAIN STAIRS

LIVING ROOM

DRIVEWAY

N

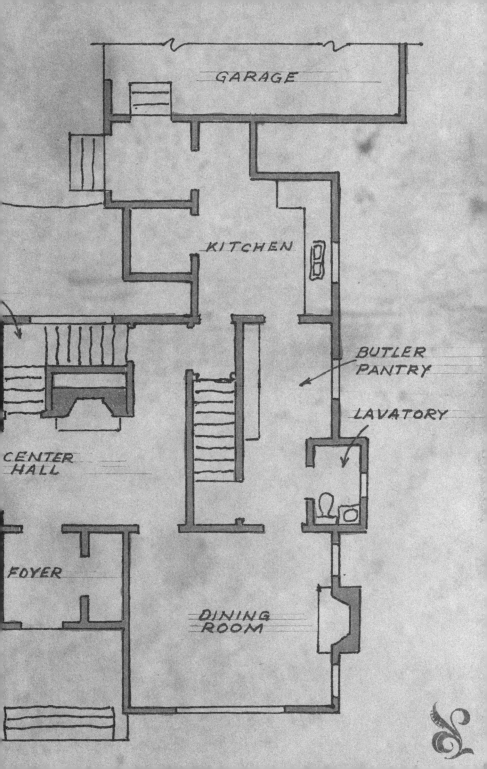

RESIDENCE
NORTH PORTAGE PATH
AKRON, OHIO

SECOND FLOOR PLAN

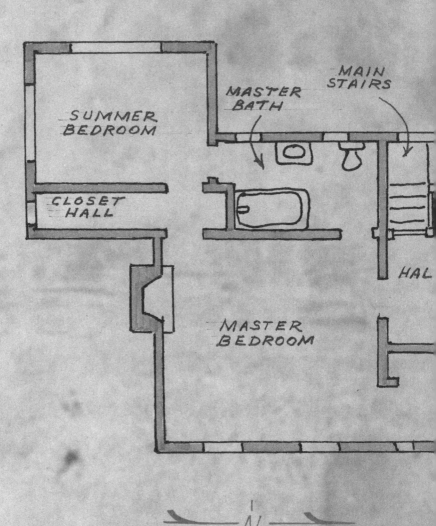

SUMMER
BEDROOM

MASTER
BATH

MAIN
STAIRS

CLOSET
HALL

MASTER
BEDROOM

HAL

N

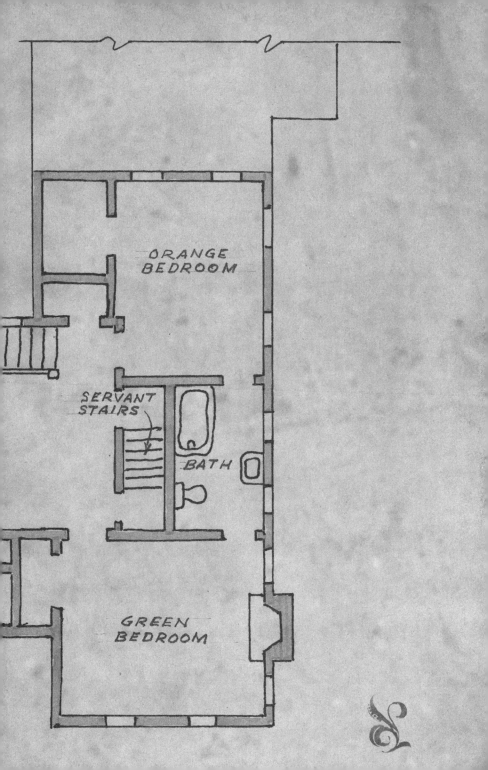

ORANGE
BEDROOM

SERVANT
STAIRS

BATH

GREEN
BEDROOM

Part I

[You're innocent
when you dream.
—Tom Waits]

lost in

the supermarket

Main aisle, Home Improvement Superstore:

We are walking with such purpose down the wide fluo-rescence of the promenade that we are not really walking so much as we are marching, propelled by the triplet American cadences of conviction, desire, and retail curiosity.

We navigate by end-cap billboards.

Adhesives/Tarps/Caulk . . .

We lead with our jaws. Our torsos strain forward in a posture of domestic yearning, pulling us into a power walk.

Conduit/Connectors/PVC . . .

Our arms swing with the edgy reciprocation of a Sawzall, trig-gered low. We squint at thumb-smeared shopping lists with utilitarian dignity.

I always wonder what that next guy is here for, the one burning holes into the shelves with his gaze. I always wonder what problem he came here to solve and if he's here because he knows what he needs or because he hopes he will find it. I wonder if he ever stops to realize

that he has prepared himself all his life for this moment, the moment in which the truth hits him with such clarity that he experiences the divinations of Meriwether Lewis:

He needs a toilet flange.

Not a wax ring. Not tape or putty. The problem is in the flange and he knows it now, oh he is so certain of this. He lay awake last night working through the possibilities of his problem and now he has arrived.

Faucets/Fixtures/Toilets . . .

Godspeed.

Me, I'm still looking.

I came here for three things:

1. a can of expanding sealant, that magical stuff;
2. another three bags of mortar because this much I've learned: a single bag of mortar is a fool's errand; and
3. possibly a hinge.

The hinge is a lark. The hinge is a red herring. The hinge is an alba-tross. A wild goose. The hinge is to replace the one nearest the floor on the billiards room door, because most of the water damage there is down low and that hinge is rusted beyond reason and salvation. It's heavy and antique and I know I will not find one here. But I have to look.

Looking for something we don't think we'll find—this is an understanding we share here in the wilds of the superstore.

We are people afraid of what might happen if our lives became comfortable.

We are people who don't know nearly as much as we want the world to believe we know.

We are fathers. We are desperate to understand our place among people who desperately need us.

Our ambition is complicated.

We look at walls and fantasize about their insides.

We consider the influence of our hands upon our tools, and of our tools upon our hands.

We have opinions about sandpaper.

I've stopped now, between *Lighting* and *Doors*.

A hinge—is it "hardware" or "fastener"?

We do not ask. We seek and discover. We, in the aisles: we are seekers and discoverers. This is our frontier. This is what we have left.

For me, today, it's this billiards room door. Yeah. A *billiards* room. It's not what it sounds like. I am not Colonel Mustard. I am not the kind of guy who lives in a house with a billiards room. Well, I mean, I *do* live in a house with a billiards room. But I am not the kind of guy who relaxes by playing snooker. Because I am not the kind of guy who relaxes. The billiards room is just, well—it all just kind of happened.

It started innocently enough. It started in much the same way curiosity led me to poke into that basement wall, perhaps the only wall remaining in this mansion that I had not been inside. *What's going on inside that wall*, I wondered, so I hammered a hole and reached inside to find out. (We do these things on impulse at my house.) That's when I found the termites. After all this time and all this work, five years of nonstop restoration, just when I thought things were settling down, just when I thought I was ready to allow things to settle down . . .

I reached into the wall and put my thumb against the center beam, and the thumb sank into the wood—*powder! nothing!*—and I realized amid this shocking new information that I was standing directly below the piano in the foyer one floor above, and I was therefore in danger of dying a cartoon character's death, piano crashing through floor, which is something I do not want to do. More than anything else, I do not want to die a cartoon character's death.

I called my father, frantic. And my father, the structural engineer, came right over and looked inside the wall.

"Nothing holding this place up but memory."

This is what he said.

He laughed. I think he lives for days like this. He is an enabler. I am a provider. I provide him with that stuff that makes fathers what they are, which is mostly trouble that needs to be corrected.

Everything can be fixed, he said. (That's the problem.) We made a plan and I acted on that plan with furious purpose to save my house from falling down. Day after day, night after night, I ripped out the rot and braced it up and poured concrete, a hundred bags. I laid a brick floor (scavenged brick—always, everything, scavenged) and then, carefully, one by one, removed the sticks that hold up the center of the house and replaced each with a new one. Stout posts. Good as new. Better! Better than new! I knew exactly what I was doing, and I didn't have a clue.

Really, that wasn't the worst of it. The worst of it was the darkest secret of all: when I reached inside the wall and found the studs teeming with termites, the pulp consumed, leaving only the layers of grain, the leaves of a gutted text—I responded outwardly with horror *but inwardly with glee!*

Because just when it seemed that there was nothing left for this place to take from us, I had begun to fear what that suggested: a life without struggle. That prospect frightened me more than the potential implosion of my family's home.

And so I took each step with great flourish and deliberation. I opened the void under the basement stairs, cutting a hole one stud-bay wide, sixteen inches, and wriggled through with my flashlight, into a space where no man had been since 1913, and there I discovered:

1. a glass vial of dried carpenter's glue;
2. a tendril of invasive vine, alive, growing up through the dirt floor, ten feet underground, without light or direction, an albino weed, the sort of implausible invasion that has defined this place;
3. a fist-size tunnel in the floor with the partly chewed remains of a rat poison box, lettered with anachronistic type, the bones long dead;

and I felt complete there in the secret dirt under the stairs and that's why, one Saturday afternoon, while the rest of the world played golf

and sipped illicit midday beers and went to a movie with the kids and did actually bother to ask if Dad wanted to come along but didn't expect anything more than the timeworn excuse—*this work has to be done*—I crawled back in there with a pencil and began to write on a stud, all the way down the two-by-four and along the floor plate and up the next stud. I didn't plan that part, but it revealed itself as inevitable: to write the story of one family onto the framework of the very place that has, for better and worse, defined them. And then to close it in and plaster it over and leave it there until someone else finds a reason to cut into that wall, some generation hence.

And I know now that these shiny new hinges will never do and that I will leave here and go home to make the old one work again. The hard way is all I know now.

2]

ignorance

and arrogance

The search began with the first press of a small cranium against the cervix of my one true love. There was a stranger inside my wife; he was trying to get out, and he soon would require a room of his own. And this would make all the difference.

Actually, he wasn't trying very hard. It probably is unfair to refer to a prenatal child as "lazy," but clearly he was not giving this his all. After twenty-nine hours of labor, the doctor was talking about using a high-tech toilet plunger to extract him. I was learning all sorts of new things that day. They would attach this thing to his head and (I assume gently) drag his ass out of there. Although I had concerns— vividly detailed ones—I had no choice but to accept this as sound medical procedure.

I was in the paradoxical position of all first-time fathers who choose to attend the birth process: trapped between the roles of spectator and participant, dressed in blue scrubs and unflattering shoe covers, standing in the harsh light of delivery with the intention of being helpful, prepared by reading and classes and enlight-

ened conversations and then suddenly cast into an overwhelming helplessness.

I did not know what to do with my hands. These flimsy, shapeless pants had no pockets. I could hold Gina's hand, but there were times when she preferred not to have her hand held. I stood to the side, awkwardly fiddling with my wedding ring. All I could do was be with her, by myself, at her side. I still do not agree with the idea of the father being absent, in the waiting room with a handful of cigars, waiting for the dirty work to be done. But now I understand the impulse.

This labor had begun sometime the previous evening, as Gina and I sat on the couch watching a *My So-Called Life* rerun. The couch, and the accompanying chair and table, were of my own making. I had cut down some trees a couple of years before to clear way for a fence and decided in the process that it was a shame to waste straight limbs of maple, so I had saved the good ones, stripped the logs of their bark, and cured them in the attic. When enough time had passed, I had fashioned them into this set of lodge-style furniture, patterned after an insanely expensive set we had admired in a high-end rustic furniture store in the Pacific Northwest. I made the furniture using only (a) an electric drill with a 1¼-inch spade bit; (b) an antique hand-me-down table saw, which I used to shape crude 1¼-inch (approx.) pegs at the ends of the logs; and (c) a lot of glue. The tabletop was made from slabs of scavenged marble that had once been the floor of a historic downtown hotel, the stately Portage, demolished five years previous.

I had no formal training in furniture making. I had no training at all. Unburdened by rules of proportion and precision, I was free to make a couch that answered only to the Muse and also, much more important, a couch that cost no more than a couple bottles of glue. Viewed from a slight distance, it approximated a living room set.

Gina called it the Gilligan's Island furniture. I didn't care. It was my masterpiece.

My secret fantasy was to use this set of furniture as the portfolio for a new life as a fantastically in-demand hippie logsmith. But this

was only a tangent of the guiding theme of my existence, which is an incessant state of restlessness, which is not the best way to enter parenthood. Even then, in the opening strain, as Gina reached to her belly and straightened with a look of beatific surprise—*it's happening!*—I was feeling profoundly uneasy.

I thought I was prepared for fatherhood. I had refinished the floor in the baby's room; painted the walls; hung a playfully primitive wallpaper border (you can never miss with cartoon bears); put a fresh coat of varnish on the woodwork; plugged the outlets with plastic childproof covers to protect against accidental death by electric shock; purchased lead-free miniblinds and shortened their cords sufficiently to guard against accidental death by strangulation; installed a tasteful yet inexpensive ceiling fan; assembled the crib; hung a pretty valence; updated the window hardware to prevent the distant, unlikely possibility of death by falling. I had spent more time and attention on redoing that room than any other room in the house. An entire *trimester*, to use the lexicon of my new chronology.

But I also was aware of a private function. I had become intimately attuned to the male counterpart of the nesting instinct, the very instinct that had found Gina baking peanut-butter cookies and scrubbing the kitchen floor in the last hours before this interminable labor began. It is the wild energy of life, unleashed in a race against time. When men redo the baby's room, it is not just because we want a safe and tasteful setting for our newborns. It is also because we secretly believe we will never again in our lives be alone in a room with our tools. Babies' rooms, as a result, are generally exquisite.

So the labor had begun. Gina was handling it almost as if she knew what she was doing. We waited downstairs on the Gilligan's Island furniture until dark, then moved upstairs to bed because it was too soon to depart for the hospital.

Seeing this as "free time," I pulled up a chair at the foot of the bed and set to work painting a table. I had been working on rehabbing this curb-find end table. Turquoise base coat; top to be stenciled with chunky geometric shapes in Chinese red. I was all about remaking

stuff others thought was useless. In theory, this table would be as cool as the insanely expensive ones at the yuppie furniture store, but under my brush that night, it was developing into possibly the ugliest table in northeast Ohio. My handmade stencils had no sense of proportion and the colors were gaudier than they had been in my imagination.

Plus, I was avoiding my wife's labor pains.

False labor. There's such a thing as false labor, right?

I make no excuse for this. I was doing the best I could.

We lay awake through the hours, watching the patterns of night-time light across the ceiling, listening to the periodic crunch of gravel next door. This was our first house, a "starter." We had chosen it because it was cheap, and because we were charmed by the features of its age: oak pocket doors; tall, well-milled baseboards; anachronistic gas light fixtures; a thick mantel darkened by the patina of its years. We had not chosen it for its "location."

On one side was a bank that included a drive-through ATM. On the other was a house that, while not technically a "crack house," did include at least one tenant who sold crack cocaine for a living. Nocturnal activity ranged from dark entertainment to the kind of anxiety that leads grown-ups to hide under the bedcovers.

The cars came and went in a quick-service cavalcade. At the ATM, the demeanor and alignment of the patrons became more erratic with each passing hour, leading to an undeniable conclusion: anyone who needs quick cash at three A.M. is up to no good. Meanwhile, faded Impalas and out-of-tune Hondas formed a constant late-night parade next door. None ever stayed more than ten minutes. Often, the cars were left running with stereos blaring, and the only consolation for me and Gina was that they'd be gone soon and maybe the next crackhead would be more considerate of the neighbors or have better taste in music.

In between this pageant was our house, which, like many of the houses in Akron, Ohio's Highland Square neighborhood, was a semi-remarkable place built in the 1920s, slipping toward a Rust Belt cliché by the 1980s, and finally reclaimed by younger people, frugal and ambitious. This house, despite scabbed and sun-ruined clapboards

covering its exterior, had much to recommend it: good bones, nice woodwork, front porch, oddball closet with stairs that led nowhere. At first, Gina and I had worked on the house together, stripping the dining room woodwork of paint, ripping out the carpet, papering the walls. We were a team. We were in love. Crazy about each other; best friends. That's how we had been from the start.

Slowly, however, and inexorably, the work became an extension of who I was. I would stare at a room sometimes and imagine what the house might look like without that wall, or if that wall were a different color, or what hypothetical complications might be involved in, say, cutting a little speakeasy window into that wall so that we could say hello to people in the next room whenever the spirit moved us to do so because lord knows these things happen. I became more and more ambitious and I concocted projects that were increasingly absorbing and absurd. I tore out a brick retaining wall that was leaning badly, replacing it with railroad ties. A practical repair. But then I spent a month chipping the mortar from every brick with a hand chisel. Why waste good bricks? Why waste a good pile of scrap mortar? Using the mortar as base material, I laid a patio with the brick, using every bit of material in a deranged fit of recycling and conservation.

This behavior reached its pinnacle when my father, an engineer who had done the site work on the parking lot for a new Kmart in the suburbs, noticed a small mountain of old-style paving bricks on the job site and discovered they would be bulldozed under. I could have them for free if I got in that weekend and hauled them away. My dad, who is simultaneously helpful and dangerous in situations like this, did the math and confirmed that there would be enough bricks to replace my badly corrupt concrete driveway. So I got out there with a borrowed dump truck and some friends and we hauled several tons of street pavers to my house and dumped them in the backyard, which was transformed into the "staging area." I removed the derelict concrete driveway by hand, breaking it apart chunk by chunk using (a) a sledgehammer, (b) a long iron spud bar, and (c) a spare hunk of maple log as a fulcrum. I lugged each of those eighty-pound, pizza-box-size hunks onto a semi trailer;

three loads were hauled away. I spread the limestone-gravel foundation by shovel and packed it with a manual tamper—a heavy iron square attached to a stout wooden handle that the user pounds and pounds and pounds until the base material is solid and the hands are numb. Then I laid every brick by hand, becoming somewhat of a neighborhood curiosity in the process, which I regarded as a fringe benefit.

I did this because the bricks were free.

This is the story of my driveway. This is how I always tell it. This is how anyone would tell it, anyone who had broken up a concrete driveway with his bare hands and a sledgehammer and replaced it with a mountain of bricks. The story would be told Paul Bunyan style. What I forget, or maybe what has taken years for me to realize—is that I was merely the laborer, that I did not know what material should comprise the base, nor how deeply that material should be laid, nor how tightly it should be compacted, nor how to install French drains so the thing didn't sink into the ground the first year, nor where to break the pitch for runoff, nor how to keep the rows straight and even. Years to realize that it was my father, the engineer, who taught me how to do everything—*everything*—because he was the capable one and I was simply a willing restless soul. I tell this story and I forget to include that I knew nothing—*this part is forgivable*—because that fact necessarily got lost in the process. If I'd known what I was getting into, I never would have taken on the challenge. Ignorance and arrogance: that's how the young succeed.

Realizing how little you actually know: that's the key to growing up. Humility comes last, and never easily, and sometimes not at all.

Someday when this realization is achieved, I'll admit I stole the "ignorance and arrogance" line from Leonard Cohen, and I'll understand why he stole it from Mark Twain.

And there we lay, in the early stages of labor, in what once had been a three-bedroom house but was now, effectively, a two-bedroom house because I am a Man Who Sees Through Walls. I had

converted two of those bedrooms into a spacious master suite. In so doing, I had unwittingly compromised the future family friendliness of this semiremarkable house. The stranger who was living inside my wife would soon occupy the other bedroom, and because we had plans eventually to spawn yet another earthling, we soon would have to address the Situation of the Bedrooms. There would not be enough of them.

Meanwhile, my table was drying in the corner and the red numbers of the digital clock were oozing toward dawn, inexorably marking the decreasing time between contractions. There was nothing false about this labor.

The suspicious headlights of the night gave way to the dawn of a brilliant May morning, full of possibility and the strangest energy I have ever experienced. I swear to God I felt the apple blossoms swell. We got out of bed and put the lessons of Lamaze into action. We paced together; pacing was good. Gina rocked in a rocking chair; this was supposed to help. As the sun burned off the dew outside, my mind thrashed about for some understanding of the new responsibilities now closing in like military helicopters.

I decided I needed to fertilize the lawn. Right now.

Leaving Gina's side, I went to the basement and hauled up the bag of fertilizer, then began marching up and down the front lawn, in carefully spaced rows, shaking out measured handfuls. (I didn't own a broadcast spreader. Fertilizing was, for me, a tactile and intuitive act. I had never failed in this.) For exactly half this time, in the rows that led back to the house, I could see, through the front door, Gina watching me from her rocking chair, with a look of concern or disappointment or both. I could explain all of this, even if I could not explain it to her. I fertilized because I couldn't *not* fertilize. It was the same instinct that had led me to strip the bark from logs and to learn the process of curing green lumber and of fashioning mortise-and-tenon joints. I had to do something, even if I wasn't sure what it was. It was spring. Spring fertilizer needs to be spread in the spring. Right? Considering that whatever was about to happen would undoubtedly

make me extremely busy, I allowed myself to believe I was using my time responsibly.

The time came. We put the prepacked overnight bag into the trunk and drove to the hospital: more pacing; coffee; lighthearted seriousness with the anesthesiologist; digital heartbeat readouts; coffee; blue gowns; more pacing; twenty hours and how could this still be dragging on?; an epidural to ease the pain; Pitocin to aid the contractions; pushing for one hour, two hours, and still—nothing. And finally, after twenty-nine hours, the tired doctor produced the toilet plunger and began tugging at the top of my uncooperative child's head, easing it closer and closer, until suddenly he emerged in a gush of Chinese red, a boy—A Son—dripping in amniotic ooze, looking like a cross between Yoda and, due to the action of the plunger, Marge Simpson. I recall this moment with affection.

A month passed, the usual stuff: singing to a wailing soul in the night, boiling things and channeling adrenaline into the void of sleeplessness. Finally the day arrived when Gina would for the first time leave the house, alone, without the baby, to attend a wedding shower. I would be in charge.

So of course that morning I decided I would plant the gardens—it was early June, a matter of responsibility—and I was standing there over a wheelbarrow full of dirt as Gina readied herself upstairs, eyebrow pencil in one hand, rocking the baby with the other, until she realized her patience with me was ill spent. I grew all my plants from seed in a makeshift attic greenhouse, and so I was surrounded by Dixie cups filled with potting soil and delicate seedlings, diligently arranging zinnias, when Gina appeared on the front porch, half made, and in a primal tone growled *get in here right now and take care of *your son**, the last two words flung high and tight, intended not as a mere brushback.

So I did.

Gina left for the shower and I wrapped the baby in a blanket and sat on the porch swing with him and the slender book I had been

reading for weeks, desperately, a half page at a time: Denis Johnson's *Jesus' Son*. We rocked and he slept and I read.

As far as I could determine right then, these were the first peaceful moments I had ever experienced. He was weightless and calm and the day was warm and quiet and I was conspicuously not working. I was reading a book on my porch swing with a sleeping infant in my lap.

Weightless.

They're little astronauts, I thought, looking at his tightly wrapped self. They live in self-contained suits, eat from tubes, eliminate waste in disposable sacs. They defy gravity, floating from pod to pod. They communicate in elaborate code.

Float, young captain. Float.

Roger that, daddio.

Float with me through this perplexity of stars and we will find our way.

I saw them coming up the street from the bus stop: the tall, angular man with the horrible gait, the Coke-bottle glasses, the greasy up-swept hair, the belt pulled one notch too tight and six inches too high, galumphing along with his girlfriend of perpetual dumpy polyester and hair that was always wet. They lived in a group home somewhere in the neighborhood and had a habit of stopping here whenever I was outside. They regarded me, I suppose, as neighborly, at least in relation to the crack dealer. I referred to them, privately and not un-kindly, as "The Freaks." He always said "Hi" repeatedly, looking at something other than me, and she spoke in an almost-there singsong, telling me how she has gardens just like these at her house and soon she'll be buying a house of her own, la la la.

I buried my gaze in *Jesus' Son*, hoping they would pass without noticing me, but they entered my periphery, coming up the front walk, and eventually I had to look up, pretending I hadn't seen them coming and was happy to see them. He said *Hi*, looking at the bundle in my lap. She started asking me about the morning glories that had

arched my front porch the summer before, which morning glories had dropped a million seeds that were now sprouting uncontrolled in the beds that I was not allowed to weed that morning. She asked if she could take some seedlings in the Styrofoam cup she was emptying as she spoke, pouring Coca-Cola on my front walk. I tried to explain to her that they don't flower the second year; you have to start them new. She asked if I had any fresh seeds and I said, well, you have to nick them with your pocketknife and soak them overnight before planting and actually I'm kind of busy here today, what with this baby in my lap and all, and her boyfriend suddenly blurted out: *Are you a Christian?*

I looked at him, confused. Then I realized he was staring at the cover of my book. I didn't have the heart to tell him the title was a Lou Reed reference to a heroin buzz, so I just said yes.

And I decided then, if I hadn't decided before:

I would never relax again.

3]

the orange
dutch colonial affair

We began house hunting in the usual way, driving around, a burgeoning family creeping toward its definition at twenty-five miles per hour: husband and wife in the front; baby strapped securely in the back in accordance with all the regulations of the National Highway Traffic Safety Administration, pausing curbside and browsing the way men look at ties when they don't really need one. It's easier to identify what's wrong with each of them than to settle on one that seems right. We slowed at the places that caught our interest, the older, big-boned clapboard and brick houses available to middle-class couples in faded cities like Akron. Places with resolute porches, skewed attics, and oddball mudrooms, and with a need for problem solving—maintenance and upgrades—that could guide restless people into settling down. More often than not, we paused long enough to decide *no, this one's not right*, and move on. Occasionally, we went farther into the neighborhoods we couldn't afford, into the rich veins of Tudor and Colonial architecture rising from the humus of a different time, when this part of Akron was studded with wealthy

rubber-industry executives. We left those neighborhoods delighted and defeated.

To someone standing at the curb, we would have looked normal. Young family; Sunday drive. But something I didn't yet understand had been growing with the increasing press of adult responsibility. We had been parents for nearly a year. We were working on a second pregnancy. Evan, the first child, was not yet walking. I was needed. And I was feeling quietly desperate, suspended between a perpetual youth and an inevitable adulthood, the way a trapeze apprentice might feel as he reaches through the not-yet-familiar dizziness for a grip he hopes will find him. I was happy in my life, aware of its relative privilege, but afraid of its potential contentment. I did not want to be content. There was so much left I wanted to do.

Therefore, I wasn't just looking for a house. I was looking for more. Of everything. Even as I gazed with seeming dispassion from behind the steering wheel, I was looking for exactly the thing I hear in Paul Westerberg's voice when he sings "Unsatisfied." Do you know that song? From the fourth Replacements album, it's one of those times when Westerberg was completely artless, which is when he was his best: a raw soul absolutely certain how badly he wanted something he absolutely could not define, except with the sound of his voice.

I wanted to do something that had never been done before. I wanted to shatter things and make them beautiful. I wanted to tear into walls and discover the bones and veins and tendons there. I wanted to hurl myself into the air long enough for the earth to turn beneath me, so that I land in the neighbors' backyard, where there is a cocktail party going on and they all turn and gasp as I crash through the glass-topped table and when they lift me up and see that *no it's not blood, it's cocktail sauce!*, they all begin dancing and the tuxedoed man lifts his highball glass and says, "Now *that's* what I call crashing a party!" and we all laugh as we have never laughed before. This is what I hear in Paul Westerberg's voice. Not something for an incomplete life, but something completely more.

That. That's what I was looking for as we tooled around the

streets of Akron, talking about the next baby, and the Bedroom Situation, which was the practical purpose of our pursuit. We wouldn't have a place to put another child. We needed more room. On that we agreed. What we each needed room for was another matter entirely.

I thought for a while that I had found the house I wanted. It was on a stretch of inner-city road, a tributary off one of Akron's foremost crime thoroughfares. It was on a historic street lined with oak trees whose limbs gestured like tremendous groomsmen at a debutantes' parade. The mansions there had once housed the city's department-store magnates; the backyards had comprised Akron's first country club, mown from a sheep pasture. Now the whole neighborhood was faded, vacant and untended. The house I wanted was a huge Dutch Colonial whose orange (yes, orange) paint had faded thankfully into a vague taupe, but the color really didn't matter at all, considering the plywood over the windows and the low sag in the roof and the auxiliary renter's staircase that clung parasitically to its side. It was a grand, sprawling shambles, more house than I'd ever imagined for my family. There was a carriage house out back and nearly an acre of land, which I know because I had checked it out on the tax maps at the courthouse, which is to say I really wanted that house.

Once a day, either on my way to or from work, I drove by, and I suspect the crack dealers thought I was flirting. Which was ridiculous. If I wanted crack, all I had to do was step out onto my semiremarkable front porch and whistle. No. I had only one thing in mind, which was the orange Dutch Colonial with the NO TRESPASSING sign slung from a chain at the front of the long dirt-and-gravel driveway. I imagined that driveway would look very cool in brick, my imagination tuned by the ambitious absurdity of personal experience. I had checked phone books and city directories but could find no hint of the owner, so I had constructed a scenario in which I could have the house for a song; they'd be happy to have me take it off their hands, *Mom having passed years ago, and what a nice young couple and yes an adorable child—you're*

young and ambitious, you just take the house; all we ask is that we be allowed
to come and see it when you're done. Yes indeed that is an adorable child.
(And good lord, the wife: she's gorgeous!)

Gina's notion was considerably different from mine, but she al-
lowed the increasingly frequent detours past the orange Dutch Colo-
nial. (I had researched Dutch Colonials in a book and I informed her
with a certain *air* that this was a *true* Dutch Colonial, which I believe
impressed her. I could be wrong about this.) So the day finally arrived
when we passed and there was a man out front, pushing a lawn mower
through the shin-high grass, an old black man in blue Bermudas. I
turned the car around and went back. The chain was down. I slowed
into the driveway. The man's lawn mower had stalled and he was pull-
ing the rope. As I got out of the car and walked toward him, I wanted
to tell him *you'll never get that thing started unless you move it out of that*
high grass there, but I didn't want to insult him. He watched me all
the way from the car until I reached what I considered conversation
distance, but still he didn't say a word and so I started:

"Hello . . ."

Still not a word from him, so I continued, "Um, I was wondering
if this house might be for sale, I mean I've seen that it's been boarded
up for a while, and—"

He was standing now and he pointed, I'm not sure at what, and
said, "Do you see the sign?"

I looked, expecting to see a For Sale sign, which I'm not sure
would have worked to my advantage: if the house was on the market,
I might not get quite the deal I had envisioned, but certainly I was a
prepared buyer, having done so much homework and all, and *surely*
you can see I intend to resurrect your fine house with tender loving care; why,
just come by my semiremarkable house in Highland Square and see the work
I have done. Imagine this driveway in brick, my friend.

But, no, I didn't see any sign, and the man launched into: "You just
come up here on someone else's property drivin' in a driveway, can't
you see the sign?"

He made a move toward me that I wasn't quite sure how to read.

I mean, he was old and skinny and I think I could have taken him, but really this all seemed unnecessary. So I apologized—*no, I didn't see any sign*—though I knew damn well there was a NO TRESPASSING sign whenever the chain was up. But since the chain was down and he had no knowledge of my previous obsessive forays, I could certainly paint myself as innocent.

Regardless, I didn't want to push it. So I left and that was that.

People who come from backgrounds like mine—Industrial-Midwestern, Catholic-schooled, socially functioning introvert—have a hard time being honest about facts that might in some way reflect favorably on the narrator of those facts, but one is unavoidable: my wife is beautiful; she looks like a movie star.

This sometimes complicates my life. Men will often ask, "How did you ever get *her*?" as though this is some sort of injustice. (The insult aside, this always makes me wonder: what exactly would one be expected to do to rightfully earn the hand of one so fair? Slay a dragon?) There is an answer to their question, but it's a much longer story than any of them would ever want to hear. The answer has a lot to do with the fact that when we met, in college, we were the sort of people who hang at the outside edge of things, the shy people, and those people generally find each other in a much different way than the peacocks they're observing. I actually had a pedigreed bashfulness: at the end of my eighth-grade year, when class superlatives were given out, I was proclaimed Most Shy. (In retrospect, it seems curious and obliquely cruel to draw such attention to the shyest person in the class for the very purpose of highlighting his shyness. At the time, I simply accepted the fact that this was the highest level of recognition I'd ever received.) After a time, Gina and I realized that we belonged together, and then we decided we belonged together forever.

Everyone's life is complicated by appearances. In Gina's case, I have seen a recurring presumption that she is pampered, or that she expects to be. As though this somehow is her reward. In fact, hard-

ship is written through her history. Gina's mother fled Fascist Sicily as a young girl in 1929, steaming nervously to Ellis Island and forging ahead to Akron, which, with its booming factories, was a promised land for immigrants. Her father, half Cherokee and half hillbilly, escaped the Kentucky coal mines. Each of them had a parent who had committed suicide. The two of them found each other in a vast Goodyear factory where they made bicycle tires, and together they raised seven children on cobbled-together paychecks from rubber shops and a basement television-repair business. Nine people lived in a house with one bathroom. The only son, Gus, fell smack in the middle—three older sisters and three younger sisters. When he was old enough, he went straight to the waterline in the basement and tapped in a shower head for himself. He later became a cop. Their household had urgency and energy, but it was not in any way romantic. It was simply necessary.

It was different in my house. My father's people emigrated from Michigan; even in the preinterstate era, the passage was not notably rough. My father woke up every morning, whipped shaving soap in a cup with a barber's brush and shaved with an old-fashioned razor, with those jaws that open to hold a double-edged blade just like the one on the cover of Judas Priest's *British Steel* album. He did this, I think, because it seemed like the practical way to shave, even though modern technology had provided far more practical ways. This was *affected* practicality. He added what might be construed as hardship into his life because he found in it some raw aesthetic value, and because there was room for it. There was such a manner of leisure and conscious choice from the moment he awoke. Each morning after he shaved, he went downstairs in a crisp shirt and tie. While the rest of the house was still sleeping, he drank a glass of grapefruit juice and wrote a note to the family—instructions or observations for the day.

Boys: Clean up the crab apples before raccoons overrun us.

When we saw him later, he was building things, not always things that were needed, but things that appealed to him in a way that I didn't yet understand. We lived in an old house, and there was always

a project under way, my father refinishing furniture or laying tile or performing sorcery on a perpetually cantankerous boiler. As children, we often accompanied him on missions to collect discarded paving bricks. A pile of excavated street bricks is to my father what a crop of morel mushrooms is to a chef. You don't plan a meal of the rare fungi, then go hunting for them. Instead, you discover them by chance in the woods, and the imagination then reveals the meal that will embrace them. In the same way, my parents' yard was filled with walks and patios and quirky structures that unfolded as a result of the antique street bricks my father found by instinct and could never resist.

My fondest memories of childhood involve sitting and watching him work on projects like this, the way he leveled crushed limestone and pounded it solid with the same tamper I used on my driveway years later, a crude but irrefutable tool that had been handed down from his father, my grandfather, the stout handle worn smooth by generations. Sometimes he gave me a ride in the wheelbarrow or had me hold the end of a tape measure; mostly he gave me hard visual evidence of the way invention grinds its way through hard work and engineering to make something that might in some way shape the legacy of the maker.

I was beginning to understand this in my own life. I had been, privately, maybe even secretly, writing a novel. I had been doing this in the way I always seemed to do things, without ever considering the practical, or potentially comfortable, way, but instead choosing the way that seemed the most bold. Like a man shaving with a thin blade and hand-whipped soap, I'd written the first two drafts by hand in spiral notebooks (red covers; college ruled). By the third draft, I'd managed to afford a used computer, and rewrote as I typed it in. I didn't know how to make the line-wrap function work, so the already out-of-control novel now spewed forward in an unintentional stream of consciousness, without pause or indentation.

I always seemed to do things the hard way, but I never made these choices consciously. (Did I? No. I did not. That would be foolish.

No one would do things that way.) I'm sure it was simply the way my instincts were tuned. Genetics. The family illness.

The novel wasn't finished. It wasn't anything I would ever allow anyone else to see. But it was important. To me. It represented the languor of predawn mornings, when some random compelling phrase might drift into my waking mind and I could follow it, up the attic stairs, to my desk and into a sentence, then a paragraph . . .

Having a child had removed that freedom. I certainly didn't resent my son for this. It wasn't his fault. That part of myself simply ended when the waking up was prompted by someone in the next room crying his lungs out, or, when the lungs were not being cried out, my own sleep became a precious thing not to be suspended for the frivolous purposes of fiction and self-fulfillment.

But there had to be *something*. There had to be.

At the beginning, Gina's basic nature and my basic nature meshed in matters of renovation. Gina understood the practicality of the "Do-It-Yourself" approach to home improvement because it saved money while making our home a more pleasant place to live. I understood that too, but I also understood "DIY" as the defining acronym of the punk ethic: when Henry Rollins and Mugger-the-roadie spent endless hours slogging around Los Angeles wheat-pasting Black Flag flyers to every vertical surface, they were not just advertising a gig. They were accomplishing much more. They were announcing their independence. From everything.

Do. It. Yourself.

Black Flag's street ethic was just as authentic as my father's shaving mug. These were my lessons. I followed them when I built the log furniture, when I laid the driveway, when I gave the bricks from the retaining wall the Gift of Eternal Life. The products were fine, but the idea that I could make them myself—that created a self-perpetuating, intoxicating energy. What appeared to be a pastime became an obsession, one with a lock-solid justification.

This was not golf. It was not garage-band practice. It was not frivolous typing. It was Shelter, a basic fulfillment of Maslow's hierarchy. I was providing for my family. How much more selfless could one be? Without my prized cartoon log furniture, we'd be sitting on the cold hard floor.

My imagination was overtaken by projects and possibilities, all of which, as I neared thirty, became necessary for a fulfillment I didn't quite understand. Maslow hadn't explained this one. Something was closing in. But I didn't need to understand, because my mind and my hands were never idle. In a halting approximation of the brick mason's craft, I built pillars alongside the new driveway, not quite plumb and not quite level. I built a gate to hang from them. I stripped wallpaper and put up new. I patched and painted, sanded and varnished. I found my hours alone. I arose some days at dawn and went to the basement, to my workshop, and stared at the pieces there, and imagined them as something entirely new. I found a concentration in these things that was becoming its own separate attraction.

After the orange Dutch Colonial affair, we began looking around at other houses. We were interested only in the old ones. We soon found we were interested only in those with large bedrooms, spoiled as we were by our two-room master suite, and only those with patios, spoiled as we were by the Patio of Our Lady of the Resurrected Bricks. The concrete driveways bored me. Shared driveways appalled me—*what if Dad found bricks and I decided to redo it . . . and the neighbor disagreed?* Nothing was connecting.

I soon began to realize that even in freshly decorated houses, I was deconstructing, tuning out the real estate agents' sales pitches, thinking instead about what I would change, how I would strip the wallpaper (since I now knew how to strip wallpaper) and how I might refinish the floors (since I now knew how to refinish floors) and how I might tear down walls (since no man can resist the fantasy of tearing down a wall). At the same time, the reality of our finances was hard-

ening. We couldn't afford any of the houses we were looking at. And even if we could, it now seemed ridiculous to pay full price for a house that was done when I intended to undo it. It seemed the responsible thing to begin focusing on houses that needed work. Gina agreed. It was the responsible thing.

And so, our lives still being carefree enough for Sunday drives, we continued looking, with one-year-old Evan strapped into the backseat, oblivious to the growing web of intrigue attached to these forays. The failed flirtation with the orange Dutch Colonial had introduced an acceptance of decay. A wall, literally and figuratively, had crumbled.

Then one day, sometime in early spring, we noticed the sign near the sidewalk on North Portage Path. The sign had fallen over. The house was barely visible from the street, more the suggestion of a house, a tall, gabled presence obscured by a heavy, untended jungle of trees and brush. We pulled into the driveway.

It revealed itself as an abandoned castle might, boldly cavalier, draped in shadows and ivy, even more mysterious up close than it had been from behind the overgrown yard. Just a few yards from a busy city street, we seemed to have entered a different place entirely, darker and cooler, radiating something like myth. The house was a looming, early-twentieth-century Tudor Revival. A thick tangle of wisteria consumed its south side. It had a series of high intersecting roof peaks, the dark brick below crisscrossed with half-timbering, inset with arched doors and vast banks of windows. Heavy buttresses anchored the main corners and a large wing protruded forward, giving it a substantial, regal bearing. Between the dark wooden half-timbers was a series of brick panels defining the front of the house; each was laid in a unique, intricate pattern: one basket weave, the next herringbone; one diagonal, the next in an X pattern, and so on. Some were regal, others playfully abstract. Even the twin dormers protruding from the main roof each had its own separate design. I'd never seen brick craftsmanship like this before. It was whimsical and stately at the same time. It rivaled anything we'd seen in the wealthier section of this part of town. I turned to Gina.

"Would you look at that?"

"I never knew this house was here," she said.

It was only then that I noticed how the chimney was crumbled almost to the roof, revealing a theme of decay that carried across the scene. There were deep gaps throughout the brickwork where the mortar had washed out. A torn screen door clung desperately to the front-door jamb. Windowpanes were broken and sun-cracked glazing hung in chunks. The roof shingles were curled like scabbed shrapnel wounds and there were holes in the roof, big ones, and *one hole in particular*, three feet across at least, sloppily covered by a piece of green corrugated fiberglass, which there's no way that thing is keeping out the water. The copper gutters were rotted through and dangling from their hangers. Every detail was draped with neglect and despair. Even so, the house stood taller than anything we had seen, its forward peak cresting the thick encroachment of forest, boldly peeking through the treetops with one window gone, like an eye gouged out in an alley fight.

The house appeared to be abandoned. It clearly had not been redone, and therefore suggested the same possibilities of the orange Dutch Colonial—a house far beyond our means that, just maybe, had slipped to our level.

We left and at first we didn't talk about it, because talking about it would be entering potentially dangerous territory, and we both recognized this. But then we did talk about it, and then we did again, but only in the hypothetical. *Wouldn't that be something?*

We went to a party, and strangely, someone at the party loudly mentioned this grand Tudor house on North Portage Path and boy was it a mess, but he was gonna buy it and fix it up quick and sell it.

"Flip it," he said. I'd never heard that term before.

And this guy talking about the house was a blowhard whom I never had liked, who wore pressed-and-pleated khakis and pristine suede bucks and had a prep school name that had always annoyed the crap out of me.

Oh, yeah? I thought.

The next day I drove back by and since the FOR SALE sign was lying in the weeds, I pulled into the driveway apron to avoid the busy traffic. I stepped out of the car, got the number off the sign, and wrote it down. I looked through the trees again. There was no way that jerk was getting this house.

It looked different than I remembered. It still gave me a thrill—all that huge, untended falling down-ness—but I also felt a distant tug of dread, neither clear nor present, just enough to wonder how long that piece of green corrugated fiberglass had been up there not keeping any water out.

I called the number. The real estate man told me, "Sorry—we're actually closing on that house today. But would you like me to send you some listings of other houses?"

I said no. And that was that.

The spring grew warmer. My method of transportation was a 1978 Toyota Land Cruiser, a crude machine designed more for the outback than the highway. I had bought it in a semidismantled state and restored it, more or less, rebuilding the body panels from old metal road signs. The engine, which could be entirely dismantled with a slotted screwdriver and crescent wrench, included parts that were not at all car parts but did the trick. There was a lot of duct tape and crimped-off vacuum tubes and homemade hose work under that hood. It was the traveling version of the Gilligan's Island furniture. With yet another project overfilling my imagination, I drove this buggy out to a friend's house in a nearby small town for rocks. He had many spare rocks and gave me the pick of the litter. Flush with my good fortune, I drove home overloaded, with tires scraping against fender wells. I unloaded the rocks and got busy.

Over the long Memorial Day weekend, I built two tall wooden forms on either side of the front walk of my semiremarkable house and filled the forms with rocks and wet mortar. I let the mortar cure halfway. Then I removed the forms the next morning and, under a

steady rain, began chiseling away the excess mortar to reveal the rocks in half round. These would be my stone pillars. These would hold the picket fence I was planning to build. I was deliberately creating curb appeal. This is a step from which one does not return. It is the act of turning one's dreams into a commodity.

A neighbor passed by under an umbrella. He was a mason who'd been a regular visitor to the spectacle of me laying the brick driveway.

"Look at the sculptor," he said.

I smiled. I'd been thinking the same thing myself. *Sculptor*. I was transcending craft to art, undaunted by the rain, stone transformed under my touch!

"You put your latex in your mortar?"

I looked at him, rain dripping from my bangs.

"Latex?"

"Yeah. The additive. So it won't crack?"

"Right, uh. No. I think I'm probably fine? Without it?"

"Sure," he said noncommittally. "Could be. Looks nice, though. That's for sure."

I had my curb appeal.

We looked at houses through the summer and I gardened in between. The morning glory arch over the porch entrance didn't thrive as it had the summer before, reaching only two-thirds of the way across, but it looked nice nonetheless, the glories smiling upon me as I drank my morning coffee on the porch swing. I was beginning to perceive our house as a stranger might, a potential buyer, considering it from the outside and not the inside.

This dispassion did not come easy. This was home, and it seemed that each passing day of our life together—me, Gina, and Evan—made this structure harder simply to leave, or even advertise for sale to some stranger. Evan danced for his first time there in the living room, clinging to the Gilligan's Island coffee table and popping his diapered hips this way and that above uncertain knees, shrieking with glee.

The song was coming at random from MTV. Rage Against the Machine's "Bulls on Parade."

"Rally round tha family! With a pocket full of shells . . ."

He was dancing for the very first time to a song that appeared possibly to have patricide as its major theme. This was unfortunate. But children teach you early that everything happens in the moment. Evan couldn't have known the choices available for this entry in our personal history. The boy was an innocent slave to the rhythm. I shrieked right back with him.

And then one summer day, the announcement came, by way of the inelegant modern convenience of urinating on a drugstore stick:

Gina was pregnant again. None of this was hypothetical anymore. We had nine months.

4]

seduction

Even as we bore down on the task of house hunting, I couldn't completely forget the Tudor on North Portage Path. Whenever I could, I chose a route that took me past it. The house seemed coy and romantic, hiding there in the middle of the city, peeking above its curtain of trees.

One summer day as I passed, I noticed another realty sign lying in the weeds. Why were these signs always lying in the weeds? I stopped for a look. A different real estate company. I wrote down the number and called that afternoon.

"Wasn't this house sold in the spring?" I asked.

There was a problem at the closing, the woman said. A dispute over who would pay for termite treatment. I tried to remove the word *termite* from her answer, hastily reckoning that termites couldn't do much damage to a brick house. Could they? I asked if I—if we, my wife and I—might be able to see the house. The woman said yes, but she would have to contact the owner to set up a time.

When we pulled into the driveway for our appointment with

the real estate lady, the sun disappeared above the arch of trees and vines—vines that crossed and doubled back and crossed again in a troubled wild lattice. We approached the front door, right at the center of the house, under a classical arch with a series of decorative panels and ornate scrollwork in its supports, the wood split and drab. A length of gray Romex wiring hung loosely from above; I eyed it nervously, unsure if it was live. The stoop was crumbling, bricks missing and loose; the sides had heaved away from the main pad, whose decayed and broken English tiles crunched under our feet like ruddy gravel. A piece of tattered Astro Turf covered part of the stoop, as though to conceal something worse. A big concrete planter, also actively decomposing, covered an especially treacherous spot, forcing us to ease along the wall. The planter contained the dry brown stem of something dead. Approaching the main entrance to this house was mostly a matter of trying to avoid personal injury.

The paint on the arched screen door was alligatored and weathered to chalk. The door behind was in the same condition, its glass panes covered from the inside with a sheet of cheap plastic that was patterned in faux stained glass.

I knocked. Paint chips crumbled down.

The door opened a few inches. It was dark inside. A middle-aged woman's face appeared, carefully rouged and framed by two heavily sprayed clamshells of hair. She smiled what seemed to be an apology. She opened the door wider and we stepped into a small foyer with a terra-cotta tile floor and a paneled glass door that led into the main house.

She introduced herself through the shellacked countenance that comes standard with a real estate license. I accepted her handshake, but I was already beyond her, drawn by the intrigue of this entryway. There was a rusty, table-size radiator cover to the left; there were cracks in the wall, cracks in the dingy ceiling, age spots in a full-length dirty mirror. And a smell, or not a smell, but an atmosphere, musty, at once wet and dry, the dark magic of antique dust, a scent that triggered something primal in me—a smell from the beginning of my

memory, when my parents had looked at and considered buying a big Gothic falling-down place in a nearby country town, with a barn and angled cellar doors and a toad my brother found and picked up and it peed on his hand. It was that same smell, and all I know is we never went back to that place. My dad must have been about my age then. He must have been making decisions like those I was faced with now. That seems impossible.

We're not allowed to touch anything, the real estate lady said, apparently including herself in the order. She handed us a clipboard with a handwritten agreement saying just that: we, as visitors, would not touch any of the owner's things. Peeking into the main house, I saw that this would be difficult. The house was packed with clutter; pathways between these things were exceedingly narrow. It looked like deep storage turned upside down. It didn't matter. If signing an agreement to keep our hands to ourselves was the price of admission, fine. I wanted in. Lured by the intrigue, I'd have signed a pledge of celibacy.

We stepped into a spacious, dimly lit center hallway with a handsome fireplace whose tiles appeared to carry a loose Spanish pattern of squares and crosses, but it was hard to tell because the tiles and the surrounding wooden mantel were covered with sallow white paint. It felt cold inside, even though it was summer. As if the warmth had never found its way in, or the chill couldn't find its way back out. All about us were piles like sleeping bears: clothing and magazines piled on chairs; boxes pushed against one another; newspapers; old photos; sheet music. To our right, near the doorway into what looked like the dining room, a black rotary phone rested on a stack of books and papers. There was furniture, some broken and buckled, some fine as can be. There were out-of-style floor lamps and racks of clothing under stiff, clear vinyl.

To our left, through a wide entrance offset with formal columns that supported a large, ornate lintel, was the living room. It was sunken, a wide expanse of room presented by a broad, curving step. At the center of the far wall was a brick fireplace, large but simply ap-

pointed, with panels across the front of the mantel and discreet curls at the ends. More than the fireplace itself, I was taken by the fact that it was coated with paint, which the wood and brick seemed to wear as an insult. Above the mantel was a huge mirror that made the spacious room seem even larger. The fireplace was offset on each side with a set of French doors. Dominating the center of the room was a magnificent harp that reached halfway to the ceiling, which ceiling had a disconcerting sag the size and shape of a claw-foot tub. The wallpaper hung in stained tatters and it was dark in there too; heavy, moth-eaten woolen drapes covered what appeared to be a roomful of windows. There didn't seem to be natural light anywhere. From the outside, the house was half glass; the inside felt like it was wrapped in a horse blanket.

I didn't notice her at first. She was in the living room, sitting amid the stuff and in fact seemed like part of the stuff herself, a small old woman with unkempt silver white hair. Perched on a wooden folding chair, in the corner between a long, cluttered set of Craftsman-style bookcases and the draped front windows, she was hunched into the shape of a question mark. She either couldn't or didn't want to look up. She was wearing a dark shapeless jacket and had a cat in her lap. The real estate lady didn't exactly introduce us, but rather she rhetorically presented a pair of facts: that we were visitors and that this was the owner.

"Hello," the hunched woman said, not unpleasantly, but she seemed to be speaking more to the cat than to us.

"Hello," I answered blankly. I couldn't see her face.

Because I assumed the house was abandoned, it seemed at first incongruous to attach the idea of an "owner." I glanced at Gina. Via eyebrows and forehead crinkles, we exchanged the sort of telepathic visual conversation that is the privilege of married couples.

Does she live here?

No no one could live here.

You think?

There's no way. Just look around.

We followed the real estate lady back up the curved step into the central hall. The floors were all carpeted in rotting patterned moss that crept up the staircase, the wall along its side covered with a dark tapestry that hid what we would later see was a dramatic bank of leaded stained glass. The heavy oak handrail dangled, broken. I didn't speak. Gina didn't speak. There was too much to absorb. We'd barely entered the house and already we were under its dark charm.

The real estate woman smiled tightly. "Like I said . . ." is all she offered at first, the space at the end of her phrase trying to do some explaining. Realtor jargon would not do her bidding here. "Fixer-upper" seemed like a thin joke and "old-house charm" couldn't get past the treacherous threshold.

The aroma was growing more complicated—cats, but also something wilder, infused with the scent of dust when it weaves itself into a blanket, spiced with the basement of a used bookstore.

She led us into the dining room, which anchored the end of the front of the house opposite the living room. The wall in the far corner had crumbled; water from somewhere. More moss carpet; a dirty chandelier dripping with diamonds; windows we couldn't see behind draperies we weren't allowed to touch. It had a fireplace with green-and-black marble and a mantel decorated with Beaux Arts garlands and ornate rose medallions in half relief across the front. Slender, Colonial-style grooved spindles supported the delicate manteltop. It looked like a trophy wife's wedding cake.

An extra-wide door opened into the kitchen, a sprawling utilitarian work space with a long butler's pantry that led all the way to the rear of the house and opened into the main kitchen room. Connected to the upstairs and basement by a network of rear staircases, the kitchen had six separate entrances, a nerve center from an era when the household functions were not to interfere with the household itself. There was an alcove where the icebox had once stood, with a little wooden door in the wall for deliveries; another alcove; and a breakfast nook. One tall, narrow door opened to reveal a wooden fold-down ironing board.

It was all painted in militaristic drab, the color of lost revolutions, and that color itself bore a nuanced patina, muffled with old grease. A dark patch along one wall suggested a chair may once have sat there, the wall stained by decades of leaning back. A stained ceiling and a wall of flaking plaster indicated a severe plumbing leak above. One door jamb was deeply scratched, as if by a dog, and covered with tattered lengths of duct tape. The windows were draped with dark green plastic curtains. The cupboard doors had rubber bands stretched from one handle to the next, holding them closed.

In the main kitchen area, spanning most of one wall, was a porcelain sink the size of a shallow bathtub, the red linoleum counter around it rotten through. The sink itself was gray with soot and grime. Danger was everywhere: danger in the stove; danger in the stained bucket under the spigot; danger in the cat-pee smell and the linoleum worn clean through to floorboards; in the olive, faux-antiqued cupboards, which, I deduced, no amount of primer could block.

I reached for the faucet handle and turned it. It trickled feebly into the bucket. Almost no pressure.

"Please," the real estate woman said. "We're not to touch."

Tucked into a corner, against a filthy wall, was a small metal utility shelf, holding a can of instant coffee and powdered creamer, paper cups and plates, a bowl of brown bananas . . .

Wait.

Someone was living here?

She was living here. The old lady.

I caught Gina's glance behind the agent's back. I nodded toward the groceries.

What . . . the . . . hell? I said with my eyes.

I know . . . she answered back.

Our guide led us forward, through a different door than the one we had entered. We found ourselves back in the central hall and followed the agent up the formal front staircase, transported now, mesmerized, unsure of which direction we had come, not touching anything because *we weren't allowed to.*

There was a gracious open hallway upstairs, a second-floor image of the one below, bigger even than our bedrooms back home, with a handsome wooden railing overlooking the staircase. It was packed with more stuff, set off by substantial wooden columns along the stairway, all painted in the same tragic eggshell that trailed all the woodwork in the house. Between the columns was a built-in bench with a velvet top, or what once had been a velvet top, now rotten, with the white stuffing hanging out, soaked and dried and dead. The bench itself was crumbling with dry rot, sagging, with a gaping hole where the center had collapsed. What manner of decay had attacked so completely? The wall beyond had eroded through layers of horse-hair plaster down to the terra-cotta building blocks. It looked like the faux distress in the basement walls of a yuppie brew pub, only it wasn't "faux." It was all terribly real.

A series of five doors opened off this hallway. Two led to the ser-vants' staircases—one to the kitchen and one to third-story maid and butler quarters. Two more led to the bedrooms and a bathroom at the north end of the house. The other, on the end above the living room, opened into a sprawling three-room master suite that occupied half the upstairs.

We went through that door first. In the main bedroom, a quarter of the ceiling had dropped and its oilcloth covering hung halfway to the floor, impotent duct tape striping its edges. The exposed lath that still clung to the ceiling joists was faded and stained from what must have been years of exposure to water from above. The intact plaster was mottled black and brown, riddled with cracks. When I looked up, I could see the shadows of another room in the next story, and above that, blue sky.

The floor and fireplace mantel were cluttered with buckets and plastic tubs and pots and pans, crammed tightly together, all partly filled with water. But they'd done little to stop the effects of the rain. Even the old carpet didn't hide the accordion of warped floorboards. I went to pull it back for closer inspection, but the real estate woman stopped me, reminding me of the rule. We looked around some more.

Despite all the things she could have chosen to comment on, Gina said she loved the color of the walls. They were painted a dusty pink, with a tone suggesting the patina of its years, appearing to be both faded by sun and darkened with soot. Tucked around a corner at the near wall was a separate dressing area with cedar closets and small English casement windows set high in the wall. At the far wall was a white marble fireplace with a wide mantel. These things became our focus. Their urgency competed with the urgency of the damage, and my imagination was making very distinct choices, selecting the pretty chandelier and not the ruined ceiling from which it dangled; focusing on the charming double-button light switch and its tarnished brass plate, willfully ignoring the surrounding wreckage of the walls.

There were boxes and piles and racks—one box filled just with coat hangers, shoe boxes in crooked stacks—all pushed into the area beyond the collapsed ceiling. It seemed as though we'd walked into a lifetime that had tumbled in upon itself.

Where did she sleep? Was this her room? It was open to the night.

One door at the rear of the suite opened to a long, cramped hallway of closets whose row of doors was streaked with brown and whose casings were rotten at the bottom. I wasn't supposed to, but I opened one of the doors and saw that the shelf was covered thickly with wet, rotting leaves, which had entered through the hole I could see in the roof valley above. On the inside of the door were tiny muddy handprints, which I recognized as raccoon. I closed the door.

There was a tall window at the end of this oddly tight corridor. I approached it, pushed aside the dusty curtain, and saw that we overlooked the driveway. The hallway fell dim as the curtain settled back into a place it seemed to have held forever.

One of the doors of this corridor opened to a summer bedroom at the rear of the house, encased in windows. The summer bedroom, sometimes called a sleeping porch, was a convention among health-conscious aristocrats of the early twentieth century. Not only did the wide banks of screened windows offer cooling breezes, but the sleepers

would benefit from the healing powers of the night air. In its present state, the healing powers in this summer bedroom would be abundant, as a large portion of the ceiling was gone and open sky was visible through the roof slats above. Also, one of the windows was broken.

One of the summer bedroom doors opened to the master bathroom, and I don't even want to go there, except to say that this must have been where the cats lived.

The tour continued back across the main hallway and through the other two bedrooms on the second floor. They anchored the front and rear corners of that end of the house, one above the dining room and one above the kitchen, and they were connected by a walk-through bathroom with a whole wall of built-in closets. Those rooms were filled with more of the same—decay loaded up with the detritus of some old lady's lifetime, an old lady who owned furs and whose furs had decomposed.

Who was she? Where did she come from and how had she come to this? Mashed together were piles of trash and expensive antiques, without distinction. What kind of person has a harp in the living room next to a pile of yellowed newspapers?

Nothing in the house seemed to work. Extension cords ran this way and that, and I began to understand that the house had only partial electricity. The real estate agent had mentioned, in as understated a way as possible, that the plumbing didn't work. Anywhere. I gathered from the old woman's posture that she had osteoporosis. Someone had to empty those buckets when they filled with rainwater. How did she manage? What did she do for a bathroom?

We went up to the third floor, the former servants' quarters: two bedrooms and a full bath, all trimmed with cherry woodwork, doors with handwritten signs reading, "If opened PLEASE CLOSE and rehook door." I opened one and looked into a large, unfinished room, the room I must have been looking up into from the master bedroom. Sunlight streamed in through gaping holes in the roof. On the floor were fifty-five cheap foil turkey roasting pans (I counted them later), lined up in rows, one touching the next, each containing an inch of

rainwater. In a back corner where there were no floorboards, one of the water-filled metal pans was set between joists, resting on the knob-and-tube wiring. And that alone would be enough, except that it was the *second* thing I noticed, the first being a wisteria—the same wisteria that crisscrossed over the driveway and covered the corner of the south wall—which had found its way in and grew in thick tangles across the floor, thriving in its invasion, with plenty of water and sun to keep it going.

We went back downstairs. Gina and I had continued trading glances of disbelief behind the real estate agent's back. When she could do so discreetly, Gina would pull the neckline of her shirt up over her nose to block the smell. We communicated with the agent only in half-knowing "mmm-hmmms" and "well-isn't-that-interestings." I had, at this point, little idea what Gina was thinking, nor she I.

I had begun counting fireplaces in my head. There was the one in the entry hall with the patterns under the paint. There was the big brick hearth in the living room and the formal fireplace in the dining room with its delicate scrollwork and slender white pillars. There was the white marble fireplace in the master bedroom and an almost identical one in the other front bedroom.

We descended a formal staircase at the rear of the house, passing through a lower-level hallway and taking another step into the basement billiards room. My fireplace count reached six, resoundingly, as my eyes rested on a massive brick hearth with fancy English tiles, magistrated by a heavy dark mantelpiece, the sort of thing around which mead is drunk. It was hard to take in its full value, though, because there was a huge billiards table in the way, a table whose green top was dominated by an amoebalike brown stain and whose ornate carved legs were split and discolored. The upper walls, where they hadn't crumbled away, were painted blood red; the lower walls were wrapped in dark beaded wainscoting. There were trash cans throughout the room, and when I got close, I saw that they were half full of water from the steam pipes. I could hear it dripping into one of them. How, I wondered, did the old lady empty these things?

As we stepped back up into the basement's formal hallway, the hardwood floorboards shifted and crunched disconcertingly underfoot. In some places, holes had rotted through. I worried it would give way, but since we were in the basement, I figured we couldn't fall far. The baseboards there had long hollow gouges and in some stretches had rotted away completely. The stairs were carpeted in a black runner with a baroque floral pattern, lush and gorgeous except that it disintegrated into burlap by the time it reached the bottom.

The end of the basement on the other side of this hallway, opposite the billiards room, was unfinished and looked as if it had been abandoned for a century. The gas burner from an old-time washing machine rested, rusting, on a concrete stanchion. In the adjacent coal room was a huge green coal furnace with an antique label that said Iron Fireman. The current furnace, a boiler, was filthy and disintegrating, dominating the center of the room, one side completely rusted away, with various-size pipes running from it, their junctions corroded, their lengths decorated with bandages of distressed duct tape and tightly knotted rags. There was a black iron contraption in the corner, as fancy as it was substantial. It looked like an ornamental nineteenth-century locomotive cookstove. I asked; the real estate lady said it was the water heater. It hissed.

When we left the billiards room and ascended the formal staircase back to the first floor, a certain reality pushed its way through the sensory overload and solidified, a reality that could best be expressed by the fact that we were *leaving the billiards room and ascending the formal staircase back to the first floor.*

A *billiards* room.

At the top of the stairs, we went through a wide door that took us into the kitchen, from the opposite end we had entered before. I paused to get my bearings, but before I had a chance, we went through another door into an arched brick alcove that opened into the outdoors. Our guide said we could go out back and see the reflecting pond. We stepped down into the rear driveway. These stairs, like the front steps, were broken and treacherous. It seemed there was no

safe way in or out of the house. The house sat on one and a half city lots, which could be described in real estate speak as "wooded," but in reality were overrun with all manner of out-of-control foliage. The same sort of untended chaos that defined the interior also filled the exterior. I looked. I couldn't see any reflecting pond.

In the backyard, wild mock orange grew in tangles of tall, chaotic bushes around the perimeter and throughout the grounds. There was a huge maple tree dominating the scene with a trunk more than four feet across, its thick limbs reaching out like the arms of Nosferatu. It darkened the entire yard. There was an ugly, open wound up the trunk, deep and wide enough to accommodate a gnome or, if it became animated and malignant in the twilight, *to swallow a small child*. Beyond the territory claimed by this dominant maple was a small forest of heavy mature trees and saplings of random height and placement. Dead limbs littered the ground, with a large pile of cut brush near the back corner of the property. There was a detached, badly leaning carport with shaggy, half-dead cedars growing along its side.

The extra half lot was on the other side of the driveway, creating an additional twenty-five feet of woods between this and the next house, which couldn't be seen from here. As I looked around, I realized I could see only hints of the surrounding neighborhood—a roofline here, a glimpse of a wooden fence through the thicket. The house seemed secluded within its own private forest.

I didn't see any pond and asked the real estate lady where it was. She pointed in the direction of a tall spruce tree growing next to the biggest yew I'd ever seen, which yew was actually growing *sideways* in order to survive under the umbrella of the spruce's limbs. I still didn't see the pond.

I could tell that this woman in business attire did not want to enter the snarl of branches, and Gina didn't either. I left them to chitchat while I picked my way through the brush to discover a large concrete pond, about fifteen feet by ten, strewn with rocks and boulders and half filled with black water, accompanied by a pretty, rustic waterfall and a second, smaller feeder pond uphill. I couldn't get all the way

to its edge because the mock orange was so thick. But the very fact of a pond, added to the six fireplaces and the stained glass and the billiards room and the ornate artistry of the brickwork between the Tudor beams and et cetera—all this was creating a heady exponent. The whole idea of this house was greater than its parts, and its parts were becoming more astounding with every turn. There was a half-rotten shed next to the garage wall behind me, and above its slanted roof, I saw that all of the mortar between the bricks of the garage was gone and one corner had crumbled.

I picked my way back through the undergrowth for a better look at the two-car garage. It was attached to the house, behind the kitchen. Its front wall was alarmingly bowed above the double doors, as if the bricks had melted halfway into a Salvador Dali illusion. The entrance was covered by heavy old barn-style doors, the kind that slide on thick rollers to open. I asked if I could open them, but of course I couldn't, it wasn't allowed, and the windows were too high up to see inside, but I could see clearly that at least some of the roof had collapsed, because the interior was washed with natural light.

From here in the driveway, I could see the damage to the rear of the house. The copper gutters and downspouts had gone green and brown and dangled uselessly from the edges of the roof and I could see that they were rotten through. (How does copper rot? I do not know.) The driveway was cracked and uneven and in some places crumbled to rubble. There was a pile of bricks next to a wild rosebush, clearly bricks from the house, dozens of them, and I looked over the facade, wondering where they had fallen from. So many bricks, and they all came from somewhere up there.

We went back inside to finish the tour.

The last room we saw was the worst. It was a solarium on the first floor, leading from the living room, with huge arching windows covering the south and west walls and an orange-red English tile floor below them. The walls were mottled with decomposed wallpaper and stained plaster, in some areas decayed down to the coarse base coat. Above us was the green corrugated fiberglass hole I'd seen that first

day. Part of the high ceiling was gone, revealing an ugly sight. Everything in that roof was totally rotten, leaves and debris spilling in, an announcement of unknowable damage. It smelled like a forest floor after the thaw. The wallpaper was in tatters. The screen door was in tatters. The draperies were in tatters. The floor was cracked. The radiators were rusted to burnt umber.

Gina and I looked up and what we saw was not the rot, but the crystal of twin chandeliers, as pretty as could be, dazzling with spite.

Our eyes met. We knew. We belonged here.

5]

what did you

wish when you threw

that rock

We hadn't expected this. We had been curious, yes. But there was so much about that house to inspire a different reaction—more negative, more cautious, certainly more ambivalent—that I wasn't sure how to read the tingle of excitement we shared when Gina and I got home and sat at the hand-me-down table in our semiremarkable dining room, a room that seemed suddenly inadequate.

I was sure, from the way Gina's face had soured at the smell, and from the way she'd shrunk from the filth and damage, that she wanted no part of this house other than to have toured it. Gina didn't even like gardening because she found the dirt to be "dirty." In a perfect world, she would have been married to a tall, handsome doctor, plucked from her homespun upbringing and transplanted into a clean vinyl subdivision. But the world is not perfect, and neither was her response to the house whose musk had penetrated the very fiber of our clothing.

"Do you think?" she asked, her words curling at the ends. "Do you think we could do this?"

The dining room where we sat was a particular kind of room, the sort of room well known to burgeoning Home Improvers, the kind of room whose remaking is relatively simple and modestly dramatic and entirely cosmetic and therefore introduces the sort of false confidence that has complicated young lives throughout history. The woodwork, which included a large window seat, had been painted white, and we had stripped the paint to reveal the very pretty golden oak underneath. What we didn't realize was how fortunate we were that the original varnish had created a barrier, keeping the paint from penetrating the grain. It slipped off like skin from a boiled chicken. We thought we were Masters of Oak. We'd hung wallpaper with a big floral pattern, a huge improvement over the dully painted walls, and an easy way to mask the cracks and imperfections in the plaster. We'd never considered the tedium of sanding. We were Wallpaper Magicians. We'd pulled back the carpet to reveal hardwood floors whose refinishing took but a single weekend. We'd tricked ourselves into believing we had a particular talent for this, when in fact we had accomplished only elementary redecorating.

"I know I could," I said. "I could do it."

"There's so *much*, though. I don't know."

"We'd have a fireplace in our bedroom."

Her eyes widened. "I *know*. It's like *Wuthering Heights*."

"And those buttons in the wall."

The real estate lady had shown us a mother-of-pearl button set into the dining room wainscoting, which she explained was to buzz for the servants, which hypothetical servants would be right on the other side of the door in the butler's pantry and could just as easily be called with a gentle "Jeeves?" or the tinkling of a little silver bell resting near the master's soup spoon. Getting up from the table to walk to the wall and press a button seemed like overkill. Then again, this house was all about overkill. (A billiards room, for instance.) But I had noticed another identical button near the front door.

"That other button must have been there in case someone rang the front doorbell," I said. "Instead of answering the door, the owner

would ring this internal doorbell and wait there for a servant to come and answer the door for him, then the servant would turn and announce that someone was at the front door, then wait for the owner to grant entrance. Isn't that cool?"

"We don't have servants," Gina said.

"Well, yeah. But we could eat boxed macaroni and drive shitty cars, and then we could save up to hire a cook and chauffer. To make the macaroni and drive us around in the shitty cars."

Gina and I were at a crossroads, and we knew it. She had grown frustrated with the increasing amount of time I was spending on house projects, but I just kept concocting more and more elaborate schemes. I was afraid of losing myself, but also afraid of losing the balance between us. There was a second baby on the way. Evan was developing at a breakneck pace. I was trying to understand us as a family even as we were actively changing, which is something like trying to understand calculus while juggling hummingbirds' eggs.

The possibility of this house seemed like some intersection of all these things, an explosion of the imagination vast and bold enough to incorporate every desirable aspect of self-actualization, realization of family, romantic love, domestic love, American beauty, and amateur masonry that I could concoct in my tragically impractical head.

Gina and I had never lived outside our parents' homes before we got married, and now we had only two impressions of home: the one that had made us and the one we had made ourselves. The idea of remaking another home into ours, one so challenging and grand—this seemed like an answer.

We didn't talk about that. Not directly, anyway. Instead, we sat late into the evening in our semiremarkable dining room, talking about the old-fashioned pearl push-button light switches, without raising the question of their wiring. We talked about the bank of leaded-glass windows across the back wall, and not about the fact that the glazing was falling from the hundreds of panes of glass that encased the house. (Because, really—on nights like this, who dwells on glazing?) We talked about the central vacuum system, which must have

been state of the art for its time, and whose machinery was still in place in the basement, looking like something from Stalin-era Russia. Throughout the house were brass fittings where the vacuum hoses would have gone in. I wondered if it still could work, which seemed an odd thought—tinkering with the novelty of an antique vacuum cleaner in a house so desperate for the most modern and powerful vacuums known to humankind.

We were, both of us, deeply engaged in selective observation, clinging to the elegance of cut-glass doorknobs in rooms whose doors themselves threatened to come crashing from the hinges.

There was no harm in this.

B y this point, I had begun talking about a Civil War–era barn that sat abandoned on property in southern Ohio owned by my friend Chris's family. I had, over beers, gotten Chris to agree (hypothetically) to allow me to have this barn, to take it down, piece by piece, numbering the pieces (as I'd seen a professional barn dismantler do, which in certain parts of rural Ohio is a bona fide occupation) and re-assembling it as my new home. I had begun dismantling that barn in my imagination, and hauling the pieces back to Akron (in my imagination), and finding a suitable place to put it back together and turn it into a house and figuring out where, for instance, the kitchen might go. I had, as I always do in these situations, asked my dad if this was possible, and he had, as he generally does in response, done nothing to dampen my enthusiasm.

Anything's possible. This is what good fathers tell their children.

These fantasies were more practical than they might seem. We didn't have much money. I had a master's degree in creative writing, which is something like a secular vow of poverty. I was working as a newspaper reporter, and had only been full-time for about a year. Gina had quit her job as a special-education teacher to stay home with Evan, running a small home-based day care to help make ends meet. As a result, every one of my convoluted plans involved some-

thing I could do cheaply, which almost always would require a vast physical challenge to succeed. By this point, that had become the formula—inexpensive and vastly challenging—and it fulfilled the practical reality of our finances; the less practical desire to find a unique place to live; and my wholly impractical, mostly secret yearning to find peace through chaos. The less this made sense, the more it made sense to me.

If I really wanted to make a house in Akron out of a barn in southern Ohio, there was no way to prove I would fail. This was a trump card. No matter what house I chose, it would still seem like a simpler proposition than *that*.

duet no. 1:

gina

I was not the kind of girl you would have expected to find in a situation like this. I am not the kind of girl I would have expected to find in a situation like this.

When kids in the neighborhood made mud pies, I kept a careful distance because I didn't want to get my socks dirty. My best friend always wanted to play pioneer; I always wanted to play with Barbie, Midge, and Ken. I had been camping once in my life, and never wanted to go again.

So I understood the first question people asked when they learned David and I were considering a house that looked like it was ready to fall down.

Why?

You would think I'd know the answer to that question, but it seems like the more I explain it, the more complicated it gets.

I knew David was done with our first house. He was finished inside, got bored, built a patio, got bored, put in a driveway, got bored, built stone pillars and a fence up front, got bored again, and

started building furniture. David was outgrowing what he could do to that house.

No matter where we went next, he was going to want to remake everything, and that was how he was going to spend whatever time he could. So why not restore a mansion?

I think the answer had begun two Christmases before, in the wee hours of the morning. We had been married six years, and I was pregnant with Evan. We had spent Christmas Eve as we did every year, at David's parents' house. We always celebrated it big. Lots of food. Lots of drinks. Five months' pregnant, I had the perspective of the wife who wasn't drinking. So I was able to watch David drink enough for the two of us. I was able to watch when his dad brought out a bottle of cognac and David, who doesn't drink cognac regularly (or maybe even "ever"), drank it like water.

On the drive home, David, weaving in the passenger seat, said he had one last little surprise to take care of for Christmas. Big secret, he said. I thought maybe he had some last-minute wrapping to do.

We got home at two A.M. and I turned on the television, setting the channel to the burning Yule log with Christmas music playing in the background. We never had a real fireplace when I was a kid, and this was as close as we came to chestnuts roasting on an open fire. I settled on the couch, tired, and waited for David to finish whatever he was doing so we could spend a few quiet moments here together before going to bed. David and I each had a ridiculous-looking pair of red Doctor Denton pajamas with a button-up flap on the rear, and we only wore these pajamas at Christmas. I couldn't fit my pregnant belly into mine, but David came galloping down the stairs in his, rosy with cognac and some surprise that had him acting like an elf.

"David, are you finished with the 'something' that you had to take care of?" I asked.

"Uh-uh," he slurred. "Justalittlesomethingtotakecareofinthe-basement."

I pulled my legs up under me and settled in with that absurd Yule log lulling me toward sleep. My head began to bob. My eyelids

were drooping lower and lower. I heard a sound coming up from the basement.

A drill? Is he using a drill?

Oh my God! He's hammered and he's using a drill!

I jolted awake and jumped off the couch, running to the basement stairs. I always felt a sense of dread whenever he used power tools down there, certain something terrible was going to happen. But I knew the worst thing was to yell for him, especially with all the noise. Over the years, I had developed a signal to get his attention. I would flick the lights off and on a couple of times and he'd stop working and see what I wanted.

So there I was, in the dead of night Christmas Eve, reaching for the light switch with a bad feeling in my stomach. I frantically flicked the basement lights off and on. The drill stopped.

"David?!" I scolded. "You can NOT be using a drill right now! You're drunk. You're going to hurt yourself!"

"Too . . . late," he said distantly, coming into view at the bottom of the stairs, just as I had begun my descent. His head was hung sheepishly and he was tugging at the stretched and mangled sleeve of his Doctor Dentons, looking like a slightly oversize child who knows he has done a bad thing.

"You drilled your arm! Didn't you? You're bleeding! What were you thinking!"

He said nothing. Just held out his arm. Inside the tattered rag of sleeve was a gnarled hole in his skin, an ugly mess that I knew would be mine to clean and dress. I took him upstairs and sat him down in front of the televised Yule log and I bandaged his arm.

Even though I wanted to yell at him, I knew there was no point. This was my life. I had a husband who had to be doing things like this, who didn't know when to stop.

Christmas morning came. My wounded husband went to the basement to wrap whatever it was that had caused him to drill a hole in his arm. He brought it up and set it next to the Christmas tree. We opened our gifts with the large package sitting there, a mystery to me.

I opened it last. It was a kitchen stool. It looked like something the Little Rascals would build. David said it was supposed to be "rustic." It was made with old scraps of lumber. David insisted he'd been saving his best piece of barn siding for the seat. It was smeared with black and red paint. David said it was a "faux finish." I wasn't in a mood to hide my disappointment, but I did my best to show appreciation, even when I tried to sit on the stool and it wobbled insecurely underneath me.

David still has a scar on his arm. I still have the stool, but have never been able to use it, for fear of breaking my neck.

rubber-city castles

For a few years in the early twentieth century, Akron was the fastest growing city in the country, rushing headlong into its nickname, "the Rubber Capital of the World." The city's tire industry was booming, and tens of thousands of people came for factory jobs. There is an old story that may or may not be myth, but is often repeated because it could easily have been true: an editorial in the *Los Angeles Times* fantasized wistfully that *perhaps one day Los Angeles . . . will be the Akron of the West!*

The city's architecture and neighborhoods blossomed and defined themselves stylistically mainly in the years between 1910 and 1935. Most of the city's visual personality reflects that era. The wealthy industrialists built mansions on the west side of town, upwind of the stench of burning rubber that defined the central city. Akron doesn't have a "millionaires' row" per se. Rather, it has twin, parallel promenades with all sorts of connecting grid work that forms a sort of millionaire's catamaran. One of those promenades is North Portage Path.

On that road, exactly one mile north of the house we were flirting with, is the most significant piece of residential architecture ever built in Akron. Early in the last century, F. A. Seiberling, the cofounder of Goodyear Tire & Rubber, traveled with his wife to England, studying Tudor style and buying pieces of old castles to be shipped back to Akron, where they built a castle of their own, the sixty-five-room, fifty-thousand-square-foot Stan Hywet Hall, Old English for "stone quarry." The Seiberling family took up residence there in 1915, and you can follow a timeline of Stan Hywet's influence through that part of Akron, with Tudor style seeping even into the street names—Hereford, Castle, Wellesley, and Berkshire. Stan Hywet is now a museum with an international profile.

Akron dropped, hard, in the Rust Belt years of the 1970s and '80s, losing the very community of tire-factory workers that had defined the city throughout the twentieth century. The city lost tens of thousands of residents, who migrated south for jobs, and it lost its status as the closely held center of the international rubber industry. Three of the four major tire companies based in Akron were bought by foreign corporations, and eventually the headquarters were uprooted from the town that had made them; only Goodyear remained.

But it didn't drop all the way. Houses in the well-built neighborhoods, for a time incongruous, fell to the remaining middle and working class; the city had enough resources and was of a manageable enough size—less than 225,000 residents—to keep itself from the harsher collapse suffered by places like Youngstown and Gary. It became a place for citizen scavengers, a place where someone with a humble paycheck but a discerning eye could settle into a home a few blocks from Stan Hywet Hall, a place where someone with the right sensibility could recognize the peculiar privilege of spawning children in a city where Goodyear blimps loll overhead and where Soap Box Derby racers gather each summer, a place that was once known as the Toy Marble Capital of the World, where clay marbles still, a century later, leach from the soil, a place that invented the Dum Dum sucker and the music of Devo and that eventually would produce one of the

world's most celebrated athletes (*games! it's all games here!*), LeBron James, who would complete the Akron myth by remaining here and building a castle of his own.

The poet Hart Crane lived here for a time, long enough to write "Porphyro in Akron"—

> *O City, your axles need not the oil of song.*
> *I will whisper words to myself*
> *And put them in my pockets.*

—before moving away and eventually committing suicide. I've often wondered why he threw himself over the railing of that ship in 1932. Maybe he discovered what Los Angeles already knew, that the world had nothing to offer like Akron.

This ramshackle house on North Portage Path didn't seem to fit. It looked like the mansions in the Stan Hywet district, but it was located a mile closer to the central city, in the workaday Highland Square neighborhood, nestled among much more modest houses and apartment buildings, conspicuous even without its condition. When you pushed through all the trees and brush, it towered like an insistent question—what is it doing *here*? Who built it, and why? I wondered what the neighborhood of seventy-five years before must have thought of its presence. Akron was in a growth spurt then, and the streets were quickly shaking themselves out, especially here, close to downtown.

The old apartment buildings in that stretch of Portage Path have a particular quirk: almost all of them are named after women, with the names displayed over the front entrances. Within a block of this Tudor Revival, there was the Betty Ann, the Janet, the Anne; Irene, Helene, and Kindy Sue. I've often wondered if they were built by proud fathers of young girls whom they wished to immortalize, or by philanderers who not only built apartments for their kept women,

but then had the balls to splash the mistresses' names over the front doors. These human names gave the buildings an aspect of personification, and I wondered if these brick ladies sometimes gossiped in the secret language of buildings about this darkly voluptuous Tudor that rose up among them.

Who the hell does she think she *is?*

I'd been driving by with increasing frequency, in a reprise of my orange Dutch Colonial forays, asking myself these questions. The house loomed with dark melodrama through all that tumbling overgrowth. One broken window in the attic had a sheet of galvanized metal nailed over it, gazing like an evil eye. More than anything, it reminded me of 320 Sycamore, the house from *It's a Wonderful Life*, made for throwing rocks and making wishes. When I was falling in love with Gina, I used to promise to turn the moon into a penny so she could carry it in her pocket. I realize this is a borderline plagiarism of George Bailey's pledge to lasso the moon, but romantic hearts have an outlaw bent.

Maybe we should have seen this coming. Each of our favorite movies—*It's a Wonderful Life* for me and *Wuthering Heights* for Gina—prominently features a drafty shambles of a house of major symbolic importance. We were cinematically vulnerable.

Here, in real life, one could not pass without wondering. How did it get this way? Who lived there? Who died? What lives had it known; what children had written on its walls; what plans had been made there; what tragedies had transpired? That, more than anything else, was its appeal. The house had mystery to burn. It had *story*.

Soon we began to learn that it was not our own secret. Anytime we mentioned having seen it, whoever we were talking to would report having looked at it as well. At first this seemed like a startling coincidence; soon it became more of a surprise if the person had to ask which house we were talking about. The house had been on the market for a year or more; apparently the old lady had kept a homespun For Sale sign in the front yard even before enlisting an agent. It seemed that every single person in Akron had been inside, or at least

peeked in the windows. Most people thought it was abandoned, and it was common to hear of innocent trespassers who tried to see in past the overdone drapes.

"What a shame," people would say.

This led to an obvious question that grew increasingly troublesome. None of them had ever made an offer. Few had even considered it. None of them ever talked about "potential." Most, in fact, spoke of it in the past tense. One story circulated about the neighborhood apartment landlord who tried to buy it at a bargain price so he could tear it down and put in paid surface parking. The place was, to most, a public curiosity, not a "house" that someone might actually "live in." Usually the smell of cat pee entered these discussions, and that seemed to provide its own answer. Most often, the theme was that you'd have to be crazy to consider taking it on. Usually, Gina and I looked at each other, aware that we hadn't stopped toying with the idea, and vaguely puzzled by the question of *why*.

I went to the public library and worked backward through the old city directories to learn what I could of its history. Property records showed that the house was built in 1913, but the directory indicated it wasn't occupied until 1917, by an inspector with the B. F. Goodrich tire company. Ten years later, the treasurer of the booming Goodyear Tire & Rubber company moved in, followed quickly by the vice president of a small rubber company who then founded a successful local shoe store. Then another owner, and then, in 1938, the family that owned it now.

Radner.

The family owned a piano store, which seemed still to be in business, though I'd never heard of it and could find no sign when I went looking. Following the clues in the directories, it appeared that the old lady married Mr. Radner in 1948. His name disappeared from the listings after 1965; hers stayed. Had she been alone in that house since then? Was that the beginning of its decline?

I also researched the real estate records. It was hard to do a price comparison to other nearby homes because this house was simultane-

ously the nicest and the worst house in the neighborhood. Other prop-
erties around it had sold in the $75,000 to $100,000 range, but when
I drove by and looked at them, I didn't see how they could provide
a basis for comparison. They were Highland Square houses, older,
well kept and semiremarkable, in a decent neighborhood. They were
safe and predictable places that played by the rules of the market, and
their prices made sense. Nothing about the Radner house, as I had
begun calling it, made sense. It played completely by its own rules, or
rather its own anarchy. Strangely, I felt as though this was a negotiat-
ing advantage.

The house originally had been listed at $165,000. It had been on
the market for about a year and a half, and the asking price had gradu-
ally come down, to $148,000, then $129,500. After the second Real-
tor took over, the price had dropped to $110,000.

Even with the reduction, the price was ridiculous. It also was out of
our range. Therefore, I decided it was irrelevant. We'd paid $40,000
for our semiremarkable house, and we were thinking that with all the
improvements, we probably could sell it for $80,000 and could afford
something maybe up to $100,000.

Every house we had looked at was more than we could pay, but
we didn't like any of them as much as the house we already owned.
Meanwhile, the pregnancy was creeping forward, pressing its hint
against Gina's belt line and creating its own pressure on our need to
find a larger house, to find the right place to settle.

She drove home from the grocery store one afternoon with Evan
strapped in his baby seat, pulled up the brick driveway, and caught
a flash of movement in the rear mudroom, just enough to be sure
something was wrong. She put the car in reverse and rushed to a tele-
phone; by the time the police arrived, whoever was in the process of
breaking into our house had fled. But we were left with the realization
that we had to move on, that whatever entertainment we pretended
to derive from living between a quick-cash machine and a drug dealer
was not the right place for our children or for us.

We had to find a house. Of those we had looked at, the only one

that had kept our attention was the dissolute mansion on North Portage Path. What if we made a really low offer? Maybe it would be rejected. But it would be something, a way to get this notion out of our system and move on.

E arl Givens was in his second career, selling real estate after thirty-four years as a Goodyear factory worker and union official. His natural idiom was the condominium. Seventy-four years old, with a head of thick white hair and the energy of someone half his age, he lived next door to Gina's sister Jo-Ann, in a cunningly efficient vinyl-sided ranch house on a street of cunningly efficient, vinyl-sided ranch houses. Those were the types of homes he was accustomed to dealing in, the kinds of places that can have warranties attached without concern. He had never dealt in historic homes, or those in need of extensive repair. Nevertheless, we chose him as our agent. He was like extended family, and we knew him to be a warmhearted man. This is how professional relationships are forged in places like Akron, by people like us.

Gina had been telling her five sisters about this house, and Jo-Ann especially had been swept up by the intrigue, picturing something from a wall calendar, something antique and romantic, something with patina and perhaps some heirloom roses. When we made arrangements to take Earl through the Radner house, Jo-Ann insisted on accompanying us.

We had prepared Earl as well as possible, but he seemed legitimately confused when he pulled into the driveway, stepping out of his sensible late-model car and looking the facade up and down.

"The tuck pointing . . . ," he said, choosing the first available travesty, looking at the wall, and then back at us, at *me*, as though I might explain.

He seemed like a man suddenly faced with the challenge of rock climbing without any previous notification, looking for a toehold as he was being prodded from behind. Jo-Ann studied the exterior blankly.

We entered and the real estate woman began the tour with her standing Do-Not-Touch order. The old lady was not here this time. Earl tried to keep a poker face, which is to say that he looked like a man trying to keep a poker face. He seemed overwhelmed by the thought of us taking on such a burden. He seemed paternally upset. At the same time, he was trying to maintain his professional attitude.

Jo-Ann made almost no effort to conceal her disgust.

"That *smell*," she said in a stage whisper. "I think it's singed my eyebrows."

She harped on the cat smell all the way through the kitchen, pausing only when we got to the living room, where she gasped with delight at the harp, that golden harp rising like Venus from the clamshell of mildewy piles. On the way up the stairs, she began scratching at her arms.

"Mites," she said. "I'm breaking out in *hives*."

I looked. She was. I decided it was psychosomatic, but said nothing.

Earl maintained some aspect of a professional demeanor, but most of the standard questions were not working for him. Inquiries about "updates" and the "age of the roof" were pretty much rhetorical.

As we stood in the master bedroom under the corrupted ceiling, trying to get a straight answer about the extent of damage hiding under the moldy carpet, Jo-Ann wandered into the dressing area. She was in a reverie. Behind a half-open closet door, she'd spotted a wedding dress, a princess sort of thing, the dress she'd dreamed of years before when she was engaged, a dress that existed only in theory, in fantasy, in Audrey Hepburn's secret collection. There it was, draped in plastic, yard upon scalloped yard of cream-colored Belgian lace, layered from yoke to hem, with a pink satin ribbon tied in a bow at the waist. Gina was standing close to her, and Jo-Ann discreetly nudged her. Gina turned as Jo-Ann lifted the plastic for a closer look.

The real estate lady pounced like a mother wolf:

"The *proprietor* gave express instructions that *no one* is to touch *anything* in this *house*!"

Jo-Ann shrank. She apologized loudly, but also in a tone that suggested she didn't think it was all that terrible just to have a little peek. Based on the agent's reaction, I was beginning to get the strong impression that she was not acting to defend the owner's wishes so much as to defend herself. She seemed afraid of getting in trouble. I knew by this point that the house was being toured incessantly by curiosity seekers with no intention of buying it, and I had a feeling that the last transaction had not fallen apart by accident. The edge in the agent's voice suggested she was losing patience with this assignment and all it entailed, and especially with Mrs. Radner.

By the time we approached the master bathroom, Jo-Ann was scratching her arms furiously. The door opened, and she gagged and coughed at the smell, shrinking back.

Moments later, approaching the stairs to the attic, she excused herself—had to get some air—and began a retreat. Earl, feeling responsible for her well-being—for everyone's well-being—said he would lead her back down.

Outside, gazing at the omnivorous wisteria, Jo-Ann made a plea to her friend.

"Oh my God, Earl. They cannot get this house. I pray they don't get this house. I will pray *every day* that they don't get this house."

8]

the man in the
little yellow truck

arl insisted that if we were to continue with this, we needed to get a professional inspection. In what was becoming a pattern of paradoxes, this seemed both completely ridiculous and completely sensible. It certainly didn't take a qualified contractor to identify the house as a wreck. On the other hand, professional confirmation would make it easier to present the offer formulating in my head, an offer low enough to require some pretty detailed evidence to support it.

I called my dad and asked him if he knew anyone who might do the job. (This is how professional relationships are forged in places like Akron, by people like us.) He said he knew a guy, a self-employed contractor who did residential work. Heart of gold; light touch. Kind of an odd duck, but a good egg, a blue-collar intellectual with a semi-bohemian past in California's wine country. Most of his current work was handyman-type stuff for his church, but my dad said he'd done some interesting historic-renovation work in California. He sounded just right.

We were to meet there on a weekday afternoon. The real estate lady had made the usual arrangements for the house to be opened up reluctantly to strangers who were forbidden to touch anything. Screw that. Today we would be touching things. I got there first and stood in the driveway, waiting for the contractor. It was late summer by then, everything in full leaf. The sun filtered through the natural roof of trees and vines—wisteria, clinging to everything like teenage lust!—and it cast golden peace over a scene whose corruption was becoming, by the day, more intoxicating to me.

I waited halfway up the driveway, which ran along the left side of the house and wrapped around the rear. As I stood there, I considered the severely overgrown cypress trees that flanked the entrance to the solarium, which entrance was cloaked in the alligator finish of dull yellow paint that covered all the windows on the house. The steps leading to the door had heaved out from the wall, leaving a three-inch gap, giving the impression of the house as a ship, leaving its dock. Up above, where the wisteria began its way into the brickwork and eventually the attic, the dark brown half-timbers were rotten through, white with mildew, and painfully warped, their nails exposed, gradually losing their grip.

Standing there looking, I felt a thrilling desire: I *wanted* this house to be bad. I wanted to own it, and I wanted it to be the baddest house in all of Akron.

A faded yellow pickup truck, undersized, scratched and rusted and spattered with paint, pulled up. It had a big white propane tank in the bed, right behind the cab. I approached. The door opened. The man who got out was a portly fellow with a beard and the thickest hair I have ever seen, like an Old English sheepdog. He must have had two follicles to every one of mine.

He took a big step backward and looked the house over before turning his attention to me.

"Did you ever see *The Money Pit*?" he asked, then grinned and extended his hand. "Steve Braun."

I shook his hand, noticing how fine it was, smaller than I would

have expected for a body as large as his, and soft, almost delicate. He was wearing jeans and a plain navy T-shirt and a pair of pull-on Red Wing boots. Even as we shook hands and I introduced myself, I saw that his focus had settled on the house. He had a Polaroid camera and he half lifted it as he stepped back, smiling slightly, with a barely perceptible exhale squeezing through his lips. He snapped a picture. The real estate lady had been inside, peeking through the curtains, and she opened the front door with that awful plastic sheet of faux stained glass to usher us in.

Steve walked into the front hallway, fanning the Polaroid he'd pulled from his camera. When it was developed, he slipped it into his back pocket.

"Which way's the basement?" he asked, taking charge. The lady pointed to the two entrances, the servants' staircase off the kitchen to our right and the wide, formal oak staircase that led to the billiards room. The agent, perhaps realizing that our inspection would require us to break the touching rule and not wanting to witness the infraction, took a seat in the living room and opened up a file folder, eyes down. We approached the formal staircase at the back of the center hall. Steve paused and grasped the round banister, oak and three inches thick. He pursed his lips.

"*That's* a railing," he said.

He walked down slowly, as if he were taking a measure of the experience of these steps, which were not mere stairs, but the Passage to the Billiards Boom. The *billiards* room.

Whatever elegance this experience may have held drained away after the stairs turned at the landing and we took the final five steps to the bottom. There, we entered the once-formal hallway with its uncertain floorboards. Under Steve's considerably greater weight, a board gave way, crunching like balsa.

"Could be termites; could be dry rot," Steve said without judgment. I think he was smiling, but I'm not sure.

We started in the laundry room. It was piled high with the same sort of stuff that filled the rest of the house. A pretty antique dresser,

water damaged and leaning back on its broken legs. Jars and bottles; piles of clothing; stacks of magazines; a motor of some sort, removed from service. Odd plastic containers, piles of hangers, a dented Dutch oven. The old lead-lined washtub sat on angle-iron legs that had rusted nearly through, and I realized that even a slight bump could bring it crashing down, ripping loose the supply lines and perhaps crushing someone, possibly me or my son or my wife or the child forming in her womb, mocking us with spouts of water from the broken pipes, twin blasts of vaudeville seltzer, hot and cold.

Normally this would raise a concern, except that the damage and danger all around us made everything seem not only relative, but psychedelically so. The ceiling drooped heavily and dripped with cobwebs and flaking paint and strange extensions that looked like stalactites made of dirt. The thick plaster on the walls was reduced to piles of horsehair-infused sand on the floor and the walls were stained and restained with rust streaks and calcified blotches where the leaky steam lines and water pipes had left their mark. The walls seemed poisonous. The whole basement smelled of something that had been soaked and dried and soaked and dried until its scent had texture in three dimensions: one old, one new, and one fermenting.

Steve was looking at the fuse box. It looked like something out of Dr. Frankenstein's laboratory, an ancient, rusted metal panel with flaking silver paint and a big single switch in the middle. On. Off. Two fat wires emerged from the top, and an extension cord appeared to be spliced onto them. The cord was draped over the water pipes and trailed off into electrical mystery. Steve stepped back, aimed the camera with those fine, whimsical fingers, and shot a Polaroid.

"We're just going to leave that alone," he said in a cautious half voice. Then, a little more encouragingly: "It'll need a new service. No saying what the wiring's like, but knob and tube is pretty durable."

We made our way through the house this way, tiptoeing between doom and hope. Steve saw the pretty things, commented on the stucco work and how no one does work like that now, not with that kind of texture. And he saw things that made him wrinkle up his face

with curiosity and disgust—the actively rotting red linoleum kitchen counter, for instance, made him pantomime a terrified shudder. He turned and gave me a reassuring grin.

"Cosmetic," he drawled.

On his way up the main staircase, he lifted his thick arms in a balletic flourish.

"Proper stairs should feel not like you're climbing, but being carried forward," he said.

There was a nice handrail there too, but it was whitened and split open from water damage; the bottom end dangled, broken, from its bracket. Doom, hope; doom, hope, all the way through.

At the top of the stairs, he pulled back the heavy brown drapes and whistled low, either at the sight of the stained glass, or at how far the casement was heaved out from the wall. He pulled back the carpet in the master bedroom and saw oak floorboards cupped and curled and mildewed not only beyond repair but beyond recognition as "flooring." When he was sure the real estate lady wasn't looking, he bent in low under one of the fireplace mantel tops and used the blade of his utility knife to scrape off a bit of paint, revealing the wood.

"It's an exotic. Maybe pecan," he said.

He hitched his belt up against his large belly, something he seemed to do whenever it was time to quit standing around and move on.

Gradually, we confirmed that the house had no running water. Every time we turned a faucet handle, we got nothing, not even air. Only in the kitchen sink did we get a trickle, but there was a large corroded hole in the drainpipe. That must have been why the old lady kept a bucket below the spigot—to collect her water. The basement lines to the washtub worked, but that was it. The electricity had been turned off in about half the house, and we presumed those fuses had been removed for safety concerns. The furnace, if it did work, was something you would not want to mess with; an entire side of its casing had rusted away, all the pipes were crusted with brown/green corrosion, and the burners were exposed to the room.

We spent the most time in the attic, behind the doors marked DO

NOT OPEN. It smelled wild in those raw, unfinished rooms; it smelled heavily of the animals that I knew must be lurking just out of sight; it smelled like wood turned back into earth; it smelled like rust and autumn in the Black Forest and the funk of an old lady all mixed together. The house had a complicated roof, and every valley was ruined; debris had piled up in them and held the water in to do its damage. Steve said raccoons will scratch away at a mossy roof and, looking up through one of the holes, I could see vivid illustration in the torn and chewed edges of the decomposed shingles. The raccoons were eating the house.

We went back downstairs. I realized that you could go all the way from the attic to the basement using only the servants' staircases, never entering the "formal" part of the house. Conversely, you could live in the decorated, oaken main house without ever crossing into the more simply outfitted back rooms. Nowadays, kitchens are formal, tricked-out lifestyle spaces. In this house, the kitchen area was more like a workshop, linked by conduits of back staircases. There was the breakfast nook, but it seemed that this was where the help would take their meals, rather than the master, say, sipping his grapefruit juice while he dashed off a note to the family.

We returned to the living room, where the real estate lady was still seated. We thanked her. Steve said he wanted to look around a little more outside, an open invitation for her to leave, which she recognized. She left, locking the door behind her. Steve walked around the back corner of the house and gave me a "c'mere" nod.

"What does she want for this house?" He was speaking conspiratorially even though we were alone.

"One-ten," I said.

"Forget that," he said. "I've never seen anything this far gone that was still standing. It'll cost more than that to fix. It needs everything. But—it's still standing. And that means it can be fixed."

That was the only thing I wanted to hear: a professional validation of my wild hare.

Still standing. Can be fixed.

We walked back toward his battered little truck. The bed was filled with rusty tools and half a bundle of shingles and five-gallon buckets.

"What's the propane tank for?" I asked.

"That's what it runs on," he said.

"It runs on propane?"

"Yeah."

"Why?"

"Used to be a gas company truck. I got it cheap."

He pushed back his thick bangs and smiled like he was smarter than everyone else who'd missed the chance on this ugly yellow truck.

Over the next few days, Steve worked up some numbers. He estimated it would take a minimum of $60,000 to get the Radner house into bare-bones livable condition: roof, running water, electricity, heat. He also said someone could easily spend a quarter million dollars rehabbing it. I immediately (and, yes, arbitrarily) cut his estimate in half, because I believed (arbitrarily) I could do at least half of the work that he insisted would have to be done by contractors. I, for instance, figured I could learn plumbing well enough to plumb a house. I knew a couple of plumbers, and they didn't seem any smarter than me. Steve said the attached garage would need to be torn down; that job would cost at least $1,000. Building a new one would cost at least $5,000 more. But when I looked at the garage, I saw two partly intact walls, which was essentially half a garage, which was enough for me to believe it could be saved. So I just subtracted those numbers. And I was pretty sure I could get some friends to help me do the roof. (I ignored the fact that that roof was higher and steeper than anything I'd ever set foot on. Much less these unwitting friends.) I was creating my own reality.

I didn't share these private calculations with Steve. Nor with Gina. In the first place, she's not a fan of me-on-a-ladder, and in the second place, she knows this is how I always do math. If I say I'll be up from the basement in ten minutes, she knows that means to check back

in twenty. In a similar calculation, I'd tricked myself into believing that Steve's number was essentially fiction, therefore I could rewrite it with a fiction of my own.

I cut his number in half: thirty grand. Then I rounded it down to twenty-five. Why not? There is power in naiveté, believe me. I had already gotten a lot accomplished in life with that power.

Make it an even twenty. We could swing that.

9]

walk into

my parlor said the

spider to the fly

Gina and I were cooking. Evan was asleep. This was how we defined our Saturday nights together: the time between when the baby went to bed and we went to bed. Before Evan was born, we had the luxury of deciding spontaneously what to do with a weekend; now we tended to treat domestic chores as "us" time, which was necessary and also its own comfort. Growing up is the process of imitating who you think you're becoming. Arriving there, if it happens, is when the imitation is no longer evident. So we were learning to be people who could coexist comfortably in a room with sharp knives and open flames and inexpensive wine.

"What if we just made a really low offer on that house?" I said, ripping up lettuce.

"How low?" she said, bending down to adjust the gas under a pot of water.

"Well, if you look at the other houses nearby that have sold recently, they're, like, in the seventies. And this one needs so much work. What if we offered sixty thousand?"

"They're asking a hundred-ten," she said. "That's barely more than half."

"I know. But I would take that house only if I could get it for a steal. I wouldn't pay what she's asking."

She straightened up.

"Sixty thousand? Won't they be insulted?"

It was September; Gina was more than a month into her pregnancy. Both of us had reached the point where we were ready to do something, either really try to buy this house, or really get serious about finding something else. We needed to take action, whatever it was. I was suspended between the house's illusion and its reality—what it could be and what it actually was—both of which were attractive in their own way. And I honestly couldn't decide which I wanted more: to get the house, or to get the house out of my system. I was pretty sure Gina was right, that we'd be rejected. The lowball offer was a way for me to be able to convince myself we'd tried, and to move on.

"Do what you want," Gina said. This is what she says when she agrees with me but doesn't want to be blamed if something goes wrong. I'm almost always willing to accept it as full approval to do something without having to decide if it's a stupid thing to do.

I've never seen a house that bad," Earl said. "The tuck pointing . . ."
He was sitting across from us in the Gilligan's Island chair. We'd invited him over to discuss the possibility of making an offer. He had that same look of concern he'd had the day we toured the house, as if he was in deep conflict between professional and personal instincts. Jo-Ann had begged him to protect her little sister from this place that had given her hives, yet she also was the one who had recommended him to do our bidding.

I looked at him, realizing that he could, if he wanted to, end all this right there. Part of me wanted him to do just that.

Talk me out of it, Earl. Give me a reason why this cannot work. Give me some inscrutable professional rejection. Radon. Mustard gas. A Gellar

in the cellar; a Woset in the closet. Tell me the Borfin's gone schlump. Say
something I can't understand and must accept on a greater faith than my
own. Tell me this simply cannot be done and that's that and the reason is
Because I Said So.

"I want to make an offer," I said.

"Can you really do that work?" Earl asked.

"I did all this," I said.

He looked around the semiremarkable living room. I had done the floor. I had done the walls. I had done the pocket doors. It was all just surface stuff, but it had trained me to believe I could do more. It was real, yes, but it was also illusory, the Home Improvement Superstore version of trompe l'oeil. I recognized a hollowness in my voice when I spoke next, confirming my request.

"I want to make an offer."

Earl set his jaw.

"How much?"

"Sixty thousand."

He frowned and shook his head.

"You can't do that. You'll insult them."

Insult? This was something I did not understand about real estate negotiation. Did it operate under some anachronistic code of decorum? Was it the only remaining aspect of American society that cared whether anyone's feelings got hurt? And if so, why? Why real estate? Why not highway transportation or digital correspondence or the buffet line? Those things could benefit from common politeness far more than the buying and selling of property.

And besides, hadn't he smelled the place? That was a ten-thousand-dollar smell, easy. Plus, I'm pretty sure I'd heard scratching in the wall. Knock off another five.

"It's been on the market for a year and a half," I said. "One deal has already fallen through. My thinking is, I would buy it for sixty. If they say no, they say no. We can say we tried and that's it."

Earl looked at Gina. I think he hoped she might swing this in a different direction. That perhaps the baby inside her would speak

more sense than the husband. But I already knew what she was going to say. Gina had always dreamed of living in a house like this, and she knew the only way she could was if we bought a wreck. She didn't want to do it, maybe, but she didn't want to *not* do it even more.

It could have been different for her. She could have married for money. She could have married for anything she wanted. But she'd married for love, and this is the sort of sweet trouble that comes from that decision. It puts optimism into the hearts of the innocent. It coos to them in the twilight. It promises moons in their pockets. It convinces them anything is possible. It leads them into the thick of disorder with only each other to find a way out.

"I want to make the offer," Gina said.

Earl girded himself for the task. This was professionally uncomfortable for him, but he knew the owner's agent was obligated at least to present the offer. He did the deed the next day and we waited. A few days passed. Earl called. They'd presented a counteroffer.

"Really?" I said.

For some reason, I hadn't considered this possibility. I'm not particularly proficient in the art of negotiation. I don't accept complete blame for this, at least not unilateral blame. It just seems to be part of my natural relationship to the world. I avoid dickering and it avoids me. When we bought our semiremarkable house, it was For Sale by Owner. We walked through it once, called the owner that same evening and offered him forty thousand. He clapped his hand over the receiver, called into the next room, "Honey? What do you think about forty thousand?" then came back on the line and said that would be fine and we were done.

As a result, real estate transactions seemed pretty cut-and-dried to me. I figured our sixty-thousand-dollar offer was all or nothing. They would either accept it or they would reject it and walk away, presumably insulted.

"How much is the counteroffer?" I asked.

"They came down five thousand," Earl said.

"What does that mean?"

"It means you're still in. It means you can make your own counteroffer."

I talked it over with Gina. We decided that we would make the same move, five thousand dollars. We also agreed that we would not get swept up into back-and-forth bidding that would end with us paying too much for the house. We would offer sixty-five; if the process continued, we wouldn't go beyond seventy.

This felt strange. I couldn't get a feel for what might be happening. There was still a vast difference between our offer and theirs. Were they thinking we would come up? Or maybe that they'd come down? I couldn't tell.

Mrs. Radner was a mystery to me. She should not have been living in that house. It was not safe. It was not comfortable. It wasn't pretty, except to people like me. But she *was* living there, which meant she was either caught in a Tennessee Williams delusion, believing this house was something it once had been but no longer was, or she was a durable and harshly determined woman who knew exactly what she was dealing with and was doing so without working plumbing, which if you ask me is pretty badass. Either of those possibilities made it hard to try to read her mind. If, as I had deduced, she had been living there since the 1940s, she was not likely to give anything up easily.

Earl presented the $65,000 offer. We waited. A few days passed. A week. My days were filled with the distraction of wondering what might be happening behind the grimy windows and moth-eaten curtains of the Radner house.

Was Mrs. Radner stringing us along? Was she giving serious thought to accepting our offer? Was she realizing that I was indeed a superior individual filled with a unique combination of yearning and vision and capableness and yea I was the Chosen One she had awaited lo those many years; I was floating into her life in a basket made of reeds, to claim and redeem her legacy?

All I knew was that the slow passage of time was having a dynamic

effect on my desire for that house. Each day, I wanted it more, and each day I was afraid that perhaps something had gone wrong, that yes, we *had* insulted her and she would not even give us the dignity of a response and I would be heartbroken. At the same time, it was all seeming less real, slipping away from tangible consciousness and into the realm of fantasy; the house was never real to begin with, this had all been a waking dream and we were back to the mundane process of hunting for houses whose prices neatly matched their curb appeal and general condition without drama or intrigue; that we would be relegated to the box that was designated for people like us, barely middle class, the Semiremarkable Box in Our Price Range. Every Saturday, the newspaper's real estate section would have exactly two (2) possibilities for us to consider, and none of them would ever bring a surprise, none would ever offer the tantalizing possibility of a life we'd begun dangling before ourselves, a life of butler's buttons and summer bedrooms. They would have homely chain-link fences or shared driveways or architecturally insensitive replacement windows and that would be our future: a future without distinction.

Why was that not enough for me, or for Gina? What was so wrong with it? I do not know. The answer, I suppose, was in the twin chandeliers of the solarium, the place where Gina's eyes and my eyes had met. Melodrama? Probably. Sure. I think that's what we were after. Melodrama: an exaggerated, fictionalized drama to buoy a life that was quickly becoming domesticated.

It's true that marriage and home and, most of all, children prompt us to become settled, to graduate toward comfort and security. But domesticity is also a place of creation, where strangers take root inside a woman's body and emerge . . . *as small humans!* Children remind us of the life outside the narrowing path of adulthood, of the danger but also the urgency and possibility. Watch the way they jump over and over and over again from the top of the picnic table, throwing themselves into the air with the belief that one of these times, maybe, *perhaps*, they actually *will be swept up into the act of flying*, carried by those wings that, until this life took over, protruded from their shoulder

blades. That they will be carried by their joyful exigency into a realm just beyond the memory and expectation of earthbound existence. They never think about the crashing.

Invariably, the father watching these children jumping incessantly from the table will ask the wrong question:

"What are you *doing*?"

The answer is in the act. The question *is* the answer:

"What are you doing?"

Exactly, daddio. I am doing *what*.

Gina was out. This was a Thursday in early October, and Gina spent every Thursday evening out to dinner with her sisters, in a social circle I envied for its raucous intimacy. Though I was not directly a part of that circle, it's where I always tried to place myself at family gatherings because it was always the most fun. Gina and her five sisters sometimes seemed less like kin and more like a group of random women who met in college and stayed close friends for life. Their ages were stretched out across a generation: Gina was the youngest, and her sister Diann was old enough to be her mother. Their appearances and personalities ranged wildly: Jo-Ann, petite and curly-headed, was refined and maternal; blond, voluptuous René would sing Motown at the drop of a karaoke nickel; Carole, wiry and zealous, was a lively raconteur.

Because of the standing night out, Thursdays had become my weekly night alone with Evan, him pulled up close to the table in his high chair like a small man here to discuss the matters of the day over cognac and cigars. Or sippy cups and pacifiers. With men, socially and emotionally, it's all the same universe, be it a mosh pit or an ice-fishing circle or a video-game tournament. We engage in shared solitude. Even in our most communal rituals, we are alone. My first job was as a ball boy for the Cleveland Cavaliers, and I first recognized this then, in the dressing room, when a group of men who were a team each sat at their lockers after a game. Never before had I seen

men together who individually seemed so alone. (They lost nearly every game in those days, so that may have had something to do with it. But still.) I have seen it many times since.

Evan and I were at the dining room table when the phone rang. It was Earl.

"She accepted."

"What?" I said.

"Sixty-five. She accepted the offer."

My insides curdled. "Well—I—I need to talk to Gina about this."

"No," Earl said, laughing nervously. "You don't understand. You just bought it."

"We—did?"

I thanked Earl for the news, hung up the phone—I didn't know where to turn. Evan was no help. I told him—*guess what?!*—and he slapped his hand against the high-chair top with the serious little laugh that was his calling card. I paced the floor, index finger tapping against my pursed bottom lip, absently inspecting the seams of the wallpaper. I turned back to Evan.

"You want to live in a house with a tree in the attic?"

"Da—"

"Do you know how to fix electricity?"

"Cup."

He held out his plastic cup. The juice was gone. I took it.

"Oh—" I breathed out hard, trying to quell the flutter inside me. "What are we gonna do?"

I put Evan to bed at seven and I waited. Gina came home. I watched her from the kitchen window, watched as she closed the old swinging doors of the garage and walked to the back door and through the mudroom that she had scraped and painted with her own hands and where not so long before she had nearly walked in on an intruder.

"Earl called," I said.

Her eyes narrowed.

"And?"

"We got the house."

She screamed a burst of unqualified game-show joy and threw her arms around my neck.

"We got it?" She pulled back to look me in the eye, cupping my cheeks in her hands. "We *got* it!"

Her reaction meant only one thing. She had complete faith in me. She had believed me all those times I said I could do this.

I felt something wind itself tight inside my stomach as I held her close.

She believed in me.

We put the semiremarkable house on the market. It sold in two weeks. Part of me wanted to grab it by the banister and drag it back to me, pleading for forgiveness, promising to be true. *Please, it was all a mistake, curiosity, I was exploring. It happens; it's natural. It doesn't mean I've stopped loving you . . .*

Everything familiar, everything comfortable, everything I thought I wanted was now in the process of trade.

We could make a decent down payment. We had applied for a loan that would cover both the mortgage and the cost of getting the house habitable, which we had set at $55,000. Just enough for a roof, running water, working electricity, and a new boiler. This work would need to be done within thirty days after closing. I was not allowed to act as the contractor. This was in writing. As such, it cut harshly into the punk-rock spirit of the endeavor. The idea that I would do it all, on my terms, without the "Man" and his "building codes" and "safety procedures" and whatnot—this was contractually compromised.

The job went to Steve Braun. I liked him, but I didn't yet have him

figured out. There are certain conundrums associated with the early stages of male bonding—especially for someone like me who frets way too much about such things—and I hadn't resolved all of them yet as far as Steve was concerned. For instance, I didn't feel comfortable swearing in front of him. Moderate swearing is part of my natural language, but, like a cigar smoker, I am acutely self-conscious about its use until I know whether it offends a new acquaintance. I knew Steve was deeply religious and so had kept our conversations suitable for General Audiences.

Drinking, on the other hand, was not a problem. When we met to go over budgets and discuss potential subcontractors, it was usually at the Ido Bar & Grill, an old-time rubber workers' hangout in his neighborhood near the Firestone factory that was famous for its delicious hamburgers, in the particularly local way that something is "famous," a designation often based more on colloquialism than achievement. (Another local hamburger joint proclaimed itself "famous since 1931," which seemed curiously specific.) We needed to get the paperwork for the construction loan in order and approved as quickly as possible. The seller's agent had introduced a clause making the contract binding for thirty days. Earl had warned us that he was getting a weird vibe from her and he didn't want to take any chances on missed deadlines.

Sitting at the bar at the Ido, Steve and I usually covered business in about ten minutes and spent the rest of the time trading rounds of beer. Although he had very little money, Steve had refined his tastes when he lived in California. We both drank Heineken, which is invariably the only import beer offered in bars with a limited selection. (The rest of the standard lineup is as follows: MGD and Miller Lite or Bud and Bud Light, but rarely both; Amstel Light; Rolling Rock and O'Doul's. This selection appears to hold true across the United States, with the possible exception of Rolling Rock, which represents the regional "wild card.") Bottled Heineken, therefore, is a cultural marker of men who fancy themselves men of relative distinction, but don't have very much discretionary cash. This category includes

semiemployed general contractors and holders of creative-writing degrees.

"You know there's a danger of divorce, don't you?" Steve said.

"Not with us," I said.

"I'm serious. I've seen it happen. It's going to be stressful. A constant mess; no privacy; and there will be the inevitable 'uh-oh' factor. Something will go wrong. Fifteen percent of what you deal with every day will be something going wrong. Guaranteed. It's the Steve Braun Fifteen Percent Rule. A lot of marriages can't survive that."

"We're ready, Steve. We know what we're getting into."

I couldn't imagine anything ever threatening our marriage. We rarely even argued. Part of this is because we are truly compatible, but part is because Gina and I are people who actively and endlessly avoid conflict. A friend nicknamed me the Playful Diplomat, a designation I accepted with pride. Nevertheless, I couldn't imagine what that 15 percent could include, or how Steve could be so certain about it. If wisdom is knowing how much you don't know, I possessed the mathematical opposite.

Steve raised his Heineken bottle.

"You still haven't seen *The Money Pit*?"

I raised mine to his.

"Nope."

One of the pieces of the title work was a mortgage location survey, which would cost $275, except that my brother Louis was a surveyor and offered to do it for free on a Saturday, if I'd be the rod man—the grunt worker in a survey crew. That was a lot of money to save and I was thankful for the offer. I'd worked on a survey crew for a summer, and knew how to handle the dumb end of the work, holding up the surveying rod and aiming plumb-bob targets for the guy who was running the instrument and making the calculations.

In what was becoming an increasingly uncomfortable routine, we had to send a request to be on the property through the seller's agent, who then relayed the request to Mrs. Radner and came back with the

answer and its inevitable restrictions. It seemed as if these requests were meeting with more resistance than before, and that the agent was beginning to reveal the strain of being in the middle. We were given permission to do the survey on a Saturday morning, as long as we completed the work between eight and ten A.M., when Mrs. Radner wouldn't be home. Fine. We could do that.

It was a cold, drizzly, mid-October morning. Louis picked me up in the surveying van, late, close to nine. He said we had to run to the office because there were no lath stakes in the back. I was nervous about the time, but there was no choice. I was, after all, merely the plumb-bob target.

Louis and I shared an affinity for home renovation. He was five years younger than me, but his tool collection was only about two years behind. Men of a certain type measure one another this way. I think he had a cordless drill before I did, which is a particular line of demarcation. He lived in a shoe box of a house in a small, semirural town outside Akron, and had redone virtually every surface, perpetually in transition from one project to the next, increasingly ambitious, much like me. In his midtwenties, he was the youngest in the family and also the most independent. He'd toured the country several times over as the drummer in an unsigned rock band. They toured in a converted school bus, an environment in which the notion of adult responsibility is acutely relative. Even so, Louis had emerged confident and capable, the guy who handled the band's money and who had learned to ably manage drunken imbeciles. It was strange for me to be riding shotgun in the survey van, with my little brother as chief, running the show. I was not yet accustomed to being a grown-up; in fact I actively did not consider myself one, and therefore could not quite reconcile him in that context. How was it possible that we both had professions and mortgages? How did we get from *there* to *here*?

Louis had not yet seen the house up close. In that gray morning, as the van rolled to a stop, he seemed at first not to believe his eyes.

"Hoe—my—gawd," he said, stepping out onto the driveway and staring up at the peaks. "That's just ridiculous."

I showed him around a bit, and I could see something like envy developing, the volatile chemistry of fraternal competition in which one brother wishes for another brother's troubles, not out of empathy, but a desire to prove himself more capable. He wanted this challenge for himself. He wanted to be the one wrangling with roof-eating raccoons. He wanted to be the one taking a moral stand to save a doomed garage.

We looked at the tree in the middle of the backyard, that massive piece of natural architecture that rivaled the house itself for dominance of the landscape. Louis looked into the gaping cavity on the back.

"That tree looks sick."

"Isn't there something they can pack into an opening like that? Some kind of tree cement?"

"I dunno," Louis said, shrugging his shoulders.

Both of us wanted to be able to say it was all right, but neither of us could. We both agreed that the next-biggest tree, the box elder that loomed over the pond, definitely was dead. Strangely, there was more comfort in that, the ability to be definitive about something in this otherwise ambiguous landscape. Dead was dead.

"Think we can take that down ourselves?"

He chortled like a trumpeter pursing his lips.

"Sure. Why not?"

Clearly he had no better idea than I did, but ignorance didn't seem to be much of a factor anymore.

We got started. One of the jobs of a rod man is to "cut line," clearing a path through the underbrush so the surveying instrument can see through to its target. (Rod men experience a lot of downtime and learn quickly to identify edible plants in the field; I once stuffed myself sick on wild raspberries while staking out a housing development.) Normally, cutting line is not necessary on a residential survey. Here, it was necessary. In fact, I did not recall ever having to chop through so much tangle just to get in position over a backyard property pin. I had to hack my way along with a machete, then crawl on

my belly in the mud to get underneath the mock orange at one of the rear corners, where the roots of an oak tree had grown around the rusty property pin.

Louis set up the gun and we started our work. Because we were separated by seventy-five feet, we were using walkie-talkies to communicate. Machetes whacking at the bushes; playing with walkie-talkies. We'd dreamed about such things in our boyhood.

"Right a bump. Left an eighth. Right a sixteenth . . ." We pinpointed the corners.

As I stood there trying to keep the plumb-bob string from tangling in the branches, I stared at the house. I'd not been sleeping much, lying in bed fretting—about the house, about the new baby, about money. With the construction loan, this was more than I thought we could afford, even though the bank said otherwise, and so I was nervous about practical things, which do not fall into my primary skill set. But I was also having half dreams, irrational flights of imagination, phantasms: about the house collapsing; about entering walls and finding a confusion of plumbing that was blasting water and could never be set square; about wild animals and electrical menace and not being able to locate Evan, my child lost in the back tunnels of servants' staircases.

Humpty Dumpty and Edgar Allan Poe and the Big Bad Wolf were allied against me.

Actually being on location, doing something, was its own kind of discomfort, more tangible. I'd been trying, as I lay awake, to recall just how badly decayed the mortar was. Now, gazing at the brick walls, I could see that it was even worse than I remembered. In some places, the pointing had washed out completely and the bricks appeared suspended in air. Nevertheless, I had insisted on removing the cost of a mason from Steve's estimates, and I already had scanned the card catalog at the local library for books that could teach me tuck pointing. For the first time, my graduate courses in research and bibliography were paying dividends.

A horn honked in the driveway. I was trapped in the bushes and couldn't see past the corner of the house. My walkie-talkie crackled.

"I think the old lady's here," Louis said.

Shit.

"Stay there," I answered. "Let me go talk to her."

I dropped to my hands and knees and scrambled through the undergrowth, branches catching and scratching at my clothes, face, and hair. The last thing I wanted to do was give the old lady a reason to be angry. When I reached a clearing, I jumped up and began to run. I misstepped and one foot went into the feeder pond above the waterfall, soaking my boot with cold black water and wrapping it in wet leaves. I sprinted down the driveway, shaking the leaves off as I ran. I slowed as I reached the surveying van that was blocking her way, clearing my throat and assembling a smile as I tried to ignore the mud on my jeans and the cold wetness soaking into my sock.

"Hello," I said.

She was hunched forward, her face close to the steering wheel, and she looked at me sideways through the half-open window of her economy car. I wondered how she drove, curved forward that way, how she managed to angle her neck so that her eyes were seeing over the dashboard.

This was the closest I'd ever been to her. Her shoulders, under a jacket, were small and bony. She seemed almost breakable. Her eyes suggested some playfulness, but her thin lips gave her face severity. When she spoke, her tone was sharp.

"You were supposed to be here between eight and ten."

"The rain slowed us down," I lied. "I'm sorry. We won't be much longer."

"Well, I need to get in and you're blocking me."

"I'll move it. Just one second—"

Holding up a finger to indicate I'd be right back, I broke into a sprint toward the rear corner of the lot, dodging saplings and thickets of wild rose. I reached Louis, who stood idle at the gun.

"Gimme the keys. Quick. *Now*."

He didn't say anything, just shot me a worried grimace as he handed over the keys.

I sprinted back to the van, jumped in, and started the engine. Portage Path is a fairly busy street, and the sight lines of the Radner property were badly compromised by the jungle that grew right up to the road. So I knew it was a challenge to back out of the driveway. I'd also been there enough times to have noticed that Mrs. Radner always used the turnaround in the back, parking her car nose forward, to avoid having to navigate in reverse. The van blocking her way had left her no choice. She paused a long time at the end of the driveway, awaiting safe clearance to back out so she could let me out.

Finally, she eased into the street and pulled slowly around the corner, apparently planning to go around the block instead of waiting on the street for me. It appeared she might actually be navigating by looking *through* the steering wheel, rather than over the top of it. I took my turn at the driveway apron. I saw an opening and pressed the accelerator. I wasn't used to backing out of this driveway, much less in a big, unfamiliar van. It wasn't until I'd finished clunking over the curb and pulling into oncoming traffic that I noticed the FOR SALE sign, suddenly bent and twisted and in the weeds again. I'd backed over it.

A car was coming up fast behind me, and I couldn't stop to fix the sign. But Mrs. Radner would be coming back around the corner at any moment. I had to get that sign up before it gave her a reason to be angry.

The walkie-talkie! I unhooked it from my belt and pressed the button.

"Lou!" I shouted into the mouthpiece. "Lou!"

Nothing. Not even a crackle. I looked at the controls. It was turned off. Driving with one hand, I fumbled for the switch and tried again.

"Lou! The sign! I ran over it! Run down the driveway and fix it. Quick! Before she gets back."

Because of the traffic, I would have to go around the block too. I turned the corner, racing to get back around to the house, though I knew Mrs. Radner would beat me there. When I returned, Louis was

standing, with forced casualness, next to the sign. The sign was back
in the ground, but crooked and very obviously bent. He smiled and
waved with false nonchalance as I passed him.

I parked the van halfway up the driveway, hoping to indicate a
respectful distance from the inner sanctum of the rear turnaround,
a broad, curving area of cracked and degraded concrete with a series
of wide, deep puddles that resembled the Great Lakes in miniature,
ending at the ruined garage.

Louis reached me as I stepped down from the van.

"I think she saw me," he said. "I'm not sure. But I got it back up."

I tried to regain my facade of calm as we made our way toward the
rear driveway.

Mrs. Radner was walking toward the back door, sharply hunched,
with a handbag and a plastic grocery bag hanging from her forearm.
She stopped when I came into her view.

"I hope you'll be done soon. You said between eight and ten."

"We will," I said.

Louis and I hurried to finish the back corners, locating the prop-
erty pins and spraying them with fluorescent orange paint, then mark-
ing them with lath tied off with bright ribbon.

As we worked, I peered at the house, hoping to catch another
look at Mrs. Radner, but the curtains gave up no secrets. There had
been something about seeing her walk into the house with a shopping
bag that put her and the place into different perspective. This was
somebody's home. Somebody bought food at the store and brought it
here to eat it. Somebody's life inside there would be ending soon, in
exchange for mine beginning.

11]

condemnation

Every city has a high school football coach whose name has the word "legendary" automatically appended. This was the case with my alma mater. The coach, a squat, unyielding man of Mediterranean descent, had been there forever, long before I had attended. In fact, he had been coaching there since before I was born. If legend is 80 percent longevity and 20 percent competence, then he, both old and competent, was 100 percent legend. Now he was coaching the final home game of his career. This would be the sort of event that attracted throngs of squat, unyielding Mediterranean men who smoked ritualistic cigars and held their personal legacies in a headlock, the sort of men who had been productive citizens without ever fully shedding their adolescence. I felt a certain kinship. High school football games were of utmost importance to these grandfathers in satin letterman jackets. I always enjoyed watching them. The satiny grandfathers, that is. The games meant nothing to me.

My dad called and said he had an extra ticket. He was going, along with my brothers Ralph and Louis and our friend Chris, the one with

the Civil War–era barn, who long had served as an auxiliary brother. I wanted a night like this. I accepted the offer.

Chris and I had known each other since childhood. He was born in the house across the street. He was about my brother Louis's age, a large young man, 6 foot 3 and 270 pounds, with no discernible muscle mass and a refined talent for making the people around him smarter and funnier. He loved cars. Despite his size, he loved little sports cars. He was too large to fit into his MG Midget, and had to have the seat removed and rewelded farther back. Even then, he drove with his knees up against the dashboard and chubby elbows at skewed angles, yet still managed somehow to shift gears with buttery precision. Riding shotgun in the Midget required a certain tolerance for being stared at.

Chris offered to pick me up. For this mission, he selected his 1995 Volkswagen GTI VR6. On the passenger-side floor, between my feet, was a roll of yellow police-line tape.

"What's the tape for?"

"Just cuz."

"Cuz what?"

"You never know."

"Never know what?"

"When you'll need to mark off a crime scene."

"Seriously—where'd you get it?"

"Found it."

"Can I have it?"

"No."

We went to the game. The coach was put out to pasture in the manner of a retiring prime minister. The old men with the cigars went to the neighboring steak house at halftime and toasted him at the bar. They returned for the second half in the glow of middle-shelf bourbon, agreeing even more vociferously that Coach was a Legend and that this was the end of a goddamn era.

Afterward, we got some beer and went back to my parents' house, where I decided that Ralph, Louis, Chris, and I should listen to the

entire R.E.M. canon, in order. My tenure in that house had ended at almost exactly the end of the vinyl era and I had left my records there, so whenever I visited, I liked to listen to them. The vinyl restriction dictated that we could conduct this sociocultural exercise only through the album *Green*, which seemed plenty long enough to make whatever point this undertaking intended. It was agreed that we would skip *Eponymous* and *Dead Letter Office*, adhering only to the proper studio releases. I estimated this would take six hours and that we could complete our musical journey well before dawn and that we had enough beer.

As these things so often go, the operation began with flashes of transcendence. The rustic chime of *Murmur* gave chills. "So. Central Rain" rebroke our hearts.

Thereafter: drudgery.

Does Document *really suck this much? How did we not know that then? We were in college; we should have been smarter.*

Sometime around three A.M., Ralph was asleep flat on his back. Louis had bailed. Side one of *Green* loomed. Chris and I decided we'd had enough. I got into Chris's car and we headed toward my house.

I picked up the roll of police tape.

"I got an idea," I said. "Take me by the Radner house."

"No."

"Don't worry. I'm not gonna do damage."

"No way."

"I wanna mark my territory."

"There is no way in the world. That's my tape. You can't have it."

"I'll pay you back. Just take me by there. You can drop me off and leave if you want. I'll walk home."

He turned the corner toward North Portage Path.

"You do one thing wrong and you'll lose that house."

"It's mine to lose. I wanna mark my territory. Just slow down before we get there and let me out."

Chris rolled to a stop.

"I'm having nothing to do with this," he said.

I got out and began walking up the sidewalk, carrying the yellow

tape. Chris crept alongside in his Volkswagen, glaring. I scowled back. He gave a dismissive wave and drove off. Fine. My house was only a couple of blocks away. I could walk.

Immediately, having stepped from possibility into reality, I rejected my original beery notion to rope off the property in yellow caution tape. I'd never really planned to do it in the first place. But I also realized I had never strolled past the Radner house as a pedestrian. Here I was, coming upon it in the night, under a harvest moon, picking up the deep autumn scent of decomposition as I passed the last of the neatly kept yards and came under the shadow of the Radner trees. I slowed, looking up. It was deadly quiet and I had never before considered the house as a peaceful place. But here it was, resting under the moon, oddly settled when not being poked for signs of life. It was fine in its condition; this was the first thing that had attracted me: the elegance of its disorder. It wore this confidently. Under the pressure to reconsider it as a safe and clean place for my family, I'd nearly forgotten that aspect of its allure—its flush of wild magnificence. I smiled. It was mine.

It seemed then, for the first time, like it was all meant to be. Everything was converging. We'd found a house. Gina was three months into her pregnancy. That left six months to get settled, to take this house under our control, to remake it as a home for the four of us to begin to grow together. We were meant to become a family here.

A car appeared, slowing down alongside me.

"Done?"

He wasn't smiling. I didn't answer.

"Now get in and gimme back my tape."

Earl got a call from the Radners' agent.

She hoped we wouldn't be upset, she said, but she'd sold the property.

To someone else.

"What?!" Earl said. "We have a contract—"

He thought she was pulling his leg. She assured him that she was not. She apologized disingenuously for any inconvenience. Acting on the boss's orders, she said, nervously sticking to her script. Deal's already done. Our contract was being disregarded. Dismissed. She tried to end the conversation quickly, as though there was no need for further discussion.

Earl is an even-keeled man, sweet and honest, with the sort of face you find on packages of cookies at the supermarket. This was what I knew of him. But I also knew the stories of the United Rubber Workers' history. There had been strikes in Earl's time as a tire-union official, the 1970s, that are the stuff of labor legend. Trench warfare. Rock-throwing, gate-crashing, steely-eyed, test-of-will epics conducted around flaming oil drums. One of my favorite photos from that era is of a group of older women marching out of a Goodyear plant, in bouffants and sunglasses, wearing T-shirts that said BAD ATTITUDE WORKER. Earl had been an officer. I was confident he knew something about street fighting.

He called and told us what was going on. He told us to let him handle it. He and the owner of his agency met that night to review our contract. They scoured the language. There was no question: it was binding for thirty days, on both parties. What was strange was that the thirty-day clause, which was not a standard contingency, had been inserted not by us, but by *them*. Earl had figured initially that after so much trouble trying to sell the house, they didn't want to lose us. Now it was our key advantage. We had it in writing—twenty-one days left to complete our end of the deal. As long as we secured financing and had all our closing materials in order, we would get the house.

Earl, composed and prepared, dialed his telephone and presented his position.

The owner of Mrs. Radner's agency, Mrs. Z, a hawkish woman, shoved her agent aside and went on the offensive. She had decided she could cancel any contract she pleased if it meant more money for her.

Earl pressed her to prove our contract wasn't valid. She couldn't. So she changed tack and said she was certain we wouldn't be able to complete our financing. She said we couldn't afford the house. She said we weren't competent buyers.

That was the worst choice she could have made.

Earl had begun to feel personally responsible for us. He was old enough to be Gina's and my father, and he felt a certain amount of culpability for the position we were in. The house worried him deeply, and yet he had negotiated us to the brink of its ownership. We'd convinced him we could handle it, and he'd allowed himself to have faith in us, despite all the troubling evidence, despite the tuck pointing, and despite the fact that Gina's sister—his beloved neighbor—was praying nightly devotions to the Patron Saint of Failed Real Estate Transactions.

So when this woman told him that we weren't capable of doing what we'd set out to do—to finance and resurrect this house—he was finally forced to make the choice of whether he wanted us to get it or not, whether he believed in us. And there was no way he was going to agree with Mrs. Z.

He believed in us, and we would get this house.

Mrs. Z dug in. She continued to argue that she had the right to sell the house to someone else. But she couldn't find a way to void our contract, and she couldn't sell it to anyone else until she did. So she continued to harp on her self-created belief that we couldn't pull off the financing.

"How do you know?" Earl asked her. "How do you know they don't have a million dollars?"

"I just know," she sniped.

He smiled.

Earl privately referred to her as a "witch." This was the worst thing I had ever heard him say about anyone. He was going to make damn sure we got this house, he said. I'd never heard him more emphatic. He was going to make damn sure we got this house, the same house that, only a day before, he really hadn't wanted us to buy.

But now we would have to ramrod everything through. Any misstep and they'd be all over us. Steve was close to finished with trying to figure out how to get from a relatively modest construction loan into a house that wasn't going to collapse on the tender flesh of its occupants. I told him to hurry.

Every time I thought of those numbers, I felt sick. The only debt Gina and I had ever had was our mortgage on the semiremarkable house, which was entirely manageable. We'd never had a credit card, on purpose, because we didn't understand how to buy something we didn't have the money for. Sometimes being afraid of math has its advantages. We'd paid cash for both our cars, which isn't any more impressive than the cars themselves. I'd bought the Land Cruiser for $750, then put two years into restoring it. So the thought of borrowing $65,000 for a house, and another $55,000 for work I would have preferred to have done myself was troubling to me, and also disorienting.

Our loan officer was working as hard as we were to get everything ready. Phone calls and faxes flitted back and forth like the bats I'd seen above the Radner chimney at dusk. The officer put in a preorder with the title company so there would be no last-minute delays. Steve got all the contractors in line, prepared the paperwork. We double-checked everything. We were ready to go. The title work was scheduled; Mrs. Radner and her daughter, whose name was on the deed, were to go to the title office to sign the papers. We'd made it. It was going to happen.

The phone calls began late in the morning. The staff at the title office didn't know what to do. Earl didn't know what to do. The loan officer didn't know what to do.

The Radners had arrived as scheduled. But they refused to sign anything. They were simply sitting in the title office, in some sort of passive protest, angry at their agent, angry at us, angry at Earl, angry at our loan officer.

Earl called again after lunch. They were still there.

Again in midafternoon. Still there.

And again near the end of business. They'd remained in the title office for the entire day, and had refused to sign the papers. None of them had ever been in such a situation. Everyone was feeling deeply weird.

How do you force an old lady to sign away her home?

Finally, at five P.M., the title-company workers insisted they leave. The day ended and no one knew what to do.

Earl and his boss huddled. They would have to play hardball. An attorney friend offered to step in, but Earl wanted to try one more time to handle it himself. He called Mrs. Z and warned her he wouldn't stand for another passion play. We rescheduled the closing, Earl watching everything like a shepherd.

Mrs. Radner and her agent arrived at the title office again. Amid the uneasiness, they presented their paperwork. Earl looked it over. There was a brief addendum, something new. It was a set of papers topped with a memo indicating that we, the buyers, agreed to comply with health department orders on the house.

"What orders?" Earl asked.

He turned the page. The house was about to be condemned.

The summary alone covered a full page, health and building code violations that had been ignored, and whose order for compliance had expired.

By authority of the Akron Environmental Health Housing
Code, Chapter 150, your attention is directed below with
orders for corrections—

Tuckpoint chimney.
Repair or replace roofing.
Repair/replace gutters and downspouts in an approved manner.

Repair or replace porch roof & steps. (Front, side & rear.)
Repair or replace garage roof, walls & floors.
Tuckpoint brick siding . . .

It was clear that these orders had been prepared merely on a visual inspection of the exterior. If the housing officials ever got inside, they'd surely evict the old lady, and the house would be condemned and likely be demolished. That's how we read it. There wasn't a single practical aspect of that building that would pass inspection. The place was doomed.

The owner and the opposing real estate company had hidden these orders from us, and I hadn't been smart enough to ask. I suppose it wasn't a shock that the house was infested with code violations. In comparison to the reality of what I'd seen, the paperwork only hinted at its uninhabitability. Much more troubling was the way all this had been kept from us. These were the people we'd been worried about *insulting*?

This explained why they'd fallen silent those days, then suddenly accepted our offer. Looking at the date on the paperwork, these final orders must have been served right after we'd made our counteroffer. They must have received the ultimatum, panicked, and figured they had no choice but to unload the house.

Earl was livid. He postponed the closing, making absolutely clear that we would not be penalized for the delay. He'd been taken for a fool, and worse, Gina and I had been led in deception.

There was a health department inspector's name on the orders. I called him. I explained the situation, that we'd just learned of the violations on the verge of buying the house, that we had a construction loan in place and full intention to rehab it. But there was no way we could comply with the deadlines in the orders.

This guy was the kind of person who spent his workday trying to snare absentee landlords and nailing plywood over the front doors of meth labs. To have someone on the phone not only offering to take responsibility for one of his problems, but pleading for the opportu-

nity—and with new bank financing—must have been like receiving a plate of unexpected office brownies. *Sure, kid,* he said. *We'll work with you.* As long as he saw progress, he agreed to go easy on the orders.

We rescheduled the closing for the following Friday. There was no point in going to the title-company office until all the paperwork was ready to sign. I stayed close to my desk at the newspaper office, waiting for Earl's call. When everything was in order, he would let me know and Gina and I would meet him at the title-company office.

I stared at the phone all morning. Finally, just before noon, it relented. I grabbed it on the first ring.

"Hello?" I said.

"David."

It was Gina.

"I'm bleeding," she said. "A lot. I called the doctor. She said to come in right away."

I went cold. It is in my nature of Playful Diplomacy to assume the best even in the worst moments, and that's what I did then. I inhaled. I convinced myself that this was a normal bit of biology and that everything would be fine. Three months into the pregnancy, there hadn't been anything to suggest a problem. It would be all right.

I rushed home to pick up Gina. We strapped Evan into the backseat and went to the doctor's office. They took Gina directly into the ultrasound room. I sat in a chair against the wall, Evan in my lap, facing me, oblivious to the medical procedure unfolding behind his back. I played idly with him, letting him grab my index fingers, then pulling my hands away, returning to his grasp, pulling away.

The doctor peeled Gina's shirt back far enough to expose the bloated belly. She rubbed blue gel onto the end of the ultrasound wand, then began rotating it across the skin, divining.

But there was nothing there to find. There was no heartbeat. There was no movement. There was no life left, just fluid and tissue.

I used Evan as a shield when the explanation began, the doctor softening her voice without emerging from the dimension of professional distance. I nodded past the thin wisps of his hair. I used his fin-

gers to keep my own hands occupied. I rubbed his back. Inexplicably, I wanted to tickle him.

Gina was crying. The doctor said we could get a second opinion, that there was a very slim but unlikely possibility of life being detected by a more sophisticated ultrasound. We said yes, we wanted to be absolutely sure, and she called a specialist near the hospital, clearing the way for us to come in immediately.

At the second doctor's office, I was separated from Gina by a curtain, sitting with Evan in a darkened room while an ultrasound technician with an intern at her side passed the wand over the tight skin of Gina's middle.

"Nope, there's nothing there," the technician said to the intern in a voice without compassion. This was her work, declaring the end of a "problem pregnancy," and there would be another waiting when the paperwork on this one was done.

I could hear Gina crying on the other side of the curtain.

It was late afternoon by the time I got back to the telephone. There was a series of voice mails from Mrs. Z, ready for us to sign the closing papers, impatience quickly turning into snippiness with each progressive recording.

We're waiting. Where are you?

I called Earl and told him what had happened.

"Oh, dear Lord," he said. "They better not have caused this."

By "they," he meant the small band of witches who had engaged him in battle, a battle he thought we had won. I didn't know what to tell him. The doctor had said this was natural; there was nothing we could have done differently, no traumatic event.

No traumatic event? I couldn't even begin to parse that statement. This trimester had coincided with the most stressful events of our marriage.

The doctor said the pregnancy probably had been over for weeks. I didn't know what to make of any of this. Everything had changed

with the announcement of the pregnancy, and now everything had changed again. I felt like I had a stone in my stomach. For the first time in my life, horribly, I felt like a grown-up.

Suddenly and completely, the house became urgent. I needed it. I needed some piece of chaos that could be mine alone. I wanted to be set free inside that sprawling incomprehensible wreck. I wanted to attack with claw hammer and crowbar, to tear away plaster and lath, to rip up ravaged flooring, pulling it all apart with my hands. I wanted to confront the wild animals, to roar back into the dark, to strip that house of its corruption and danger, to make it clean and safe and someday beautiful. I wanted to be alone with a problem to solve. Because that was something I thought I could understand.

Finally, we closed on the house. In an act of spite, Mrs. Z refused to deliver the keys to Earl, denying him a standard professional courtesy. He had to drive out to her office and retrieve them himself. He brought them to us quietly, apologetically, feeling as though he had led us into harm. We assured him he had not. Some things just happen and you don't know why, and you will never know why.

He placed the keys in my hand. The house was ours.

Part II

[Unscrew the locks from the doors!
Unscrew the doors themselves from their jambs!
—Walt Whitman, *Song of Myself*]

[12

oh dream maker

you heart breaker

wherever you're going

i'm going your way

After the miscarriage, there was a breach in the space between us. It was hard to define, like bad air. Gina and I shared the loss equally, but I know we each experienced it differently. How could we not? Our child had died inside her, and there is no human way for me to understand that the way she understood it.

She was healing, and I was doing whatever I could to make her comfortable, but I wasn't always sure what the right thing was. One night I played a disc of Henry Mancini covers that we'd been listening to all summer and fall, music played by a band called Oranj Symphonette, whose uncanny membership included Tom Waits's horn player, P. J. Harvey's guitarist, and Dave Brubeck's son. That seemed to brighten the mood, but when "Moon River" came on, Gina started to cry, and then I started to cry. This helped some, but not in the way I had expected.

In the hospital, Gina went through the dilation and curettage procedure. This is to remove the remains, vacuum the uterus clean. Afterward, I sat at her bedside holding her hand. The nurse kept bring-

106] David Giffels

ing her blankets that came from a heated cabinet and wrapping them tightly around her; the feeling I felt when I put my hand underneath those blankets was one of the most physically comforting things I've ever experienced. The stupidest thing—a warm blanket. But it was real. Whoever invented this Hospital Blanket Warmer is both genius and saint. All hail this person. Back home, I had nothing like this to offer.

I did not like the feeling of forced adult responsibility. I had briefly experienced some version of it when we first got married, as though my new status carried a requisite change in demeanor, but then I realized I was having more fun as a married person than I was before, and that pretending I was suddenly Ward Cleaver was missing the point. I was responsible enough in my life that I didn't feel a need to wear a necktie or drive a new car or quit digging through used-record bins to prove to the rest of the world that I was an adult. When Evan was born, I actually felt less like a grown-up. This took me by surprise, the way his arrival primed untapped childishness from me. When you realize that playing peekaboo is part of your adult responsibility, that information opens entire new vistas.

What's the point of trying to act ten years older than you really are when everyone around you benefits more from you being young and carefree? I'm not talking about a grown man trying to act like a teenager. I'm talking about not repressing the parts of the self that remain relevant and useful. I didn't rush out and buy a new pair of Chuck Taylors when I turned thirty, but I also didn't quit wearing the ones I already had. They were perfectly good shoes. Also, after age thirty, it takes a lot longer to wear out a pair of sneakers.

But now this philosophy had become reflexive. If welcoming a child into my life had made me feel younger, losing a child brought the burden of adulthood to bear. In the weeks following the miscarriage, I felt *older* than I was. I did not like this feeling.

Earl had worried that the stress of the negotiations, and of the house itself, had triggered the miscarriage. We were sure, after countless questions to the doctor, that it hadn't. In fact, with the passing days, I found that the distraction of the house was bringing us closer

to normal. We were talking about what absolutely would have to be done in order to move in.

With December approaching, we were due to take full possession of the Radner house in two weeks. We had the keys, but the contract gave her fourteen days to finish moving her stuff out. So it was ours, but it wasn't yet running-naked-through-the-hallways ours. We would take full possession shortly before Christmas. We would continue to live in the semiremarkable house for a month while the brutal first phase of restoration tore through. Then, ready or not, we would move in.

The first phase of work inside the new house would be for me alone, a week and a half of gutting and prepping, and then, just after Christmas, the contractors would come in and repair the roof, plumbing, electric, and heating. Once Mrs. Radner was finished moving out, the race would be on.

Thirty days to undo half a century of decline.

As daunting as it seemed, that was something I could understand. Thirty days to carve out a working kitchen; a safe, clean bedroom for Evan; and a living room stable enough to bring in Gina's little group of day-care kids.

Until now, the deadlines had been tied to the arrival of the baby. The whole project had been tuned to the pregnancy. Now I was thankful for this other deadline, a way to reorder the urgency of it all.

Gina had become an expert on lead abatement. In fact, she had become somewhat obsessed with the subject. Houses painted before the mid-1970s are considered hazardous because the older paint contained lead. When the paint flakes into chips and dust, it can lead to elevated levels of the heavy metal in the bloodstream, which can cause neurological and other health problems, especially in children. It was safe to assume no painting had been done here since well before the federal government's 1978 ban on lead in consumer paints.

Gina was not going to allow any child into this house until every surface that might come within that child's reach was safe. She had

consulted with experts. She had accumulated file folders thick with brochures and Internet printouts. She had bought home-testing kits. She had made arrangements to borrow a HEPA vacuum, which doesn't allow any dust to escape back into a room. She had located a local paint store that carried lead-blocking primer, and had informed me she would not move into the house until we had used it to seal every potentially hazardous surface. She had mail-ordered a shipment of a specialty cleaning product that, given its price, may well have been made of Turkish heroin. This lead-abatement stuff was expensive, and I was dreadfully afraid we were on the verge of bankruptcy.

I'd done a little research of my own, which is to say I'd talked to Steve over beers one night. He acknowledged that, while Gina wasn't doing anything wrong, she might be overdoing it a little.

"I chewed my share of windowsills as a kid," he said. "I was a connoisseur of windowsills. And look at me now."

But that's as far as he would go. He told me that the best thing I could do would be to listen to Gina, that this could all go very badly, very quickly, if I tried to impose my will.

"You've gotta clean and paint anyway," he said. "Why not do it her way?"

I had one last option. I'd read that you could neutralize lead by cleaning with Cascade dissolved in water. I offered this alternative to Gina. I told her I could buy Cascade right up at the Walgreens, for a few dollars a box, and that I would buy as much as we needed. But there was no negotiation here. It was true: the only way this could ever work was if Gina and I could both feel comfortable with the house. I had no way to provide that feeling yet. So if purchasing an upmarket elixir to neutralize the poisonous windowsills would help, I decided, reluctantly, that it was money well spent.

Most of the members of our families hadn't seen the house yet. We couldn't wait to show it off, so we arranged an impromptu open house. The doubt that had always been part of my stew of emo-

tions regarding this leap had begun to grow, and I was feeling a need for the people who cared about me most to tell me, yes—I had made a brilliant life decision. Even if they were lying.

We had highly conditional access, which we figured allowed us at least to tiptoe through with a few people, using library voices. It was only a few days before full possession, and I figured the moving process must be far enough along that Mrs. Radner was no longer staying there at night. The early winter had grown deeply cold, and Gina and I both hoped she'd found some warm and comfortable place to finally be done with her struggle.

We called my parents and Gina's parents, and a few of Gina's sisters. And Chris. He had become fascinated by this house. He had no skill or interest in any matter of construction or domesticity, but he recognized the value of this house as a giant vessel for commiseration. He knew his role well. A sidekick who can crack wise is almost as useful as someone who's good with a drywall knife, which he was not. (Despite his relative lack of craft, Chris was always helpful in matters of brute strength. Whenever I needed to pull down a tree or crash through a wall, I called in the giant.)

The little group of us arrived after dusk—both sets of parents, Chris, and Jo-Ann. Walking up the front steps was like doing the box step through a minefield, avoiding the missing tiles, pulling back when something felt like it was going to collapse underfoot. When I got to the front door, I didn't know if I should knock or use the key. Mrs. Radner might be in there. But it was my house. But it was still sort of her house.

I hadn't even put the key on my ring yet. It was loose in my pocket. I reached in and produced it: hard, shiny evidence of a new truth. Yes. It was my house. This was my key.

I put the key into the lock, turned it, felt the tumblers click. I pushed the heavy door open and stepped into the foyer. The house was dark.

"Hello?"

"Anyone here?"

No sound came back.

I turned back to the little group on the front stoop, some of them looking up at the neglected brickwork, others looking down at the shambles of red tile.

I pressed one of the buttons on the panel of mother-of-pearl light switches. A dusty candelabra light came on overhead. I'd been in the house enough times to know that the lighting throughout was unusually dim—when it worked at all. There wasn't a bulb over forty watts in the house; all of them had a gray layer of dust; and many of them were of a different shape than the modern ones I knew, less spherical, more cylindrical, with sort of a wide incandescent nipple on their ends. The very lightbulbs had gone untended for decades. Antique lightbulbs. Who knew?

I made a sheepish, half-formal gesture, sweeping my arm toward the main entry hall.

"This is it."

Jo-Ann crinkled her nose as she entered.

"Oh, Gina, you poor dear," she said, and reached out and put her arms around her sister.

My dad stayed at the rear. He had seen the house. He had encouraged it, and had offered, as he always did, to help. Like Louis, I think he even envied the prospect of such an audacious undertaking, which may be why he hid from us the fact that my mother privately thought we were doomed.

Chris was shaking his head and chortling.

"I can't believe you did this," he said. "What were you thinking?"

"I prayed every day," Jo-Ann said.

Gina's parents scanned the interior dispassionately. They'd raised seven children. Gina was the last. They were tired out by life, and they'd learned long before to allow their children to find their own way. This was not so much a philosophy as a matter of practical necessity. Any parent of seven children who chooses to micromanage is bound for an early grave. Even so, I was worried about how they would react, and I watched them closely. We had told them

about the house, and her mother had said, "Well, David's always been handy . . . ," with as much certainty as she could muster.

Her father, an optimist, made a cursory scan from the entry hall. "You've got your work cut out for ya," he said, and patted me on the shoulder, a vague attempt at reassurance.

I led the group through the parts of the house with working electricity. It didn't appear that Mrs. Radner was any further along in moving her stuff out. This alarmed me, but I was aware that I needed, in this context, to project myself as a man in control of his surroundings. The truth was that the place was just as mysterious to me as to them. The truth was that I was on a desperate deadline: I had saved enough vacation days to take off the week before Christmas, and the work I planned to get done then was vital for keeping everything on schedule and on budget. I had to make it all happen. I would be doing all that demolition and prep work, opening up walls and ceilings to allow the plumbers and electricians access. I certainly hadn't budgeted time to empty a house of forty years' worth of debris.

By the time we reached the upstairs hallway, Jo-Ann and Gina were covering their noses with their shirt collars. This was how Gina always walked through. I wondered if this would become her daily habit, if she would begin wearing surgical masks as a way of adjusting to her new home. At least they weren't complaining of hives.

We went into the master bedroom. My mom gagged melodramatically.

"The cats," I said.

"You've got no ceiling," Gina's dad said.

"I have some," I said, gesturing toward the part that hadn't collapsed.

Chris had wandered over to the bathroom door. He opened it.

"I'm in here," came a voice.

I turned. Mrs. Radner was sitting on the toilet with a cat in her lap and a flashlight at her feet. We all froze.

"I'm sorry," Chris blurted, quickly closing the door.

"It's all right," she said from behind the door. "I was just getting some things together."

I looked around the room, mortified. My mother had her hand over her mouth, holding in a howl either of laughter or shock. I nodded frantically toward the door to the hallway. If ever the word *scram* was to reenter colloquial speech, this would be the time. Jo-Ann was already halfway to the stairs.

"I was just showing my family the house. We'll be gone in a minute," I said to the bathroom door as I backed away.

As a single organism, we descended the stairs silently.

"I think she was taking a dump," I whispered when we returned to the entry hall.

"She was not taking a dump," Chris said. "The lid was down. She was just sitting."

"Anyway, she couldn't have been," my dad said helpfully. "The toilet doesn't work."

"How many cats does she have?" my mother rasped.

"No idea," I said. "Enough."

Jo-Ann mumbled something through her shirt collar.

We filed through the front door. I closed it and locked it with my key.

[13

master

of the house

The morning of possession arrived. I was up before dawn. In the familiar surroundings of my basement workshop, I prepared my tools carefully, the way an Army Ranger might contemplate and organize his arsenal. A few years earlier, I had made a long wooden toolbox out of lumber left over from another job. It was impractically heavy and looked like something an Amish carpenter might bring to a job site. I filled it with my tools, filing them in an orderly way. I would need the small wrecking bar to chisel along the edges of my plaster tear-outs. I would need the big crowbar with the curved hook to yank out the material. A radio and a long extension cord that would allow me to tap into whatever live outlet I could find. A charcoal-filtered dust mask. Leather work gloves. Tape measure. Side-cutter pliers. Utility knife. A pencil and notepad. A camera and two rolls of film, sealed in a plastic bag. And my hammer.

My hammer was a prized possession. My parents had given it to me as a Christmas gift when I was a boy, a sixteen-ounce claw hammer with a hardwood handle. When the head came loose a few

years later, I took it to my grandfather's house in the country and we went into his workshop where he put a steel wedge into the top of the handle to tighten it, pounding it home with his own hammer, a darkly primordial thing that seemed actually to have curved to the shape of his hand. Twenty years had passed, and it had never come loose again. The handle was weathered and worn, scraped and softened at the edges, and it felt as comfortable in my hand as Gina's fingers. That hammer had been places only I had been: underneath the semiremarkable front porch; high in the rafters of the old garage; in the Land Cruiser's undercarriage, tapping against an unresponsive solenoid.

I had one other tool, in a separate case. My father had loaned me his almost-new Sawzall.

My friend Chuck once asked me a barroom hypothetical: If you could have only one tool, what would it be? The question, coming from him, was entirely philosophical. Although he had grown up on a farm, Chuck had vehemently avoided any contact with hand tools and their functions. Before I answered, Chuck told me he'd posed this question to his father, a lifelong farmer who had answered without hesitation: a set of vice grips. The jaws are widely adaptable as wrench and pliers. The steel is durable and heavy enough that the spine can be used as a hammer. The end of the release lever is flat enough to use as a screwdriver. The edges have enough bite to dig up earth.

That was a good answer. The true answer, of course, is that this isn't a fair question, any more than asking a parent to identify his favorite child. You love them equally, for different reasons. I loved my wrecking bar for its simple indestructibility in the art of destruction. I loved my pull saw for its fine teeth and backward savvy.

But given the question, I went with the Sawzall. It can't do everything and its range is limited to the length of its power cord, but that same description could be applied to Keith Richards, and that's good enough for me.

With a distinctive red handle and trigger at the rear, a body that rests in the nontrigger hand, and a long blade that extends forward,

a Sawzall looks kind of like a child's image of a snub-nosed machine gun. It operates with reciprocating mojo, the blade jutting sharply in and out, and it will cut through almost anything: wood, plaster, metal, a frozen beef shank. It can handle fine jigsaw work and it can take out a small tree. It can ease between boards to slice through a nail and it can rip boldly through a wall. If you had to, you could use its body as a hammer, and one of the blades would serve as a screwdriver. Or a putty knife. Or, in a pinch, a notched trowel.

The clincher, however, is the name—Sawzall—a can-do moniker whose z-bearing descriptive wordplay is quintessential postwar Americana, displaying the same panache as Cheez-It baked snack crackers and Alpo Chew-eez Bacon Flavor Chew Stix.

"Sawzall," I imagined the handsome middle-aged pitchman saying to a conference room full of power-tool executives with a confident raise of the brow. "It *saws . . . all*."

"Eureka," they would have responded in chorus. "Eureka and hallelujah. *Sawzall!*"

This tool also fills a unique niche—it's one of those power tools that is standard in most contractors' tool collections, but not in most homeowners'. Possession of a Sawzall denotes a particular level of commitment. If you're toting that red case, you mean business. I did not own a Sawzall. But thanks to my dad, I possessed one.

My father always had loaned his tools generously, but there was something in his selection and presentation of the Sawzall that seemed precisely correct—formal and symbolic—and I think he knew that even better than I did. It was a demonstration of affection: Italian fathers kiss their sons on the cheeks then smack them on the backs of their heads. Germanic Industrial-Midwestern fathers loan their power tools.

Steve and I had taken a preliminary walk-through, using a red marker to outline areas that needed to be opened and making notes on the walls, the way a surgeon makes a cutting pattern on a

patient's skin. I had lain awake, visualizing my job, planning that first crunch of steel into plaster and lath. In my mind, insomnia leading to Zen, every step was clear. Despite the impending chaos of demolition and roughing-in work, I was as focused as I ever have been.

I dressed that morning in my favorite work jeans, boots, and, knowing it would be cold inside, several layers of shirts, thermal followed by pullover followed by flannel. Loading a stepladder and tools into the truck, I made the short drive to the Radner house and parked halfway up the driveway. Steve had ordered a thirty-yard construction Dumpster, which was positioned up close to the house, in a tangled pachysandra bed, strategically parked beneath the front master bedroom window, which would be my dumping spot. As the early sunlight picked through the tangle of scratchy trees, I carried my toolbox and Sawzall case to the front door. I paused. This was it. Mrs. Radner was gone. I was alone, entering for the first time with this as my very own. I unlocked it with the key that now had joined the others on my ring, and went inside.

The house was cold. I could see my breath. They must have turned down the furnace when they finished moving out. I stepped into the front hall and stopped short.

Nothing had been moved.

Nothing.

The house was marked by the same narrow trails between piles and boxes as the last time I'd been there. She'd given up. She'd left everything behind.

I didn't know how to get my head around this. I had a schedule to keep. I could throw everything in the Dumpster, but I needed the Dumpster for my demolition. Plus, it would be overflowing before I even finished the living room.

The curb? The garage? Where could I put all this?

I went upstairs. More of the same. I looked in a bedroom. Boxes and piles. I looked into another. The same. I felt queasy. What was I going to do?

I opened the master bedroom door.

There, sitting hunched in a chair in the middle of the room, beneath the rotten ceiling, surrounded by metal pans and buckets half full of rainwater, sat Mrs. Radner.

She had a box of photographs at her feet and a stack of them in her lap.

"You're still here," I said, part question, part observation, part invective. My voice pinched itself off.

I didn't know what to say next. A confusing adrenaline burned upward from my collar to my ears.

"Yes," she answered. "There's so much . . ."

I'd come to know that eye contact with her was made difficult by her osteoporosis, a characteristic that made her even more elusive. So hard to read. She was like the ghost of her own house.

My research on the house had suggested the likely story of its decay: her husband had died in 1965, which seemed to be the end of maintenance on the place. This was her home, and she had stayed here, most likely like the frog in the pot of water whose temperature slowly reaches boiling. I don't think she saw the house as it was. I think she saw it as it had once been. There were pink tags pinned to tattered, mildewed draperies reading, "These go with the owner." To her eye, I believed, these were the same window dressings she'd selected at the finest shop, custom tailored to complement the wallpaper, which too was now faded, stained, and torn.

When Gina and I first realized she was living here, we agreed that if we didn't buy the house, we would call the city housing department and let them know what was going on. The house wasn't safe to live in. We knew that even before we knew of the expired warnings. But now what?

"You—can't stay here," I said. "I have to start tearing out ceilings and walls. Today."

I couldn't tell if I was feeling anger or pity. I think it was both. It had never before occurred to me how closely those emotions could coexist. Mostly, I was trying to figure out how I could do this work that desperately needed to be done with all her mildewed piles of earthly belongings strewn throughout the rooms.

"We're just not done," she said flatly, her fingers resting on the photographs.

I was not cut out for eviction. I paused, thinking. In the cartoon catfight between Anger and Pity, Pity momentarily stuck its head out from the swirling cloud.

"Is there—I don't know—a room I can empty into the hallway, and start there?"

"Oh, I suppose the other front bedroom."

That would be a start, then. I just wanted action, anything, and if it was hauling her stuff, so be it. I left her, closing the door behind me as I reentered the main hallway. I paused. Had I been firm enough with her? What if she didn't leave? At all? What was I supposed to do? Who had possession here?

I carried all my tools into the other front bedroom, set them in a corner, and began moving things out. Nothing was in moving boxes, or in boxes at all. It was all haphazard. I began gathering together armfuls and hauling it out to the hallway, the one overlooked by the diamond-patterned stained glass and defined by the rotting built-in bench between the pillars. This hallway, and the one below it on the first floor, had received the least amount of water damage, which was worst near the eaves and in the roof valleys. But there was significant water damage here nonetheless. Its source was the rusty radiator under the bench, which even now hissed and bubbled from a bad line.

I laid the first pile near one of the oak railings that overlooked the stairwell. Every stick of woodwork in the main part of the house was painted with that chalky white paint, the same paint that covered the fireplace tile in the main hallway. The only contrast was light blue paint over the brick hearth in the living room, which was hardly a relief. Why one would paint a brick fireplace, much less paint it blue, is a matter to be researched in interior-decorating guides of the postwar era. If we don't study history, after all, we are doomed to blue English hearths. I didn't know when I was going to address that problem, or how. I had removed paint from brick. I had also once helped my dad clean a long-haired dog that had fallen into a pit of tar. I'll take the dog.

I returned to the bedroom for another armload. There were boxes of Nixon-era mail-order catalogs, piles of coat hangers, musty clothes, an old Wheaties box, outdated telephone directories, clothing draped under the protection of yellowed space-age vinyl—the archaeology of a house that had not changed owners in more than six decades. I gathered together as much as I could and hauled it out. I dropped it at my feet.

This was crazy. This stuff all looked ruined to me. Junk. I wondered if I should go back into her room—which, technically, was no longer her room—and be more firm. But I just didn't know how to do that. I felt strangely as if I was violating her privacy.

An hour after I'd arrived, the room was empty. I went in and closed the door, trying to return my focus to the work at hand. This, Gina and I had decided, would be our bedroom for the first phase of a plan that, admittedly, was not so much a plan as a large hopeful guess. The sprawling master suite was too much to take on at first. This smaller bedroom was in better shape, which is to say the area of damaged ceiling above and damaged floor below and damaged wall and streaked and dry-rotted closet doors in between suggested a smaller roof leak here than in the master bedroom. Everything was relative. It had a fireplace, more modest than some of the others, but a fireplace nonetheless.

Like the master bedroom, this room looked across the front yard. For the sake of identification, we had begun to refer to it as the Green Bedroom. This was based on the particularly ugly shade of paint on its walls, a green that denotes a particular time and mind-set in the American experience. It marauded the nation in approximately the same era and with approximately the same market saturation as *The Brady Bunch*. It is a blend of Libby's canned peas and the AMC Gremlin. This was the green of the Green Bedroom. As with several rooms, the walls were set off with elegant trim work, like giant picture frames within the perimeter of each wall area, intended to give the room presence and depth. Here, though, everything was flattened by the greenness of the walls and the continuation of that endless ribbon of bland

eggshell woodwork. The only presence and depth here came from the water damage that had eaten through the plaster, disintegrating it and leaving abstract relief sculpture in its wake. The worst of it was over near a prominent, built-in armoire, the shelves and drawers of which were filled with the shit that had fallen down through the rotten roof above. (Including, literally, shit. Squirrel, I believe. Or bat.) The oak floor was badly warped. It looked like a Mission of Burma record I had once left in the sun, wavy and useless for any purpose other than as an example of how not to treat things.

I set my ladder there, where the ceiling gaped open, in order to begin tearing out all the bad plaster. I stepped back, eyeballed the ladder's position, adjusted it. Satisfied, I went over to my Amish tool-box and withdrew my wrecking bar and hammer. The bedroom door was propped shut with the toolbox. It was a smart, heavy door with a tarnished brass lock and cut-glass knobs and a full-length mirror, in which I caught a glimpse of myself as, for the first time in this house, I ascended my ladder.

Cue trumpets.

I, Toreador.

I am prepared for this moment, prepared by fate and apprenticeship and bloodlines, the product of canny Michiganders and able Ohioans. Ladies, if you will, feel the smoothness of this hammer, the influence of my tender years and precocious talent on its shape and feel. This hammer is ready, as am I. We were boys together and now we are men. Do not fear this wrecking bar, for I know well its heft and bite. It is dangerous, yes, yet in my hands it is tamed, compliant. It will do my bidding. Check out these work boots, ladies: they are seasoned and ready. And these Levi's that are my skin; they, as I, were Chosen for this Moment, for their straight legs and brass rivets, dandily cuffed at the bottom (adjusted in the mirror), faded and scarred by adventures I will whisper only in the dark and only to you. These are the pants of Springsteen, ladies. Examine closely the Levi's® -brand patch

above my right buttock and behold: a mule team cannot rend these jeans apart!

I, Toreador.

But of course, I had no audience. In fact, I had the opposite of an audience: someone within earshot who was not supposed to be there and whom I did not want to hear me. A hunchbacked old lady in yonder bedroom, a drag on my enthusiasm, an acute distraction, a buzz kill idly sifting through the remnants of her years. I didn't want her to hear the sound of my demolition, tearing down walls in this house of hers. Or mine. It wasn't clear to me. Who in the hell did this house belong to?

I reached the ladder's third step. I peered into a hole in the ceiling, locating the joists. The whole house, walls and ceilings, was finished with old-style lath and plaster. Thin slats of wood spanned the joists and studs, with narrow spaces between, creating a loose framework. They were spread with a coarse base coat, something like cement, then skimmed with the finer plaster finish coat. The craft took a level hand, a steady eye, and a healthy rotator cuff. Wall plastering has become anachronistic; it mostly disappeared with the development of plasterboard, which was much easier to apply, but less substantial.

My first job here was to remove the vast areas of plaster and lath that had been damaged by water, and also to cut holes in the walls to provide access for the plumbers, who would replace all of the pipes from the ground up, and the electricians. My plan was to cut clean, square openings along the lines of joists and studs, so it would be easier to cut and fit drywall sheets when the time came to close it in. If nothing else, I would be precise in my destruction. Steve would be pleased.

I found my mark. I set the blade of the wrecking bar against the stained plaster. I squared my jaw, squinted for aim. I drew back my hammer, eyeballing its impact point at the blunt end of the bar. I drew back my arm, loaded up with the force of my yearning. And then—

I tapped.

The wrecking bar barely dimpled the plaster. To my surprise, I was afraid to smash full force into the ceiling. Timid. Tentative. I didn't know how to rip into the wall; I didn't want my destruction to do damage. I wanted somehow to perform constructive demolition. I had unwittingly prepared myself to believe this paradox was possible.

I repositioned myself, steadied my feet on the ladder, and tapped again, a little harder, this time piercing through to the wooden lath with one corner of the blade, opening a slice perhaps half an inch long. Crumbs of plaster trickled down. I eased the tip ahead, tapped again, and ahead and again, creating a perforation in exactly the line I wanted to follow. If nothing else, my holes would be clean and precise. Steve would be pleased.

After twenty minutes or so, my forearms had grown tight. I stepped back from the ladder and looked. I'd gone about two-thirds of the way around the area I wanted to remove, an area roughly three feet by three feet. It appeared that I would be able to drop it nice and clean. This would be the tidiest job of tear-out these contractors had ever seen!

I took my radio from the toolbox, an old clock radio that I kept for use on dirty jobs like this, jobs that would destroy a CD player. (I went through a cheap CD player every year or so, ruining them with the dust and abuse of construction/destruction. I tried to be careful with the discs themselves, but sometimes you have to change your music despite the paint on your fingers. I could date the heavy-rotation periods of various discs by the color of the fingerprints along their edges. Guided By Voices is baby's room blue and Suzanne Vega is front porch gray. Liz Phair fell into a glob of paint stripper and was never heard from again.) I plugged the radio into the room's only outlet and flipped it on. No sound came out. Of course—this was one of the rooms with no electricity. I went into the hallway with my extension cord, scanning the eggshell baseboards. I found an outlet. I went to plug in the cord, but it was three pronged and the outlet was not.

I returned to my toolbox in the bedroom. Against all warnings

and regulations of the Underwriters Laboratories, I took my pliers and snipped off the grounding prong. I went back to the hall, plugged it in, snaked the cord to the bedroom, and I had a radio. I set it quietly to *Morning Edition*. I'd worked on construction sites in college, and often was the first to arrive, and I would always begin by turning on NPR. I'd grown to love the voice of Bob Edwards, which offered the same warm addiction as General Foods International Coffees. But I was the grunt, and whenever the Trades arrived, they immediately switched to the classic rock station. It didn't matter that it was my radio. On a job site, the radio is public property. I hate the sound of Duane Allman, therefore, in direct proportion to my affection for Bob Edwards. But now I controlled the airwaves.

I returned to the ladder and finished my careful tapping. Satisfied with this first step, I traded the hammer and wrecking bar for my red, long-handled crowbar, which I would use for pulling down the perforated material. Back up on the ladder, I hooked the crowbar's end into an opening between the lath and gave it a hard yank. Wood splintered and plaster and dust crashed to the floor. Blinking the soot out of my eyes, I looked up to see that the wreckage had not at all adhered to my painstaking linear perforations. The pieces of lath that extended beyond its edges had pulled out large chunks of rogue plaster. This hole was ragged and uneven. I scowled. It was time for the Sawzall.

I unplugged Bob Edwards and replaced him with the cord that extended from the red-handled reciprocating saw. I gave the trigger a test. The saw chattered powerfully. Back up on the ladder, I set the blade into an opening and began following my lines, cutting a clean stripe along the joist, the saw jauntily slicing through each lath with the rhythm and commanding bounce of a pirate ship's bow cutting across the ribs of ocean waves, the ship's lady bustily leading the way.

I finished my cut. Soot clouded the room and I was covered with sawdust and grit.

"Hello?" a voice called from downstairs.

I went to the railing.

"Who's there?"

"It's Steve. I came to see how you're coming along."

This was good. This was good timing. I had something to show him, something to prove my capability, my Sawzall prowess. I went down to the main hall, where he was standing in his baggy jeans and flannel coat, his eyebrows raised in question to all the stuff still piled about.

"The old lady's here," I said. "I'm working around her for now."

"*What?*" he rasped. "She can't be here. She's got to get out."

"I know. I told her. I don't know what else to do."

"Told her? She's not *allowed* to be here. Period. This isn't something open for discussion. The possession date's today. What if she gets hurt? Who's liable?"

I hadn't thought about this. All I wanted that morning was to release my anticipation, not to be hindered by such matters as legal possession and personal injury. I just wanted her to evaporate. But Steve wasn't game for letting me pretend she wasn't there.

I put up my hands.

"I'll deal with it. I will. Just—for now—come and see what I've done."

He shook his head. He looked worried. I led the way to the Green Bedroom.

Steve stopped in the hallway, where, thanks to my work, the Radner piles were bigger than ever. He shook his head. He nodded toward the door to the master suite, raising his eyebrows to ask *In there?*

I nodded.

"I hope this stuff's gone by the weekend," he said, loudly.

I wondered what might be happening on the other side of that door.

I gestured hard for Steve to follow me into the Green Bedroom. He entered, looked up and then down, inspecting, his eyes settling on my dad's Sawzall.

"That's a virgin," he said, softening.

I wasn't sure how to take that. It seemed almost like an insult, as though the saw (and by extension, its user) hadn't paid its dues.

"My dad's," I said.

"It's nice. Take care of it. And don't leave it here overnight. Once there are people working in here, nothing's safe."

I nodded, then turned my eyes up to the ceiling.

"Cut my first hole," I said proudly.

"Mmmm-hmm. That's a start. But you're gonna need to go all the way to the wall there, so you can get up inside and insulate after the roof's done. Don't worry about being neat. It's tear-out—just rip it down."

My heart sank. I'd wanted him to compliment my workmanship, to take note of the clean lines and the authority of my vision.

"You're gonna need to pick up the pace, too. There's a lotta demo here, and you've gotta have it ready before the subs come in."

He squatted halfway and hitched his belt up, tucking in the front of his T-shirt, announcing he was on his way to another job. I walked him downstairs and watched from the front door as he returned to his battered yellow truck with the piggyback propane. I closed the door and returned upstairs.

"Mr. Giffels?"

She was at the master bedroom door, one hand on the jamb, her neck craned to look up at me.

"Yes?" I said, flanked by mounds of her stuff.

"I need to tell you about the furnace. It doesn't shut off. There's a valve on the side, and a glass tube. You have to fill it until the tube is full and then shut it off manually. At night you have to turn the thermostat all the way down."

I looked at her. My eyes must have betrayed my bewilderment.

"The leaks," she said. "It loses a lot of water."

"Okay," I said.

How? I wondered. How did she manage this? How was it that she couldn't keep the house in basic working order, yet could manage a badly malfunctioning boiler, the likes of which would confound a jaded grade-school maintenance man? How could she understand and balance the dynamics of a pressurized steam system that could no

longer regulate itself, yet not address the fact that it was *shooting water at the fuse box*? How could she maneuver those trash cans of steaming water in the basement that filled up each day from the leaks, but not address the source? (She had attempted to repair some of the pipes by tying rags around the leaks. But still.) It was all backward logic. Couldn't she see that she was doing everything the hard way?

Then again, isn't that what I was doing? Her hardship was the result of conditions beyond her control. It had crept up from the bushes. I had invited mine through the front door, the front door plastered in that hideous stick-on plastic mosaic. She owned her hardship outright; mine came with a mortgage, and a signed agreement to accept whatever trouble this house had, known or unknown. I had agreed to take on her problems. I had not only accepted, but in the end *begged* for these burdens.

Which of us was the fool?

"You can't stay here," I said. "It's not safe. And I have to get this work done."

"I know, Mr. Giffels. A truck is coming tonight."

But it did not happen. Not that day nor the next. As the week crawled forward, I continued moving her things toward the exits, each day choosing a room that I cleared and attacked, each day growing bolder in my destruction, chopping and yanking at the lath until my shoulders grew weary, no longer checking the mirror to see if I looked cool. I did not. I had a patina of soot that the shower did not remove, smoke-colored fingertips and black pores, a growing hieroglyph of nicks and scratches in my skin, bandages on knuckles that I wrapped with duct tape so they wouldn't fall loose at the first rising of sweat.

The voids in the ceilings had begun to give up dark secrets, heavy, tangled nests that dropped along with the filth and plaster. The round, cottony ones I recognized as mouse nests. Others were more elaborate, large and clever, some woven with faded plastic ribbon.

Steve chuckled when I showed him one.

"Raccoon."

Raccoon? I had discovered half a dozen of them in one room alone, between the ceiling joists of what was to be Evan's bedroom. The notion of this as "the baby's room" was completely incongruous. It was laughable. I had put so much planning and effort into his bedroom at the semiremarkable house, and here I was dropping vermin nests onto the floor of a room that looked like something abandoned after the bombings. The back wall was crumbling between windows draped with stiff, yellowed plastic sheeting that hung in shreds. The window shades behind this were stained and torn. Ice formed on the wall of the closet, which was situated above an outdoor alcove whose ceiling had collapsed; there was nothing between this closet and the single-digit nighttime air except a fraction of an inch of hardwood floor, which is not known for its R-value. The only suggestion that this room had even been entered in the modern age was its carpet: garish orange shag that screamed like Janis Joplin on bad acid. For the sake of identification, we had begun referring to this as the Orange Bedroom.

Half the week had passed. I returned again before dawn, no longer expecting to find the place magically cleared. I turned the key in the front door, set my tools in the foyer, and pulled the door behind me.

Something was different. At first, it was a smell, but no—it was a feel. It was physical. It was warm. Hot. Humid. I didn't see my breath. And then I heard it. Water rushing somewhere. I entered the center hall to discover steaming water raining down into the fireplace, running across the floor. The boxes and piles and carpet all around the fireplace were soaked.

Shit! Shit-shit-shit!

I'd forgotten to shut off the furnace valve. It had been refilling all night without regulation, force-feeding water through the leaky system. I didn't know whether to run downstairs to shut it down, or upstairs to see where this water was coming from. Instinct took me upstairs. The carpet sloshed under my feet as I sprang to the staircase. I reached the upstairs hallway and saw that the radiator there was shooting water out from its faulty connections, spraying everything around it.

I raced to the basement, fumbling through the dark because the lights along the way didn't work. I got to the furnace and shut off the valve. I cracked open the drain to bring the level down to the line on the glass. Steaming water ran across the floor, around my feet, toward a floor drain that I already knew was stopped up with the sand of decomposed walls, and it would take hours to seep through.

Afraid now that I'd made the system even more dangerous, I turned the thermostat all the way down. I went back upstairs. The air in the center hall was heavy and humid. For the first time, I felt warm in here. Poking halfheartedly at one of Mrs. Radner's boxes, I confirmed that, yes, it was drenched, and the next one too, and the next one. I pulled what I could to a dry area, the sodden boxes falling to pieces between my fingers, and I did what I'd been dreading.

I had Mrs. Radner's daughter's phone number scrawled on a corner of paper in my wallet. Because her name was on the deed, she was the one ultimately responsible. I went to the ancient black rotary phone and popped open a musty canvas camp stool leaning against the wall. I sat and dialed the number.

She answered. I told her the house had to be empty by the end of the day. She told me she was going to sue me. I asked her why. She said because we never should have gotten this house. I told her that was none of my concern. Our contract was valid, it had been squeezed and scrutinized and challenged by her own agent. If she wanted to sue somebody, it was her own Realtor.

I am not one who deals well with confrontation. My stomach was tight. I tried to keep my resolve. Nearly twenty years later, my status as the Most Shy child in the St. Hilary School eighth grade was not serving me well. I had to try to set aside the sympathy I felt for a woman who seemed lost inside her own life. I knew this was hard for Mrs. Radner; I sensed that it was more than she could bear to accept in total and so she had narrowed her focus to, for instance, a stack of photographs in her lap. I recognized this condition. It was what I had felt holding Evan in my lap at the doctor's office, narrowing my focus to the fragrance of his hair so I wouldn't have to deal with the larger coldness around us.

But I did what I had to do. I told the daughter that if the house was not emptied that day, whatever remained I would haul to the curb. She ended the call bitterly, with lingering threats of litigation.

L ouis arrived eagerly that late afternoon, straight from work, with a change of clothes. He was going to get to help me rip down the billiards room ceiling. This would accomplish the dual purpose of exposing long runs of ruined water and steam pipes and eliminating five hundred square feet of ruined plaster. We had my dad's spud bar, a six-foot-long, twenty-five-pound iron rod with a spade tip at one end and a flat knob at the other, perfect for punching up into a ceiling and bringing it down. This bar had come from my grandfather's farm, a prized family possession that had the power to prove manhood.

I'd told Louis about my showdown earlier in the day. He arrived ready for battle. He changed into his work clothes in the dark basement stairwell and brushed brashly past a coatrack as he returned to the upstairs, looking at it as if he might kick its ass.

"You want her out, I'll kick her out," he said in an intentionally loud whisper.

"They're leaving. Just be cool."

Mrs. Radner, her daughter, and an indentured nephew had arrived in the afternoon with a moving truck. The young man seemed none too keen to be there, but he and the others had been making steady, if slow progress, hauling items one by one into the yellow rented truck in the driveway.

"Have you looked under the carpets yet?" Louis asked.

Having refinished the hardwood at his own house, he was eager to see what kind of flooring we had under all that green carpet. Until now, I hadn't been able to look, shackled by the Do-Not-Touch rule that seemed still to hover with the presence of Mrs. Radner.

"No," I said.

"Well, come on! Let's do it," he said, heading out the pantry door and into the dining room.

I followed him and chose a spot where the carpet met the marble fireplace hearth. I bent down and tugged at the edge, but it was nailed tightly to the floor.

"You got a knife?" Louis said.

"Yeah," I said. The utility knife in my back pocket had practically become an appendage. I pulled it out, glancing back to see if any of the Radners were in view. I felt as if I was violating their house, preparing to cut into a piece of carpeting that belonged more to them than to me. I pushed the button that extended the blade from the tip of the knife and made a pass at the carpet. It didn't cut through and I slashed again, harder, laying open the carpet. Louis peeled it back.

"Look at that," he said.

The oak was golden, and although the varnish was worn off, the wood itself had a warm, even grain. It looked to be in good condition. Except where my knife had left a curved slice in its surface.

"Nice going," Louis said.

"Wasn't my idea," I said.

Louis and I headed toward the basement to begin work. Mrs. Radner passed us going the other way, her arm raised overhead, holding a clothes hanger draped with a fur coat, or, rather, the shoulders of a fur coat, trailed by the mangy tatters of what once had been the front, back, and sleeves of a fur coat.

Poor, sweet lady. As long as it went into the moving truck, I didn't care.

Louis and I went into the billiards room and closed the door behind us. He was smitten with this house, with its decadence and grandeur. He couldn't wait to punch holes in it. He reached for the spud bar I was holding. At first, I resisted. If I gave up the spud bar, I'd have to be the one shoveling the debris into trash cans while he had all the fun of smashing out the ceiling. But he was a guest, and so I allowed him first crack. He began ramming the blunt end of Grandpa's spud bar into the ceiling, knocking big holes and yanking downward to bring plaster crashing onto the rustic tile floor. I followed, scooping up the mess with a flat shovel and dumping it into a plastic garbage can.

The room was soon a dense, gritty cloud, each ugly crunch followed by a crash of wood and plaster. I started into Louis's wake on a short ladder, using my crowbar to rip down the remaining lath. We could barely see each other in the dust. I smeared my fingers periodically across the lenses of my glasses, which did little to improve visibility. We were a machine. We grunted and yelled into the effort:

Come loose, you stubborn mother . . . CRUNCH!

The joists released eight decades of accumulated soot; vermin nests; cilia irritants; the wood curls left by the planer of a long-dead carpenter; decomposed plaster; and a gourd-colored, foil-lined package, which a leading archaeologist (me) believes was also left behind by the original carpenters, bearing the label of Five Brother's Pipe Smoking Tobacco and marked by this predecessor to the surgeon general's warning: *Every person is cautioned, under the penalties of law, not to use this package for tobacco again.—Fifth Dist., State of Kentucky.*

The trash can was only a third full, but I could barely lift it. I hefted it onto my back and humped upstairs toward the Dumpster.

On the way, I passed Mrs. Radner, making her way to the moving van, carrying a single item: an Avon catalog.

I glanced at the cover:

1972.

Later that evening, Gina arrived to begin taking down the kitchen cupboard doors. She planned to take them to the semiremarkable house, where she could paint them in the basement, away from the mess. I tried to kiss her, but she pulled back from my soot-smeared face, blowing me a kiss instead.

"Will they really be out tonight?" she whispered.

"I think so," I said. "Nobody messes with me."

She smirked.

"Hello, Louis," she called toward the dust cloud at the bottom of the stairs.

"Hey," he yelled back.

"Thanks for helping."

A crunch of spud-bar-on-plaster came in response.

I returned to the billiards room and shoveled another pile into the trash can. When it was full, I hauled it to the Dumpster. On my way back, I detoured through the kitchen to see Gina. Mrs. Radner appeared at the other entrance, down the long corridor of the butler's pantry, and stopped halfway.

"Mother?" her daughter called from somewhere. "Do we want this coat hanger?"

Mrs. Radner looked up at us with that sideways tilt, and turned her attention to Gina.

"Don't ever let this happen to you," she said.

And then she was gone.

landing

I found my swinging spot. Every house has one of these, a place in the overhead architecture that invites the hands to take hold so the feet can leave the floor temporarily. It is good for the constitution, mental and physical, to do this from time to time, to disconnect from the floor, to push back against gravity. These swinging spots are generally found in doorways and staircases. Some are more conducive to a single, spontaneous chin-up, others to a trapeze maneuver. Mine was of the latter variety.

I say I found it, but really it found me, the first morning Mrs. Radner was gone, definitely gone, and I felt a rush of release: now—it was mine! Or more mine than hers, anyway. These things are never clean. But there was definitely a shift in momentum. And I felt pretty good as I came down the main staircase for the Sawzall and glimpsed, Steve Austin style—*naah—naah-naah-naah-naah*—the lip of floor that extended beyond the second-story balcony, just barely within my reach, positioned above the landing where the staircase made its dramatic turn into the main entry hall.

Instinct took over. I am a former boy; my body knew what to do. My arms rose and my fingers hooked themselves over that lip. Before me were the final six stairs to the first floor. I swung forward with the grace of Tarzan when he knows Jane is watching. The spirit of improvisation carried me into the ultimate swinging-spot maneuver: when I reached the apex of my forward arc, I let go.

As I was carried forward through the air, I felt the tingle in my lower back, the premonition of my spine cracking against the front edge of six stair treads, bringing the full power of Newton's curse (150 pounds of Impulsive Human Male x force of gravity + the fact that you should know better by now, etc.). I noticed, in the split second as I passed it, that the heavily ornate lintel that sat atop the wooden columns framing the entrance to the living room was not wood (as I'd believed) but rather cast in plaster; a crack confirmed this. (Why is everything in this house defined by its disrepair?) I made a mental note of this.

And then I landed.

I did not crash. In fact, were this the Olympics, golden-haired commentator Peter Vidmar would be telling the home-viewing audience that I'd "stuck the landing." I turned to the judges and fired them a smile of toothy confidence. I had passed through a breathless unknown, injected a flourish into my routine that was as unnecessary as it was graceful, which is the very definition of art.

Even the Russian judge says, "Ten!"

I retrieved the Sawzall case and went back to my work.

The labor found its own rhythm. In the same way I'd felt confused about my location in some of my early visits, lost in the sprawl and the staircases, I now found myself confused about time in this long and disconnected week. Only a few days had passed, but it felt like an era. This house was so filled with the past, and so oblivious to the present, that it seemed to send static interference into chronological time. Days ran together, nights found themselves suddenly on the doorstep of dawn. Within that long week of preparation before the contractors would arrive, I never could say what day it was.

I continued to arrive every morning before first light, my face and hands stained with the previous day's soot. I felt constant pressure to eke out every possible moment as I prepared for the coming assault of the contractors. The outside temperature was sticking close to zero and the house was penetrated with coldness, its very cells pinched and brittle. I trudged to the basement, calibrated the dangerous furnace, and returned to wherever I'd left off in the process of organized destruction.

With the house cleared, I began to wonder further back into its history, to imagine how it might have appeared when it was brand-new, and how it might have felt to whoever first set foot in these rooms, freshly finished, still sweet with varnish and paint, shiny and pristine. Now that I was faced with pulling the house back from its demise, I wanted to know who had been here at the very beginning, and why they had built this house so grandly here, in a neighborhood where it didn't seem to belong.

The more comfortable I became in the house, the more it seemed I'd waited my whole life for this. Above me was an attic that, due to rodents and other unsavory issues, Gina wanted no part of: a suite of servants' quarters, two bedrooms, and a full bath. Aside from the billiards room, it was the only part of the house where the woodwork hadn't been painted. It was pine, or maybe poplar, stained in a dark cherry finish, the prettiest woodwork in the house even though the rest was oak. It was exempt from the eggshell paint only because it wasn't deemed worthy. Why waste good paint on the help? But now it would be all mine—an office, a writing retreat, with one room just for books and another just for writing, with French windows that I would throw open in the springtime and gaze out at the neighboring buildings, at Janet and Kindy Sue.

And below me, two floors down, was a basement that Gina even more vehemently wanted no part of, a sprawling catacomb anchored at one end by a billiards room—*a billiards room!*—with that grand

English hearth, and at the other end by a coal room—*a coal room!*—and an attached furnace room, with crude brick and tile walls and an uneven concrete floor. I planned to remove the coal-stained dividing wall, and this would be my workshop, the place for my tools and workbenches and scheming, a crude place nobody wanted but me, and oh did I want it.

Could a young man hope for more? Not one, but two places of my own, with doors that closed behind me, a place to arrange all the things no longer allowed in the tasteful and domesticated Main Living Quarters. The velvet Elvis and the Frederick Remington print in the cheap frame; the fake dog poop and the pencil holder made from a beer can; the contraband bowling pin and the tattered Jolly Roger, and—*yes*—the molting deer trophy with the damaged snout, plucked just in the nick of time from someone else's trash!

Virginia Woolf had it right, but not all the way right. Men too need a room of our own, and not just for the shallow things, not just for the airplane liquor bottle collection and the tattered Sonic Youth flyer yanked from the barroom wall as we filed out from the show lo those many years ago. We need a place to be alone.

An attic above, for the mind, and a cellar below, for the soul.

Mine.

This emergent sense of ownership was as corporeal as it was spiritual. With no working plumbing in the house except the washtub on those questionable legs, I'd been pissing in a floor drain in the basement, until one day when I opened a door down there and discovered a small lavatory I hadn't known existed. It emerged from a shadowy corner, like a grotesque mirage. The tile floor was broken, heaved up and uneven, and the toilet was foul and ringed with brown, but it worked. I began using both floor drain and toilet, without distinction. I chose whichever one happened to be closer; given the state of things, I felt that two rudimentary receptacles rather than one constituted exponential progress. I mentioned this to Gina one evening over dinner and she insisted that I use the toilet.

What began as an abstract challenge now had become a harsh phys-

ical test. I hardly slept, working some nights until the cold and exhaustion and poor lighting led to hallucinations. I wore a respirator and still my nose and lungs filled with a thick black sludge. I coughed it up all night. The soot got in my pores and would stay there for weeks.

As that week ground toward its finish, I threw plaster and festering carpet and broken toilets from the upstairs front window into the Dumpster parked below. I threw things I might want later out a back window into the garage, taking advantage of the huge opening in the rotten flat roof, each crash of debris pissing off the feral cats that lived in the poison trash below. When I lay down at night, I shook as my body contracted.

Strange things emerged as I dug deeper into the wreckage. In a basement closet, I found shelves of old jars, each with a single grocery receipt sealed inside, dozens of them, dated twenty and thirty years before. Some were receipts for a single item—a twenty-cent loaf of bread. Why were they here, so carefully preserved?

In the attic, I counted those foil turkey-roasting pans—fifty-five of them lined up in rows to catch the water that poured in. Some, between joists, rested on live wiring: water and metal and electricity in uneasy union. And I wondered anew how this old lady had managed, not just the physical strain, but the psychological strain of such a situation. The rain poured through the roof, leaking through the gaps between those pans, then down into the master bedroom, through the gaps between *those* pans and buckets, and all the way down into the first floor, where it had destroyed one wall and stained the floor. In the billiards room below, the leaky steam and water pipes picked up where the roof damage left off; their constant dripping and hot pressurized spray had decimated everything.

I had visitors most days. Chris brought his mother, a staid and efficient woman from a well-kept aluminum Colonial, for a tour of this house she'd heard so much about. She walked in, endured a cursory introduction to the place, and walked back out, quickly, with her face taut. She seemed actually to be upset with me as she negotiated the front steps, cautious heels crunching in retreat.

"Nothing on God's green earth could make me take on a project like that," she declared over her shoulder on the way to the car.

Chris and I smirked with pride.

As the week ticked down, I became more and more apprehensive about the arrival of the subcontractors, and the loss of the idea that, despite the chaos, this project was somehow under my control. Their reign would be brief, but brutal. Preparing for their arrival had brought on all sorts of unpredicted challenges. I had, in essence, been cutting open the patient in preparation for the specialists to come in and perform surgery. Subcontractors like their holes big and clean. It was my job to make them that way, which was seldom simple. The tubes for the internal vacuum system, for instance, conflicted with the route the wiring wanted to take and I had to adjust accordingly. I chose the openings carefully to avoid the delicate plaster moldings and I chose pathways through the walls that would save the stucco from destruction. These concerns sometimes led to roundabout access holes, but I was doing whatever I could not to destroy the house any further.

Most contractors don't like restoration work, especially on older houses, where the quirks become more confounding. Chimneys take inscrutable turns; fishing wires through walls is an act of dead-end telepathy. But these were the very sorts of things I cherished, the aspects of personality that made a house more than an inanimate dwelling.

The oddities were only part of the challenge here. Ironically, the house's intrinsic durability was an impediment to fixing its decay. The plaster in some places was two inches thick, and where it hadn't been eroded by water, it was like marble, almost impossible to remove. In a fit of frustration, I'd thrown my beloved hammer full force against a wall in the billiards room and it had bounced off harmlessly. Not a dent. Try that in a modern subdivision. You'll be picking up your hammer from the front yard.

When Steve had informed me that the mauve-and-white basket-weave tile floor and its four-inch-thick mortar base would have to be removed to get to the pipes in the master bathroom, I'd balked.

I could never replicate tile work like that, and removing the floor would require a jackhammer and days of backbreaking work. Instead, as Steve pushed back his ball cap and scratched his thick scalp, listening, I'd insisted I could cut out just the section where the pipes were and save the rest.

"Maybe," he said. "You can try it."

I was determined. With a masonry blade in a power saw, I carefully removed the section that covered the drain line. I carried the disembodied hunk of floor to a corner of the basement; later I would chip the tile free, piece by tiny piece, and reset it in new mortar after the plumbing was done.

Steve always responded to these plans with a smile that was a cross between bemusement and approval. He liked jobs like this, but he especially enjoyed playing the role of negotiator between me and the subcontractors, most of whom, I was learning, spent very little time contemplating (for instance) the concept that the cells of a building are mutated over time by the souls of the humans who occupy them and therefore changed forever. Mostly, they wanted wide floor-to-ceiling openings to make their work easier.

Too, I think Steve liked the idea of having a role in a process that was going to change a young family's life. He liked the idea that he could protect us from some of the pratfalls and difficult negotiations about to unfold, from some of the mistakes that could destroy the uninitiated. I didn't recognize this then. I didn't recognize just how much all this was going to change us. But I think Steve knew.

I still wished I could do everything myself, but I was slowly beginning to understand the value of moving my wife and child into a place that would not require them to wash from a bucket by candlelight.

15]

treasure

On the final Saturday before the workers took over, a few days before Christmas, I was upstairs prepping one of the bathrooms. One Dumpster already had been hauled away, and I was well on my way to filling the second. As I dragged a heavy garbage can to the front master bedroom window and hefted it up to dump it, I saw Steve's yellow truck in the driveway. I called out for him to join me.

We were going to try to figure out the best way to access the plumbing to the second upstairs bathroom, which had a door at each end, connecting the Green Bedroom and the Orange Bedroom. The conversation played the recurring theme: the easiest answer was to tear out the floor and expose everything. This was fine for the plumbers, but not so fine for the person who would have to remove the concrete floor and replace it after they were done. That person was me. So I'd been eyeballing the configuration and I was pretty sure we could get to the plumbing by removing part of the wall in the adjoining butler's staircase.

As we stood in the Orange Bedroom discussing this, Steve lifted his cap and pushed his sheepdog bangs back, then pulled the cap on backward to get the bill out of his way.

"Let's take a look at what we're talking about," he said, pulling a penlight from his shirt pocket.

There was a little door in the bedroom wall, two feet high, that opened to give access to the plumbing end of the tub. Steve tugged up his pants legs and dropped heavily to the floor in front of the opening, propped himself on an elbow, and leaned in for a look with his flashlight. I stood over him, hands on my knees, trying to peer in. Steve craned his neck in one direction then the other, mumbling through the possibilities. Then he stopped.

There was a piece of rusty wire twisted around one of the pipes. Steve hooked a finger over it and pulled. We could hear something scrape back in the narrow void between the bathtub and the wall.

"David," he said. "I think we found a treasure."

"Right," I scoffed.

"No—really," Steve said. He was drawing the wire closer, and then I saw what he was talking about. The wire was attached to the handle on the end of a blue metal box, about the size of a shoe box. Steve drew it out and rolled up into a sitting position, crossing his legs Indian style. I sat down across from him. We both looked at the box for a long moment. It had a lock on the front.

"What is it?" I said.

"I think it's treasure," Steve said again.

I picked it up and shook it. I felt something clunk one way and then the other.

"There's something inside."

I looked from the box back to Steve.

I got a screwdriver from my toolbox and sat back down. With nervous fingers, I worked the tip into a corner of the box and pried upward. We could see the papery edge of something inside. We looked at each other again.

"Gimme that," Steve said, and without another word, he pulled

the box from me, reached over by the door where my hammer lay, raised it above his shoulder, steadied the box with his other hand, and smashed the hammer down on the lock.

It broke open and bundles of money spilled out.

"Holy *fuck*," I said, breaking the unspoken profanity clause.

My mouth went dry and heat rushed to my ears. I slapped my hand across my forehead and rolled backward.

"Holy *fuck*," Steve said.

I sat back up. Each of the bundles was held together with a two-inch-wide bank wrapper. I picked one up and flipped its edges across my thumb, bootlegger style. The paper felt stiff. The top bill was a twenty, but it looked different from a regular bill. I looked at the wrapper, yellowed, with a faded purple stripe down either side.

L. Williams was written in pencil, in curlicue script.

Below that, a date: 3–15–30.

Then the amount in the bundle: $2,000.

Then the handwritten notation: *Okay*, followed by a single letter, *R*.

I had never held $2,000 in cash before. I counted the bundles. There were seven.

"Fourteen thousand dollars," I said to Steve. We were both still wide-eyed and blank.

Steve put up his hand, offering an awkward high five. I slapped his palm with a burst of involuntary laughter. It was nervous laughter. I had no idea what to make of this.

I asked Steve for his flashlight and stuck my head into the hole. Who had put this here? How long had it been forgotten? What if there was more?

What if there was more?

Our reaction was spontaneous. We would turn this house upside down. We began right there, intoxicated by the space around the tub, trying to penetrate it with our eyes, bringing in a stronger work light, reaching in until our shoulders were nearly dislocated, fingers groping into the dark void. Nothing. Then we began an intense, methodical search through every corner of the house, beginning with the access

door behind the master bathroom tub, and leading to every cavity we could conceive of.

We were a perfect team. Steve knew how houses went together, where the hiding places might be, but he was too large to crawl into the small places. I had never considered what might be in the attic knee walls, but I could fit inside one and I wriggled in with abandon.

Along the way, Steve regaled me with legends of job finds, a long oral tradition among contractors. He'd once heard about a carpenter finding gold doubloons in a hollow newel post, a popular hiding place for valuables. (Immediate mental scan: no, this house had no newel posts.) He knew people who'd found money behind drawers; we pulled every closet and built-in armoire apart. We went to the attic and I climbed up in the rafters, feverishly searching places I'd previously been frightened to approach, knowing the population of critters that had to be lurking somewhere up there. We tapped on wainscoting and prodded floors. We looked up chimneys and tugged at stair treads. For hours, we searched, charged with energy and intrigue, forgetting completely that we were still careening toward the deadline for prep work.

If we were hiding money, where would we hide it? Where?

By nightfall, we were certain we'd covered every inch of possibility. We'd found nothing more.

My God—I hadn't called Gina. I picked up the phone and told her to come immediately. She probed for the reason; I told her to drop everything and *just. come. now.*

Steve and I set up a little guessing game for her. We were giddy. We closed all the doors leading off the second-floor main hall—six of them. When Gina arrived, we yoo-hooed for her to come upstairs.

She approached with her brow furrowed and a curious smile, Evan in the crook of her arm. She would not allow him on the floor with all the dust and debris. He had been in the house only a few times. We were protecting him from this place that soon would be his home.

"Pick a door," I said.

She pointed to one.

"Nope," I said.

She tried another.

"Nope."

She went through all of them, not choosing correctly until the last one.

"That's it," I said. "Open it."

She walked into the Orange Bedroom, looking. I began to re-create the story, acting it out with the narration. I opened the little door in the wall, drew out the box, finally opening it . . .

"And *this* is what was in it."

She was dumbfounded at first, not sure what to make of it, the delay diluting her game-show reaction. The presence of the money in the room made everything feel different, slightly off center, almost as if there were another being with us, influencing how each of us interacted with the other.

Her eyes grew wide. Her mouth dropped open.

"It's . . . *real?*"

As the story wound down, Steve said he needed to go. We looked at each other and shook our heads, still not believing. Then he went downstairs and out the front door.

"You should give him some," Gina said to me.

I had already considered that, but it was just one of hundreds of random, confusing thoughts I had endured that afternoon.

"You think?"

"He's the one who found it."

"True. But how much?"

"Half?"

"I can't give him half. Can I?"

"I don't know. What's right?"

I heard the yellow truck start in the driveway. I looked down at the box. I reached in and grabbed one of the bundles then sprinted down the stairs and out to the driveway.

"Here," I said, thrusting it through his open window. "Merry Christmas."

He looked at it for a long moment. He was thinking; I have no idea what.

"Thank you," he said, and tucked it into an inside coat pocket. "Thank you."

He smiled and shook his shaggy head.

I went back inside.

It would seem that there is no downside to finding $14,000 in the wall of your home. But that is not the case. Not at all. Money is never simple.

Even amid the initial euphoria, I found myself afraid of the cash. I didn't know what to do with it. I wasn't even sure what it was. It didn't look like real money. The colors didn't have the range of modern bills; these looked more like parchment, more monochrome. The numbers and graphics were different, antique looking. "The United States of America" was written across the top instead of on the side; the 20s in the lower corners were enclosed in ovals. Andrew Jackson's face was much smaller, and the image was different—he looked less heroic, almost homely. Is it possible that dead presidents have been visually glamorized in the media age?

It didn't feel the same, either. It was stiff and brittle and the paper seemed thick.

It occurred to me that this money might be worthless, out of circulation, decommissioned, empty scrip, something like that. Or counterfeit, or some sort of old-time play money, or a speakeasy's illegal stash. Pulp fiction.

Then there was the question of who it belonged to. The only people Gina and I told about it—ever—were my parents, because my dad is and always has been the person we go to with questions like this. To this day, when there is an Important Life Issue, Gina will say, "We need to ask your dad," and then we do. If you had asked us hypothetically the day before this happened, "What would you do if you found thousands of dollars hidden in the wall of your house?" we both would have answered, "Ask Dad."

146] David Giffels

So that's what we did. My dad called a tax-attorney friend and, through a discreetly vague presentation of the situation, determined that there was no question we were legally entitled to the money or, for that matter, anything else that we found in the house.

But then there was the moral question. Did someone else deserve this money? It still wasn't clear to me who had lived in the house in March 1930. The city directories indicated that it changed hands a couple of times in that period; even then, there's confusing information about which members of the family who owned it actually lived there. The people we bought it from didn't own it until several years later. Plus, who else might have stayed here in the meantime? Maybe there were servants, a boarder . . .

The date on the bank wrappers was four and a half months after Black Tuesday, the October 29, 1929, stock market crash. Fourteen thousand dollars would have been the contemporary equivalent of $134,500, using the consumer price index. Our theory was that someone, frightened by the national economic crisis, had stashed this away for safety.

But who hides thousands of dollars in a house—and then forgets about it? Did someone die suddenly, without the chance to reveal the secret? Or was there some reason to keep it a secret, something illegal?

And how had it survived all the damage and rot? How ironic was it that one of the only spots in the house dry enough to preserve paper currency was *directly underneath a bathtub with ruined pipes*?

My head spun with the possibilities. My conscience said that this money had been forgotten for nearly sixty-seven years and belonged to whoever found it. My conscience was aided by the fact that this was the only pleasant surprise left behind in this house, and it was accompanied by an uncountable number of unpleasant surprises, including an almost tongue-in-cheek Property Disclosure Form that, for instance, had both the No and Yes boxes checked under the question "Have you received notice of any building or housing-code violations?"

But still, it was hard not to think about the ethics of found money. Did I give Steve enough? He was the one, after all, who had found the wire. He could have kept quiet and come back to investigate after I was gone. Or did I give him too much? Was I depriving my family of whatever security that $2,000 might provide, considering the dangerous economic instability of our new living situation?

And what if we'd missed it and one of the plumbers found it a few days later? Would we ever have known? Would he have turned it over to us?

And still, even after the search, the question: *Is there more?* Which raises another question: Why was greed the first response?

Money is complicated. And I had way too much on my mind to deal with it right then. Consumed by the immediate chaos around me, I returned the remaining six bundles to the metal box, closed it as well as I could against its broken lock, wrapped it up with the wire, and took it home to the semiremarkable house, where I hid it in a safe place and tried to forget about it for the time being.

Christmas wedged itself into the process. Before everyone made their way to my parents' house for the annual Christmas Eve gathering, I invited the family over for a quick ceremony to christen the house. I'd bought a couple of bottles of cheap champagne, and I poured it into plastic cups for the guests, who stepped over stacks of baseboard and around piles of rubble in a shabby approximation of a holiday open house.

I carried Evan on my hip, his body thick in a sweater, and walked him through the house, showing off my achievements of destruction. The house had changed radically, and I realized that in the reactions of people who had seen it just a week before. They didn't say it looked better. It didn't. Only that it had changed, radically. Which it had.

We all went outside onto the front stoop. I handed Evan off to Gina and raised a bottle of sparkling wine like a hammer I was about to drive into a corrupted wall.

"I—what?—christen thee, I guess," I said.

"Careful you don't knock the house down," my dad said.

I grimaced and swung the bottle hard against the brick wall.

It bounced off.

I smiled sheepishly. I swung again, harder, but the bottle still didn't break.

A third time, and still, nothing. It never went like this with First Ladies and battleships.

"Try the corner," Gina said, backing farther away.

I aimed the bottle of cheap spumante at the edge where the house stepped forward confidently to meet the yard and I brought it down sharply, with both hands. It exploded in foam and glass. Everyone clapped and we all departed, leaving the mess behind.

I'd been promising Gina I would scrub the filthy walls of the attic servants' quarters. There was no rational reason to do this. The house was only going to get dirtier, and the attic was the least of my concerns. We had no kitchen sink, for instance. In most houses, this would constitute a crisis. Here, it was just one of dozens of matters far more pressing than the grimy walls in the servants' quarters.

I had wanted to keep that huge porcelain sink that spanned most of the kitchen counter. It had the stage presence of a Packard. But Gina hated it—she said it was way too shallow. Plus, the counter was rotten and would have to be replaced. My dad had offered to build a new counter and cabinets as his contribution to the monumental task of getting us into a house where we would not have to dine like troglodytes. To his way of thinking, if we were going to put in a new countertop, we should put in a more practical modern sink. Not only was I outnumbered, I was outnumbered by my wife and my father: an exponential combination. I gave in. I bartered with the heating-and-plumbing contractor—I would give him the sink in exchange for a used radiator that we needed for the summer bedroom.

These were the kinds of negotiations that made it hard to justify

spending my final night of preparation scrubbing the attic walls. Gina was correct in at least one regard: we needed someplace to start moving boxes to from the semiremarkable house, and the servants' quarters would be the least-disturbed area. And Gina would not allow anything, even a moving box, to come into contact with an unclean surface. Besides, I'd learned that, with so much to do, it was easier simply to point myself toward a task and dig in. Prioritization was futile.

I dragged my long extension cord up from the second-floor hallway and draped it over the railing in the servants' quarters, plugging my work lamp and radio into the double receptacle. Westwood One was broadcasting a No Doubt concert, which was marginally better than dead silence.

The servants' quarters occupied the bulk of the third floor, with two bedrooms and a full bathroom connected by an L-shaped hallway that overlooked the staircase. The large main bedroom stretched from the front to the rear of the house, with windows at either end set into alcoves that peeked out from the dormers. The rest of the attic consisted of the large unfinished spaces that housed the wisteria and considerable evidence of wildlife.

Because this was the farthest possible location from a working faucet, my scrubbing involved an insane system of water hauling. The only source of water was the basement washtub. The water heater, stamped with a 1908 patent, still worked, but it was an obsolete, ornate iron monster, gas fired, with coils inside that heated the water as it passed through. It was almost elegant, but also deadly. The plumbers told me that those old water heaters are like time bombs, with their gas lines and open flames. When one of those suckers blows, it shoots through the roof like a rocket.

I'm just a girl in the world . . .

There was no way to adjust the temperature on the water heater, so what came out was about one degree below boiling. I began the

agonizing process, filling two five-gallon buckets in the basement, hauling them up three flights of stairs to the frigid attic, then scalding my hands as I hurried to scrub the walls before the water turned ice cold. Most often, it turned to near mud before this could happen, as I removed years of soot and dust.

Struggling up three flights of stairs with two hot, splashing buckets . . . scrubbing in the near dark accompanied by tinny '90s ska . . . down the stairs with frozen fingers.

Repeat.

· This went on late into the night until, finally, I could no longer face another trip with the heavy buckets or another chirp from the voice of Gwen Stefani. I stopped. It was time to go home.

I shut off the furnace valve, turned down the thermostat, and gathered my tools. I had done all I could. The house was as ready as it was going to be. Steve and his crew and all the subcontractors would arrive early the next morning and whatever control I felt I had would be lost.

Before I left, I walked out back to the rock-lined pond. It was half full, with decaying tree branches sticking up through the ice. I stepped onto its frozen surface—no idea whether it would hold my weight—and moved to its center, stopping there in white silence, cold and strong and uncertain.

I tilted my head back against the aching muscles of my neck. The sky was clear and the moon was bright and everything glittered in the sharp air. As my breath collected and disappeared before me, I watched as a brown rabbit hopped to the middle of the white yard and stopped under the huge dying maple, its nose in the air, perhaps sensing me.

I watched it, wondering what it was doing out in the cold, so late at night. I wondered at its tranquillity.

My time alone had ended. I had done what I could. Now the crews of strangers would arrive and for a month I would wonder how anything had ever seemed, even for a moment, peaceful.

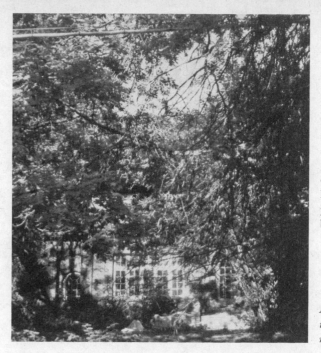

Peering through the trees at the living room windows and front door. "The house was barely visible from the street, more the suggestion of a house: a tall, gabled presence obscured by a heavy, untended jungle of trees and brush."

All photographs by the author unless noted.

"It revealed itself," after the brush was cleared, "as an abandoned castle might, boldly cavalier, draped in shadows and ivy, even more mysterious up close than it had been from behind the overgrown yard."

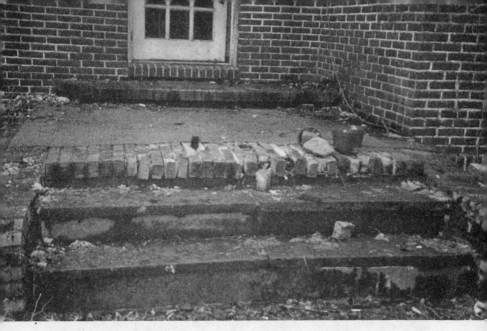

"Approaching the main entrance to the house was mostly a matter of trying to avoid personal injury."

The attic roof where it meets the chimney, in the front corner nearest the driveway. "The rain poured through the roof, then down into the master bedroom, through the gaps between pans and buckets, and all the way down the first floor."

A storage room door in the attic with instructions that were not clear until I opened it. "On the inside of the door were tiny muddy handprints, which I recognized as raccoon. I closed the door."

The attic floor, directly above the master bedroom. "On the floor were fifty-five cheap foil turkey-roasting pans lined up in rows, one touching the next, each containing an inch of rainwater."

The master bedroom, on the morning we were to take possession. "She was like the ghost of her own house."

In the garage. "The joists from the partially collapsed roof dangled haphazardly, like pick-up sticks dropped from the sky."

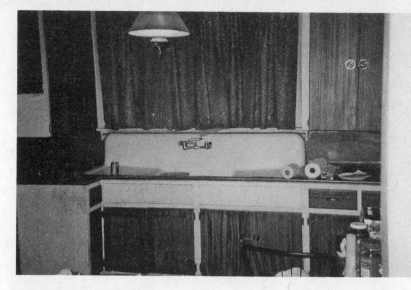

"In the main kitchen area, spanning most of one wall, was a porcelain sink the size of a shallow bathtub, the red linoleum counter around it rotten through. The sink itself was gray with soot and grime."

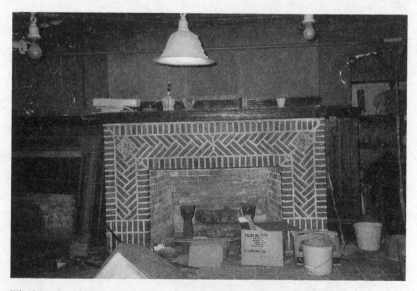

The basement billiards room. "My fireplace count reached six, resoundingly, as my eyes rested on a massive brick hearth with fancy English tiles, lorded over by a heavy dark mantelpiece, the sort of thing around which mead is drunk."

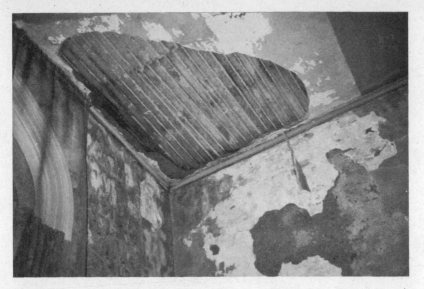

The solariumm ceiling, front corner. "The walls were mottled with decomposed wallpaper and stained plaster, in some areas decayed down to the coarse base coat. Above us was the green corrugated fiberglass hole I'd seen that first day. Part of the ceiling was gone."

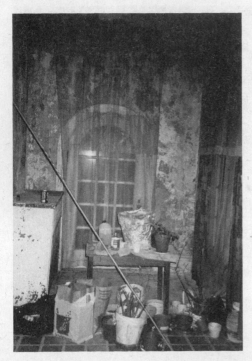

The solarium door, which opened to the front yard and into a thick tangle of weeds and wisteria. "Our eyes met. We knew. We belonged there."

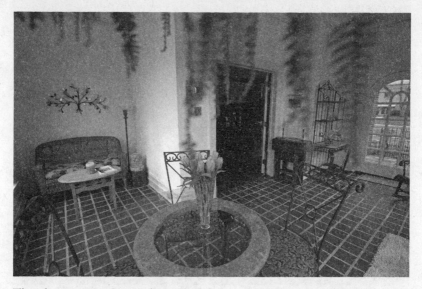

The solarium, 2008. Gina and I restored this room together, and it's where we spend most of our time in warm weather. The room that seemed the most wrong now seems the most right. *Photograph by Jeff Swensen*

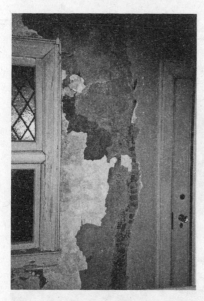

The upstairs hallway, at the back of the house by the stairs. "The wall beyond had eroded through layers and layers of horsehair plaster down to the terracotta building blocks."

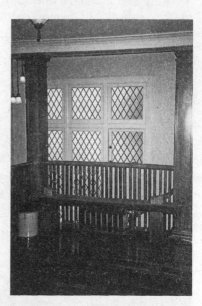

The same upstairs hallway, 2008, with woodwork stripped, restored, and refinished. On sunny afternoons, the amber-and-gray stained glass casts the hallway in brilliant golden light.

The center hall, 2008. The doorway on the left looks into the dining room; the living room opens on the right. The open floor plan and spacious rooms have made this our family gathering place, home to weddings, funeral receptions, holiday celebrations, birthday parties, and also some unconventional indoor roller-skating.
Photograph by Jeff Swensen

In the main stairwell at home, 2008. "My people! My people!"
Photograph by Jeff Swensen

[16

a bustle

in the hedgerow

The first thing the intruders did upon their arrival was to send a sniper detail out with a cordless power saw to cut a hole in the front hedge so they could drive straight up into the front yard and park their contractor trucks there. This was a direct affront to my policy of sensitive demolition. It was also detrimental to the landscaping, such as it was.

I arrived at eight A.M. and found that I could not get into my own driveway. I had to park on the street, and I stopped at the sidewalk, staring with bewilderment at the truck entrance crudely hacked through my shrubbery.

This hedge was nothing to write home about: a leggy, uneven row of barberry that clung in tatters to the front edge of the yard like the fringe on one of Mrs. Radner's coats. But still. My guiding principle was that nothing is unworthy. I had saved every stick of woodwork I'd removed from the walls, even the rotten, insect-eaten crown molding from the solarium that crumbled to dust under the action of my attempt to salvage it. I had marked the location of each piece

with an orange grease pencil: Solarium NE corner; Mast. BR Crown, etc. I had scavenged the porcelain handle from an antique toilet, the stained, corroded bowl and tank of which even I wouldn't consider saving. (Heaving a dead toilet through a second-story window: deeply cleansing.) I had saved the pieces of the rotten bench between the second-floor hallway pillars. When it came to architectural salvage, I was like the inner-city schoolteacher in a Lifetime network movie. Everything had value. Nothing was unworthy of my bleeding heart.

Yes. I had plans for this barberry hedge. What plans, I couldn't say exactly. But those plans did not include hacking an unauthorized access road through them. The subcontractors had arrived all at once, at dawn, an occupying force. This stage of the rehab had scarcely begun, and already I was faced with a question of authority.

Who was in charge?

This question went straight to the core of my conundrum. I had wanted to do this myself. I had wanted to do *all of this* myself. This house was my white whale; everything else was black water. After my early spell inside the rooms alone, I'd begun to feel more confident that I could in fact do it myself. All of it. (Even the roof. Over the holiday, I'd probed a couple of in-laws who had construction experience about their thoughts on whether, "hypothetically," I could handle the roof myself and they'd answered beerily: "Sure! Why not?" They believed in me, I was certain.)

I had designed and built a new set of treated-lumber legs for the cumbersome antique washtub in the basement—the same washtub everyone else said would have to be replaced with a new plastic one. I did this because I couldn't understand the purpose of spending a lot of money on something I wouldn't be as happy with as what I already had. And I did it to prove I could save what everyone else had abandoned. This had been a lesson. Some extra thought, some extra work, and most of the parts of this house could be restored. Even the garage. Everything could, potentially, be turned back into what it once was or turned into something else. The carport in the backyard was leaning so badly that my dad and I had toppled it simply by tying a rope to

a rafter and giving it a yank. It fell straight down, into a heap. It was junk. But now its lumber was stacked alongside the house, the bent nails removed, ready to be used for roof decking.

I felt as though I was striking a blow for preservation. Steve challenged this, questioning whether even the most ardent preservationist would consider saving stained and twisted one-by-sixes (and pulling all their nails!) when new, straight, clean roof boards could be purchased commercially at a reasonable price.

Absolutely, I explained: the more ardent the preservationist, the bigger the cheapskate. The instincts go hand in hand. It's true—we embody the best and the worst characteristics of scavengers.

Maybe my way was impractical, but this was my house and I wanted to do things my way. Regardless, matters of urgency and practicality and mortgage stipulations dictated that I put the task of reviving the house's major organs into the hands of Others. And the first thing the Others had done was to choose their own entry point willynilly through the hedge and to chop it open without regard for any Big Truth. The next few weeks were going to suck.

Would Henry Thoreau have allowed such a thing? Would he stand idly by while punks on wave runners violated the horsepower limit on Walden Pond?

No. He would not.

Would Henry Rollins have allowed rival members of the Circle Jerks to follow behind him tearing down his wheat-paste flyers?

No. He would not.

Would Henry Aaron have backed off the plate after a fastball high and inside?

No. He would not.

This was my home. That was my shrubbery. It was time to establish my authority.

I strode through my front door and I tracked down Steve Braun and I tattled.

He was sitting on the base of one of the living room bookshelves, looking over some paperwork.

"Someone chopped down the front bushes," I said.

He folded his little hands against his belly and looked out the window across the front yard, where trucks were parked haphazardly between the trees.

"Yep," he said in an exhale. "Someone did. Let's go find out who."

We went to the kitchen, where a group of men I'd never seen before were hovering near a Krispy Kreme box. I knew all the subcontractors—the bosses—but had not yet met their henchmen. To me, they looked like the extras in a bad high school musical, listed in the Cast of Characters as "toughs."

"Who cut through the hedge?" Steve asked.

In his voice, with that audience, it sounded kind of petty, as though he were asking, "Who touched David's G.I. Joes without permission?"

"Uh—I did," one of the men said in sheepish apology. "We had to get in close to unload and the roofers were blocking the driveway."

"Let's ask before we do things like that," Steve said.

They nodded in the sort of way convicts nod when asked by social workers whether they consider themselves rehabilitated, a nod that indicates sincere belief in a principle the nodder doesn't fully comprehend.

We left and went into the living room.

"Everything is going to happen fast now," Steve said. "They're going to want to do things their own way and it's going to be up to you to say what you want. You have to be vigilant."

I needed to be at work, so I took a quick walk through the house, trying to be vigilant. It was all suddenly different, actively in transition and out of my direct control. In the basement, the plumbers had set up sheets of plywood on sawhorses, on which they had carefully arranged copper elbows and unions and valves, the way I used to lay out the parts of a Revell model before assembling it. They'd already begun cutting off and ripping out the old galvanized pipes.

I introduced myself to the man working there.

"Arthur," he said, extending his hand. He was friendly, and spoke

in a banjo-tuned Appalachian twang. Shabbily bearded, with a cam-
ouflage cap that looked like it was grafted to his skull, he had the ap-
pearance of a hunter who'd been in the woods a week.

"Heard about your hedge," he said. News was traveling fast. "Guys
shouldn't do stuff like that."

He bent down and picked up a section of old galvanized pipe.

"Look at this."

He pointed the end toward me. It was a solid bar.

"Master bath sink," he said.

There was no indication it had ever been an actual pipe, with, you
know, a hollow center? For water to pass through? Arthur jabbed the
end of a screwdriver into one end, demonstrating that the corroded
center was as solid as the iron of the pipe. He grinned at me.

"They're all like this."

I nodded. This was dramatic, yes, but not surprising. When you
have an attic exploding with vegetation and wildlife, your tendency
to be surprised by such things becomes recalibrated. Arthur, after all,
was standing only a few feet from the steam-pipe leak that continued
to spout from its failed duct-tape patch toward the fuse box.

"We're gonna make it all brand-new," he said.

I smiled and turned to leave.

"Hey, nice job on the washtub," Arthur said as I started up the
back staircase. "Very professional."

I thanked him and went back upstairs, with the word *professional*
growing tendrils and curlicues and long, elegant chains of multicol-
ored blossoms inside my head.

Pro-*fesh*-inal!

There was a man in the kitchen unscrewing the plate from a push-
button switch. This man had Rod Stewart's hair. I don't mean this
figuratively, as in, "He had hair much like that of pop singer Rod
Stewart." I mean he appeared actually to have purchased the scalp of
Rod Stewart on the black market and had had it surgically affixed to
his head. It was blond, spiky, and magnificent.

He looked at me.

"Are you the owner?" he asked in a rich, almost cartoonish British accent.

That was it. He may as well have asked: "Do ya think I'm sexy?"

How was this possible? How could it be that Rod the Mod was picking up extra cash working as an electrician in Akron, Ohio? Although this seemed unlikely, I could find no other explanation. I wondered at what point he'd bring out the trademark soccer ball and kick it into the crowd.

Rod appeared to be in his fifties, with tight crow's-feet around his eyes. He was carefully dressed, in tight jeans and a zip-up sweater.

"Yes," I finally answered, extending my hand. "David."

"Well, David, I'm Norman," he said, accepting the handshake.

Right. You're "Norman."

I understand. Bit of trouble back across the pond, right? Misunderstanding between you and the tax man, maybe? A dustup with Rachel Hunter?

Well, don't worry, "Norman." We'll keep this our little secret.

"You wanna keep these push buttons? I can give you nice new switches."

He flashed a salesman's smile.

My vigilance returned.

"No," I blurted. "We are keeping all the push buttons and all the fixtures unless Steve tells you otherwise."

Rod Stewart clasped his hands.

"Very well."

F or the next several weeks, every time I entered the house, I was pelted with questions and confronted with decisions and confounded by chaos. There was a kind of jazz being played by the various trades, with the plumbers and heating guys laying down a groove that the electricians used as their melodic counterpoint, all of it set against the top-down nail-gun rhythm of the roofers: *schunk-schunk-schunk.*

You want the scrap copper?

Rebuild the tub handles?

Where are we gonna put the fridge?
Sure you don't want new switches?

Strangers were wandering in, often without knocking, as though the house was now open for self-guided tours. It became a daily matter of course to find some self-invited guest snooping in the upstairs closets or trying to get a look behind the plywood I'd tacked over the stained-glass windows to shield them from falling debris. Our possession of the house seemed to have turned it into communal property. We had taken a local curiosity and amplified it, and now the mysterious Tudor on North Portage Path was a local sightseeing destination. The contractors were constantly leaving the doors open, and every time I walked in, the place was crawling with strangers, some on the payroll, some not. The many people who'd decided *someone would have to be crazy to take on this house* wanted to see which crazy people had made that very decision.

All I know is it's an odd feeling to have a stranger poke her head into the bathroom when you're knocking a hole in the wall and call out: "Yoo-hoo! You have time to give a tour?" And it's an odder feeling to recognize this as suddenly normal.

To some degree, this was a comfort. So many of the visitors offered encouragement. Even those who called us crazy seemed in some way to validate the complicated yearning and ambition behind our decision. With no turning back, and with the lingering heartache of the miscarriage, Gina and I were both frightened, about the immediate future and about the longer term. There seemed to be no question that we would spend the rest of our lives here. It would take years just to get the house to a state of comfort, and then, we believed, it would be a place we would never want to leave. We had to believe that. We were young and negotiating a life of infinite possibilities and now our future surrounded us, in brick and tile and stucco and scrolled woodwork—infinite possibilities, still, but all in terrible need.

So yes. We wanted validation for what we had done. When other old-house renovators visited, we clung to them, hoping for some fraternal secret to be revealed. We wanted to be reassured that we would

be all right here, to be told we had made the correct decision. Perhaps even to be praised, held up as community pillars, as warriors and saints in the cause of preservation. Mostly what we got were the same questions, over and over:

Oh my God have you seen The Money Pit?

No. I have never seen *The Money Pit*. (Did you bring beer?)

Are you gonna do all this yourself?

Yes. Of course. I live for this kind of thing. (I have no choice. I am afraid. I was bluffing. I have no idea how to tuck-point and look— the bricks are falling from the buttress there at the solarium corner! Lying loose on the ground! Someone said you can use a pastry bag filled with mortar . . .)

When do you think you'll be done?

Hopin' to get it wrapped up before dinner.

What made you decide to do this?

It's a long story.

My father couldn't stay away. He loved being in the house, loved the idea of it, loved suggesting how things might be repaired, loved choosing little corners of his own to work on. Often, if I was absent, he was my surrogate, answering questions from the curiosity seekers.

And when they asked him the question everyone seemed to ask— how long will this take?—he gave the answer he knew to be true.

"Forever," my father said. "It's only finished when you sell it or you die."

I stopped in one early afternoon. Stepping over a pile of splintered crown molding, I came upon a big black trash can. A heavy stream of water was pouring into it from above. I looked up. Through a gaping hole in the ceiling, I saw one of the plumbers, squinting through the drain hole of a bathtub with its bottom-end plumbing removed.

"Lunch?" he said.

"Yeah," I said.

"Doughnuts in the kitchen."

I continued on. I grabbed a doughnut and went upstairs. An electrician I hadn't seen before was kneeling in the summer bedroom, eyeing a length of surface-mounted electrical conduit as though it might speak to him and explain what he should do with it. I introduced myself.

He was trying to figure out where to route the wiring, which would feed to an outside security light overlooking the driveway. I told him I wanted the light to be centered over the windows so it would look symmetrical from the outside. He said the intersecting interior wall made that impossible. I asked if he could run the surface mount to the corner, then fish the wire into the wall to get it the rest of the way to where I wanted it to go.

"Don't worry about making a hole," I said. "They're all over the place."

I was getting better at this sort of seat-of-the-pants problem solving, but these constant small-detail negotiations were wearing me down. Vigilance was a drag. The problem was that I never thought about doing things the easy way. This was never on purpose. It just never occurred to me. The subs, on the other hand, always knew the easy way and advocated for it with the sly vehemence of annuities salesmen.

"I can't do that unless the boss tells me," the electrician said. "I can't afford to lose this job. I gotta save up for my new teeth."

He peeled back his lips in a big grin to show me a mouth with two teeth in it.

In some ways, it felt as though the house was undergoing a benign exorcism, with the spirit of the Radner family slowly being replaced with our own. I was somewhere in between. As quickly as this house was becoming my domain, I also was feeling more strongly that it had steeped so long in the spirit of the Radner family that my own family could never displace the old presence. This is not loopy mysticism. It has as much to do with the permanence of cat piss as with spiritual phantasms.

The Radner family's final push to empty the house had lost steam

around the bottom turn of the landing to the basement. Although the upstairs had been picked clean, literally down to the last coat hanger, a lot of junk remained there in the underground. I'd hauled most of it to the Dumpster and the curb, finding a few pieces to keep. Under a pile of old clothing, I found an antique white pedestal sink, big boned and chunky, a twin to the one that still stood in the master bathroom. A cardboard tag was attached by a piece of wire to the corroded faucet handle:

Upstairs bathroom.

This had been removed from the bathroom between the Green and Orange Bedrooms, a room that contained one of the few fixtures that didn't appear to be original to the house, an ugly midcentury vanity, poorly built and water damaged. There was nothing wrong with the pedestal sink. A little replumbing and the bathroom would be restored. This sink reaffirmed yet another of the house's ironies. One of the main attractions was the thoroughness of its authenticity—nothing had been maintained, but almost nothing had been altered. We could peer through the filth and wreckage and still see how the house was supposed to appear. It directed the course of its own restoration.

I found other things to keep. A little cardboard box from the H&A Selmer band instrument company, with a faded mailing label to the Radner Piano Company. A stack of the company's invoices. An old American flag with forty-eight stars, stuffed into a peach basket.

In my research on the house, in an old city directory, I had run across a display ad for the family's music store. I'd made a copy and enlarged it so I could frame it and hang it near the front door. The past gave this house more meaning than I could ever give it.

The shelves of a basement storage room contained what appeared to be every piece of hardware ever removed—window handles and drawer pulls, curtain rods and hinges. Some of them were even labeled with notes indicating where they'd come from. Piecing the evidence together, I figured this to be the work of Mr. Radner, who must have been meticulously efficient. And this evidence suggested that in

an age of distinct gender roles, Mr. Radner must have fulfilled his role so well that Mrs. Radner never had to learn how, for instance, to change a faucet washer, much less to consider the importance of a watertight roof. That would have worked well enough while he was alive, but his death in 1965 also apparently marked the beginning of the house's decline.

I walked in one day and stopped cold. I stared, hoping that my stare would change what I was seeing, because what I was seeing was so completely wrong. Someone had cut open a stud bay right up through the stucco wall in the main stairwell, a wide, ugly gash halfway up a fifteen-foot wall.

The only significant feature of the entire sprawling mess of this house and grounds not heavily damaged by water or neglect or wild animals was the handsome stucco work on the interior walls of the main first- and second-floor hallways. It was richly textured, but also compact; the plaster whorls had been finished almost flat, in a way that gave it a softness. Steve had commented on it the first time we walked through the house together, and said it would be hard to rep-licate. In my prep work, I had taken great pains to direct everything around those walls. All that forethought now lay in a pile of freshly cut plaster and lath on the landing.

"What. The. *Hell?!*"

Rod Stewart was thirty feet away, on a stepladder next to the living room fireplace.

"Uh-oh," he said, not really to me but to the general situation. He came down from the ladder and joined me in the front hall, both of us facing the hole in the wall.

"Yeah—uh—that. Arthur said he needed to route the pipes up to the master bath."

Arthur.

He'd established himself as one of the good ones, reliable Arthur in his sketchy beard and camouflage cap. The one who'd compli-

mented my washtub legs. But no more. In a flash of imagination, I took on vapor form, shooting up that joist bay into the master bath *Ghostbusters* style, then emerged as a velociraptor, because a velociraptor has an admirable combination of razorlike claws and lightning agility, and Arthur seemed like a pretty squirrely guy. He would not escape. Not if I was a velociraptor with phantasmagoric superpowers. I, as a velociraptor, would bring vengeance, swift and sure.

I looked at the wall again. Pipes to the master bathroom? This was the only way? No. No! I'd already considered that. It was *not* the only way. I stepped down into the sunken living room to look at the wall's opposite side. It was covered halfway up by a big set of bookcases, but I'd already accounted for that and had opened up a channel there in the bad plaster above the bookcase. I had thought through all of this. I had cut the correct hole two weeks before. Arthur's hole was not only a violation, it was a redundant violation.

Steve appeared. I flung my arms toward the damage.

"Look! Look at this!"

Although many of the workers had expressed appreciation for the "character" and "charm" of the house, few of them seemed to adapt to it in any meaningful way. Even Rod Stewart, who was always the first to arrive (impressive, given that his hair must have taken at least half an hour to spike each morning) and who genuinely seemed to be enjoying this job—even he had pointedly repeated his offer to replace the push buttons with new switches, the implication being that these old fixtures were trouble for him.

The workers were talented and professional, but these walls didn't mean anything more to them than any of the other thousands of walls they'd encountered in their careers. A wall, to a plumber or electrician, is the thing that stands between him and the wires and pipes. It was to him as female genitalia are to a gynecologist—simply a passageway to the plumbing. Stucco was someone else's concern.

Steve was the only one who took my seemingly minor concerns to heart, but even in him I sensed that this was a professional rather than personal position—a customer-is-always-right approach.

He said he would take care of this with Arthur, although I couldn't see what good could be done now. The hole was open. No amount of smoothing over would replace my precious stucco. But I was not the one to make this case. Steve was.

The next day, Arthur arrived with a dozen doughnuts.

"I brang you a peace offering," he said, tacking a hopeful smile to the end.

duet no. 2:

gina

The phone rang. I was standing downstairs in the dingy central hall, exhausted.

The phone was sitting on some worker's sawhorse. It was an ancient black rotary phone, so full of grime that when you dialed it, you had to push the dial backward with your finger after each number. It sounded like a fire alarm.

I picked it up. "Hello?"

"So," came the cheery voice on the other end. "Do you feel like a princess?"

I looked down at myself. I looked disgusting. Filthy jeans with holes in the knees. Black beat-up combat boots. I examined my hands. They ached from the constant abuse of cleaning, scraping, painting, and hauling. For weeks, that's all I'd done, trying to get this house ready for us to live in. I'd scraped old carpet glue from vast spaces of floor, on hands and knees, an inch at a time. Fingernails? What fingernails? I used to have them. Now there were raw nubs.

On the other end of the line was Danny, a dear friend from the

neighborhood we were moving out of. Only days before, when he learned we'd be moving soon, he'd come for a tearful good-bye, bringing us a loaf of banana bread, as he did every week or so. He lived in a subsidized apartment across the street from our house. Everyone in that apartment was elderly or disabled. Danny lived there because he was HIV positive. A close friend of his once told us that Danny loved us because we let him hold our newborn son. He knew from bitter experience that people often kept their distance from a disease they didn't understand.

For weeks, he and I had talked about the excitement of living in a huge Tudor house neither of us could ever have imagined. I looked around me.

Princess?

Next to the fireplace was a cooler that was serving as our refrigerator. We had no idea when we would have a real kitchen with a real refrigerator. Under my feet was hideous green carpet loaded with burn holes because David, for some reason, had told the workers it was okay to put out their cigarettes in the carpet. Plumbers, electricians, and carpenters were going this way and that. Curious neighbors regularly wandered in from off the street, never knocking, strangers just walking right in like they owned the place.

All my life, I'd dreamed of having a fireplace. Now I had six of them, and none of them worked, and the house was freezing.

Princess?

I was just now beginning to recover from the worst emotional pain I had ever felt, coming to consciousness in a recovery room, alone, after undergoing the procedure to remove the dead fetus from inside me. Hospitals should let family members in the recovery room. I wanted David to be there when I came to. Instead I just lay there in that dark room and cried.

For weeks, I tried not to cry in front of Evan. That's not how I wanted him to see me. In that sense, this house was a welcome distraction. I didn't have time to dwell on the miscarriage.

Princess?

166] David Giffels

A few days before, I was trying to clean the black out of the grout in the master bathroom shower, scrubbing it back to something close to its original white. I would soon begin calling this the "Scratch-and-Sniff Bathroom" because it stank of old cat urine, and the more I scrubbed the wood at the thresholds, the more it seemed to release the odor. I was standing in the bathtub, which was even filthier than the grout. Lying on the floor nearby, installing a toilet, was a plumber named Jim, a no-nonsense guy who mostly listened to me chatter as I worked. He hardly ever smiled. I was beginning to sound like a TV commercial, talking about the amazing power of the grout cleaner I was using when I stepped out of the tub and directly into my five-gallon bucket of murky water.

My combat boot was soaked. Water sloshed all over the floor and up my pants leg. I pulled out my boot. Jim stared at me for a second, then burst out laughing. I joined him. What else could I do?

When I was in college, I'd fled my parents' house and moved in with my sister after spotting a mouse run across my bedroom floor while I was reading Stephen King's novel It (which is not the book to be reading when you see a rodent creep into your room). After two months, I'd agreed to return home only when I discovered that my sister also had mice, and my dad assured me he'd caught the one that had sent me packing.

"See?" he said when I returned home, pointing to a mousetrap. "I caught the mouse. Now you have nothing to worry about."

"That's not the mouse, Dad. The mouse I saw was gray. That one's brown."

Now I was moving into a house that could be featured on Animal Planet. I agreed to move into this house under the belief that all this work would seal the house off from the great outdoors. I knew it would still be filthy and falling apart. But I had told David I would not live there unless all the rodents and spiders and bats were gone.

Did I feel like a princess?

"Not exactly," I said into the grimy black rotary phone.

I think Danny understood.

the guns n' roses
late-night drywall crew

Evenings and weekends, stolen moments during the day—I
spent every possible minute trying to get the house ready. But
it wasn't enough. January was ticking down. Our month was
running out. We were days away from moving in—hours, really—and
we had nowhere to sleep, no kitchen, nowhere to put our baby.

I called the man who'd bought the semiremarkable house from
us. I asked if there was any way he could delay moving in, to give us a
little more time. I said we'd pay rent. He was in the military and had
a housing allowance that was covering his stay in an executive suite in
the suburbs. This was free money for him. An extra week? Sure, he
said. He could hold out a little longer.

Despite the stress, or maybe because of it, my tolerance for chaos
grew. At the end of most days, after the contractors were gone, I
pushed dust and scrap into a pile with a broom, scooping up most
of it, pushing the rest into the fireplaces, knowing that it was only
a matter of hours before a prodigious new mess was made. Grand
Tudor hearths, six of them, were reduced to trash receptacles. In fact,

they served the function so well that it seemed almost as though this were a forethought of their design.

In that state, with the bulk of the mess pushed toward the corners, I considered the house clean.

In that state, Gina considered the house filthy.

One of the least understood and most challenging characteristics of marital disagreements is that, very often, both sides of the argument are completely valid. The problems arise when one or both of the parties can't recognize the validity of the other side.

There are no straw men or women in a marriage.

Popular culture has falsely simplified this dynamic down to a sitcom Man-vs.-Woman thing. *Ha ha ha we're so different we don't even speak the same language laugh track ha ha ha.* In truth, the idea of diametrically valid points of view seems less a result of gender differences and more a result of the intensity of the relationship. There are few more deeply intimate relationships in human life than marriage. A marriage is, after all, not two separate people coexisting (those are "roommates"), but rather one unit comprised of two formerly separate units, just as water is something distinctly different from hydrogen and oxygen.

Gina said the house had to be cleaned.

I said it was a waste of time.

We were both right.

The house needed to be clean. Soon. And not only clean, but child safe. We were on borrowed time, literally. And the place was not ready. The refrigerator and stove sat in the front hall, still in their shipping boxes because the kitchen was in no state to accept them.

But despite this need, there was no point in cleaning the house. The dirt was ubiquitous and perpetual, regenerated each day. We'd left the moss green carpet down as a drop cloth. I'd given the workers de facto permission to use it as a place to crush out cigarette butts, spit, wipe the ends of caulk guns, and scuff mud from their boots. It was the perfect surface. It could accept anything and I would rip it all out at the end, put it in the Dumpster, and start fresh with a house full

of dull, water-damaged oak floors. Scrub them once with the insanely expensive lead-neutralizing elixir and you're good to go.

Cleaning the house now would make no more sense than me trying to exfoliate the black stuff that had stained my pores.

Someday, later, when it was time. Soon. Hopefully soon. But not now.

Gina saw all this differently. The electricians were done in the dining room. The radiators had been rehabbed in there. There was no plumbing. Sawhorses and ladders, sure. But those could be moved. No one *needed* to be in there. Why couldn't this room be deep cleaned, lead abated, and sealed shut?

We took the dilemma to Steve. He listened, smiling inscrutably, then nodded his head in deliberation.

"Yeah," he said, easing into his answer, still thinking it through. "Yeah. I don't see why not. You can clean it. We'll work around you. You just need to barricade anyone from going in there."

Steve, the same person who'd raised the concern over how this renovation would affect our marriage, recognized the importance of taking Gina seriously. It's true that there was no wrong answer: the rooms needed to be cleaned, and by equal measure, cleaning them was folly. But there were different reasons for the rightness of each answer. And this was a case where Gina's ability to stake some claim in her new house outweighed my claim. Steve Braun was pretty smart that way.

And she did stake a claim. She amassed a team of her sisters, the Sicilian Cherokees. Jo-Ann, René, and Carole arrived with Gina early on a Saturday, wearing bright rubber gloves and inelegant clothing, carrying buckets that contained rags and sponges and steel cleansing pads and rust removers and trisodium phosphate and bleach and cleaners heavily scented with lemon and pine. They marched past the grizzled and flanneled bunch of us, with our mouthfuls of nails and the crude hand tools dangling from our belts.

Each of them chose a problem to attack. René, blond and brassy, declared that we should have a proper main entrance. She went straight to the vestibule inside the front door, ripped down the hal-

lucinogenic faux stained-glass plastic, looked the room up and down and turned back to her sisters, boasting that she would restore the grout to its true color.

"Whatever it is." She giggled.

With steel pads and a brush, she dropped to her knees and began.

The house that day took on an entirely different tenor, the women's voices and laughter filling the rooms, their music different, more chipper, the civilized approach they took to eating their lunch, the very fact of their work, so foreign to what had preceded it.

The sisters took a shine to Rod Stewart, who flirted masterfully in return. One of the carpenters asked me on the sly about Gina's sister Carole—*Is she married?*—eyeballing her as she, covered with sweat and grime, red faced in determination, ripped up the gorgeous/decrepit carpet runner from the rear basement stairs, raising billows of cat hair and decades of dust, her arms ropy with muscles and veins, sneezing violently, perpetually yanking an insubordinate bra strap back into place.

Engaged, I said.

René complained loudly, but kept at her scrubbing.

"I've sweated off four pounds," she called into the main house. "I'm going to need to buy a new wardrobe."

Jo-Ann was somewhat of a legend in the housecleaning community, a woman whose chrome fixtures at home gleamed like a Liberace photo shoot, whose floors were scrubbed as harshly as a nunnery's, and on whose kitchen counters one could perform pediatric heart surgery. I did not expect Jo-Ann to show that day, not after she'd bailed midway through her original tour, bristling with hives and choking against the smell. But she did. She did show.

Her prayers had not been answered, but she wasn't finished yet. She had a challenge to meet: her cleaning skills against this, the Everest of dirty houses. She pulled her rubber gloves on tight and went to work with Gina in the dining room, a potential showplace at the front of the house that was faded dull and layered with old soot and the new dust of construction. They started with the ceiling, at op-

posite corners, scrubbing every square inch. Then they moved their
way down the walls. They did the windows, the floor—they ignored
my direction and removed the carpet, exposed the naked oak; it was
no longer protected; it was no longer protected from *me;* it was vul-
nerable and clean. They scrubbed the fireplace, the ceramic logs, the
marble hearth, the Beaux Arts scrollwork in the mantelpiece; they
cleaned the wainscoting and the fancy moldings; they cleaned the
mesh grates over the radiators; they cleaned the little mother-of-pearl
servants button; they shined the doorknobs and hinges and escutch-
eons, scrubbing the ridges of the door itself with a toothbrush. They
even cleaned inside the wall where I'd gutted bad plaster and had not
yet hung drywall.

All the while, they barked at anyone who came close, but also
proudly called for their attention—*Don't! Don't come any closer, but
look! Look what we've done!*

For all the drama of demolition and reconstruction, this was
something entirely new. The house: clean.

When I approached the doorway that afternoon, filthy from head
to toe, and was allowed to stand at a distance and look, I was stricken.
Their rubber gloves had been snagged and ruined hours before and
they stood there bare-handed, dark hanks of hair sprung wild from
their ponytails, their sweatshirt sleeves pushed past the elbows, hands
on hips, smiling.

A room in this house was clean.

On the other side of their threshold was a wholly different atmo-
sphere, smelling of Christmas trees and promise. The windows! The
bank of windows that had been covered with a tattered drop cloth for
some damn reason that I don't even remember now what it was, but
whose drop cloth had just stayed there because no one thought to
remove it—now those windows were gleaming and clear, stripped of
the tarp and cleaned inside and out, cutting a sightline from dining
room to the wooded front yard and North Portage Path beyond.
There was a world out there, revealed by ammonia and the stubborn-
ness of sisters.

I, demolisher, saw clearly the value of the cleaning and those who cleaned. I embraced this other point of view. We were different. But we could coexist. It was a Benetton moment.

That was the last I, or anyone, would see of that room for a long while. When they finished, Gina and Jo-Ann sealed the doorways tight with heavy plastic sheeting and duct tape, attaching signs—KEEP OUT—that appeared to have been written in blood.

There was enough money left in the budget to close up some of the ceilings and walls. Steve and I had hung some of the drywall, but we hadn't taped and finished any of it. For all the work and challenges and self-crucifixions I wanted to hoard for myself, finishing drywall was one job I didn't mind granting someone else. The sanding is miserable, Sisyphean work. It grinds on the shoulders. The dust is tormenting; it irritates the skin and eyes and it settles everywhere. I'd done a kitchen wall at the semiremarkable house and found the ubiquitous white powder all the way up into the bedrooms. Cleaning it up is almost as bad as creating it. You sweep and vacuum and wipe and mop and it still leaves a residue. It's like cleaning up mud with a muddy rag and a bucket of mud.

So yes, when Steve and I met at the Ido in mid-January to hash out the last of the budget, I was happy to give some of this work to someone else. Steve had gotten estimates, and the best price came from a guy who was going to bring in a crew after hours for a few nights.

They arrived around dark. As they filed into the house, they appeared more suited to serve as roadies on a Guns N' Roses tour than to make my walls plumb and square. The first one was at least six foot six, with the physique of an elementary school flagpole squeezed into a pair of spandex-tight black jeans and chunky black Reeboks, unlaced. His long blond hair appeared to have been teased and sprayed since preadolescence, tired and damaged, a twisted frizz that stuck out in all directions. He may have been the most physically apt drywaller

in the history of American craftsmanship: it appeared he could do textured ceilings simply by dipping his head into a drywall bucket and hopping around the room.

The next guy was tall and skinny too, but with a little potbelly poking out from his tight sleeveless T-shirt. He had feathered blond hair down to his shoulders and acid-washed jeans pegged to the ankle. I decided he was the rhythm guitarist. Next was a quiet little guy in an army fatigue jacket who walked with a limp. (Drums.) And finally, a compact, broad-shouldered guy in a white T-shirt who looked like an aging Scott Baio, with brooding eyes and dark hair parted in the middle. (Bass, coproducer.)

The boss (Reuben Kincaid, I guess), an unnaturally energetic young man about my age, immediately began handing out business cards printed with the sort of vague specificity that indicates he does "anything" and "everything." As far as I could gather, he was involved simultaneously in the entertainment and construction industries and had read one of those books on how to become a millionaire so he could become a millionaire himself and write one of those books. About how to become a millionaire. He said he had worked as Cyndi Lauper's road manager and was "waiting to head out again." (Given that a pop-cultural eon had passed since the popularity of "Girls Just Want to Have Fun," it occurred to me that this might be a long wait.) Also, there was something about him dabbling in investments. He seemed to be involved in a lot of projects unrelated to enclosing and sanding my gaping walls. But he also clearly was someone who Gets Things Done. Almost immediately, he had his crew mixing drywall compound, setting up ladder scaffolds, and countersinking some of my poorly driven screws. Simultaneously, he had managed to squeeze out a nickname for Steve: Stevie Ray Braun.

He did not give me a nickname. I noticed this, even if no one else did. There was always a certain kind of distance between me and the other workers. I consistently had been working alongside them, but even in our most relaxed moments, at the end of a workday, talking about something other than the work, I always felt separate, like I

wasn't one of them. I could never figure out if it was because I was an amateur and they were the professionals, or because I was the owner and they were people I had hired. They either felt superior or inferior. As diametrically opposed as those options were, each was equally possible.

I certainly know how I felt. Utterly inferior. Until they'd arrived, I had believed that I was a capable person and that I could figure out the work they did and do it myself. Now, I saw them doing this work with hardly a thought, simultaneously eating doughnuts and talking about a basketball game or a child's algebra homework. And that made all the difference. Rod Stewart could fish wire and complete the circuit on a two-way switch in the time it would take me to wonder blankly if there was a specific standard height for a light switch and start wandering around with a tape measure to find out. (Although I've never found an official answer, fifty inches seems to be the norm. I know this because I can go into a strange house in the dark, grope along the wall, and find the switch right there, where it always is, at shoulder height. But the real mystery is that this height feels *exactly* natural to me, the most perfectly ergonomic position for a light switch. Which makes me wonder: does the towering drywall guy feel like light switches are too *low*?)

Within an hour, the drywallers had claimed territory throughout the house. The tall, wild-headed one was taping off the repairs in the "baby's room," a room whose decay made it seem more suitable as a horror-movie set. The rhythm guitarist was hanging board in the adjoining bathroom. The guy in the fatigue jacket was in the hallway, mixing up mud with a blending tool attached to a power drill. Downstairs, the brooding one had set up a plank across two sawhorses and was working to feather a distinct dip in the ceiling.

He was talkative, but serious, as if something preoccupied him. I was working around him, painting the walls with a noxiously strong primer that would seal in whatever poisons, real or imagined, might be contained there, within reach of small children. These walls were cracked, corroded, and unfinished; painting them without first repair-

ing them would be pointless except for one not-insignificant detail: children would soon be here. That thought would seem laughable were it not so true.

Gina had been increasingly stressed and obsessive about any surface that might contain lead paint, and we had argued with equally increasing frequency about the amount of time I was required to spend cleaning and sealing when there was so much other work to be done. I found nothing heroic about scrubbing and priming, certainly nothing as heroic as, say, insulating the attic. This was seriously compromising my "epic."

I had come to call this the "Gina work" in the way devoutly religious people speak of the "Lord's work"—the otherwise thankless duty necessary for eventual salvation.

As we worked, the drywaller on the platform was telling me how he had recently hung a new ceiling in his mother's house and after he'd gotten done, he'd noticed a screw pop—a dimple where one of the screw heads had pushed back through the patch of drywall compound. It's amazing, he said, that in two hundred square feet of otherwise flawless ceiling, a quarter-inch imperfection can ruin it. He said he couldn't even look at it and was planning to go over on his next day off to repair it.

I didn't want to say so, but I envied him. To flirt with perfection, to be one screw pop away—I yearned for such a problem. Meanwhile, I was rolling expensive primer over damaged walls, performing meatball surgery in direct mockery of anything like perfection. Someday—soon, I hoped—I would return to these walls and transform them from this state of triage to a condition that would be corruptible by a screw pop. For now, that felt like a long way off.

When I was a kid, I read a story in *National Geographic* about a man painting a mural on a cathedral ceiling. He'd spent a considerable amount of time on a pair of angels up beyond the woodwork, in a spot that couldn't be seen from anywhere except his scaffolding, which, of course, would be dismantled and removed when his work was finished.

"Why?" the journalist asked him. "Why spend so much time on a detail no one will ever see?"

"God will see," the man answered.

I wondered if I ever would find that place here.

We worked late into the night. Reuben Kincaid had won a negotiation on the subject of textured ceilings, showing me a thatch pattern he could do with a roller that looked acceptable and relatively Tudoresque. More important, it was quicker and cheaper than a flat finish. With time and budget dwindling, I'd agreed to it. He set up an air compressor in the driveway and ran the hose up to the master bedroom window. With a spray gun, he was shooting the ceiling with a layer of compound that he would then go over with the roller.

The fatigue-jacket guy came limping fast into the room.

"Uh, some of Akron's finest are here," he shouted over the sound of the spray gun.

We looked at him. The boss set down the hose.

"What?"

"The police. When I said 'Akron's finest,' I meant police."

"I know that," Steve said. "What are they doing here?"

"The noise. You better go talk to them."

I followed Steve downstairs. Two policemen were standing in the driveway, next to a squad car parked behind the line of work trucks and vans.

One of the neighbors had complained about the noise of the air compressor, they said. It was after midnight.

Neighbors.

Did I have neighbors?

Yes, I suppose I did have neighbors, although this was the first time that notion had occurred to me in any sort of conscious way. Of course I knew there were other houses and apartments all around, but with all the overgrowth separating us and with my isolation inside the house— my very overt, High Concept isolation—not to mention the fact that I still lived somewhere else, I hadn't really put myself in that context. The Fortress of Solitude? Had neighbors? How provocative.

Steve explained what was going on inside and asked if we could have five more minutes to finish the spraying. The cops agreed, but said they were going to stay and make sure we shut it down.

Neighbors. My first interaction with my new neighbors was to inspire them to call the cops on me.

The Guns N' Roses Late-Night Drywall Crew continued their work over the next several nights. They walked on stilts, some of them, their clothes and faces and hair spattered with the white pudding. They were H. G. Wells's Martians, Cirque du Soleil performers, the lanky wild-haired bunch of them smoothing the ceilings this way and that, their arms in graceful strokes and circles, their sanding dust sometimes turning a room to a white pixilated haze: stiff-walking giants feeling their way through a cloud, snow-blind, running their fingers across walls and ceilings seeking the bumps . . . Braille . . . phrenology . . . the teenage touch of skin.

The house grew powdery and white; it looked and felt so much different, pillowy, muted and monochrome. The cleanest mess one could ever imagine. Late into the night, they worked.

I knew this place best at night. I had been there alone so much in the dark. I knew that in the raw unfinished rooms of the attic, in the dark, alongside the shocking snake of wisteria, with moonlight streaming through the rotted slats, gleaming on the pans of standing water—I knew that everything sounded *different* there, that outside was in and inside was out. Unrolling batts of insulation, I'd heard a terrifying scream one night that had turned me cold; it sounded as if it had come from within the room, from somewhere very close to me.

Did it? Did that really happen? Or was it true, that thing you figured out later, that sound carries into these attic rooms in strange ways. Wait. Hold still. Listen? Hear that passing car? See how it sounds closer, like it's inside the house? It's just the room. It's just the room that makes things sound that way. But, still—who screamed? And why?

This was the house that belonged to me. This was the part I'd

claimed, the first part that was truly mine. I'd taken possession of the house at night with only me in it, an important step, a first exorcism. I owned that. Soon I would be claiming more, the house in other guises. Gina would arrive, and Evan. We would insinuate ourselves, displacing old presences. A new family. A new family with neighbors, *neighbors who complained.*

Cable television. This house had never seen cable television. We would introduce it here, another toehold. MTV would make its debut in this anachronistic living room, changing it forever.

Teepee. I need teepee for my bunghole: we would laugh in a new language here and the walls and floors and ceilings would hear us and receive us and they would be changed. They would be changed because we were here inside them, laughing.

A garbage disposal: we would give this house its first garbage disposal! We were pioneers! Pioneers with heads of cabbage and eggshells to grind!

We would be bringing new things and reinventing the old. We would reclaim the floors from under the moss; we would find the gold inside them waiting for release. We would pull the blankets from the windows, strip the crackled oilcloth from the walls, twist hundred-watt bulbs into the dusty fixtures.

Luminescent brilliance: burn, Sylvania, burn!

We would pump this house full of color and light.

It is not too late.

Resistance is futile. Salvation is at hand. We are here; we have arrived on the fine white cloud of remaking. We will touch every square inch of every square foot of every square yard. It is only a matter of time.

plans and

their executions

We were on the blimp.

Gina and I were sitting next to each other inside the Goodyear blimp, bobbing just above the pavement, peering out the window at the grounds crew holding the bottom rail so we didn't float away prematurely. We looked at each other with the breathless expectation of Phileas Fogg and Passepartout setting off on their eighty-day journey.

These were the first significant moments we had spent together since all this began, since the miscarriage, really, that did not directly relate to the task of our new home. It may seem illogical that these moments were being shared on a seat inside the gondola of a Goodyear blimp, a surreal chamber that few civilians ever enter, but these were strange days for us; illogicality and surrealism seemed the only appropriate themes. We awaited liftoff.

It was overcast. It is usually overcast here; this is our defining light. One of the stanzas of Akron myth claims that we are the second cloudiest American city, after Seattle. The Emerald City has managed

*180*] David Giffels

to make cloudiness part of its charm, a superlative, a funky badge of honor: the Cloudiest. They proclaim it on stickers affixed to the back bumpers of their Swedish microvans and their Japanese hybrids.

In the Rubber City, it's just . . . cloudy. We are fans of the Cleveland Indians; we are fated never to be first, even in the category of bad weather. A staple of our midwinter reading is the perennial newspaper medical feature about seasonal affective disorder, the clinical term for the psychological and physical strain that results from lack of sunlight. Acronym: SAD. These news articles are strictly functional, informing us that, yes, there is an explanation for our collective depression. Whether one finds comfort in that knowledge is, I suppose, a matter of outlook.

Instead of sunshine, then, we have the blimp. A floating paradox: retro and futuristic, ominous and whimsical, one of the largest things that flies, yet "lighter than air." Originally designed for war, it's now a giant advertising balloon.

Everywhere else, the blimp is an entity of television, hovering over major sporting events, instantly recognizable yet necessarily distant, like Vanna White. Here, it's like the ice-cream truck. You grow up in Akron, you grow up attuned to a particular frequency of drone, not helicopter nor plane, but *blimp*, with its own specialized thrill, the promise of some oblong, ungodly thing crawling into view. It happens all the time. The drone. People know when one is coming. They know this without looking up—

But they always look up.

And now Gina and I were inside one, an extension of the journalistic research I was doing on Akron's rubber companies. This was a fact-finding mission, yes, but we were holding hands. We may as well have been leaving for Paris. We looked out the window, watching the blue-suited members of the grounds crew with fascination.

What if one of them doesn't let go? What if he goes floating along with us, dangling, legs akimbo, swinging to and fro. Will this experience make his life better, or worse?

Better, I think. It might seem that as commonplace as the blimp is

in Akron, riding one would be less exotic here. Instead, the prospect is all the more tantalizing. Rides are rare. This is Akron's divine sanction. We are Brahmin. We are Holders of Golden Tickets.

We had spent that morning together, buying toilets. I had a revelation: this was probably the only time in our life that we would buy three toilets at the same time! I declared this to Gina as we pushed dual carts through the Home Improvement Superstore, seeking wax rings. She agreed, yes, she could not think of another situation in our future life together when we would need three new toilets simultaneously. She seemed less enthused by this than I was.

The toilets were progress. The toilets meant the plumbing had made its tedious way through the walls and was ready for its business end. This was a part that Gina and I could do together: select plumbing fixtures, shop for a ceiling fan, choose a Formica color for the countertop my father was making. And despite our different motives and desires for this new phase of our lives, we could agree that real commodes, new ones with reliable pipes meandering through the walls to the basement source, that these were an improvement.

Wax rings! Wax rings!

There was no downside here. There was no disagreement. Toilets were good.

But mostly, we had been apart. For weeks, Gina had been handling a lot of the semiremarkable end of the move while I continued working every spare moment at the new house. I just wanted to get us to moving day. Then, even though the work would continue to consume us, we would at least be together, in the same space, sharing something instead of working at it from opposite ends. Then we could talk again about a baby, about the family that this house was supposed to hold.

But the idea of "moving day" as a specific "day" had become disconcertingly fluid. We were a week from the deadline to vacate the semiremarkable house, but I didn't see any possibility of the new house being habitable in seven days. I tried to keep this to myself.

I tried to be optimistic. I tried to keep my focus on these few moments of relief, time together with Gina on the blimp. I tried not to worry.

The low thrum of the engine suddenly intensified into a higher thrust as the men on the ground backed off, a stage exit, releasing their ropes in a looping flourish, releasing us to the sky, lockstep in reverse, beating a uniform Busby Berkeley retreat, and we rose, lighter than air, hovered/flew/bobbed—yes, this is unlike any other transportation, more like open sea than sky, but definitely sky, a kind of perspective never before allowed. There were horses in corrals not far below; our shadow crossed over them, they were oblivious and heavy and beautiful. There were ice fishermen on the white oblique, ice fishermen in voluntary isolation, finding lonesomeness to be the only valid companion on these cold and sunless days. One of them raised an arm and waved. One *always* waves at the blimp.

Gina and I sat close together, warmth between us magnified, my reporter's notebook neglected, unnecessary: there was no way we would ever forget any of this—*Look: someone wrote "HI" on the roof of that garage!* A greeting for the argosy, for the privileged few who pass this way.

The pilots navigated out loud, not with "vectors" and "headings," but by physical landmarks: "Hang a right at St. Bernard's"; "Follow Market Street west."

"Where is your house?" one of them asked. "Want to go over?"

We looked at each other. Our house? Where is our house? Which one?

"Yes," we said. "On North Portage Path."

And then, as we crawled across the damp and dismal sky, we found the markers we recognized:

There! That's the Walgreens! Follow the line north . . . is that it? No—wait—is it?

Yes—that's it! That's our house! I can tell by the Dumpster!

We snapped a picture, stole a kiss, squeezed our hands together.

We can see our house from here!

* * *

We were in limbo. With the days—the very hours—dwindling on our rented extension in the semiremarkable house, we called the new owner and asked again if we could buy just a couple more days. He agreed. Day by day, we were paying his mortgage while he lounged by the executive-suite pool. For us, it was a drain on funds that we were supposed to be putting toward light fixtures and paint and the rest of the items on the perpetually growing list of basic necessities.

That was going to be it, though. No more extensions. We needed to make the break. The downstairs was getting close. The work was nearly finished, which meant the daily mess was nearly finished, which meant we could clean and paint with lead-blocking primer to make it safe. Upstairs, we'd decided to close off the master suite, leaving it unfinished for the time being. We would concentrate on getting Evan's room clean and safe and the next-best bedroom in shape for Gina and me. We could get settled and move forward.

Nearly three months had passed since the miscarriage. That time had been filled with the crushing distraction of the house, as comforting in its way as a hairshirt on a sinner's skin. But now the doctor had said it was safe to try again. The subject was difficult, a minefield of ironies. The reason we'd begun looking for a house was because we were having another baby. Now here we were, with more house than we'd ever imagined, but no baby on the way. And all I could think of was the question: how could I ever deal with a new baby with all this house to handle? Would it all be too much?

Gina was the person I always could confide in on problems like this. But this was different. I had promised too much to her. She had put too much trust in me. To say it out loud—that I was overwhelmed—would be to unravel all the logic that had brought us here. I kept it to myself.

The kitchen was ready for its appliances to be moved into place. But that could only be done once I'd decided what to do about

the floor. The kitchen floor was a conundrum. It was covered in li-
noleum, gray-green and speckled with black and blood red, so badly
worn in the high-traffic areas that the old black adhesive showed
through. And it smelled. It contained a concentration of the smell
that permeated every surface where the cats had been. This floor was
an acid trip, a psychedelic confusion that was at once oldfangled and
otherworldly. Gina made the mistake—an honest one; I don't blame
her—of saying she would like to have a tile floor in that kitchen.

This room was of vital importance to her, to this entire opera-
tion. Gina loves cooking; it is her passion and one of her great talents.
Therefore, a considerable part of her imagination of this house, of
its Idea, was the thought of one day stirring vast pots of pasta for
the family gatherings this place could hold, her kitchen filled with
the warmth of boiling water and the aroma of sautéed garlic and the
company of people she loved who always, without fail, despite the ac-
commodations elsewhere, gathered around her in the kitchen.

But still. A tile floor? Good lord! The cost and the time and my
God all those corners and crannies—the tile cuts alone would be two
days of work.

An honest mistake. There was so much to think about. My brain
was tired of identifying problems and thinking of solutions, my body
tired of following them through. I pleaded. Couldn't this just *not* be
a problem? Couldn't we just live with the floor for now, deal with it
later? I could just cut away that ragged, peeled-up edge that keeps
tripping us, leave it rough for now, just for a while, just until I deal
with—what?—with everything else I need to deal with.

It did smell. Like ammonia, sort of, but really like nothing else
but cat piss. Thirteen years earlier, a cat had peed in my guitar case,
and it still smelled. There is nothing that compares to that smell or its
feline refusal to fade. That smell permeated the house, but in certain
areas it intensified, chiefly in the master bathroom and this floor, a
strong yellow-brown stinging smell that strikes the throat as much as
the nose (and the eyes as well), a smell with a thousand needles, with a
sulfuric sucker punch, a low-rent old-folks home liquefied.

I allowed myself to wonder, just for a moment, about this problem that I did not want to be a problem, not for now. Was the smell in the linoleum itself? Or had it seeped into the grain of the wood below? And then I was not wondering anymore, because it does not work this way. These problems are like pornography: if one allows oneself a glance, and insists it will be only a glance, that glance is likely to linger and the lingering will lead inevitably to action.

So my wondering about the linoleum brought up the subject of what was under it. Wood. Wood was under it. What kind of wood? Hardwood? Pretty oak waiting for me, the maker of things of wood, lover of wood, speaker of the language of wood, carver/builder/gluer of logs into rustic furniture not unlike (in the eyes of some) the furniture crafted (far more crudely, and with less artistic vision) by the castaways on the hit television show *Gilligan's Island*?

Had Gina done this on purpose? Had she mentioned "tile" knowing full well a tile floor was out of the question, but that its mention would lead to me standing here, now, at the entrance to the butler's pantry, paused on my way to some other job, paused just long enough to wonder, not about tile, but about *possibility*, which is always my downfall. Criminy! She knows my every weakness! I think she did this on purpose.

I poked the tip of my utility knife under a corner of linoleum that had lifted slightly. Just a peek. Just seeing what this is about. No commitment. Just a guy with a knife, passing through. The surface underneath was black with the hard, dried crust of adhesive. I scraped with the tip of the knife. Harmless gesture. Yellow. Yellow wood. Pine. Probably pine. Probably old pine—definitely old pine—which can be very pretty. Desirable in its day. Harder than the cheap modern steroidal pine. But no, now we're talking about removing the linoleum and removing the glue and sanding the floor and staining and coats of polyurethane, three at least, no—four; this is a kitchen.

Crap.

"Is there a machine that takes up linoleum?"

I was on the phone with the tool-rental place.

Of course there's a machine that takes up linoleum. The more detestable the job, the more likely someone has invented a power tool for it. That is human nature; that is the nature of invention; that is the nature of Men. Necessity, yes, but convenience even more. Convenience is relative, of course, especially when you're talking about something that has been glued down to a subfloor with the premise of it being permanent, because the same spirit of invention applies to *attaching* these things as applies to *removing* them. The world is at war with itself. My kitchen floor was a microcosm of the vast cosmic conflict. Plus, it smelled like cat piss.

The machine was hard and vicious and relentless. It looked like a compact, muscular vacuum cleaner, but with a thick, sharp steel blade, six inches wide, attached to the front. The blade lay flat against the floor, and when the trigger was pulled, it reciprocated, jittering itself between the linoleum and the subfloor, peeling up the material with malice.

Or that's how the instructional video might have shown it. In theory, and in certain practical applications, it did work this way. But this flooring was like everything else in the house, old and untended and beyond any normal expectations. In the areas where the floor had received the most traffic, the bond between the materials had intensified; the linoleum was fused to the pine not just by glue, but by human action, the comings and goings and the lingerings there, the passage of the eras, by life itself, creating a new compound, a chemical/metaphysical hybrid of linoleum, glue, wood, and human mystery so thoroughly enmeshed that it would have to be sorted out atom by atom.

I attacked those areas nonetheless; in some cases, the jutting blade dug gouges and sent up ragged yellow splinters—pine; definitely pine. When I was finished, I had a floor no longer covered by the gray-green linoleum. I now had a floor covered in swirls of black adhesive hardened to something like mortar. Also it still smelled.

There was no turning back. I couldn't leave it like this. I would have to find a way to remove the glue. My dad had none of his usual practical insight. But he did have an electric paint scraper, a shrewd

tool that, like the linoleum remover, operated with a reciprocating action. It was more the size and configuration of a hand vac, with a three-inch scraper attachment that chattered away. My dad brought it over and we gave it a try. It seemed like it could work. It definitely seemed like it would work better than scraping by hand. I plugged it in, chose one end of that long butler's pantry as a beginning point, dropped to my hands and knees and began.

An hour later, I'd gone two feet. The floor was coming clean, mostly. But the pace had inspired me to think of ways to improve the process. I went to the basement washtub and drew myself a bucket of scalding water. I splashed some onto the floor, spread it around with a scrub brush, and set back to work.

Eureka. Soon the adhesive had softened. It was coming up more easily. I spread some of the near-boiling water ahead of me, and forged ahead. Not so stupid. I am a solver of problems.

The hot water soaking down into the wood was releasing the aroma of cat piss, so I was working in a cloud of that rancid, jaundiced smell. In addition, while it was softening the glue, the water was also creating a goo that was growing in volume and scope as I progressed. Soon, whenever I stood up, it was difficult to straighten my legs because the cloth of my jeans had stiffened with a coating of old glue, resurrected and reconstituted.

The incessant vibration of the scraper was making my hands go numb. Or maybe it was the water, which eventually turned cold, so the area just ahead of me was warm and gooey and scrapeable, while the area directly underneath and behind me was frigid and damp and stiff with rehardening glue.

My hands grew more numb, and tingly. They ached. The constant hard chattering of the scraper must be wreaking havoc on my nerve endings, I thought.

Halfway through the floor, I stood up for a look. My legs and arms were covered with a thick, stiff crust. And my hair. In pushing my hair back, I'd gotten the sticky adhesive in it. The floor was soaked and still had a milky haze. It would take some heavy scrubbing to get

off the residue. The area I'd finished was an improvement, somewhat resembling a wood floor. But it was gouged and imperfect, certainly no match for the oak floors under the mossy carpet and crumbling padding that covered the rest of the house. There were gaps and nail holes and stains.

Wait—

Paint! I could save this floor with porch paint! I am a genius. A genius of wood! The paint would seal in the smell, and it would make an attractive, relevant surface, rustic and workmanlike, perfect for a servants' kitchen. I wouldn't have to rent a sander and the painting could be done in a fraction of the time as refinishing.

I set back to work in the sodden mess, invigorated. My hands were really tingling, something between numbness and a stinging sensation. And my knees too and up into my wrists. It seemed to be getting worse. Definitely. It was definitely getting worse. I leaned forward on my palm, and pulled it back—a shock!

I leaned back on my knees. More gingerly, I touched my hand to the floor. It stung! I did it again, just to be sure my nerve endings weren't acting funny. Shit! Ouch! Hurt! Hurting shock!

It occurred to me then: I was on my hands and knees on a floor with a layer of water on which was resting the live connection between the electric paint scraper and the extension cord, the same cord from which I'd snipped the grounding prong that very first day. The water was conducting the current in a layer across the entire floor.

This floor was coated with raw electricity!

I jumped up, very much aware of the blessing of rubber soles on my boots, and backed away to a dry area. I scampered back and yanked the cord from the wall with a tentative, teeth-gritting tug.

And it was going so *well*, I thought bitterly, working to straighten the glue-stiffened arm of my shirt. I considered the problem. I was so tired of looking at problems and identifying solutions. I pulled apart the connection between the scraper and extension cord, dried the prongs on the tail of my shirt, and reattached them. I wrapped up the connection with a triple layer of duct tape, sweet duct tape, and I con-

tinued. It wasn't as bad as before, but I was aware, for the remainder of the day and deep into the night, that if I died of electrocution while scraping adhesive goo from midgrade pine soaked in cat piss, Gina would mourn me epically.

So now we had a kitchen floor. This was good. A kitchen floor was a good, solid, obvious indication that this was a house people could live in. I had painted it with polyurethane porch paint, slate gray with a hint of blue. I thought it looked rustic, old-fashioned, 1920s workaday plank flooring. Gina hated it. She wanted tile; I wanted something that wasn't piss-stained linoleum. I thought of this as a compromise. She thought of it as an ugly floor that was nothing like the kitchen she'd imagined in her dream of the house we were trying to make our own.

To me, the right answer was anything that wouldn't require any more attention for now, because we didn't have any proper sort of place to put our eighteen-month-old son and time was running out. Also, we'd sort of been ignoring the issue of our own soon-to-be bedroom not having an entire ceiling.

By the end of that week, it seemed we'd made no progress at all beyond the kitchen floor, which I don't think Gina was even counting as "progress." We'd scheduled a moving van and a swashbuckling crew of brothers and brothers-in-law, plus Chris, the auxiliary brother, for Saturday. We were moving. There was no way we were going to beg for more time in the semiremarkable house. The new house would never be ready, not in any traditional "move-in condition" sort of way. We knew that now. We'd been joking about our "five-year plan," which we told people would take "approximately ten years," and our "ten-year plan," which would take "approximately twenty," and so forth. We thought we had no delusions about what we were getting into. In a way, I suppose, this was true. We knew what we knew, and we didn't know what we didn't know. But increasingly, these informational borders were not mutually recognized. (I, for instance, knew

there was something living in the attic room above Evan's room because I had heard it scurry and purr nervously—and possibly growl —when I was up there stuffing insulation into any space I could stuff it into. Gina, for instance, did not know this.)

With our options narrowing, we arranged for Evan to stay with Gina's parents for a few days after the move, just until we got things ready. The words sounded hollow, but faith, even in hollow words, had carried us further into this endeavor than either Gina or I cared to dwell upon. At this point, we didn't even know what "ready" meant.

We pieced the kitchen together. When I plugged in the refrigerator, I realized I no longer would have to keep my beer cold by storing it in Evan's icy closet. That was progress. I wondered when we would use the stove for the first time, what meal we would make. I began to think in very real terms about what it might be like to live in this house, to go to sleep here at night and wake up here in the morning, to think of the rooms, not as makeshift workshops or problems to be solved, but as living spaces in which I might one day walk, perhaps even barefoot, with a warm cup of coffee and a newspaper and the easy carriage of a man not burdened by the question of what it was that had possibly growled at him.

in residence

We had just enough furniture and possessions for all the helpers to complain about, but not so much that we couldn't justify doing it ourselves. After the ordeal of the previous weeks, the prospect of moving a household seemed like a simple morning's work. We began early, loading the rented moving van and whatever trucks the helpers could provide. I complimented all of them on their studlyness as they asked silly questions like: *What's in these boxes? Rocks?* (One of them did contain rocks.)

A late-January slush was falling, accumulating on the front walk and the brick driveway, forcing us to take careful half steps as we loaded the Gilligan's Island furniture and the dismantled beds and the hand-me-down dining room table into the truck.

As we pulled back into the driveway after dropping a load off at the new house, our friend Danny came slipping and sliding across the icy street, his wool overcoat unbuttoned and flapping wildly as he held out the warm loaf of banana bread he'd hastily baked.

"I forgot this was the day until I saw the truck from my window," he said. "Here."

He offered the foil-wrapped loaf.

The urgency of the new house had kept me from dwelling on how much of Gina's and my life together was defined by this other place we'd lived in for six years. Danny's small gift made it impossible to ignore. We were removing ourselves from a part of ourselves. This was supposed to be the easy part, but it wasn't.

The moving crew tore through the bread before I ever got a chance.

Virtually every stick of furniture we owned was either a castoff or a curb find or homemade. Shortly before we'd closed the deal on the Portage Path house, I'd spotted a hefty old drafting table, warped and weathered to gray, sitting on a curb on garbage night, straining backward against partly dismantled legs. I tried to put it out of my head, but that would be like Mother Teresa blowing off a paraplegic panhandler. Soon, I had called my brother-in-law for help and rushed back, worried in my gut that some other plucky soul had beaten me to it. But no, there it was, maybe a little shabbier up close than I'd remembered, but good enough to justify carrying it the two blocks to my house. In an adrenalized flurry, I'd repaired and refinished it just before the possession date.

Now it would make its debut as the anchor for the upstairs hallway at the new house, which is to say it would be the only piece of furniture up there. We didn't have nearly enough furniture for this house. We'd told people this was a place we could "grow into," which really meant that this was simply too much house for us. We had never intended on having this much house; now, as we calculated how our current furniture would be spread over more than twice the surface area of its previous setting, it became clear just how ridiculously large the place was, with wings and hallways and back rooms and on and on and on.

But for now, the modest amount of furniture was a blessing, as most of it was to be stacked in the hermetically sealed dining room, which Gina allowed to be opened for the moving day, insisting nev-

ertheless that the plastic remain draped over the doorway as a sort of threat. The only rooms that would be set up for proper use were our bedroom and the kitchen. Those too would have plastic draping the doorways. Two-mil plastic sheeting had become the Veil of Completion, a force field against the chaos of the rest of the house.

Late in the morning, a car with government plates pulled into the driveway. Two men got out and slowly approached the solarium double doors, where we'd been loading in the furniture. One of them had a clipboard with a stack of papers. They were looking up, scanning the house. Chris was standing at the back of the moving truck, along with one of my brothers-in-law, watching.

When they finally approached, Chris asked if there was anything he could help them with.

One of the men introduced himself. Health department inspector. The other one, eyeballing the facade, smiled.

"Is this the house that was in the paper?"

I'd just written the first of what was to be a casual series of essays for the newspaper about our restoration.

"Yes," Chris answered. "This is the one."

The inspectors looked at each other in silent consultation. The one with the clipboard scribbled a signature on the paperwork.

"I think we're okay here," he said.

Could it really be that simple? Maybe they weren't accustomed to people keeping their word. Maybe they thought the new roof was enough to stanch the erosion. Maybe they just wanted to get through a stack of Saturday work orders.

"That's it?" Chris said.

"That's it," one of the men said.

It was no longer their problem.

The sun was inside the room. It was inside the blanket and the sheets. It was under the pillow. It was in my eyes and my ears and my mouth, under my fingernails, through my hair, all yellow bril-

liance, sharp as a bite of sweet onion. Despite its bold announcement, I woke to it slowly, with the dreamy awe usually reserved for children who've forgotten they'd spent the night at a cousin's and must slowly orient themselves to the strange ceiling and the strange walls and the strange smell and a strange need for reconciliation: *I am who I always am, but nothing else is what it always is.*

Gina was here, yes. Gina, and the sun.

I was here, waking up for the first time in the house.

I blinked.

Ceiling, yes. Or part of a ceiling. Ceiling and the brown-gray void of rafters and knee wall above, mystery and old soot visible through the hole I'd cut that very first morning, that morning with Mrs. Radner lurking down the hall. And walls. The green walls of the Green Bedroom, pea soup except where they were patched with flat white compound. And floor, wooden floor with an open wound where the cupped and split boards had been removed.

But mostly: windows. Windows behind the slats of heavy old aluminum venetian blinds, still tangy with the scent of the bleach Gina had scrubbed them with in the bathtub, a terrible clean smell. The sun cut through them, the brightest light I'd ever seen in this house, kamikaze sunlight coming in flat and fast.

I blinked.

I am who I always am, but nothing else is what it always is.

Should I? Should I pull back the covers and set a foot on the floor? That would be the first in a day of firsts. The first time I awoke in this absurd, stupendous place and set my day in motion with the touch of a footsole to the worn, flat oak.

I should. I should do that, savor it, take in its full experience.

Or should I wait? Should I wait for Gina, so we might do it together, share the entire sensation of it?

No, she'd want coffee first, and socks.

She was breathing in a way that suggested she was trying to inhale the entire room. It would be a very long wait, if I chose to wait. So I chose instead to do it alone. I pulled the heavy comforter aside and

reached my right foot to the floor. It touched. Then the left. And I stood: standing for the first time in the house where I lived, where *we* lived, in the place we were making ours.

I left the room, quietly closing the door behind me. It began to sway back open. I closed it again. It slowly swung back. I bent down and eyeballed the latch. It was out of synch with the strike plate. Not even this, the simplest of mechanisms, would offer its *click*, the aplomb of alignment. To close a door behind me and have it stay closed: someday this pleasure would be mine.

I stepped into the grand central hallway, over to the balcony, its chunky railing coated in sad eggshell paint. And then I began down the main staircase, *carried forward*, as Steve Braun had described it, into the brilliant, glowing main hall.

It felt like privilege. It felt like I'd been granted the privilege of being here in a place where nothing was right, where closed doors were not closed doors, where my worldview was taunted by makeshift curtains fashioned from drop cloths and taped-up sheets of newspaper. Here, now, in this first morning, it was privilege.

I went to the front window, gazing out into the tangled grounds, selectively ignoring the gap in the barberry hedge. I saw something moving. A brown rabbit. Was it? It must be—it had to be. It must be the same rabbit I'd seen that night in the cold when I stood on the pond. How could it not be? This was my Overt Symbol, the Bunny Rabbit of Placid Reassurance. A little on the cute side, kind of obvious in a tenth-grade American Lit sort of way, but you take it where you can get it. It was real, and it was right.

We were now residents, but Evan was not. This was the place where we were supposed to realize ourselves as a family, yet the act of moving in had split our family apart. We had no place to put our child, and so he was living with Gina's parents. This was backward. Upside down. We had all these rooms, and not one for him? The goal had been simple enough: a basic functioning kitchen

and a clean safe place for Evan. Then we could be normal. But we had nothing.

We made a plan. We would drop everything else and Gina and I, together, would sweep in and transform the Orange Bedroom from a ruin to a place for our son. There was a lot to do: sand, scrape, caulk, seal, rip out carpet, clean, paint. We began on a Sunday morning in late January, the day after the move, and vowed we would not stop until we were done. The rest of the world would be watching Green Bay battle New England in the Super Bowl that day. Not us. We would work side by side to bring our baby home.

Around us, a seemingly endless denouement had continued: inspection and last-minute fixes, workers retrieving materials and tools, lowering ladders and wrapping up change orders. Naively, we had thought that the workers would all finish on some uniform deadline, that there would be a magical *click*, on, say, the third Monday in January, and the house would go from public construction site to private almost-livable space. Instead, everything seemed to ebb and flow—finished, then not finished, safe then not safe. Even that day, Super Bowl Sunday, we had to negotiate around a makeshift scaffold in the stairwell, where the last of the Guns N' Roses Late-Night Drywall Crew, the brooding guy with the screw pop in his mother's living room ceiling, was finishing the area above the stained-glass windows, which were still covered with protective sheets of plywood.

The drywall contractor had agreed to take on this job only if we would pay an hourly rate, rather than a whole-job estimate. With curious precision, the number of hours required to box in most of the open ceilings and walls had worked out to cost exactly what we had left in the budget. When this guy in my stairwell finished, we would be down to empty. Fifty-five thousand dollars would be gone, and we would be in a house that still drew long stares of puzzled concern from first-time visitors who seemed unswayed by my insistence that the house was *greatly improved* because it now had electricity and running water.

Why? they continued to ask. *Why would anyone do this?*

The question originally had seemed like a compliment. I had taken

it as rhetorical, a testament to my capability, my potential. Now, it was beginning to turn sour in my stomach, to tighten around itself. *Why?* I wondered secretly back to myself. *Why did so many dozens, maybe hundreds of people look at this house and deny whatever romance it suggested because it was just too wrong to be made right again? Why would anyone do this?*

I felt like I wasn't allowed to admit this to anyone. Least of all, to Gina. She had faith that I could make the house of her dreams from a pile of sand. It was not unfounded faith. I had told her so. If I failed, I would be failing her. I couldn't let that happen. And yet—this fear was growing. It was growing with the daily realization of what lay ahead, with the very fact that no one could enter through the front door because the steps were too treacherous. The simplest thing. The front door of the house—off-limits. I'd put an orange caution cone there. Go around to the side, it suggested, where the steps are somewhat less dangerous.

And I couldn't fix that problem because to fix *that* would be to not fix Evan's room, which suddenly had to be done. Matters of urgency were bouncing in a chain reaction. The question of where to begin was mockery.

So we just—began. Gina and I squared off in opposite corners of the bedroom, prepping the walls, scraping, repairing, working through the morning and into the afternoon. Despite the outside cold and the fact that we were keeping the thermostat as low as possible, the closed doors and the steaming water in our buckets and the constant activity concentrated heat in the room. We were sweaty and grimy. The windows fogged.

In the afternoon, I was leaning forward on my ladder to caulk a gap in the crown molding. My fingers were coated with globs of caulk from trying to smooth the surface. Gina, dressed in a thermal shirt, jeans, and combat boots, was hunched over a baseboard, scrubbing with rubber-gloved hands. Her hair hung shabbily from her ponytail. As she leaned to reach a corner, I noticed a band of her lower back, perhaps five-eighths of an inch of skin exposed where her shirttail had crept up.

Skin!

I stepped down from my ladder, ambled over, tapped her arm. I raised my eyebrows, silent-movie style, and nodded toward the door that led to the bathroom, which then opened to our bedroom. Her eyes narrowed and she shook her head adamantly, then paused.

Her lips soundlessly formed the words as she pointed to the door, on the other side of which was a Friend of Axl.

There's someone *right there*!

I nodded again, toward the other direction. She looked at one door, then the other, and, well—yeah.

We collapsed secretly onto the disheveled blankets in the Green Bedroom, under the open rafters, breathless with the shocking electric thrill of teenagers one thin wall away from capture.

A short while later, still flushed, we went down to the basement together for paint and paintbrushes. The brooding guy was working from a ladder in the hallway that led to the billiards room, the hallway with the crunchy floor.

We stopped to see how he was progressing.

"Almost done. I want to get home to watch the game with my son."

His son. He would spend the afternoon with his son. In a house! With walls and ceilings and running water! What a wonderful thing. What a wonderfully normal thing. The Super Bowl! It brings families together!

"That's great. That's great that you get to spend that time with him."

"Yeah, everything I do, I do for him. I work every minute I can. Overtime, weekends. It's all for him. I want my son to have a good life."

"That's great. That's great you're doing that for him."

"Yeah, I missed too much of his early years. Now I want to spend as much time as I can with him."

"Missed?"

"Yeah. Well. I spent some time in jail."

"Oh. What, uh—if you don't mind us asking?"

"I got in a fight."

"Oh. Yeah, well . . . you know—it happens."

"And the guy kinda died."

"—"

We are in the house—with a *murderer*!" Gina hissed after making a hasty excuse to rush upstairs with paint cans. She'd closed the bedroom door and turned the latch and was standing at a defensive angle, one arm raised in an approximate karate pose. I didn't have the heart to tell her the latch didn't work.

"Well, he's been here for a week," I said. I have no idea why that was supposed to make any difference, or for that matter, why I felt a need to minimize the fact that we were, indeed, alone in the house with a convicted murderer. I had developed a new habit of diminishing everything in an attempt to soothe. Losing touch with reality seemed like a valid coping mechanism.

"I *know*," she rasped. "We talked all the time. He was my favorite one."

She glared.

"We had *sex*," she said. "With him in the *house*. He *killed* somebody. With his bare *hands*."

"Well, it doesn't sound like it was intentional."

The concept of accidentally killing someone in a fistfight was, admittedly, foreign to me. I had only been in one fight in my life, in fifth grade, and that was only because my older brother was fighting *this kid's* older brother, and somehow it had been arranged that we, the respective younger siblings, would mix it up in a sort of undercard event. The fight was a bust; in the opening grapple, I reached up and, on purpose, popped the loose lens out of my glasses, not only ending the fight, but attracting the sympathy of all the bespectacled children in the crowd gathered around us.

So I was at a disadvantage not only to provide perspective on this particular level of manslaughter, but also to defend myself and my wife in the event that the drywall hanger suddenly decided to satisfy his bloodlust before heading home to watch the Super Bowl with his son.

But he did not murder us. Instead, he finished his work, unwittingly holding us hostage behind a bedroom door, where Gina and I continued our own work, acutely distracted and relieved when finally, at dusk, he washed up and departed.

I called work first thing that next morning, pleading for a personal day. I'd stayed up all night, prepping and painting into Monday, and I decided the best course at this point was simply to burn it out. Gina had gone to bed sometime before dawn; I was tired and tireless, in a marathoner's hallucinatory zone, all of me directed toward the end of this project, which I knew, given another twelve hours, I could finish in one epic forty-eight-hour cycle. That potential accomplishment fueled me: the Challenge and the Meeting of the Challenge. It fueled me more, in fact, than the idea of bringing Evan home.

That was fine, though. Right? It was self-reconciling. Wasn't it? Just because my real energy was focused on solving the room, on completing a task, on finding the self-satisfaction of starting with nothing and ending forty-eight hours later with a finished room—*without having slept!*—that didn't in any way suggest that I wasn't pining for my little boy to come home, that I didn't yearn for him in the same way that Gina had yearned for him before turning in, teary and exhausted, a few hours before.

I recently had read a memoir Helga Sandburg wrote about her father, Carl, "the people's poet." She was a widow, close to eighty years old, living in Cleveland. I had met her and interviewed her and was smitten. (How could I not be? She had a personalized sketch from James Thurber hanging on the wall. A back-of-a-napkin sort of thing. An offhand gift. From *Thurber*.) In her book, she wrote about her memories of her father working in his barn on his biography of Abra-

ham Lincoln, times during which the family was forbidden to disturb Father's Important Work, alienated from the man they adored:

Sometimes a child is sent out to my father, bringing him a glass of milk or a pot of coffee. He responds absently.

I had stopped writing in the mornings. I could no longer justify that kind of solitude and concentration, but I was finding a similar depth and density in this new work that had overtaken me, a new way to be alone, absorbed in a problem, actively working toward its resolution, a low-rent version of the enlightened self-reliance achieved throughout the American experience with dark lyricism by men who always seemed to be named Henry—Thoreau, Aaron, Rollins, John Henry—each improved by his isolation.

Is that what I wanted? Is it even possible? Can a man exist as a solitary being in search of his own possibilities and at the same time be a competent father and husband? Does one of these desires have to be compromised for the other? Or worse, sacrificed? And which one is his true self?

I wanted my life to be filled with everything, spilling over, chaotic: books, music, chainsaws, brickwork, babies, drinking, writing, furniture building, Sawzalls, sex, cartoons, big sloppy breakfasts, all in the same day, every day. And I wanted to be alone, completely alone with an idea that I could explore to its marrow, no—down to the studs—the way Carl Sandburg was alone and engrossed in his exploration of Abraham Lincoln and America and Her People. In a barn. The man had an entire *barn* for this.

Was that so much to ask?

And now I had found it, and it was perfect, in its way: chaos and solitude, lock solid, unquestionable, as long as I ignored the truth—that no one can have all those things without being supremely, ruinously selfish.

No! I am doing this for my child! That would be obvious to anyone: *look at him, working through the night, all self-sacrifice, fingers to the bone, nose to the grindstone, candle at both ends—to make his family whole again!*

What was I doing?
I was no longer sure.

He came home two nights later. Our first dinner together felt like an anticlimax, with us crowded around the Gilligan's Island coffee table in the dining room, all the rest of our furniture stacked into a looming wall before us, teetering in the imbalance of an over-taxed plan of action and the growing realization that this would be our new way of things.

He slept beautifully.

the puzzling case
of the missing hammer

I couldn't find my hammer.

I always know where my tools are. At any random moment in my adult life, if God commanded me to hand Him, say, a five-sixteenths Allen wrench, I could do it on a dead run with my eyes closed. I have no idea what use God would have for an Allen wrench, but they say He works in mysterious ways and few tools are more mysterious than Allen wrenches.

Regardless, my hammer was not where I'd put it. I knew I must have returned it to my toolbox. I *had* to have put it there, to have laid it carefully in its designated place. My toolbox was the one oasis of organization in this vast jumble. I took pride in the discipline of its maintenance. But it was not there. Neither was it in the bedroom where I'd been working, nor on the living room bookcase that had become an auxiliary tool area.

The bookcases were a tragedy. In their day, they must have been solid and elegant showpieces; now they were ruined, reduced to service as makeshift workbenches. They were of Arts-and-Crafts influ-

ence, grooved and inlaid, each covering an entire wall on either side of the detailed pillars that framed the living room's wide entrance. Their dark walnut finish had been painted with that omnipresent off-white and the water damage had left the wood contorted and dry-rotted. So now these shelves held piles of tools and scrap lumber. I sorted through their contents, first methodically and then frantically, but my hammer did not turn up.

I asked Gina. Hammer? She didn't know. Why would she know where my hammer was? She didn't understand about me and my hammer.

My mind narrowed to a singular, almost desperate quest. *Find . . . the . . . hammer.* Its loss was not just practical, although it was indeed that—I was without the most basic tool in a renovator's arsenal. But its disappearance implied something much more unsettling—that after only a few weeks of living in this house, I had lost control, that I could no longer maintain order even within two cubic feet of toolbox.

Since moving in, we had been improvising a new lifestyle. This felt like a third phase—first, I had been here alone, then here with the other workers, and now here with my family. The constant was the work. Evan's room was done. Gina's and my temporary bedroom was enclosed and tidy in a rustic, patched-together sort of way. The downstairs central hall and adjacent living room were safe and clean. The kitchen was functioning, and I was working every night and through the weekends to finish it, *really* finish it, to make it an example of what a room in this house could be after its transformation. There was a way to walk through the house, if you chose the path carefully, that could make you believe we were not so crazy after all.

But you couldn't veer off that path. And the search for my hammer required that I did veer off that path. I went to the basement. I didn't want to go there. The very act of walking down the stairs prompted a visceral response, a cringe, an urge to turn back and ascend to some other, more approachable disaster. It was a cataclysm, and it had been since moving day. My helpful brothers and brothers-in-law and Chris, the whole blessed bunch of them, had dumped all my tools and other

basementesque paraphernalia in haphazard piles that crashed into already existing piles of construction materials and debris, around which were arranged kitchen cupboard doors (sixteen of them), propped on scraps of two-by-fours, awaiting a second coat of paint. The table saw was at the back of one of the rooms; accessing it required using the flotsam of Moving Day as Twister-style stepping stones: left foot on lawn mower; right foot on paint can; left foot router table, right foot shingles, etc. But even gaining access to the table saw no longer was enough, because orienting oneself to use it now required straddling a five-gallon bucket of drywall compound without knocking off the box of nails perched on top. Which was not exactly kosher, safety wise, it being a power saw and all.

The hammer was almost certainly lost in this mess. The basement had swallowed my hammer. It was a hostage of disorder. There would be retribution. Whatever had to be done upstairs would have to wait. The workshop and tools had to be put in order or everything would fall apart.

But how? The basement was split roughly in half, with the formal billiards room and adjoining hallway/sitting area comprising one half and the more raw laundry room and workshop comprising the other. It was all piled with stuff, as much stuff, I realized, as when Mrs. Radner had been here. I decided I would move everything into the laundry room, which was bigger, sixteen by sixteen, with a large adjoining storage room and closet. Then I could clean and paint the workshop and shift everything into there, allowing me to clean and paint the laundry room, then move half the stuff back, in a Rubik's Cube arrangement.

I visualized. This is how logistical challenges are approached, right? This is how problems are solved. By visualizing.

Okay. (Closing eyes; visualizing.)

First I would empty the workshop room. This would allow clarity. With the room empty, I would remove the wooden wall that enclosed the former coal room and open the space up into one big workroom. Then, with the wall gone, I would move the bulky old coal bin into the corner. It was too big and too evocative, historically and industri-

206] David Giffels

ally, to discard. But before moving it, I would hack all the crumbling plaster free from the tile walls. And then I would paint the walls. Yes, it was all falling into order. While the floor was clear, I would mix concrete and fill the rectangular depression where the old boiler had been mounted. But it wouldn't make sense to do any of this without first snaking out the drains, which were full of sand from all the crumbled plaster. The blockages would be gone. It would all flow. And then I could nail up shelves and mount hooks and everything would be organized and in its place. Except . . .

I couldn't nail up shelves.

Because I couldn't find my hammer.

It never occurred to me to replace the hammer. This was not a mere nail-pounding tool, some hardware-store commodity. This was My Hammer. This was the hammer I had carried since childhood, the hammer my grandfather had repaired in his workshop (shrewdly organized, I realized in retrospect), the hammer that built the toolbox that contained (theoretically) the hammer. The circle could not be broken. I was going in. The basement was my Entebbe.

I called Chris. Chris would be good. I needed help moving some of the larger items, the washer and dryer, the table saw, that big old coal bin. I couldn't ask Gina. She hated the basement. She hated all basements, and this basement most of all. I wouldn't ask her to come down here, and she wouldn't come if I did. This basement crunched underfoot and dangled with cobwebs and crept with spiders and centipedes. Also, I had found poop down there. Mouse, maybe. Yes. Probably. A mouse could leave pellets that large. If it were a large enough mouse.

I was so certain that the basement must contain colonies of brown recluse spiders that I shook every box and piece of cloth violently, away from my body, jumping back if anything fell out. Everything I had read about brown recluse spiders scared the hell out of me, mainly the fact that their venom can open a wound that resists healing and gradually spreads, a so-called "volcano lesion" that expands with gangrenous progress, like a flesh-eating virus. And everything I had read about brown recluse spiders confirmed that this house was a potential

haven for them. They prefer dark, undisturbed hiding places, such as the folds of cloth that has been undisturbed for long periods (check) and old boxes (check) and neglected shoes (check) and cluttered closets (check). Although I also had read that brown recluse spiders are rare in Ohio, every experience in this house had convinced me that unconfirmed dread was not an overreaction, but rather a prudent and rational approach. Spider travel agents, in all likelihood, offered cut-rate airfares and resort packages to this very basement for brown recluses looking to indulge themselves in every brown recluse pleasure. This place was the Amsterdam of brown recluse existence.

So Chris came over one evening and the two of us emptied the workshop room, cramming everything into the laundry room. I had rented a drain snake the weekend before and cleared the floor drains. Chris, as was his wont, hung at the edge of the work, positioned more for conversation than physical assistance. Also, he was drinking my beer.

I began with the wall that had enclosed the old coal room, using my big red crowbar. I refused even to *borrow* a hammer—a matter of principle—and therefore would be flying makeshift until I found mine. Antique black coal dust rose and settled with each punch and yank of steel against wood, and soon I had a filthy pile of splintered tongue-and-groove boards, filled with rusty bent nails, which I insisted on stacking in the other room for future use.

"This is garbage," Chris said.

"That is not garbage. It's vintage lumber. Probably old-growth pine." (In truth, I had no idea.)

"It's garbage. Half the boards are split and they're all warped and full of holes."

"They're tongue and groove. It's good stuff. I can use them for roof decking when I rebuild the garage."

Chris reluctantly helped stack the lumber, making an exaggerated point of holding each piece with his fingertips, far from his body, as though these were not boards, but porcupines.

When the room was clear and the unstable plaster had been hacked from the brick and tile walls, we set in to see if we could move

the old coal bin. With the coal wall gone, the bin was sitting in the center of what soon would be my workshop. I wanted to get it up against the wall, where it would occupy the least amount of floor space. The bin was a large cylinder, about the size and shape of a fifty-five-gallon drum, with a round, riveted lid and a heavy latch and hinges that made it look like a submarine hatch. It was painted metal-lic green and had an animated picture of a fireman on the graphically handsome logo, with the majestically badass brand name Iron Fire-man. It looked like a museum piece. With a long base that probably had extended originally to the furnace, it also looked like it was going to be a challenge to move.

Chris and I approached it like sumo wrestlers, angling for the best position and estimating our girth and potential impact against the Iron Fireman's girth and potential resistance. We leaned in low and put our shoulders against it.

"One—two—*threeeeee* . . ."

Nothing.

We stepped back.

"Let's try it again," I said.

"It's not gonna go," Chris said.

"One more time."

We set our feet and shoulders even more resolutely, screwed up our faces, and strained against the Iron Fireman. It leaned slightly, but only for a second, returning to the demeanor it had maintained since the Carbon Age.

My face red, I stepped back again.

Fulcrum. We needed a fulcrum. My grandfather's spud bar was in the next room with all the tools. I set it up as a lever with some scraps of two-by-fours stacked underneath. (Scrap lumber? Useless? Ha.) I would raise one end of the Iron Fireman and Chris would push his 270 pounds against it. I found a solid spot for the tip of the bar, stead-ied my hands, and pushed downward.

The end raised slightly from the floor, and Chris was able to get it to scoot a few inches. But, still . . .

"It shouldn't be this heavy," I said, wincing.

Wait a minute. I turned the latch and opened the lid.

"Shit."

"What?"

"Look."

Chris stepped up to the opening.

"You're kidding. How old do you think that is?"

"Twenties, maybe? When did they stop using coal?"

"Do you think it's worth anything?"

"It's coal. It's what you get in your stocking for punishment."

We managed, a few inches at a time, to get the Iron Fireman up against the wall, as much out of the way as it ever would be. Over the next few nights, I cleaned and painted and moved my workbench into the room, arranging my tools there the best I could. My hammer had not turned up.

The other workers had all finished, but now, halfway through February, Steve was still wrapping up details, stopping by the house most days. I caught him one day at lunchtime and asked if he might have seen my hammer.

"What'd it look like?" he asked.

"Claw hammer. Wooden handle."

"Yeah . . . ?"

He pulled his own hammer from his tool belt. Claw hammer. Wooden handle.

"Any tattoos? Identifying scars?"

He took me out to his truck. In the bed, behind the propane tank, was a bucket of tools. There were three or four hammers in there.

"Pick one out," he said.

This was kind of him, but it didn't solve the real problem, the problem of losing something that had the value not just of sentiment, but of orientation. In my own dwindling way, I could still understand myself in the context of my old hammer; it reminded me of how I had done

things before and things I might have learned. Obviously, those parts of myself still existed without my hammer, but even so, it seemed, with so much looming over me, and so much need for that orientation, like the worst possible time to be losing it. But I guess that didn't matter. It was lost. It was gone. It had been snatched and swallowed by the house. And this was no time to be turning down the gift.

I pulled a hammer from Steve's bucket. Claw hammer; wooden handle. I used it that night to mount wall hooks for my tools, including one for itself.

Was it? Was it one night? Or two? Or a week? Was Chris there the whole time? Or just one evening? It was all of this and none of this. I remember Chris being there the whole time, certainly I remember that: him making suggestions like instead of painting these raw catacomb walls with the vivid pastels I'd bought in a Quixotic attempt to brighten the place (and scare off the brown recluses), that we should just scrawl revolutionary slogans and make it like the MC5 clubhouse.

Kick out the jams!
Fight the power!
Stick it to the man!

"The man," Chris said dryly. "I'm pretty sure we *are* the man."

I painted it pastel.

Yes. Yes. He was there all that time.

He must have been. I remember him telling my favorite joke of all time:

"Why are turds tapered on the end?"

"So your butt doesn't slam shut."

But then—I know this did not happen all in one night. I know this for certain. I know there were nights alone, nights when I negotiated with my exhaustion, with my own good judgment about how late was too late, nights when Gina came down, bleary eyed, and insisted I come to bed, prompting me to bristle: *this has to be done.*

We had never been the bickering type. Now this transaction was becoming a staple of our existence here, and it was more complicated than it seemed.

Gina would accuse me of being a workaholic. I would gesture to whatever job had absorbed me and insist it *had to be done;* there was no choice. She would tell me we've got the rest of our lives to finish the house. I would insist that stopping was the same as going backward, that I had to keep pushing, every day and every night. Eventually we would end without resolution.

After only a couple of weeks in the house, it was as though I was having an open affair, cheating on Gina not only *in* our home, but *with* our home. I was stealing time away for some dalliance with a paintbrush or my strange new hammer. I was leaving her for the evening, but I wasn't going anywhere except to the next room, where I would give myself completely to the floorboards.

This is what I had wished for; this had been my conceptual stroke of genius. I had found a place for myself that couldn't be construed as self-*ish*.

Selfish? Writing a novel is selfish. Ice fishing is selfish. Golf is selfish. But making a home: what could be more generous?

And I did feel that way, and that feeling complicated my reaction. Part of this endeavor was to reopen the house as a gathering place, a part of a community.

The motto of Stan Hywet Hall, the fabled mansion just up the road, was engraved in stone over the main entrance and is as true a statement about the nature of Home as has ever been written:

Non Nobis Solum.

Not for us alone.

This was an aspect of my own purpose, and Gina's too: to remake this into a place for family and everyone else. To save it for the world, to restore its generous intent. The recent stream of visiting strangers had opened up that understanding of a home being both private and public.

But now—so soon—the implications were becoming clear. If I decided I wanted my old life back with Gina and Evan, some era that

seemed far more distant than just a few months ago, a life in which I had the choice to be free with them, to be available, well, that would not be possible. However our family would grow, it would grow in a completely different way now because we were suddenly transplanted into strange and treacherous soil and the only way to survive would be to adapt. We had entered an epic together, and now its full weight was becoming evident. If I failed, I would lose everything.

I was beginning to feel a heavy burden of guilt over this. I had led us into a situation where I was distanced from every aspect of family except "home." I felt an urgent need to get things to a point where we could be whole, where the parts could be back in balance. I needed to work my way there as quickly as possible. To stop would be to go backward.

So those late-winter nights blurred together. Chris was there, and he wasn't. Days passed, and they didn't. I was alone, and I wasn't. But I was. I *was* alone. I was alone when I found, in the farthest recess of a dark basement closet, a green glass prescription bottle with the name Mrs. John Radner and the date 3-23-61.

One capsule before breakfast and one before supper.

Who was this person whose name was typewritten on the label? Who was this person who opened this bottle and took its pills, one before breakfast and one before supper, before I was even born, before my parents were even married?

And Shinola. I found a stout little cardboard package containing a full brown bottle of Shinola. Whose shoes had been spiffed up? What nervous appointment might have prompted the extra step of shining the shoes? Or was this a house where the shoes were addressed with military precision, weekly, on Saturday mornings, lined up and shined to be ready for the week ahead?

I found the broken end of a toy, the neck and headstock of a plastic TV Pal banjolele. And the box from a Davy Crockett plate, bowl, and mug set.

Eat with Davy!
Exciting scenes!

Blazing action!

How could one digest one's food with such a flurry of backwoods drama?

(Perhaps that's what those pills were for.)

I knew there had been a daughter. But these seemed like a boy's things. Had there been a boy? Had I missed something in trying to read between the lines of the old directories?

How much could one know of the lives a house has held? What filled the spaces between these left-behind clues? What transpired between the pages of the 1968 credit union pop-up desk calendar I found on a shelf?

She was alone, left alone. He died in 1965, I knew that. She was alone in this sprawling house and she chose to stay. The daughter must have been here with her. She would have been young. A son, maybe. Or not. Someone to play the banjolele.

And that harp. Did she play the harp? What might a day have been like here?

Take the pill before breakfast, sit down with shined shoes, and play the harp.

The husband was gone. By the year of the credit union calendar, he'd been gone three years. What then? If I walked into the house then, transported through time to the very place where I now stood, what might I have found? The same sunshine I'd found my first morning here, with a harpist inspired by its light? A child strumming along on the banjolele?

Would the kitchen have been pristine, freshly cleaned, the linoleum smartly mopped and waxed, smelling of lemon? Would the moss carpets have been vacuumed with a hose plugged into the wall's brass fitting, the machinery humming in the basement?

Or did it rain that day? Did the rain roll off the shingles with flat efficiency, into copper gutters, through clay pipes, and clean away? Were the roots of the trees already finding the weaknesses there, easing a tendril into the fraction between one pipe and the next, beginning their slow, inexorable crush? Was the wisteria drinking in the

rain, a young brash romantic thing brushing against the brick? A flirt, no hint that it would gradually, imperceptibly grope and tighten and slowly begin to choke and then force its way in.

Did the plumbing run free, with clean, cool water, all you could drink, hard, full pressure to the white porcelain? Did the button switches click effectively, sending insulated power to the forty-watt bulbs?

Who sang here, and what song? Who cooked here, and what food? Who mourned here, and why? Who laughed, and for what reason?

Why are turds tapered at the ends?

So your butt won't slam shut.

Once, there was color and light here. It is true. It has left its traces. Look—open this door and look at its spine, protected, not corrupted by the grime nor the damp nor the rubbing of the cats nor the fading of the years. Look at how white it is! The white of Colgate, of Titian, of Kilimanjaro. White, reflecting back to the eye; giving, not taking. This is what was intended. This is what life wants. Look at how these windows are: they are clear, free now of the heavy drapes and the blankets and the clumsy dime-store shades. Look at the front door, stripped of that plastic nausea. Look and see. That's what these windows are for. Seven hundred thirty-three panes of glass wrap this house and now they will shine—733! I counted!—and they will shine for a reason. So the world can enter and this will not be for us alone.

On this, Gina and I agreed. If we were to save this house—if we were ourselves to be saved—it would be by color and light.

The rest would all be struggle.

the numismatist

I still had the money hidden, but it kept drawing attention, like a drunken stowaway. When Gina and I painted the back bedroom where we'd found it, it dawned on us midway through that marathon job that we'd unwittingly chosen the colors of currency—parchment for the walls and dark green trim. Also, you never really realize how many pop songs have money as a theme until you have a secret about money. When we were working in there, one of the contractors' radios drifted in with that classic rock song that goes "money money money money—muh-neee!" And then, it being a twofer Tuesday, the Beatles' "Money (That's What I Want)."

The day before we moved, I had taken the blue box back to the new house and stashed it in the attic. I felt like I was being watched. Even though I was alone, I carried it inside my coat. I was scared of it. Beyond the *idea* of being $12,000 richer, it had done nothing to improve my life. And even the idea was suspect. I still didn't know if the cash was valid. And I didn't know what to do with it if it was.

In the weeks since we'd discovered it, the money had introduced a

vague discomfort into our relationship with Steve. Anytime he men-
tioned anything about his financial situation—from not being sure if
he had enough in his wallet to buy lunch to the ongoing issue of how
long he could keep the little yellow propane truck running—I felt as if
there was some implication. Did he think he deserved more? When-
ever we made reference to it, even in private, we spoke in a conspira-
torial code. It was always "the bundles," never "the money." His own
$2,000 bundle was hidden, as well. I'd told him not to do anything
with it until I'd explored how to deal with it, with no idea as to how I
intended to accomplish that.

One afternoon, as his contractor stint was nearing an end, Steve
pulled me aside, into the kitchen.

"Listen," he said, "I could really use a little boost right now. Have
you learned anything more about our bundles?"

"I haven't, Steve. I just haven't had time to deal with it."

"Well," he said. "I could *really* use it."

"Soon," I promised, but nothing more.

With Gina and me, it was the same. We talked about "the box," but
never what was in it. We talked about "the find," without mentioning
by name what we'd found. We'd told nobody except my parents, and
the longer we treated the subject this way, the more it seemed that
keeping such a secret meant keeping it even from oneself. *That which
shall not be named.* This blue metal box crammed with twenty-dollar
bills was less a tangible object and more a void, a negative image of
itself; discussing it was a process of *not* discussing it.

Within that elaborate code, Gina and I had established at least this
much: we had very different views on what to do with this hypotheti-
cal $12,000. She wanted to sink it straight back into the house, to hire
more workers to come and do more work in an attempt to get more
quickly to some hypothetical stage of normalcy. But I'd just seen a
$55,000 construction loan disappear like drywall dust up a Shop-Vac
tube. We had no savings beyond the profit we'd made on the sale
of the semiremarkable house, and the few thousand dollars that re-
mained after we made our mortgage down payment was dwindling

quickly. I wanted to put the money into some sort of savings plan. I suppose this was really just a more fiscally responsible version of my instinct to keep it hidden away.

Then we got our first gas bill:

$1,300.

One. Thousand. Three. Hundred. Dollars.

I showed it to Gina. We froze. We looked at each other. We looked at the bill. We'd never had a gas bill over $200 at the semiremarkable house. This couldn't be right.

I called the gas company.

"There must be something wrong with the meter," I said.

"No," the woman said. "There's definitely nothing wrong with the meter."

"Then it's an estimated bill and someone screwed up."

"No," she said. "It's based on an actual reading."

"But I've insulated. And we put in a new boiler. And we closed up the big holes. And with all that, it's still higher than it ever was when the old lady was here. How can that be?"

"It *does* seem high," she said.

It always seems like some significant nut of diplomacy has been cracked when a customer-service representative goes off script. Like a character has stepped out of the movie screen and into real life. She seemed actually to have joined my perplexity over a monthly gas bill that represented more than most people paid for their first car. (In my case, this applied also to my current vehicle.)

"It was never this high before," she said, clicking through the records. "If you give me the addresses of some similar houses in the neighborhood, I can tell you their average monthly bill so you at least have a comparison."

With the phone to my ear, I stared out the front window in vain. I didn't even know how to form an answer.

"There—aren't any houses like this in the neighborhood."

She offered to look up a few addresses anyway. As she did, I thought about the past month. The thermostat certainly was set higher than

it had been when Mrs. Radner was here, tweaking that cranky boiler to keep the house just above freezing. And the doors had been open constantly as contractors came and went. Maybe. But still. This bill was real, and announced the beginning of an ongoing, unimaginable, unmanageable expense.

The woman was trying to help, but ultimately there was no help to give. We lived in a huge, old, shockingly inefficient house without a single storm window, a place so drafty that I'd watched interior doors creak open on windy nights. I thanked her and hung up.

Adapt. The only way to survive is to adapt.

"We're going to have to sell the house," I announced.

Gina didn't have an answer to counter with.

"That's it. It's over. We can't pay bills like that."

"Maybe it's all the traffic in and out," Gina said. "That solarium door was open *constantly*. Maybe now it'll be lower."

"I don't know. I don't know." I looked at the bill. "I do not know."

I must have looked as if I was preparing, not to attempt a deposit, but to rob the bank. I approached the teller nervously, glancing sideways, looking down. My face felt warm. My hand was locked in my pocket, flat against the stiff bills. My plan was to try to deposit a small amount, see if it cleared, and then, as stealthily as possible, ease all of the bundles into our account. I had written a deposit slip for $100 and folded it around the bills.

"I'd like—to make a deposit?" I mumbled.

As nonchalantly as possible, I slid the five bills, covered by the bank slip, across to the teller. He couldn't have been more than twenty years old, wearing a necktie in the broadly knotted sort of way that announces it will be a very long time before this thing feels natural against his throat. He took the slip. I watched his eyes attempt to make sense of the bill that he was holding between finger and thumb, rubbing it almost imperceptibly. He held one up to the light, then looked at me.

"You want to deposit? This?"

I looked at him, trying to make the word *yes* come out of me as naturally as possible, but it sounded more the way an assassin answers after he has been fingered:

Are you he?

(— yes —)

"I need to—um—hold on; I'll be right back," he said.

I could run. It's only a hundred dollars. Leave it and this stupid plan right here and now and just go back home to "the bundles" and "the box" and stuff them back under the bathtub where they belong.

But no—he had my deposit slip. And now he was all the way back by the office door with two middle-aged bankers, comfortable in their own neckties, looking at the twenty, then at me, then the twenty, speaking in hushed tones, joined now by another, a woman as young as the teller. She'd come from a cubicle beyond the door, and she looked too, at me and at the bill.

I pushed my clenched hands deeper into my pockets. The teller returned. The older bankers disappeared back into the office. The young woman lingered near her door, watching.

"Do you have more of this?" he asked, his voice cracking slightly. Now he too seemed guilty of something. This cash was poison. Touch it and accept its fate. My instinct was to apologize to him.

"Some," I said. "Yes. It was put away . . ."

Steve had suggested that, if asked, we say this was "family money" but that seemed too close to a lie that would require a further succession of lies to uphold. Lies and money do not go well together. And why lie in the first place? What were we hiding?

It was put away. That was the truth.

"We *can* deposit it," the young man said, speaking slowly, leaning slightly forward. "But we think you might want to show it to a coin dealer first."

The young woman came up next to the teller, lured by the secret. Their interest took on the candor of youthful fraternity as they leaned in across the stacks of teller's slips and the chained pens.

"We can't *tell* you? 'Cause we don't know?" she said, giddiness pressing against her green professional demeanor. "But we think it's probably worth more than face value."

"Really?" I said. "How much?"

"We don't know. That's why you might want to take it to a coin dealer."

My mind groped for something solid.

"Do you—know of one?"

"There's one in the next strip mall," the young man said, jabbing his thumb in that direction.

The place had red-flecked wallpaper that, despite the fact that it was a carryover from its previous life as an ice-cream restaurant, carried a hint of bordello. Its walls were covered with antique lithograph prints and advertising posters, busy and sumptuous. I skulked through the door, mentally rehearsing my opening line, when I saw that I would be faced with the additional problem of another visitor standing at the counter, talking to the man behind it.

This man, presumably the owner, had a slender frame draped in a crisply starched white shirt, dark hair slicked back. He wore gold jewelry and held a cigarette between his fingers. It may have been a customer he was talking to, but they weren't talking about coin dealing. With the demeanor and crackly midtenor pitch of a radio talk-show host, the man in the white shirt was engaged in a monologue about the news of the day. I stopped, at first pretending to read a vintage B.F. Goodrich advertising poster, and then actively reading it. This was the company that had employed my house's first owner. I'd spent so much time lately wondering about the previous occupants of the house, who they were, what their lives were like. I wondered if this fanciful ad may have hung in that first owner's office—or even the house itself—back in the 1920s.

On the counter was a stack of business cards. "Mad Money," the shop's name, was written in shaky horror-movie script below a deranged-

looking caricature of a man who I realized, after a couple glances back and forth, was the same man standing behind the counter.

RON SCHIEBER
PROFESSIONAL NUMISMATIST
ESTABLISHED 1964

I didn't want to interrupt. More important, I didn't want to discuss my bundles with someone else standing there. So I held back, at middistance. Soon enough, Mr. Schieber recognized the situation, probably a regular occurrence in his line of work, and deftly aborted the cracker-barrel conversation. The visitor left with a friendly nod and I approached the counter.

"And what can I do for you?" he asked, maintaining the radio-host charisma.

"I was told you could, um, tell me if this is worth anything," I said and laid one of the bills on the counter.

Stupid. Of course he can tell me. That's what he does. Right? Isn't that what "numismatist" means? Or is that stamps? . . .

He took it in his fingers, held it up, turned it over, nodding.

"Just this bill?"

"No. I have more. A lot."

"Like?"

"Twelve thousand. All in twenties. In the original bank wrappers."

He didn't ask, but I said it anyway, the thing that wasn't a lie, which therefore somehow helped me feel like I wasn't lying. Which I wasn't. (Money is complicated.)

"It was—put away."

"Right. I'd like to see it, just to see what condition it's all in. But I think, yes, I might be able to sell it. Let me check into it. You come back with some more of it and we'll talk."

* * *

I returned a few days later, this time with one of the intact bundles in an envelope. That first, brief visit to Mad Money had prompted me to consider these bundles differently, as artifacts, and to wonder about them anew. The bills in their smart little packages were pretty, in the way that government stuff is pretty: formally ornate and ornately formal. And the idea that my hand, in all likelihood, was the first hand to touch them in more than sixty-five years—that created its own kind of connection to the mysteries of the house. I'd found the same connection shortly before, when I pried off a baseboard and discovered part of what appeared to be a lumber-delivery tag, a stiff piece of card stock, brown with age, stuck to the back of the wood. The lumber company's name was missing, but the description remained:

LUMBER, LATH, SHINGLES, SASH, DOORS, BLINDS
AND ALL KINDS OF MILL WORK
CHICAGO JUNCTION, OHIO

Below, in cursive script: To McMiller Construction Co., Akron.

In reality, this dog-eared tag, no bigger than a business card, was as inconsequential as the Home Improvement Superstore receipts that were piling up around us at an ungodly rate. But its age and its direct connection to the hands that built this house—built it so well and with such fine materials that it had withstood this staggering level of neglect and damage—that made all the difference. "McMiller" and "Chicago Junction" were foreign to me, but also intimately connected—to each other, to the house, and now to me.

There was a vast story inside the walls, separate from but parallel to the story outside them, strung with cobwebs of clues and puzzles, written in its own language. Some sort of vine was growing, anemic and undernourished, through the gap between the baseboard and wall in the solarium, and I traced it to the basement below; it seemed to have its origin deep underground. It grew without light, but like all living things, it yearned for it. What sort of thing lives in that world?

The walls provided a narrative structure. They held secrets, and as I opened them and entered, they gave up their ghosts.

A pencil. I found the nub of a carpenter's pencil, flat and thick, sharpened with a knife, resting on the header inside a door frame. McMiller's, perhaps? One of his men?

When I tore out the damaged ceilings and walls in the kitchen, I found the wood inside heavily charred, black as carbon, with the texture of driftwood. I traced its path—a fire at some point had consumed the entire kitchen and butler's pantry; I later found continuing evidence of this fire down into the basement. When? How? What tragedies had happened here?

So the little blue treasure chest from underneath the tub was part of a growing story. Ron Schieber looked at the bundle I brought to him, which confirmed that the bills were all in good condition. He'd done some research and determined that we could get the best price if he sold the bills in spaced intervals, a few bundles at a time, a few months apart. Minus his commission, the $12,000 would net us a little over $17,000. Gina and I had decided, considering the shock of the gas bill and the emerging inevitability of the unknown, that it would be best to put the money into a safe investment account, keeping it as a hedge against the growing expense of living in a house we thought we'd gotten as a bargain.

how to evacuate squirrels
with an electric guitar:
a practical guide

February pushed forward, and our life was settling into some-
thing like a routine, which is to say that certain elements of our
previous/mostly normal life began to reemerge from terrified
hiding places as we pleaded with them to comfort us in the bedlam.
Gina was satisfied enough with the lead encapsulation downstairs to
allow the Gilligan's Island furniture and television into the living room,
the décor of which could be described as "early triage": dull oak floors
stripped of their carpet; patched ceiling sanded flat and unpainted;
white primer covering the uneven walls, bookcases, and baseboards;
mismatched bedsheets over the windows. It was clean, nothing more.

The contractors were finished. Rod Stewart and Arthur the
plumber and the Guns N' Roses Late-Night Drywall Crew were off
to new adventures. We wrote the final check to Steve and had him
over for dinner; he brought a cake on which he'd written Building
Memories in stiff block letters of blue icing. He seemed alien in civil-
ian clothes, a sport shirt and khakis. He was leaving. He was done.
He had softened this process, humored us and managed things we

could not have managed ourselves. The Steve Braun 15 Percent Rule had entered our language. Gina and I were emerging from the most intense and off-putting months of our life together, ready to begin trying to find whatever it was we were looking for here. Steve was off to do it all over again in someone else's house.

Evan and I had our Thursday nights back as Gina returned to her weekly dinners with her sisters. Being in the house was psychologically draining, bombarded as we were by the constant information of our disorder. So she was grateful for the few hours away. I, on the other hand, would have dinner with Evan, spend some time reading with him, put him to bed—and go back to work. I'd been trying to finish the kitchen, but any room with six separate entrances has approximately three miles of woodwork to caulk, patch, and paint, so progress was slow. The agony of detail work had led me to develop a corollary to Steve's rule: the last 10 percent of a project takes as long as the first 90 percent.

Evan had been trying, to the best of his toddler ability, to tell us he was hearing scratching in his room. I put his—and Gina's—worries to rest by explaining that it was just the branches of the unpruned black-walnut tree outside his window brushing against the house.

I was lying.

It was not the branches, although they were indeed touching the house and already had torn off some of the new roof shingles. So I suppose in theory it could have been the branches. But I was lying nonetheless, because in saying this, I was withholding significant information. I knew that the source of the scratching was almost certainly squirrels. Or possibly mice. Or bats. Or something very large that had made a deep, flat, muddy nest far back in the new pink insulation, something that smelled strangely of horse.

I knew these things because their evidence was confronting me with alarming and increasing frequency.

I was catching a mouse almost every night. Gina didn't know this, or at least she didn't know its full extent, because I, as a mouse assassin, operated with stealth and speed. Most mornings, I stole quickly

to the kitchen before she got downstairs, grabbed a sheet of newspaper, and used it to shield me from seeing/touching the trap and its quarry from the gap between refrigerator and wall. Cringing, I tossed the corpse into the mass grave in the garbage can out in the garage.

This arrangement represented its own irony, because I had come to realize that the attached garage was the likely haven of the mouse infestation. The only times I had opened the huge rolling carriage doors had been to dump construction debris in the short spells between Dumpsters. (We'd already filled four of them.) The garage was such a disaster that when I showed people pictures I'd taken of the interior, they could never tell which way was upside right. And neither could I. The joists from the partially collapsed roof dangled haphazardly, like pickup sticks dropped from the sky. What remained of the flat roof was covered with a thick layer of rotting leaves and branches, plus shingles and bricks that had fallen off the house. A black-walnut sapling—a volunteer from the tree outside Evan's window—was growing straight out of the roof, four feet tall. The bank of three windows across the back wall was held in place only by the sand of decomposed mortar; they were rotten and sagging. The only thing that seemed to be holding the structure together at all was a huge I beam that connected the far wall of the garage to the wall of the house, a steel support at roof level that refused to give up its hold, despite everything collapsing around it. This was also what made the structure impossible to tear down—dropping that I beam would rip a huge chunk out of the side of the house.

The floor was deep with piles of trash and sodden debris. Feral cats were living in there, the otherwise unnerving presence of which would seem to have the thin silver lining of controlling the mouse population, but apparently not. Were the mice coming into the house to escape the cats, only to be snapped up in my traps? Or had these historical enemies entered into some sort of unholy alliance in the sprawling decadence of my garage? I do not know. I simply know that I was mowing down mice at a rate that suggested a population with more extras than *Ben-Hur*.

I was becoming a queasy expert on rodent behavior. My latest area of clandestine research had taught me that February is the first mating season of the year for squirrels, when the males put together love nests in preparation for baby making. It had also taught me that a family of squirrels establishing itself inside a house is exponentially problematic. I thought the roof tear-off and all the activity inside the walls had cleared the wildlife out of the attic, and in fact that seemed to have been the case temporarily, but the eviction was fleeting. I learned this quite suddenly when I went into one of the unfinished attic spaces one day to put away a moving box.

As I stepped through the door and simultaneously clicked on the overhead light, a squirrel flipped into a sudden, startled spin to face me. For a hugely suspended moment, we stared at each other, frozen in identical "what the hell are *YOU* doing here?" expressions.

Then, just as quickly, we both scampered off, frightened.

Oh, pigeons too. Pigeons seemed to have found a way in.

This house had been overrun with woodland creatures for so long that they considered *us* the intruders and seemed intent not only on returning to their rightful homes, but on punishing us for disrupting the natural order. The squirrels went at the eaves with unsettling aggression, leaving bright splintery piles of chewed and scratched lumber below them as they opened their jagged holes. As part of my daily routine, I began wandering around the perimeter of the house, neck craned upward, looking for the latest damage. The squirrels had a knack for choosing not only the spots that would be the most difficult to reach via ladder, but also the pieces of wood that had been the most trouble to replace. A squirrel shredded the end of a decorative corner joist that Steve and I had carefully traced from the rotten original and hammered to replicate the chisel marks in the Tudor beams—only to find that there was no entry point once the damage was done. The perpetrator had moved to the next joist bay and power-chewed through a soffit board.

So around dusk one Thursday evening, I sat with Evan in his room, his clean safe room, newly painted, softened, warm (if you

stayed close to the radiator)—as close to normal as any place in the house. I was sitting on a rocker with him in my lap.

All fathers, sometime in the infant stage, wander into an improvised lullaby, words and melody that come from nowhere except the imperceptible rocking and the quicksilver breaths of a settling child. It will become that child's theme song, private as the scent of a favorite stuffed animal and meaningful only to those who were present at the moment of its creation. Parenthood is the only venue I know of where sentimentality is not only acceptable, but necessary. Softly, I began to sing.

"Now is the time for all good men
To close their eyes and go to sleep . . .
Now is the time for all—"
Scritch-scritch-scritch-scritch-scritch—
(stop)
Scritch-scritch-scritch-scritch—patter patter—scritch—scritch—
Evan looked at me.
I looked at him.
I looked up at the ceiling.
Back at him.
Scritch—scritch-scritch—

"Wassat?" I smiled the big TV-host smile, head playfully cocked, trying to pretend this was a game. Evan had discovered the brown rabbit that lived in the yard, and every morning we did something like this, watching from the living room window, hoping for an appearance. Anything that moved out there, I'd say, "Wassat?" and he'd tense up with barely containable anticipation.

Maybe this was the answer. Maybe we would simply accept the creatures in the house as part of our new life, not just nuisances to be tolerated, but an exciting addition, a learning opportunity, a flash of excitement, something to fill us all with the childlike joy of glimpsing wild things twitching in our purview.

No. Gina would never go for this.
Scritch-scritch-scritch-scritch-scritch—

The sound was directly above us, exactly one five-eighths-inch thickness of drywall away. I set Evan in his crib and stood on the rocker, balancing myself. With my head near the ceiling, I could hear purring.

They purr! Squirrels purr! Who knew?

Scritch—scritch scritch—

I made a fist and slowly reached up toward the spot where the sound was, then—*bangbangbangbangbang!*—I hammered as fast and loud as I could against the ceiling.

Evan, both hands clinging to the top rail of the crib, looked at me with eyes narrowed, a look poised for either terror or elation. This is when a child needs his father the most, when the unknown is so close and the world urgently needs explanation.

"Wassat?" I said, trying to balance on the shaky rocker.

He blinked. Something like worry wrinkled across his face.

Purrrrrrrrrr . . .

Bangbangbangbangbang!

"Daddy? What dat?"

My options were limited. Even he, at twenty-two months, knew I was not trying to scare away a black-walnut tree.

"It is a squirrel," I said as matter-of-factly as possible.

"Where's a squirrel?"

"In the attic. He's just trying to stay warm. He can't hurt you."

"Oh. Jus' warm?"

"Right."

That seemed to work. A toddler doesn't have the same conception of natural boundaries as a homeowner. Small furry animals are desirable to him, and them being in the attic is no more unusual than, say, the presence of Little Bear in the television set.

I got him settled and tucked in for the night, turned on the baby monitor, and headed downstairs to put in a kitchen shift. Before long I heard it, transistorized:

Scritch-scritch-scritch-scritch-scritch—

(pause)

"*Daaa-deee!*"

I went up to his room.

"Squirrel," he said, blinking.

I looked at the ceiling. The sound was coming from the same attic room where I'd had the brief face-off with the squirrel. I looked at Evan.

"Okay. Daddy'll take care of it."

I approached the door darkly. I did not want to go in there. This was one of the doors that had been latched and labeled with the hand-written warning to keep it that way. Now I understood why. Keeping wild animals at a distance—even a compromised distance, with their own designated living spaces—this was just one more front in Mrs. Radner's epic battle with her own house. Now I, as the inheritor of that battle, was going to have to go Rambo. On a squirrel.

I turned on the light. I undid the latch. I turned the knob. I opened the door a few inches, slowly. I leaned my head in.

"Yeee-yahhhh!"

I wanted to make sure they knew I was coming.

I entered. The room had wide plank flooring. Judging from the sound in Evan's room, the squirrel was underneath, in the joists. Or squirrels. I really had no idea.

I stood still and listened.

Scritch . . . scritch-scritch . . .

I crept to the source of the sound and dropped into a crouch.

Scritch-scritch-scritch-scritch . . .

I could feel it in the boards. This was the closest I had ever been to a squirrel. Maybe an inch away. It was oddly thrilling. I put my ear to the floor.

Puuurrrrrrrrrrrrr . . .

I could feel its heartbeat.

I leaned forward on both hands and positioned my mouth directly above the squirrel.

"Grrrrrrrrr!" I said. "Raaaaahhhhrrr-raaaahhhhhrrr!"

The purring stopped.

Scramble—scurry-scurry!
(pause)
Scritch-scritch-scritch . . .

Creeping forward on hands and knees, I followed the sound. I put my fingernails against the floorboard, with my face against the wood, and continued my counterattack:

Scratch-scratch-scratch-scratch-scratch! *Rahhrrr-rahhhrrr-raaahhh-hhrrr!* I answered.

I suppose my intent, in growling at the floorboards, was to make this hidden squirrel believe he was being stalked by a Giant Squirrel, which in retrospect seems like maybe I was overthinking it. Yelling "Get lost!" probably would have had the same effect, which was basically to get the squirrel to move a couple of feet this way and then that way within the void between ceiling and floor. Eventually, he fell silent, but I knew he was still in there. And probably feeling pretty good. Despite the Large Thing Growling, his hiding place was secure.

I scratched the floor and growled one last time and left.

The next morning at sunrise, I heard the sound coming through the baby monitor. Gina heard it too.

"What is that?" she said.

"Squirrel," I said, trying to make it sound normal.

She sat upright in bed.

"Where is it?"

"In the attic. It's contained. It can't get into the main house."

"It's in the *house*? What do you mean 'contained'?"

"Well, it's in a part of the house that doesn't connect to the part of the house that we're in."

She had not spent nearly enough time inside the walls to accept the significance and—yes—the rightness of this distinction.

"It sounds like it's in Evan's room."

"It's not."

"We can't have this." Her voice was pitched. She sat upright, rigid. Redness crept up her neck. "I cannot live in a house with squirrels."

She was close to tears, angry and threatened.

"We have to get it out of here! What am I saying? *You* have to get it out of here! Now!"

"I—will."

I hurried downstairs to get rid of the dead mouse.

In the late 1970s, the Fender Musical Instruments Corporation upgraded its classic Twin Reverb amplifier, adding a pull-out boost to the master volume switch, which put extra crunch into an amp that already cranked at over one hundred watts. I am not a gearhead. I don't even refer to myself as a musician. I am not the kind of person who would know, or even necessarily care about this information. My philosophy toward musical equipment is the same as that of Mitch Easter, coproducer of R.E.M.'s classic early albums. In an interview he once said that if he likes the way a piece of equipment looks, he'll get it to sound the way he wants it to sound. That, I could understand.

So when I, at eighteen years of age, bought my first real guitar amplifier, it was in the dusty back room of an Akron music store, the used section, and it was chosen solely for its appearance, for its silver grille and gemlike red On light that looked just like those on amplifiers I'd seen behind Peter Buck of R.E.M. and Joe Strummer of the Clash, both of whom qualified as my guitar heroes because they played guitar in a way I could imagine myself playing, which was "rudimentarily." It happened to be a Fender Twin with a master-volume pull switch. I paid a couple of hundred dollars and when I took it home, I found, tucked behind the reverb springs, a square condom wrapper and a package of rolling papers. I had inadvertently purchased sex, drugs, and rock and roll. All I could deduce at the time was that I had a lot to learn.

Now, some years later, standing under the long, slanting roof joists in my attic, listening to the scritch-scritching of what I had come to realize was not one, but several squirrels (at least), I determined that

the Fender Twin was the loudest thing I owned. This would be the key to my plan.

I lugged the amplifier in from the servants quarters' bathroom. One of the advantages of having way more house than you need is the ability to use the servants' bathroom solely for the storage of music gear, which, I realize, is a dynamic that never finds its way into most people's consciousness. I dragged in an extension cord and plugged in the amplifier. I rolled the volume knobs to 10 and pulled out the boost on the master volume. I clicked on the standby switch to warm up the vacuum tubes and carefully leaned the amp forward, bringing it to rest facedown, with the speakers directly over the hidden squirrel den, inches away.

The Boss DD-2 Digital Delay, introduced in 1983 and popularized by versatile Police guitarist Andy Summers, was the first digital delay available as a "stomp box," allowing guitarists onstage to obtain state-of-the-art effects through a foot pedal, effects previously available only through unwieldy studio racks. Its most distinctive function was the Hold setting, which allowed a guitarist to set the effect pedal's tempo to coincide with that of a particular song, play a note, step on the pedal, and have that note repeat indefinitely while the guitarist could play live over the top of the digital track. For instance, one could strike an A chord, step on the pedal, and have a rhythmic "A-A-A-A-A" start chunking along on its own, leaving the guitarist free to noodle in the key of A. I had heard musicians create enveloping soundscapes with that effect. I myself had never been able to accomplish much more than an infinitely repeating A chord that continually threw off my rhythm, which was less than digitally precise. But I understood the theory. I took the DD-2 into the attic room and connected it to a patch cord.

For the purpose of squirrel removal, I selected the 1986 white Fender Stratocaster, Japanese made, maple neck, stock tremolo. Not the most desirable guitar in the collector's world by any means, but a durable instrument that, by virtue of a locking nut, almost never went out of tune. Also, it had an unusually shrill tone in the high end. I plugged it into the DD-2.

All I needed now was a brick. Thanks to the influence of my father, I happened to have a small stack right there in the "library" segment of the attic—paving bricks left over from the semiremarkable drive-way that now served as bookends. I retrieved one and returned to the guitar setup.

I checked all my connections one last time, then leaned down and flipped the power switch. The amplifier hummed. I positioned my left middle fingertip over the highest string, just behind the upper-most fret, struck the string full force with the pick, and stomped on the DD-2.

EEE!-EEE!-EEE!-EEE!-EEE!-EEE!-EEE!-EEE!-EEE!-EEE! . . .

Holding my foot against the pedal, cringing from the sound, I carefully leaned the guitar neck against the amplifier, then held my thumb against the pedal while I transferred the brick into the place where my foot had been. The entire history of rock and roll—techno-logical, spiritual, cultural, medicinal—pulsed in a single bleeding note through the dual Celestion Sidewinder speakers (aftermarket addi-tions), through the rough tongue-and-groove floorboards and straight (theoretically) into the comfort zone of an undetermined number of squirrels who were impeding my son's ability to sleep and my wife's ability to feel comfortable (or, more accurately, no less *un*comfortable) in her new home and my ability to prove I had everything under con-trol. Pete Townshend's rotator cuff and Jimi Hendrix's teeth and Janis Joplin's epiglottis and Kurt Cobain's burning stomach and Chrissie Hynde's faux leather stilettos were distilled into a single, shrieking, incessant note.

Flush with my own cleverness, I sprinted down two flights of stairs and out the back door and around the corner of the house to watch (theoretically) the squirrels streaming from their freshly chewed holes, never to return.

I stood there, under the corner of the garage where the mortar had washed out completely, causing the bricks to collapse into a random diagonal pattern while still somehow remaining within the plane of the "wall," a place I never felt comfortable standing because I knew

that, from time to time, bricks simply fell off this house and this was a likely place to be hit by one. I do not wish to die an ironic death.

I watched, certain this must be the area where the squirrels were coming and going. But . . . nothing.

The sound was shrill and grating. Horribly loud; nearly as loud outside as in. I looked away from the eaves to see if the neighbors were out, but I didn't see anyone through the tangled bushes.

How could they still be in there?

Maybe they'd left immediately, at the first sound, before I got a chance to get out here. Or maybe they'd taken a different course. I knew the configuration of the walls from the outside in, and knew that a squirrel could hypothetically travel through the floorboards into a knee wall and up and over into the other large, unfinished attic room, covering most of the area I'd described to Gina as "contained."

Or maybe these were incredibly determined squirrels and they were going to wait it out. If that was the case, it was beginning to look like I was going to have to admit defeat, because it sounded like an air-raid siren was emitting from my house. Or Yngwie Malmsteen in a particularly uninspired rehearsal. I still hadn't met any of my neighbors, and considering that they had already reported me once for a noise complaint, and that this was far more disruptive than the grinding hum of an air compressor, I figured it was time to pull the plug.

I returned to the attic, removed the brick from the DD-2, and broke down the gear.

Further research revealed that apparently every adult in northern Ohio has an opinion on the best way to get rid of squirrels, and every one of these methods is different and each is declared to be foolproof. They all seemed to involve items from a ladies' dressing area—perfume, mothballs, etc. I tried as many as I could, without success. My attic was still infested, but now it smelled like a rich lady's funeral.

My quest led me into a phone conversation with a trapper, which

was just the latest in a series of experiences I'd never considered would enter my life. Modern-day trappers are a zealous bunch, with colorful nicknames that invariably include modifiers like "Varmint" and "Critter." They have their own entries in the yellow pages; one in the Akron book boasted that it was "certified by the National Goose Academy."

The trapper I talked to, Polecat Pete or something like that, sounded like the sort of person who scratches his beard with a dinner fork and changes his flannel quarterly, which is to say that he was absolutely credible when he told me the only sure way to get rid of squirrels is to trap them and take them at least five miles away. Use peanut butter for bait, he told me, which came as a welcome surprise because I was expecting him to recommend something like catfish entrails.

So I began trapping squirrels. And trapping them. And trapping them. I set a humane trap in approximately the same spot where I'd placed the amplifier, baiting it with peanut butter. At least once a day, I responded to the unmistakable announcement of capture: the violent, wiry thrashing of a terrified squirrel trying to escape from the cage. Whenever I entered the room, the captive rodent would freeze, heart pounding against its little furry chest, usually with peanut butter smeared on its snout and hands. (Hands? Does a squirrel have hands? Yes—dainty little squirrel hands.) At first I felt triumphant, but this continued for days and weeks. How many? I lost count. Ten? Twelve? Fifteen? Like Redcoats, they just kept coming; squirrels above and mice below. Each time I trapped one, I carried the cage downstairs, put it in the trunk of the car, and drove it to a wooded area that the odometer assured me was six miles from home. At first, I held the cage as far from my body as possible, all muscles tense, and rushed to the car in an awkward sprint. With the passing of time, however, this act took on the ritual tenor of walking the family pet, and I would speak conversationally to the agitated squirrels, sometimes giving them nicknames.

I started plugging holes. I pumped expanding foam into the holes

in the garage wall—gaps and broken spots in the clay tile, abandoned openings where pipes and conduit had once passed through. I climbed a ladder and nailed scrap pieces of copper flashing over the squirrel holes. The more I did this, the more I realized just how full of holes the house was. Gaps between window frames and bricks. Missing fascia boards. Missing bricks. Openings where the wisteria had pushed in. Repairing the roof had seemed like progress—it *was* progress—but it was illusory. There were no longer holes large enough for men to pass through. Now there were holes, countless numbers of them, small enough to channel the underground, one burrowing body at a time, always and forever, a ground war to undermine the folly of feeling secure under a new roof.

On my way back from dropping off a squirrel one day, I took a nostalgic detour past the semiremarkable house, a place that seemed so distant from my current situation.

The roof: it was green. Green! *Bright* green. Kelly green. Astro Turf green. St.-Patrick's-Day-at-the-sports-bar green. The worst color of green you could possibly put on a roof. Did it even need a new roof? I don't think it did. I'd had it looked at—what?—three, four years ago. The inspector who scoured the place before the sale said it was sound.

Worse, the house was wrapped halfway up with tan vinyl, enveloping the pretty wooden lap siding, the siding for which we'd so carefully chosen colors—blue and gray and burgundy and pink. (Pink! We had pink accents! We were fearless and tasteful!) We had chosen those colors so carefully and so few years before. What?—six. Only six years. That paint should have been good for at least ten more.

A pickup truck with ladder racks was in the driveway. The crew was there, on-site, making it green and tan. Who would choose such colors? And in the front yard was the sign for a waterproofing company.

Waterproofing?

The basement was dry! Nothing. Nothing more than a little condensation on one foundation wall and only after a *really* heavy rain. It was an old house. This was nothing. He was lucky. He was lucky to have it.

Who the hell was this guy? What was he trying to imply? I could just imagine what the neighbors must be saying. Not the ones in the crack house, they probably didn't care, but the ones two more doors down, the ones who'd admired the brick driveway and commented on the stone pillars that day in the rain. And Danny! Danny knew! He'd been inside dozens of times. He must be thinking this guy was a lunatic, pouring all these improvements into a perfectly good house. I wondered if anyone had complained.

Tan! It wasn't even tan. More like beige. Vanilla. The most bland, unimaginative color you could possibly select to cover the distinctive contrasting paint. And it was vinyl. Over wood. When I was in college, I'd spent a summer, under the direction of my father, pulling the aluminum siding off my parents' house to expose the original cedar shingles, then repairing those shingles in preparation for repainting. That was the order of things. You have wood; you keep it. You don't cover it up.

If I was a different kind of person, I'd already have stormed up that driveway—*my* driveway, my brick driveway, my masterpiece—and asked just what the hell was going on here.

But all this passed. All this passed in a dizzying fireball of realization, gone as quickly as it had overwhelmed me, burned through my senses and my sensibilities.

This was not my house. Soon, very soon—as soon as the siding was up, we would be all but erased from there. The fence, the driveway, the walks—who would know where those had come from?

Would anyone ever ask? Would anyone ever care? Do we all disappear so quickly?

And did it have to be *green*?

Part III

[It's only finished when
you sell it or you die.
—family proverb]

a cautious return

Gina was pregnant again.

I wanted to believe this baby had been conceived in that stolen wocka-wocka in the Green Bedroom, with the murderous drywaller lingering outside the door, the first time in the house, which in some way might, if not neutralize or reclaim what had been lost, might at least make this feel like the right kind of a new beginning. That this would be the baby who was *meant* to be here, as an inextricable part of the place, its seed planted simultaneously with ours, a bold, undeniable marker of our way. Which isn't to say the other baby *wasn't* meant to be here—

No. It couldn't be that simple. It doesn't work that way. The fact was that we had begun again, and it was a joyful thing, yes, but muted and tangled up in all sorts of cautions and earth-tone realities. So soon after the mourning of the loss of the last baby, and also overshadowed by the grim possibility that if it could happen once, it could happen again, we accepted the changing of the color on the drugstore stick as a glimmer of hope, regarding it the way one regards the flame of a

vigil, through glass darkened with the by-products of fire. We agreed to keep it a secret, not wanting to go through the process again of having to backtrack through the mental Rolodex of family and friends and acquaintances—God, did we really tell *her*? *Why?*—and announce: sorry, false alarm, as you were, nothing to see here, do over, etc.

Having to explain a miscarriage was embarrassing in the sort of heavy way that all adult failure is embarrassing, in a way that no one ever really admits, but is undeniably so: we are judged, even on things beyond our control. Gina felt as if something was wrong with her, as if she wasn't a fully functioning biological being. A human body had died inside her own body, and despite all the assurances that this was natural, normal, all well within the acceptable ranges of medical possibility, well, we both knew that a certain percentage of people in our social circle were thinking maybe she wasn't fully capable as a woman. That something *was* wrong. With her.

Meanwhile, this new pregnancy carried with it an unwitting burden. The pending arrival of a second child was what had set all this in motion in the first place—the search, the house, all the unexpected trouble that had followed. And the removal of that cog had created a glaring imbalance, making it easier to question whether we had acted rashly, which of course we had, but rashly in a way that could be proven unjustifiable. This poor child inside Gina now, barely the size of a rice grain, had already inherited a level of responsibility most children don't experience at least until they begin driver's ed.

We played it as cool as we could, although there is always a unique energy shift between a couple when a pregnancy has been announced, a certain kind of carefulness and attentiveness and also awkwardness and uncertainty and worry.

One night soon after, I came home at eleven o'clock following a late interview in the basement rehearsal studio of a local amateur heavy metal band—an interview periodically interrupted by the bass player's wife passing through to advance her laundry—and Gina said there was or had been or could still be someone in the attic. Some*one*, she said. It had to be a person; nothing else could be making a racket

like that. She was scared out of her wits, imploring: why did this stuff always *always* happen when I wasn't home?

I immediately straightened up and determined before any words escaped from me that I would not dismiss her as the victim of her own overactive imagination. (Even though—come on—if there *was* an intruder, why would he go straight to the attic and start banging around?)

"When did you hear this?" I asked.

She was trying to contain her anger. She was angry with me, partly for not being home when she needed me, partly for not being a more aggressive exterminator, mostly for broader and more vague issues of failed romanticism. In this case, I had done nothing directly wrong, but sins of omission bring their own punishments.

She clutched the top of the blanket to her collarbone.

"It was exactly nine eighteen. I looked at the clock because I wondered if it was too late to call your dad. Because *you weren't here.*"

"Where was it?"

"It sounded like it was right over the master bathroom."

"Above the radiator?"

"Yeah. Right around there."

I inhaled the possibilities, which actually were probabilities, and exhaled: "I'll go see what it is."

I have spent a lot of energy in my life selectively ignoring information that others might consider "pressing" or "paramount." This is how one comes to live in a condemned house. When extended to its conclusion, this tactic usually ends up causing more trouble for other people than for me, and because Gina is the person I spend the most time with, I suppose this trouble is mostly hers.

I knew that what she'd heard was almost certainly not a squirrel and almost certainly not a man, but something in between, and most likely the thing whose information I had been ignoring with increasing frequency. That information included a) the previously mentioned fluffed-up/matted-down section of pink insulation; b) the strong musk of something that smelled large; and c) a piece of poop

244] David Giffels

the size of a full-size Snickers bar, discovered just two days before and summarily ignored.

So what I did next was partly dishonest and mostly cowardly, but, I think, understandable.

I knew this was a raccoon. And I knew that if it was a raccoon, my seeing it firsthand would not do any good and in fact might be dangerous. So I went up to the attic and approached the door behind which was the large unfinished room that had previously contained fifty-five cheap foil turkey roasting pans, each half full of rainwater, and that still contained parts of a vigorous wisteria. I opened that door just far enough to reach around for the light switch and flipped it on. I poked my head in, tried to suppress the cringe that ran through me, then quickly closed the door and idled there in the servants' quarters for a few minutes, feigning a "full sweep" of the attic. After sufficient time had passed, I returned to Gina with as much authority as I could assume.

"First of all," I said, all manlike, "there's definitely not a person in the house."

She looked at me, not very consoled. She'd had a good hour and a half to make that conclusion herself, which hardly served as solace.

"There was an animal in there. Probably a raccoon. But I don't see it now. It's contained. There's nothing I can do about it tonight. But I will take care of it tomorrow."

She started to cry.

"I cannot live like this. This is not what I agreed to."

"I'm doing everything I can. I am doing *every thing I can*."

"The house was supposed to be together by now. I said I could live with us fixing it up. But this is crazy. It's no better than before we began. It's worse. People don't spend fifty-five thousand dollars and have raccoons in their houses. This is *not normal*."

I put my fingers to my temples.

"I can do it," I said. "I can do it all. But I can't do it all at *once*."

"All at once? There's a *raccoon* in the attic! When are you going to do *that*?"

"Just—let me—"

I dug my fingernails into my scalp.

"Christ! It's contained! There is nothing I can do tonight."

She put her head down, shaking with a sob.

"This is not what I agreed to."

I was not sure then what we had agreed to.

First thing the next morning, I listened intently for activity in the attic, but heard nothing. I went outside to inspect the area around the master bathroom. I'd come to be able to read the underside of the eaves as sailors read the clouds, but I hadn't seen any openings large enough for a raccoon. Eventually, however, my vigilance led me to a recessed corner, in the shadow of the eaves and partly obscured by a stretch of downspout. A hole: a missing brick, with a crown of chewed beam above. The damage was not new, not golden-orange like the fresh squirrel holes, but darkened with age and use. That had to be it; it was right where Gina had heard the sound and right near where my evidence suggested the animal had been coming and going. But I didn't think raccoons could climb up a straight brick wall, and there didn't seem to be any other way to access this hole. Nevertheless, I felt a shallow sense of empowerment—something to fix—and an even shallower pulse of vindication. All of the evidence I'd been ignoring supported the theory I'd been trying not to think about. Even in a situation like this, being right is its own satisfaction.

I heaved open one of the carriage doors and pulled my aluminum extension ladder from on top of a pile of debris. I propped it against the side of the house and climbed up with a mouthful of roofing nails, a scrap of copper flashing, and the replacement hammer that I grudgingly had begun to think of as "my" hammer. As I neared the hole, I could smell the same animal musk I'd been smelling inside that area of the attic. This was definitely it. I positioned the sheet of copper over the hole and nailed it in place, taking the extra step of using a couple of concrete nails to fasten the bottom of it to the brick mortar.

I gave it a tug to make sure it was secure. I lowered the ladder and went inside.

"It's taken care of," I announced.

That night, at exactly 9:18—not 9:17, not 9:19—Gina and I, relaxing in bed, sat up suddenly and froze. The sound was a combination of thrashing, scratching, and growling, loud and absurdly violent.

"Is that—what you heard last night?"

"Well, yeah—but not like *that*."

I rushed to the master bathroom. I could hear snarling and the desperate ripping and scratching of something right in the corner where I'd . . . covered up the hole.

I'd trapped it.

In my house.

Crap!

They're *nocturnal*!

Stupid-stupid-stupid! Crappity-crap-crap-crap!

Gina was in the hallway, in a defensive stance near Evan's door, behind which he slept, oblivious.

"What is it?" she hissed.

"It's a raccoon. It's trapped. I have to let it out—"

I ran to the top of the stairs, then hung at the banister, not exactly sure—well, actually, with *no idea* what to do.

I hurried back to the bathroom and looked out the window, where I could see the flashing I'd nailed up that morning. If I climbed up and pulled it loose, I'd be attacked by a furious raccoon at the top of a ladder, which is the way cartoon characters die. Not me. No way. On this there can be no compromise: I refuse to die a cartoon character's death. If I could reach out the window with something and yank the flashing loose—maybe I'd be far enough away that it couldn't get me.

I ran to the basement and got a portable work light and my long

red crowbar. Then back to the bathroom, which now sounded like a den of banshees. I pointed the light toward the hole, reached out, hooked the bar's claw over the top edge of the flashing, and, with gritted teeth and adrenaline-drenched sweat gathering at my temples, I yanked hard at the copper.

It came free, clattering to the ground below, and I quickly pulled back from the window, slamming it shut and turning the hasp tight. I waited there, grinding my teeth as I peered out the window. The unseen animal had fallen silent as soon as the crowbar bumped and scratched against the side of the house. I watched for half an hour, but neither saw nor heard anything.

The next night, I crouched in the darkened bathroom, waiting, a watch with a lighted dial resting on the sink. This room still smelled deeply of house cats. At precisely 9:18—not 9:17, not 9:19—I heard a stirring and then what sounded like a brick being rolled across the floor, then some sort of a bumping and shuffling. (God, she was right—it *did* sound like a person up there.) I watched under the moonlight as a handlike paw reached cautiously out of the hole, pulled back, then reached again, resting on the angled drainpipe. Then another hand, followed by a masked face—not three feet away it began to emerge and oh my lord how big is this animal? The size of a German shepherd! Coming out of my house! Through a hole not much bigger than a grapefruit! But how—how will this thing get away? There's nothing to stand on.

And then in one deft motion, this huge dumb ball of fur answered the question with an act of breathless grace, defying gravity and logic. The raccoon wriggled its torso out of the hole until everything but its haunches was extended in midair, like a ship's lady pointing off the bow. One hand reached blindly above, catching the edge of the roof. Then, in a single flourish, the entire body did a sort of upward flip, rolling onto the roof and scrambling up and out of sight.

How long had he been doing this? And how did he figure it out in

the first place? It's not like he could pause there and plan his actions. And how did he know when it was 9:18?

I considered the fact that there still could be another one in there, but I couldn't allow this one back in. So I set my work light in the bathroom window, shining toward the hole, then went outside, set up the ladder, and climbed up with my hammer, the flashing, and a mouthful of nails.

I replaced the copper, climbed down, collapsed the ladder, returned it to the garage, and went to bed, feeling more defeated than triumphant and more impressed with the raccoon than myself.

A s the pregnancy settled in, Gina was feeling tired, going to bed earlier. She'd lie there for a time, the sort of forced relaxation that inevitably prompts reflection, something like watching a pot for signs of boiling. Some nights I'd sit there at her side, fully clothed, on top of the blanket, in limbo. Part of me wanted to crawl under the covers with her and talk, the way we used to. And yet I was anxious to find a way to drift back to a few more hours of work, promising myself I would quit at midnight. I was tired too. Winter was pushing into spring; I'd been at this pace for close to three months. It was a struggle to begin working again at nine o'clock at night, but I knew from recent experience that once I got going, the work was tolerable. I could listen to music by myself and feel as though I'd inched ahead toward some small milestone of completion. If I just could get the kitchen to look and feel like a normal family's kitchen, then Gina could feel more comfortable, and if she felt more comfortable, I could feel a little better about what I'd gotten all of us into. We could pretend we were approaching something like normalcy.

Kitchen? Sure! We've got a kitchen. Doesn't everyone?

And so I lay there one night, leaning up on one elbow in faux repose, wearing a pair of paint-crusted jeans with the knees blown out, waiting for the appropriate moment to return to a pile of disconnected window hardware.

"Don't work tonight," Gina said drowsily.

"I have to. I have to keep ahead of it."

"Ahead? Ahead of what? It'll be there forever."

"It doesn't work that way. It has to be done. It's not going to finish itself."

"I feel like a single parent. I'm always alone. I want you here with me."

I sighed.

"You'll be asleep soon. What difference does it make if I'm working?"

"You don't get it. I want you to stay here with me because I want you to stay here with me. Because it's where you belong."

I stayed there till she fell asleep. Then I tiptoed to the door.

I was so close. Just a few more nights like this. I was determined to finish the details of the kitchen before moving on to the next major project. I had vowed from the very beginning, based on the advice of my father and Steve, who had more experience with such matters, to take projects one at a time, not to start a job until the preceding one was finished. As tempting as it was to move on to the living room, which I'd targeted as the next room to attack, I was trying to keep this promise. And so I kept at the drudgery of the details, where, indeed, the devil lay. The closer I got to the end of this job, the more elusive its conclusion was. The finish line kept inching just beyond reach.

I had begun to hate, with unreasonable specificity, whoever it was who had painted the hinges in this kitchen. I cannot tolerate painted hinges. I consider them a moral outrage. The only reason hinges get painted is because the painter is too lazy to remove the door or window and its hardware and paint the right way. It is a selfish and antisocial act: it leaves the mess for some future painter to clean up.

Not only did I have to remove all the doors and windows and paint them the right way, which is always the hard way, I also had to remove the old paint from the hinges. Have I mentioned that this kitchen has six doors? This kitchen has six doors. At three hinges per

door, that's eighteen hinges. This kitchen also has six casement windows, each with two hinges. Some were so heavily coated with paint that they wouldn't close properly.

Laid out before me on a thick blanket of newspapers were thirty sets of hinges, all slathered in pinkish paint stripper the color and consistency of vomit from a child who has eaten too much watermelon. I slid a disc into the CD player. Morphine's album *Like Swimming* had just come out, and I had been playing it on repeat through this phase of the job, drowsy low-end beatnik rock that seemed the only sound track for these long nights.

"Your eyes are like a diamond mine," Mark Sandman sang in a husky whisper, "deep and bright inside . . ."

Pulling rubber gloves onto my hands, I settled on the cold concrete of the basement floor, sitting cross-legged. I began to push half-heartedly at the sludge with a putty knife.

This situation with the animals was wearing me down. It was disturbing, not because it was so bizarre to have such varied and intense wildlife activity in a residence intended for humans, but because it *wasn't* so bizarre.

This house belonged to animals as much as it belonged to us, and it had been that way for a long time, far longer than we, the intruders in this ecosystem, had been involved. No matter how hard I tried, I could not claim ownership of this house. On warmer days, a musk emerged from the walls, an animal smell that defined the house as much as its architecture. In one spot in particular, in an attic wall above our bedroom, a rancid odor was growing in acuity, suggesting active decomposition of something recently dead. All the scrubbing and air freshening in the master bathroom had done little to eliminate the tang of cat piss, and I'd come to notice that under certain conditions—particularly when a pot of pasta water was boiling—the kitchen floor still released its scent of urine. I secretly prayed that the scent association would not creep into my psychology and sour a heretofore beautiful relationship with Gina's pasta.

For all my diligence, the squirrels had not abated; they came and

went from the attic with the joie de vivre of shore-leave sailors at a Polynesian whorehouse.

But the low point had come the morning after I, in a not-entirely-thought-through attempt to set a better mousetrap, had decided I could accelerate the mouse extermination with something other than the standard snap traps. And I, standing vapid in the hardware store aisle, had chosen glue traps. And it was not until I wandered into the kitchen one morning, barefoot, bleary and a little hungover, and saw a mouse, set in a sort of offensive lineman's stance, rocking slightly back and forth, staring at me terrified and incredulous—it was not until then that the obvious occurred to me.

Glue traps do not kill mice.

Dealing with a live mouse is a whole lot worse than dealing with a dead one. I was caught midstride across the kitchen, staring down my dilemma. And also the mouse's dilemma, which definitely was worse than mine.

Our eyes locked. We both seemed to be having the same response:

What the hell was I thinking?

And why were these things even allowed? Seeing the effect of the trap, it was obvious that they are unnecessarily cruel. What is their point?

I considered trying to free it, but for many reasons, that appeared impossible. I tried to wind back time, wishing I'd allowed this poor, pathetic mouse the dignity of instant death, a spring-loaded steel snapper thingie that would have brought a quick end via spinal trauma.

How long had he been stuck like that? What horror had he endured? How many hours of life-flashing-before-its-eyes can one mouse handle?

The notion of a mouse tribunal crossed my mind, in which I'd be tried for crimes against rodents, with a gallery of exiled squirrels testifying in support.

I crossed my arms. I put my hand to my forehead.

"I'm sorry. God. I hate this."

I slid my hand down my face, tapping my fingers against my upper lip. The resolution was obvious. I was going to have to do what the traps had been doing for me all these weeks. The question was, "How?"

I released a long sigh and got two sections of newspaper from the pantry counter. I folded one in half to stiffen it, and used it to scoot the fused-together mouse-and-trap onto the other section of paper, trying to do this without looking, which caused me to lose my aim and drop the contraption on the floor. The mouse's head was thrashing back and forth now and I selfishly wished it would just die of fright. But no, it seemed tireless in its attempt to yank itself loose.

Finally, I got it scooped up onto the newspaper and I went outside, pushing the screen door open with my butt. I set the whole thing down on the driveway and chose the largest brick I could find in one of the debris piles alongside the garage. I shook my head heavily, lamenting my own stupidity and the mouse's misfortune. Then, standing as far away as I could while still being in arm's reach, I held the brick up high, positioned it, turned my head, clenched my jaw—and let go.

Most of the paint came off the first hinge in a puddle of pink-and-white pudding. I began to push away at the remaining goop with a piece of steel wool. Thirty hinges. Thirty hinges in the kitchen alone. And no one would ever even know I had done this. Who does this? Who even thinks about such things? What in the world is so important that one would stay up half the night, nostrils stinging with the smell, the occasional spatter burning the cheek? Why spend so much time on a detail no one will ever really see?

God will see.

Right? God appreciates a clean hinge. He appreciates a homeowner with the moral compass that directs him not to paint door hinges, and even more, God appreciates a homeowner willing to undo the injustices of the past, with Strip-Eez and steel wool. Surely this must be so. I was improving His world.

I started to count in my head the number of hinges in the house.

The master suite. Including closets, the master suite had seventeen doors. *Seven-teen*. I tried to remember if the closet doors had two hinges each, or three—let's just say three for the sake of argument, so that's fifty-one hinges—and I began to estimate how long each hinge was taking me here, now, and therefore how much of my future, my precious remaining time on earth, would be spent cleaning paint from hinges.

Was it really a virtue to do things the right way? How much time playing catch with my son would be lost to the hinges in this house? Just the hinges!

If "Cat's in the Cradle" enters as a theme here I am finished.

Gina had asked me to stay, for just one evening, by her side. And I had denied her that, sneaking away the moment her eyes closed and her breaths grew longer. She almost always fell asleep before I did and I used to love to watch it happen, the way the sandman spell softened her countenance and her breaths rose and faded into a wordless lyric. Falling asleep while someone is watching is an act of complete trust, and I had cheated that by leaving. I had done this not so much because I wanted to, but because I believed I needed to. I hated myself for that, and I didn't know what I wanted anymore.

My only option was to work harder. From my vantage, cross-legged on the cold basement floor, the only way out of this mess was to work myself out of it. I believed that I could. I believed I could bulldog my way to a proper life in a proper house and we would all be better people for it. The harder I worked, the sooner this could happen. The baby would be here. Evan would just be entering his age of awareness. Gina and I would be over this difficulty. We would sit together as a family in our reclaimed kitchen, taking turns opening the casement windows to admire the clean steel along their spines.

With my gloved fingers, I scooped together a puddle of the toxic pudding and began, one after another, to press the heads of the painted screws into it, lifting them by their points, setting them up in rows like they were plastic army men. Now, just wait for the stripper to soften the paint . . .

Thirty hinges, eight screws per hinge; thirty times eight . . .

the optimist's lament

Spring came, and with it came new piles of chewed wood. I found the piles in the attic. The wood was finer in this case, more like sawdust than the crude splinters left by the squirrels. This was the work of carpenter ants, which required the hiring of an exterminator, which required spending a few hundred more dollars. The gas bills had gotten more reasonable, relatively speaking, as we got the house under control, which is to say we tacked up sheets of plastic that flapped and clattered against the windows and kept the thermostat down close to sixty and got the monthly bills to under a thousand dollars. This seemed like progress in its own meager way. Even so, the house was costing a lot of money in a lot of ways we hadn't planned on, and every week or two was bringing some new unexpected expense. Another Dumpster, another $150. Blown Shop-Vac motor, $100. Stray roofing nails regularly found their targets in our car tires, and every few weeks we'd have to spend another twenty bucks on a repair.

I was constantly worried about money, about whether we would

lose the house because it had sucked us dry, about what we would do if, say, one of the cars broke down. My visits to Ron Schieber at Mad Money were complete. He had sold all of the bundles and we had set up an investment account, hoping the $17,000 would grow slowly and safely and act as a counterbalance to the jackknife unpredictability of our new lifestyle. It seemed like the money would be easy to ignore this way, out of sight and out of mind, but instead it was a distraction, as the urge grew to nibble away at it, to withdraw a few hundred here and a few hundred there. Each month, we resisted, but each month, the subject arose again.

Gina could have gone out looking for a teaching job, but that would have destroyed our whole idea of how we'd planned to live as a young family, with her and the kids at home. The whole system of two parents working to afford day care for children who were in day care because the parents were working—that seemed to us like a zero-sum game. We just wanted to feel like a proper family. We didn't need extra money to buy extra stuff. Just enough to live in a way we could feel comfortable.

But this big house had introduced a constant series of ironies and hypocrisies. It was starting to become clear that this was a more expensive house than we had imagined, and that because of it we would never get ahead, never achieve some small sense of leisure. And yet the house itself was studded with the implications of leisure. This was supposed to be a manor, an estate, every aspect of its design pushed the impression that this was the home of a person who never worried about money, who never considered the imprudence of vast central hallways, larger than most houses' living rooms, which were, in essence, wasted space that needed nonetheless to be heated. The butler's buttons, the stained glass that filled the central hallways with gold every afternoon, the six fireplaces, the grand entrances, the heavy wood and English tile: all of this was an announcement of sophisticated indifference. This was supposed to be a place where a man could spread out the morning paper in, say, his solarium, wearing silk pajamas and dressing robe, where he could sip his grapefruit juice

from a Viktor Schreckengost glass, a grand mastiff bitch at his feet, idly jotting doggerel poetry in the leather-bound journal on his lap, breathing damply onto the glass of his monocle (not an affectation, but a wholly appropriate, utilitarian monocle, leading a trend soon to take the nation by storm—someone get *Esquire* on the horn, pronto!) while the photo unit from the J.Crew catalog lurked in the wings, snapping picture after picture, the camera so hungry for this.

"Sweet mother of pearl! Lookit that hair! I've never seen such glorious bedhead! *Print it!*"

The several-hundred-dollar exterminator treated the house, squirting extra poison onto the attic rafters where I'd found the sawdust piles, leaving a powdery white film where the fat black ants seemed to be nesting. One by one, they dropped like raisins. When he was done, he took me for a walk around the outside to show me just how vulnerable we were. Branches touched against the house all the way around—those were insect footbridges, he said. Rotting limbs, dead trees, and half-decomposed lumber were scattered across the nearly half acre of grounds. Termites need three things, he said: dead wood, dirt, and water—and that's all we had for groundcover. But his real destination soon revealed itself.

"That garage," he said, "has got to come down. I won't even treat it."

Without going in, he pointed through the windows at the collapsed joists. Even through the grimy glass, it was obvious to him that the wood was infested.

"Until you get rid of that, you're gonna have wood-eating insects and they're gonna get into your house."

I felt stupid and defeated. The garage was my stand. It was my statement. I was the only person who believed it should be saved, who believed it *could* be saved. But it could, it could! It had to be saved. That garage stood for the preservation of the house's original architectural character. It stood in gritty protest of modern America's knee-jerk disposable culture. It stood for the enduring quality of this house, evidence that the basic structure could sustain even the worst damage.

And yet, it barely stood.

I gave a sort of noncommittal "Okay," which caused him to stare at me a second longer than was comfortable, indicating that he knew I was lying and thought I was a fool.

I wasn't going to tear down the garage. In my head, I put it on the list of Things That Needed Immediate Attention, which list had been growing weekly all through the winter and early spring. It was April, and soon to be May. The baby was due December 9, and I needed to have three bedrooms done by then.

December 9. We knew the date, and we tried not to think about it, which of course means our shared subconscious was consumed with it, the date gouged into our nervous systems. Awake at night, my hand resting lightly on Gina's round middle, we had done what we had promised we would not do. We had chosen names. Lia, for a girl. Jack, for a boy. We had, in whispers, confirmed the preference parents-in-waiting pretend not to have, but almost always do—we both knew what we wanted and we both wanted a girl.

As before, the impending arrival of a child created an urgency vis-à-vis the bedrooms. Our living situation was teetering on an edge between irony and nonsense. The reason we had begun looking for a house in the first place had been to have enough bedrooms for everyone in the family, and now we were in a house with six bedrooms, but only one that could be considered habitable. This was an awful lot of trouble to have moved so far backward.

And yet, at the same time, with equal reason, I wanted to do the living room. I felt as though a finished living room would be a huge step toward taming the interior. Which would make Gina feel more comfortable, more settled, more willing to continue with this thing whose "adventure" was wearing thin, which in turn would make me feel better about something that was keeping me awake at night.

Gina and I had done some shopping at a local paint store that sold factory-second wallpaper for $3 a double roll, and we'd found a paper for the living room with a black background and huge gaudy flowers, pink and yellow and green. We'd chosen paint colors for

the woodwork—yellow for the bookcases and French doors, a loud soda-fountain green for the baseboards, crown molding, and fireplace mantel—all gloss, no muted finishes for us. This house had been so dark and enclosed for so long; these choices were an announcement. Color and light! We are Bringers of Color and Light!

I'd discovered that if I stood at the railing at the top of the main staircase, framed by the bank of stained glass, my voice would echo as if in a cathedral, and I'd taken to making bold pronouncements when I reached that spot in the morning—my pulpit, my dais, my ivory tower:

My people! My people!

This was how I always began.

This is the revolution! This is the awakening! We are here! We are here! And this is ours! All in this house must fill it with joy and be themselves filled with joy and whosoever denies this edict will be banished—to the dungeon! We have a dungeon here!

Always, when I followed the resonant echo of my words down the stairs, I would find Evan and Gina, smirking or blinking flatly, announcing that this was far more entertaining to me than to them.

And so the living room decorating scheme would follow these overblown soliloquies, would be a physical manifestation of the Revolution, of the Awakening. Not a single person to whom we gave an advance preview of these wallpaper and paint colors actually said they *liked* it; some may even have given hints as to how they *disliked* it, but we didn't hear. In retrospect, we were fooling nobody but ourselves. The paper and the colors were awful, tacky and inappropriate, and yet when you are charging ahead, you grasp whichever weapons shine the brightest and you advance by sheer will, damn the carnage, leave that mess to be cleaned up later.

This was color. This was light. In boxes and cans, resting near the bottom of the basement stairs, waiting its turn.

Meanwhile, we still didn't have a front stoop.

I'd written another installment about the house for the newspaper, and it had brought another round of strangers who said they'd looked

at the house, either toured it or watched it from the curb, wondering, considering. They would approach the front door for their impromptu tours. If I saw them coming, I'd point animatedly toward the side of the house, where the solarium door offered a less treacherous entrance. They wanted inside. They wanted to see what they'd always wondered about. Some people said they were glad we were saving it; others said they'd always fantasized about trying something like this; still others said they'd imagined for years what might lurk behind that overgrown yard on North Portage Path. Always, without fail, there was the implication that we must be crazy.

There were two ways onto the flat garage roof. One was to climb out the window of Evan's bedroom and drop a few feet onto its surface. The other was my ladder. My ladder was an apt companion to this restoration project, a sad and unwise thing that no one else wanted. I'd bought it at a thrift store, a twenty-four-foot aluminum extension ladder whose legs bowed considerably when the ladder was extended even a short way. I had bolted lengths of two-by-twos to reinforce them. This helped some, but when Steve or Chris—each of whom outweighed me by at least a hundred pounds—tried to climb it, they quickly reconsidered as the ladder bowed deeply and appeared ready to snap, scrambling down like bears testing saplings and thinking better of it.

I considered dropping from Evan's window, but it occurred to me that the roof might collapse under me, so I played it safe, leaning my wobbly ladder against the garage wall and climbing to the top.

The garage was a twenty-by-twenty brick box attached to the farthermost rear corner of the house, under the looming blue spruce and its accompanying overgrown yew that suggested the entrance to the area where the pond remained hidden in the underbrush. I'd never been on its top before, and even though I knew of the roof's condition from seeing it through the window, the closer view was staggering. The tree that was growing directly from the roof was in the greeny

translucence of early spring bloom, in excellent health, and the whole surface was speckled with green shoots pushing up from the mulch that had accumulated up there. It looked more like forest floor than the roof of a residential structure. It was peppered with asphalt from the decayed shingles, and bricks and sand and chunks of mortar that had fallen from the house's rear chimney, which rose above its surface. This describes the front half. The rear half was collapsed. Through the wreckage, I could see the debris in piles on the garage floor. A feral cat looked at me curiously from the shadows below.

The parapet wall surrounded the perimeter, standing four feet above the roof level, creating a second-story courtyard effect. I swung one leg up over the top of the wall, then the other, easing myself down onto a spot that appeared solid. I wanted to get a better look at the front wall, the area above the garage doors that bowed out as though the bricks and mortar had warped. I picked my way carefully, testing each step, staying close to the edge, my hands on top of the wall.

At the front of the garage, leaning over the edge, I could see that the mortar had turned entirely to sand. The bricks were heaved forward in a pronounced convex, years and years of nature's progress against the craft of men.

"Hello."

The voice sounded as if it was coming from my level, not the ground. I looked one way, then the other, confused.

"Over here!"

I turned behind me. There stood a man, on his own roof, leaning on a broom. It was the next-door neighbor, on the flat overhang above his back door. A second-floor storm door was propped open behind him.

My first neighbor! With the winter and all the furious activity inside, I had yet to meet anyone in the immediate neighborhood. And now it was happening here in the sky, as though we were chimney sweeps exchanging pleasantries.

I turned around to face him.

"Hey—hi there," I said, and some social instinct led me to step forward, hand extended. "I'm—*unnnggghh!*"

In one violent plunge, my foot went through a rotten place in the roof and dropped me straight down so that now I was stuck crooked, with one foot dangling inside the garage, stuck all the way to the groin, and the other foot still planted up on top, awkwardly split, pain shooting into my upper thigh where the shattered planking had gouged into the muscle. I reached forward for something solid, fearing I might fall all the way through.

The neighbor, eyes wide, was leaning back, with the broom in front of him as if in defense.

"My God—are you—do you need me to call someone?"

Driven more by humiliation than survival instinct, I yanked myself forward and upward, freeing my wounded leg and rolling sideways onto a spot that felt solid. As quickly and casually as I could, I struggled back to my feet, edging toward the wall.

"I'm okay," I said, pushing a smile like someone passing a kidney stone. "I forgot there was a bad spot there. Nothing. I'm fine."

He was still holding the broom in front of him.

"Do you think—maybe you should come down from there?"

"I'll be okay. I just need to stay away from that one bad spot."

My thigh was burning with pain and I did want to climb down and go inside to look at it, but pride would not allow me to suggest that I wasn't in control even though, clearly, I wasn't in control.

"I'm David," I said. "I guess we're neighbors."

"Jim," he said, nodding his head slowly. "You're sure you're okay?"

"Yeah. I'm sure."

"Boy. Looks like you've got your work cut out for you. We've been wondering—we didn't think anyone would ever buy that place."

"Yep." That's all I could think to say.

The neighbor disappeared through his storm door and the pain had subsided enough that I decided to forge ahead before going inside to see how badly I'd hurt my leg. Once again, I edged along the wall

toward the front of the garage, the area above the carriage doors. I rested my hand on the top course of brick.

It moved.

The entire course shifted slightly forward. I gave it a little shake. Sand sifted down, landing with a *poof* in the driveway. Holy crap. Nothing was holding all this brick in place. I wrapped my fingers around the brick where my hand lay. I lifted it, and when I did, the entire center of the wall gave way, collapsing with a dense crash into the driveway, a cloud of dust rising above it.

My breath came up short. *How long* had all these bricks been waiting to fall? What had held them this long? What if someone had been down there?

What if Gina had been down there?

Or Evan?

I looked down. I was still holding the capstone. The fallen bricks had opened a jagged V. I tossed the brick I was holding onto the pile below and leaned over the wall to see how solid the rest was. I found that I could remove the pieces just by pulling at them. There was no adhesion left in the mortar. At all. Sometimes they came out one by one, sometimes small sections tumbled loose. In no time, I'd removed the entire section of garage wall above the doors. The bricks had rested on a steel I beam, which was now exposed. I could see that it was nearly rusted through on one end. I kept pulling at the bricks, as far as I could reach, and they just kept falling, and it began to occur to me that maybe I was weakening the structure and the entire garage would simply collapse, bringing me down with it, in bitter proof that everyone but me had been right about this.

I found the brickwork to be more solid near the corners, but then I found more loose brick in the rear wall. The structure proved itself to be in a sort of limbo, undecided as to whether it wanted to stay upright or drop. The crumbled back corner and the newly tumbled front wall said one thing; the wall attached by the heavy center beam to the house said another. There was something to be saved. There was always something to be saved. For now, I needed to get rid of the

evidence to the contrary, the heavy rubble below me, the pile that undermined my best hopes.

Our house was falling down. This was a simple truth. The more I tried to fix it, the more it fell. As quickly as I could, I began filling my wheelbarrow with bricks and hiding them around the corner.

The little man appeared in the rear driveway one afternoon while I was working on the garage, pulling out a rotten window casing. His frail body was squeezed into a pair of blue jeans and a stained khaki shirt with a magnifying glass poking from the pocket, a decimation of white hair combed across his scalp. I barely knew him, but I knew his reputation well. He was a sort of elf who appeared at houses throughout Akron, usually unannounced, usually bearing an unearthed blueprint or obscure archival photograph, something the owner might want, so that he could get what he wanted, which was access. His name was James Pahlau. He was the foremost authority on the architectural history of Akron, a title to which perhaps no one else aspired but which none could hold so well.

He lived alone in one of the subsidized apartments across the street from our semiremarkable house; he had once knocked on our door there and asked if we minded if he parked his aged Oldsmobile in the bank parking lot alongside our driveway, because it would not go in reverse, and he didn't have the money to fix it, and therefore he had to park in places he could negotiate without backing up. He was, as far as I could tell, a pauper, yet I also knew he was in the process of donating his expansive and wholly unique rare book collection to the University of Akron archives, hand-delivering it one grocery bag at a time.

Mr. Pahlau carried extraordinary amounts of information about the finest structures in Akron, and he boasted, in his fey and artful way, of his ability to get inside them to match his research to tangible reality.

It is hard to say who, at that moment, was the bigger geek: he, for

264] David Giffels

having discovered an amazingly obscure piece of my house's history, or me, for recognizing immediately the status of owning a house that warranted Mr. Pahlau's attention.

"You're the new owner?" he lisped, holding a manila folder before him, half offering, half shield.

"I am," I said, lowering my hammer. "Or we are—my family and me."

"I have something here. A picture," he said. "I made a copy for you. It's black and white, but it's a color copy. They look better that way, you know. Oh, that Kinkos does a wonderful job . . ."

I approached him, introduced myself, thanked him for taking the trouble.

"This house was in a book," he said. "Back in the twenties, a book about the art of brickwork. It's the only house from Akron. I found the book at an auction. I think I might have the only copy in existence."

He held the folder toward me. I opened it. There it was, the house as it had appeared about ten years after it was built, the lines and edges clean.

"Residence, Akron, Ohio," the caption read. "Frank & Wagner, Architects. Note the attractive handling of the brick in the timber work of the second story."

In the picture, the yard was clear and the horizon flat; what was now a fully developed residential neighborhood looked more like farmland. Off the rear corner, I could see the maple tree in the backyard, now massively overgrown and dying, then a sapling. The house looked exactly as it does now, except correct. Nothing had been changed at all since the time of its construction. The only changes had come via neglect. The beam under the master bedroom window, now eaten by white fungus, was then dark and smartly square. The copper gutters, so recently unscrewed from their misery, were straight and sound, with fancy decorations where they met the downspouts. The main chimney, now stubbed off at the roofline, rose in its full complement of courses, with decorative rows stepped out in relief.

And there—in the arched solarium door. Was that a person?

I peered into the photocopy, trying to make out the image. It did appear that someone stood there, looking out.

Who?

The more time I had spent here, and the further I had entered into the texture, the more deeply I had wondered about the lives of those who had been here before. And especially at the beginning—who had built this house here, and why?

For all the curiosity this photograph inspired, my attention was riveted by the hint of a person in the doorway. I wanted that connection most of all. I wanted to know whose lineage we had joined.

I wanted this copy, and before I had a chance to ask, Mr. Pahlau offered it.

"Would you like to see inside?" I offered in return.

"Oh, my, yes. I've wanted to get inside here for years."

We began at the back, in the kitchen, and moved through, room by room, drawing commentary and little peals of delight from Mr. Pahlau.

"You know, this house was designed by Frank and Wagner, a very prominent firm, and oh my, it's every bit as fine as the mansions they did up near Stan Hywet. . . . Oh look at this—I just love how they did every room in a different style—some Early American here, some Arts and Crafts there. All these fireplaces are completely different . . ."

I took him to the master suite, still in its raw state, and he swooned demurely at its grand scale and the decadence of the extra rooms— the summer porch and the dressing area with its cedar closets, the long corridor that separated the rooms, lined with closets and built-in drawers and shelves, the bathroom with its deep lavender tile. In the main bedroom, he lingered over the chandelier and the fireplace and clasped his hands.

"Oh!" he said. "They built such romance into this house. They did it so well!"

"Do you know," I asked, "why this house is here? It doesn't seem like it belongs, you know? Like it should have been a mile up the road, with the other Frank and Wagner mansions."

"There was not much here then," he said. "Those houses up the road—they were the equivalent of the suburbs. You're right. This one's in between. It doesn't seem to belong here. It's not part of the houses farther north, and it's not part of the mansions down on Market Street. But there has to be a reason. No one would go to all this trouble without a reason. But I don't know. I don't know the answer."

I looked at the picture. I wondered again who was looking out at the photographer from a spot that, seventy years later, would be directly below an ugly hole covered with green corrugated fiberglass.

Mr. Pahlau asked if he could see more and we continued, off into every room, until his curiosity was fulfilled.

For the first time in weeks, I felt good about this house, reconnected with the original thrill it had inspired, a thrill reflected in the responses of this little man who had traded a picture for the pleasure of seeing what it had to offer in return.

my people my people

The early buds were pushing through their casings, green tips appearing at the ends of the winter-gray limbs that clawed the landscape with haphazard fingers and arms, poking and scratching me as I began to explore the grounds. The yard wrapped around three sides of the house, and seemed deeper than a site map might have indicated because of the denseness of the trees and undergrowth. When you entered the yard from any direction, it felt like entering the woods. Tulips and daffodils had appeared in clumps here and there, suggesting extinct garden beds but offering no hint as to the boundaries or shape. From both far and near inspection, there was no indication of a previous order, no indication that this had ever been anything but wild. The only evidence I'd seen of any human activity was a large mound of cat litter at the base of a tree near the rear of the property, the dump site for the litter boxes that (following my nose) presumably had been kept in the master bathroom. There was no grass anywhere, just dirt and clumps of weeds hardy enough to exist in the understory.

But as I pushed into the undergrowth, I found curious evidence of gardening activity. In the backyard, I came upon three bricks set in a triangle; between them was a leggy sapling, maybe eight inches tall. In another such triangle in the side yard was a sprig of holly, a baby. Someone—it had to have been Mrs. Radner—had carefully set these tender shoots off from the overwhelming anarchy of the yard, and apparently not long before. Had she transplanted them? If so, what was the purpose? There was nothing to suggest their location was special. The whole grounds were a thick, random forest; no area had been kept tame. These plants were the landscaping equivalent of those buckets and pans set against the rain. The sky was falling and she was helpless to stop it, but she tried, and she tried, and she tried. And so, out here, among thousands of plants, large and small, trees and mosses, all wild, capricious and unpruned, feeding on its own decay, she had defined two of them, using bricks that had fallen off her house, defined them in an apparent attempt to tame them and reclaim her sovereignty.

If you give the wind a name, do you control it?

No. Of course not. This is the hubris of the human race. We fool ourselves, drawing lines in the dirt as though to define it, and every so often a giant wave or wind or rupture from below comes along to wipe it all away, to remind us, and yet we never learn. We go on fooling ourselves that we have brought order to the universe because we have set three bricks into a geometry we understand, a geometry we ourselves invented.

But I understood this impulse. Right then, with the hint of warmth on the edge of a spring breeze, I wanted to reset the stones in the pond, and yet like every romantic whim of the last few months, this one came with the insoluble muck of complication. Resetting the stones would require emptying the pond, which would have to be done by scooping out the water, bucket by bucket, and dredging up the fetid black humus in its bottom, pulling out the sodden limbs. Who knew what might be living in there: snapping turtles, leeches, eels, exotic parasites that would turn intestines into posthumous medical journal

fodder. Who knew what might be dead in there: lost dogs, clumsy
raccoons, missing prostitutes, a coelacanth. But I couldn't scoop out
the water until I'd cleared a path, and there was no sense in clearing
a path unless I planned to prune the whole area. And if I planned to
prune, I should be starting with the limbs that touched the house, the
ones that had already torn shingles off the roof and right now were
providing ingress for infantries of ants.

What's this?

A corner of cut sandstone peeked up through the decomposing
leaves in a thicket just north of the pond. I pushed through the brush
and scooted some leaves away with my toe. It was flagstone, the corner
suggesting a fairly large piece. I picked up a stick and scratched away
more leaves, but a thick tangle of fine roots kept me from scraping
very far. So I started jabbing the stick along the ground, finding that,
three or four inches under the mulch surface, everywhere I poked,
there was something solid. I scraped away another spot. More flag-
stone. More poking, more scraping, and after a while I had the rough
outline and impression of a sprawling sandstone patio, the individual
stones at least three feet square, stretching from the wall of the garage
to the edge of the pond. It was completely hidden, completely grown
over, completely forgotten.

I wanted to go at it right then. I wanted my patio; I wanted it drip-
ping with impatiens and feathered with ferns. I wanted a pitcher of
gin and tonic and the glow of Chinese lanterns and a reflecting pond
that actually would reflect instead of sucking all light into its muck.
But I couldn't. All I could do was put this patio and this pond and
this fantasy of reflection out of my mind, forget about it until some
hypothetical future. This was my only choice. I had to make places
for us to sleep.

I came home from work one evening and cut through the kitchen
to look for Gina and Evan. There is a daily joy unique to the heart
of someone who each morning leaves behind the people he loves and

each evening returns, a sketch of exodus and reunification built into the artifice of the forty-hour week. I knew that feeling well. In my earliest weeks and months as a father, not so very long before, there were days when I had to leave my desk at the newspaper office and go out into a stairwell in the parking deck and stare at the wall, overwhelmed with sadness at being separated, and wait there until the swell of anxiety subsided. It was a complicated thing: at the same time I was feeling my independence threatened (a contrived independence, really; I was as dependent a soul as existed), I was pining for the very things that threatened it. I remembered this feeling; it was the feeling of falling in love: from my earliest time with Gina, I remembered months and months of stomach-turning conflict: desire and suspicion; coolness and desperately counting the minutes till the phone rang; tenderness and aggression. And I came to realize that one falls in love with one's own child, that the nature-vs.-nurture question is a reflexive one, that love is both bred into a parent and learned by experience.

Daily, I came through this kitchen, calling into the abyss, calling for people lost in the hallways and wide-open spaces, floating in the mansion's high imagination, friendly ghosts bumping among chandeliers and plaster crowns, perhaps gone exploring in the cobwebs and soot of the interior void, somewhere in the dark: calling for them to come to me, to welcome and (possibly) worship me, to allow me the privilege of their radiance.

My people! My people!

And on this particular day, I took the route toward the dining room, through the long butler's pantry, crossing my rustic and wholly appropriate gray-painted floor (genius, pure genius; I don't care what Gina says), running my hand along the gloss of the newly varnished countertop, taking conscious relief in this first completed act of revival: *the kitchen, finished.*

Yes, all of that passed through me as dirt through a worm, the wordy rappinghood of someone alone so long with his thoughts (this *is* what I asked for, right?) that he begins to talk to himself in internal monologues, and this stream of consciousness led to my arrival along-

side the wall of the bathroom, a new wall, a new lavatory cunningly retrofitted into a former breakfast nook. And there I saw it:

Seven indentations, each the size and shape of a fingernail, freshly marring the wall, a wall I had finished painting only a few very late nights before. The tiny half-moons cut through the blue paint into the white wallboard.

I freaked.

"Jeeeee-naaaahhhh!! JEEEE-naaaahhh!!"

She came running in, alarmed.

"What?! What?!"

"What the hell is this?!"

I gestured, Hamlet style, toward the wall.

Her voice took a downward curve.

"I know. Don't be upset. Evan did it. With his Little Tikes hammer."

I wrote about this not long afterward in one of those newspaper essays. I did the comfortable thing for everyone, which was to cast the event sitcom style.

"My knees go weak; a low moan catches halfway up my throat," I wrote then. "I beat my breast in the manner of a Sicilian funeral mourner."

(Laugh track. All is forgiven.)

That's not what happened, though. That's not what happened at all. What happened was, I screamed for Evan to *get in here right now*. Which he did, trundling in on his chubby two-year-old legs, a look of I'm-not-too-sure-what-I'm-walking-into-here weighing down his eyelids.

"Did you do this? Did you?"

"Yes."

"You did this?"

"—yes—"

"Don't you ever-ever-*ever* bang on the walls! Ever! Do you understand?"

He was starting to cry.

"Do you understand?!"

"Yes."

"Go. Go away."

He ran off. Gina stared at me.

I had shamed him. I had shamed him with direct regard to our house, or more accurately at that moment, *my* house. (Ownership of a piece of a house is ascribed directly to the last person who improved that piece. The kitchen floor, for instance is "the kitchen floor" until someone tracks mud across it. Then the kitchen floor belongs to the person who just mopped it, prompting the inevitable self-referential lament: "Who tracked mud all over *my clean floor*?")

Never mind that all Evan ever saw me do was bang on walls with a hammer. Never mind that this exchange was drawing me dangerously close to the maudlin lines of folk-pop (*Cat's in the Cradle, my boy was just like me*, etc.). Never mind that in a house still digging out from under condemnation orders, seven tiny dents were a mere nothing.

In that moment, the only thought in my head was that *nobody* was going to undo something I thought was done.

After I turned this into a newspaper anecdote, I got a call from a woman named Joan Reisig. She and her husband were in the midst of a decades-long restoration of a century home in a nearby town and they had raised a family there. A kindred soul, she had taken special interest in my project and often had offered encouragement and commiseration.

Leave the nicks there, she said. You have no idea how valuable those will be to you one day, nor how soon that day will come.

I didn't. I wiped them out with my drywall blade, my strokes reflecting growing expertise, and I sanded them clean away and painted them into the flatness of the wall.

It was later, alone, that I tried to explain to Evan why I'd yelled at him. As so often happens in parenting, I was listening to what I was saying more than he was, and I couldn't hear anything in my voice that convinced me I was right about anything other than the fact that, yes, it is indeed wrong to dent a freshly painted wall.

[27

duet no. 3:

gina

There were times when I loved the house. In fact, there was never really any time I didn't love the house. But there were many times when I wished we'd never taken it on.

There were times when I just wished we could be a regular family in a normal home. I wanted us to be able to go to the zoo, or to the park, or swimming, or to a movie. All the other moms complained that they couldn't get their husbands to do anything around the house. I couldn't get mine to stop. People sometimes ask if I regretted moving in here, and sometimes I say yes, and they think it's because I hated all the mess and inconvenience. It's not that at all. I'd gotten used to dirty socks. I just wished David would spend more time with his family and less on his family's house, but we were stuck in a life that never felt normal.

One spring day, I walked up to the third floor to tell David something. I was absolutely horrified to find him hanging backward out the window, with his knees hooked over the windowsill, leaning back into midair forty feet above the ground, painting the window frame. The

only thing keeping my husband from plummeting to the ground were the fingers of his free hand gripping the edge of the window molding.

I screamed. I ran to the window and grabbed his legs.

"Oh my God! David! What are you doing? You can't do this! You're going to fall out! You're going to kill yourself! I can't let you do this!"

David kicked his legs and screamed from outside, "Let go of me! What are you doing? Let go of me right *now*!"

I dropped to my knees and tightened my grip on David's lower legs, squeezing with all my strength.

"I can't just let you fall out of the window like this! I have to do something! I'll hold on to your legs. I'll keep you from falling!"

"You're going to *cause* me to fall, Gina!"

"Why in the world are you doing this? What are you doing!"

"How did you expect me to paint the window?"

"David! I bought you a forty-foot ladder for your birthday!"

"What? You think a ladder would be safer? Let *go* of me!"

His upper body still out of view, he continued struggling.

"Then we should have hired painters. David, you have to stop this right now! You're *going to fall*!"

I tightened my grip.

"I am not going to let go until you come back in this house!"

He began to kick his feet back and forth in an effort to escape my grip.

"Let go of my legs! *You're* going to *cause* me to fall!"

And then I thought—did I weigh enough to hold him if he fell? I imagined David slipping out the window along with me holding on to his legs from the knees down. Our child would be orphaned.

"I am going downstairs *right now* to call a painter to come and paint these windows!"

"Don't . . . you . . . dare!"

I wasn't going to win. I knew that. To David, paying someone else to work on our house was a fate worse than death. I reluctantly let go of his legs.

"I have to go downstairs, then. Because I cannot stand here and watch you fall to your death. How could such a smart person do such a stupid thing?"

I went downstairs, totally forgetting why I had gone to the attic in the first place. I made the sign of the cross and prayed, all the while waiting to hear the thump of David's body hitting the ground.

Did I feel like a princess? Hardly. I felt like Cinderella. Not the one in the magic glass slipper. I felt like the Cinderella with the scrub brush and the tired knees and raw fingers and a castle full of floors to scrub.

28]

i will whisper
words to myself and put them
in my pockets

There were pieces of rabbit everywhere. It took me a while to realize it was, or rather had recently been, a rabbit. At first what I saw was pudding, curious brown pudding, on the floor near the rear of the garage. And then a wisp of fur. And then, behind the trash can, a head. A brown rabbit's head, slashed and gored.

In the perverse logic of my recent life, this was the first time I could consider the garage a "mess." Chris and Louis and I had brought down what remained of its collapsing roof, climbing along the rafters, prying and cutting and riding the beams slowly toward the ground, with the same unencumbered glee of Robert Frost's "Birches" boys, except for Chris, who more resembled Slim Pickens astride his *Dr. Strangelove* H-bomb. I yanked the black-walnut sapling up by its roots and carried it down the ladder, pushing my way through the brush toward the pond. In a clearing, I kicked out a little depression in the dirt and planted the tree like a rugged little victory flag. I rented a Bobcat and the three of us cleared the shell of the garage, filling two Dumpsters with the garage's toxic waste and its mouse/cat/termite/carpenter ant/brown recluse habitat. Evan watched us from the window with awe: men and

machines. We'd swept and hosed and, for the first time in a generation, the half-ruined garage was clean. One wall stood. The others were dismantled down to what was solid. The roofless, jagged shell suggested it was ready and waiting for me to prove it could be saved.

Now I'd come home from work in midafternoon, planning to spend some time on the living room. It was a beautiful spring day, warm and sunny and fragrant. Baseball on the radio. A rare day with a long afternoon to do some work, which is how I defined my best days: by the amount of work they could contain. In fact, I was feeling so buoyant on this particular day that I'd decided, what the hell, I would blow off the living room and instead spend some time demolishing the front stoop. I deserved it.

The rabbit, of course, was the same brown rabbit I'd seen that deep winter night out by the pond, the rabbit Evan and I had been watching in the mornings, our little visitor. How could it be anything else? A murder investigation would be impossible, but my rush to judgment was complete and I implicated these feral cats that were tramping around the grounds with their pissy arrogance. They still believed they owned the garage. They'd gotten squirrels and birds and they seemed to kill for sport, often leaving a great deal of what, in the eyes of a hungry cat, would reasonably be considered "meat." As always, however, guilt and its placement was ambiguous. Glancing toward the rear living room window that offered a view of this scene, I turned from post-crime witness to chief inspector to accomplice, all in a matter of half a minute. More than anything else, I needed to get this cleaned up without Evan trundling over to that window and seeing me. I needed to get rid of the body.

I had been dealing with a lot of death for the past several months, and a moral hierarchy had evolved. Although I tossed mice into the garbage with nothing more than the previous day's classifieds for a shroud, some animals, especially those that had not invaded the poorly secured boundaries of my domestic space, were treated to a more formal interment. A dead robin I found in the yard; a squirrel I discovered frozen in panic in the otherwise humane trap: I had taken to burying these

animals at the bases of trees, in a symbolic gesture of rebirth, death giving itself over to life, the commingling of organics, etc. The only problem was that most of those burials had taken place in winter and now I saw that many of the trees at whose feet I had gently left the fine-boned innocent victims of nature's cruelty were themselves dead.

I began my morbid task. As a ruse, I threw a few battered bricks into my wheelbarrow and parked it in the driveway. If Evan saw me out there digging a hole under the yew, I could say I was scavenging for bricks, which I often did back there. All through this area near the pond, they turned up like cigarette butts at a public beach, bricks that had fallen off the house.

I'd like to say I chose this spot because of the powerful symbolism of the yew tree, whose branches grow down into the ground to form new trunks, invoking rebirth. It's often been used as a religious symbol; many believe that Christ was crucified on a yew and religious institutions commonly plant yews on their grounds. Additionally, in the context of this house, with all its conflict and deception, the symbolism was richened by the ironic fact that all parts of a yew are poisonous.

In truth, however, I chose the yew because it grew next to the garage, and grotesquely sideways, and was wildly unpruned, thereby affording me some cover from a toddler's potential gaze.

After digging my hole, I returned to the garage with a flat shovel. There was surprisingly little blood, but a lot of other internal material. Fur, in small tufts, was scattered throughout the garage, mostly along the twenty feet of back wall. Judging by the debris field, this poor animal must have been penned in and ripped to shreds as it tried to escape, running this way and that along the rear wall, finally gutted and decapitated in the corner. Besides the head, I found a foot. Otherwise it was all unidentifiable bunny matter. I scooped it together as reverently as I could, which was not very reverently at all, and, trying not to look, I dumped it into the hole, covered it over, and hosed away the residual gore.

Back inside, I scrubbed my hands and tried to get Gina's attention so I could tell her what had happened. Instead, Evan came running up and threw his arms around my knees. I picked him up and held him, hoping

he would never notice that one small part of what we shared had disappeared. There was no way I would ever tell him about this, I thought. I could never bring myself to explain that such a small, delicate thing as that could be destroyed so capriciously and so completely, and that I felt guilty for bringing the rabbit to his attention in the first place.

I was still learning how to be a father, and beginning to realize it is not a process of incremental successes, but of random failures. The one thing I was consciously and, I suppose, monumentally trying to do right was to provide a home for my family. And now, holding my son in my arms, I recognized the distance it was creating between us. And I didn't have a clue how to change the course. There was a lot of room to get lost in here, and I was discovering more of it every day.

I had begun having a recurring dream, in which I opened a door in this house to reveal another wing, a vast place with hallways and rooms, untouched and decadent, vague and creaky and musty and dark, wind and shadows sliced by the rafters of the rotten roof. The condition of my real house had improved, it was becoming more stable, but my imagination still craved the ruin, still remained attracted to what had drawn me and Gina here in the first place: the idea of what it once was and the suggestion of what it could be, suspended in a tattered cobweb, draped in the velvet of decomposition. Romance, in other words. What concerned my waking self was how I reacted in that dream: with relief. Relief that I would never be done.

This was not a lightning-bolt revelation. It would take years to sort out what was really happening. I was suspended then between growing up and being a grown-up, between tantalizing possibility and low-gloss reality. Pouring my energy and concentration into the physical work of the house allowed me to believe in all the things I *could* have done, had I chosen to direct my creative energy elsewhere. There was no need to pursue another draft of the uncontrolled novel, or to try to deconstruct the dynamic of the middle eight in a perfect pop song. Choosing the house allowed me the delusion that I could have done all of those things and more, but I had simply chosen otherwise.

This kind of self-delusion is harmless, but only to an extent. I had

a writer friend who referred to his children as "his novel," with the same implication that his artistic potential was a given and he was simply applying it to parenthood. What I hadn't considered, and was just then coming to realize, was the cost of my choice. Even as I held my two-year-old child, I felt an urge to set him down so that I could go back outside and practice the craft of amateur masonry, which is an ugly thing indeed. Especially if you have seen me lay brick.

And so it came to pass that I was leaning forward on a stepladder in the living room, positioning a paste-heavy sheet of ugly black-flowered wallpaper on a brilliant May afternoon, when Gina cried out from all the way across the house, her voice carrying down the long ramble of the dining room and into the reverberant central hall, past the grand entry hearth and through the columned archway:

"David, oh God, I'm bleeding—"

She was already crying when I reached her. The rest was all dead hope. We knew the baby was dead when we called the doctor. We knew the baby was dead when we drove to the clinic. We knew the baby was dead when we sat in the anteroom, waiting, speculating in lies—"sometimes this happens; it might be normal"—because Gina allowed then that she had been sensing something not right inside: a deflation, a flatness, a nearly imperceptible loss of momentum. We knew before one doctor and then another broke the suddenly familiar news that the baby was dead.

When we finally returned home, that same sheet of wallpaper was dried and stiff, clenched to the ladder top where I'd let it fall. I had the task of calling the people we'd foolishly told of the pregnancy, insisting that no one visit or send food and good God, no flowers. We didn't want the place smelling like a funeral home.

And then we were alone, the three of us, in a bedroom whose walls were the color of a void: a flat anachronistic green, a color chosen by other people in another life, and a color that I began to hate with mathematical specificity. I resented the color because of the chain of

hypothetical events it represented, a complicated step-by-step ma-
chinery that my mind had sorted out and managed to hold clear. Ev-
erything would click in this fabricated order:

1. the master bedroom would, with great effort and flourish,
 be transformed while.

2. Evan remained in the room that was to become the baby's
 room and Gina and I moved into the master bedroom,
 thereby allowing

3. the temporarily vacated "Green Bedroom" to be finished
 and repainted for Evan, at which time

4. the infant would move from a bassinet at our bedside to
 Evan's former room and Evan would move into his new
 room and the four of us, in a dizzying show of precision
 and progress, of *rightness*, would be situated in new bed-
 rooms, the bedrooms that would be our proper places for
 the duration and we would be settled, defined, and estab-
 lished as a family, and all of this would finally make sense.

It had all been tuned to the arrival of the baby.

The blinds were drawn. The door was closed. The overhead light
was dim, the fixture still clinging to Mrs. Radner's forty-watt bulbs.
Gina was under the covers, her knees drawn slightly upward to pro-
tect her middle from Evan, who was crawling actively around the bed,
unable to understand the implications of his elbows. I had brought
Gina a glass of wine, suddenly allowed, but without joy.

This was the first room I had touched, the room where the very
first bite of my wrecking bar's blade had revealed me as inept, where
my imagination had hit reality's wall and everything had changed.
That first day here, I had felt briefly exuberant and superior, with
Mrs. Radner, woeful Mrs. Radner, hunched on a chair two rooms
away, and I thought she was being relieved of this house because she
was an unfit caretaker, and that I was the chosen successor because
I was young and invincible and so filled with the forces of life that

they overflowed from me and required such a vessel as this to contain them. That this was not fate but justice.

And now I wished there was someone down the hall who had lived longer than me and had seen more and knew more. Someone who could offer, if not an answer, at least the distance of understanding.

Instead, it was the three of us adrift on a queen-size bed.

I lay on top of the blanket, allowing Evan to play. I had offered to take him somewhere else, to give Gina some rest and quiet, but she wanted him here. We told him there that night what had happened, but it didn't seem to register. He had fewer questions than we had prepared for. He didn't have the capacity to be sad about something that was never real to begin with.

We asked the question in every way possible. We asked each other. We asked doctors. We looked in books and read Internet posts. We were ourselves asked the question, haltingly, with improvised tact, by the few people who knew we'd lost the baby.

You don't suppose, you know, that there's any chance the . . . house might have caused . . . this?

The doctor said no, absolutely not. That we were only at the outside ring of what was considered "at risk." She set aside her chart and leaned forward on the rolling stool, emphasizing above all else that there was *nothing we'd done wrong*, that there was nothing we could have done to prevent this, that nature had chosen this course.

Others said the same. I didn't believe them. I couldn't believe them. I lived in a different reality, with its own mythology and its own system of punishment. The more they tried to soothe, the more I believed that there was no way the house *couldn't* have caused this. Every possibility existed: the emotional stress of adapting to this environment, the physical stress of all the work, the filth and the smells and the dust of the house's antiquity stirred up by our quixotic attempt at salvation. How could I ever believe otherwise? I had brought us into this house and the house had claimed the child.

clearing

We mourned again but it was different this time, our attentions irrevocably diluted, and our belief curdling from the previous confidence that this was a tragic anomaly to the creeping apprehension that we had built our future on sand.

Summer in Akron arrives in a mocking series of fits and starts, with tiny buds bursting free from the ends of branches, naked and yawping, only to cower the next day under whips of sleet. Then a day of warm breezes, then a late frost, and so forth, until you find yourself in it, sunburned and slapping at mosquitoes, not really sure how it got there and apprehensive that it will all be taken away. Gina, still watching children in the living room, used her spare time to indulge Evan, and perhaps herself, taking him swimming and to the zoo. She asked me to come along with them. I said I couldn't. I knew she believed I was choosing the work over them, but that wasn't the full truth. It was more complicated than that. I was trying to prove myself worthy of her faith in me, to make this house into what I had promised it could be. The house was beginning to define us in its intrinsically paradoxi-

cal way: as the thing that held us together and the thing that drew us apart.

Every little victory on the restoration carried a failure somewhere else. But even this was complicated. Gina was just as thrilled as I was when the living room was transformed from a dank, dilapidated space to a garishly decorated gathering place. We had spent a long weekend painting side by side, just like in the early days at the semiremarkable house, and she had been caught up in the same enveloping focus that I felt, the linear accomplishment of painting one hundred feet of baseboard with nothing in mind except turning the final corner to the end. We would put Evan to bed and work late into the night, drinking beer and laughing, both of us caught in the self-perpetuating energy of a task that can be completed in one grand flourish. We played They Might Be Giants records—her favorite—we played all of them, in order, loud (Evan was a remarkably sound sleeper), in the same way I'd tried and failed with the R.E.M canon months before, but this time we succeeded, spinning them one after another, relieved for this, for a return to a shared *something*, and relieved for the drama of completion, and for the small revelation that we were still the same couple we had been at the moment we had looked up at that solarium chandelier and felt certain of our future. The living room was bold and gaudy and the colors were completely wrong, but it would be years before we could see this, and it would never, ever matter.

I enlisted Chris and my brothers Ralph and Louis one weekend to clear the front yard, to unveil the house from the decades of torrid overgrowth that kept it from public view. Louis had recently announced that he was buying a broken-down, bat-infested old farmhouse out in the country, a decision he openly attributed to our father, who was forever enticing us with the allure of scavenged wrought iron and loose brick—*the streets are lined with gold!*—and with his own continued examples of projects at once practical and audacious. I wanted to believe that somehow I had made this lifestyle seem so attractive

that Louis couldn't stand it and had to get in on the action, but the way he spoke of it was more as though he had succumbed to a genetic disease.

The four of us yanked at vines, climbing and swinging. We hacked down brush, feeding it into a wood chipper. We felled trees, one after another after another, creating a huge wood pile in the side yard and enough mulch from the chipper to spread around the entire front yard, which, in lieu of grass, gave it at least a uniform surface.

A middle-aged woman came from across the street, friendly and exuberant, leading with a six-pack of beer, Welcome Wagon style.

"I've lived here my whole life," she said. "I grew up in that house and live there now with my husband and kids. All my life, I've never been able before to see this house from my own windows!"

Another neighbor came, an older, wiry guy with an anchor tattoo. He watched the carpenter ants pouring out of one of the trees we'd cut down, then he disappeared and returned with a spray bottle, which he began squirting onto the tree, leaving a milky film. Immediately, ants began curling in midstride and dropping, dead, far more dramatically than when the exterminator had sprayed the infested attic rafters. The bottle was unmarked. Chris asked what it was.

"Ant killer," he responded dryly. "Don't ask."

We all backed up several steps and watched.

We had reopened the place to the world. The yard looked shockingly bare, like the head of a bedraggled fugitive whose long, matted hair has been shorn. A new round of visitors emerged, people pausing in their cars on the street or pulling into the driveway apron to look, as though this house had pulled some Brigadoon trick. Exposed now to the neighborhood, we were more likely to be pulled toward the sidewalk by passersby, people wanting to know who had finally taken on this house, wanting to tell us stories.

"I think I had sex in that backyard once, back in high school," a friend confided. "I thought it was abandoned."

"You know," a neighbor said, "the old lady used to come out in the middle of the night and rake the leaves."

"We always called it the Addams family house," another neighbor told us.

The removal of the trees introduced an entirely new intensity and quality of light to the interior. This house was designed to bring the outside in; all those windows were meant to fill the big rooms with sunshine, and now they did. The very fact of that was revelatory; even the dull gray floorboards began to suggest some glow beneath their dormancy.

The house was emerging from a long illness, blinking in the daylight, still weak, still with most of the healing to be done. But it was returning to something long forgotten, it was finding a way back into its community. In midsummer, I tore apart the front stoop, demolishing the bricks to their foundation. Only the final step at the threshold was salvageable. The rest of it lay in piles of bricks and rubble alongside the front walk. I propped a mailbox on one of the piles, the mailman no longer able to reach the front door, and my dad, as always, helped me design a new stoop and explained how to lay the brick and I went to work.

With an out-of-town sister visiting for a week, Gina invited all her sisters—Jo-Ann, René, Carole, Barbara, and Diann—over for pizza and a movie. They were going to spend the evening together watching *The Money Pit*, which by then had become its own punch line:

"Have you ever seen *The Money Pit*?"

"No, I'm too busy working on one."

I sat cross-legged on the half-finished front stoop, mashing bricks into a bed of wet mortar. As dusk gathered around me, I could hear the sisters inside, the familiar pitch of their sorority: boisterous laughter, contention, and unanimity. I felt unusually alone.

It was August, and the stagnant pond out back had become cloudy with mosquitoes. The clatter of bats overhead was not enough to eliminate so many insects, and so I kept dropping handfuls of mortar to slap my neck and forearms. An experienced mason never touches the mortar with his fingers; I regarded the stuff as clay, to be shaped and squeezed, smoothed by hand onto a brick, the excess scraped off with fingers after each brick was pressed into place. I smeared great globs of it onto my

bricks, regarding the trowel in the same way a Caucasian Ohioan regards chopsticks. Soon, blood had begun to seep from my fingertips with no apparent source. The top layers of skin had worn off. My raw fingertips were so painful I could barely button my shirt each morning. But nothing would stop me. This was my custom: instead of learning the right way to do something, I applied arrogance to my ignorance, forging ahead despite my self-created obstacles. When I prepared for an evening of bricklaying, I put gauze around each tender fingertip and wrapped them tightly with duct tape.

As the six sisters laughed and yelled in the living room, pointing at Tom Hanks on the screen, I brought out a set of shop lights and continued my work past dark, making slow progress, never quite plumb and never quite level, a constant compromise. I was an apprentice with no mentor other than need.

Finally, it grew too dark to see what a mess I was making and I dumped the rest of my mortar bucket in the yard, hosed everything off and went inside. The sisters were still in the living room, and they turned to greet me, pausing in unison as I held up a hand in greeting, each finger in a gray bandage.

At once, they all burst into laughter, and once they began, they couldn't stop, asking me then to hold up the other hand, bringing another round of even more uproarious laughter, so I wriggled my fingers, aware that there was something funny about them even if I didn't know what it was.

They'd just been watching Tom Hanks with his fingers bandaged in exactly the same way, and I'd walked directly into one of those situations where everyone is laughing, not with you, but most definitely *at* you.

I still haven't seen *The Money Pit*.

In a house where wreckage and repair were ubiquitous and ambiguous, we tried again.

Gina was under closer observation by her doctor now, taking medication, and by early fall she was pregnant once more. The announce-

288] David Giffels

ment came as before, with a positive hit on the home test, but we were hardened against euphoria. Even hope was distant.

It was September. We'd been in the house for nine months, a gestation period, and those long spells of inescapable introspection, tempered by the lessons of recent life, had led me to a compromise. We had a kitchen now, and solid footing to the front door, slightly less jungle, and a house that was clean and enclosed in most of the parts we needed it to be. Small things, hints of progress, a path through the pandemonium—basic elements that helped place the larger work ahead into better definition.

And so, finally, I gave up the nights. However it would end, I didn't want another pregnancy to pass the way the last one had, when I'd believed I couldn't yield to Gina's request to stay with her at bedtime. This was hardly a noble act—I was simply conceding to something I should have been doing all along. And it wasn't even complete—there would still be occasions when I would force extra hours into the evening to complete some job that seemed to need me. There would be even more nights when the work tugged at my attention and I had to force myself to ignore its incessant call. But it was a concession to the first real truth I'd learned here:

As much as I was trying to change this house, it was changing me more. It was changing all of us, but I was wrong to believe I had no choices.

At night, we sat together in Evan's room, singing or reading a book or making up a story. In the soft glow of a table lamp—forty watts, the way they were meant to be used—we could believe we'd conquered this one corner of a larger confusion. Then Gina and I went to bed, somewhat like normal people do.

the ghost
at the window down
the hall

Gina's sister René had been telling us all along that she sensed something down the hallway, in that odd peninsula of closets that bisected the master suite, squeezed between the main bedroom and the summer bedroom. She said it gave her chills. This hallway seemed like an architectural afterthought, a long, narrow passage lined with closets and with two separate entrances. A total of seven doors were cramped into a twelve-foot-long, two-foot-wide corridor, making it look like the set for a Bugs Bunny chase scene. There was a window at the end, facing south, overlooking the driveway and facing Akron's main thoroughfare, Market Street, a couple of blocks away. Even when the bare bulb in the ceiling was lit, it seemed dim and shadowy.

René had gone in there one night and said she definitely felt something, a "presence," which, in the cosmos of René, was significant because René considers herself to be psychically sensitive and attends to this consideration with great pride and devotion. Her Web handle is "Sister Mary See Things." She said her hair stood

on end when she approached that window. She said there was a ghost.

Maybe there was and maybe there wasn't. That same space is where I'd found muddy raccoon footprints on the inside of a closet door, so the idea of it being inhabited by something otherworldly has to be taken within the context of the worldly. The floor in there had been warped beyond salvation; I'd removed it and repaired it with plywood. The oilcloth on the wall was weathered to a crackled, alligator-skin finish. So it was rustic and creepy and strange down there by the window, but there were plenty of nonspiritual explanations for that.

Everybody wanted the house to have a ghost. Even I did, in a way. There is some aspect of past lives left behind in old buildings, I'm sure of that; that's why I'd spent so much time wondering about the people who'd lived here before. But the idea of "the spirit world" is broad and dicey territory. What we all wanted was a ghost story.

The house where Gina and her siblings grew up included a bedroom with lavender walls that they all generally agreed was haunted. With nine people in a four-bedroom house, they each had a turn sleeping in there. In childhood, each of them had experienced something freakish in that room, each story markedly different from the next:

Gina: "I saw a woman with wavy black 1930s hair and a frilly black dress sitting on the dresser with her legs crossed, pointing at me and laughing. And there were words floating in the air around her."

Barbara: "It was a huge darkness, sort of a black caped image standing in front of the door. Whatever it was, it didn't want me to leave that room."

Jo-Ann: "When I was a little girl, I woke up and there was a rooster sitting on my chest."

Diann: "We had a Ouija board. Heavens, it became addictive!"

Carole: "The Ouija board said I was going to die when I was forty-two."

René: "This spirit—'Mrs. Gardner'—used to come to me—sitting on the dresser and talking to me all the time. She asked me to play jacks with her. One day after a nightly visit from her, the phone rang and it was a woman on the phone asking for Mom. When I said Mom wasn't home, the woman told me to tell her . . . *Mrs. Gardner called.*"

Gus: "I never saw shit. They're all nutty fruitcakes as far as I'm concerned."

I wondered if the sisters had all experienced elements of the same story, if all these apparitions were connected to some elusive spirit saga. In trying to piece this together, I always, for some reason, ended up dwelling on the rooster.

Nevertheless, I thought it was a silly idea when the newspaper suggested I invite a psychic to the house for a Halloween story. I believe it's possible for some sort of ethereal residue to be left behind by human beings who have died. But I do not believe it's possible for someone who makes her living sussing out this sort of unprovable information to be objective or even reasonable. This proposed psychic had some sort of local radio show and worked in a "metaphysical resources" shop. And now she had the opportunity to be publicized in the newspaper. So it would seem very much in her commercial interest to sense something that no one else could sense. This psychic had done a few other projects with the paper. The previous Halloween, she'd found all sorts of supernatural energy on a tour of allegedly haunted sites in the Akron area, which appeared under the headline Ghost Chasers.

The dark secret of writing on deadline, however, is that bad ideas start to look like good ideas with the passing of time. I suppose, sadly, that this is true of every aspect of life. Halloween was approaching and I had nothing better to offer.

She arrived on a weekday afternoon. Gina, much more intrigued by the visit, had arranged for the day-care kids to be away during the tour. We ambled out into the driveway together, I with a notebook in my back pocket. She stepped out of her car.

She was gorgeous.

Gorgeous, like, drop-dead, Barnum & Bailey trapeze-artist-astride-the-lead-elephant/Cleopatra-wrapped-in-snakes/Bathsheba-beckoning-to-the-divan gorgeous. She was slender and well built, about my age, nearly as tall as me in her stacked heels, with gypsy skin and thick, looping curls of black hair draping her shoulders. Her features were sharp and acute, and she had intense green eyes that *had to have been* tinted contact lenses, but really—who cares? Would it have mattered if they were fake? I would have been no less afraid of them, and make no mistake, in the boiling stew of my initial reactions—astonishment, lust, curiosity, awe, concupiscence, humiliation, advanced lust, guilt, submission, regret, shame, hunger, thirst, hoof-and-mouth disease, repentance, resurgent lust—no reflex was stronger than fear.

I do not do well in the presence of beautiful women. It had taken me most of a year to ask Gina out, even though she was practically holding a sign that said: Please ask me out; I will make this as easy for you as possible. Even then, it took months and more nerve than I actually possessed. In fact, I screwed it up so completely that she had to pretty much hand-hold me through the process, allowing me to believe I actually had taken the lead when in fact I had not. (*The Bridge on the River Kwai*. Does anyone really take a beautiful girl on a first date to see *The Bridge on the River Kwai*? It's a miracle sometimes that I have survived at all.)

In the time it took her to step away from her car door, I, standing next to my wife, already had committed imaginary adultery and obtained a mental passport in preparation for our passion-filled open-ended Morrocan escapade, which escapade would definitely involve horses.

When that fantasy passed (what? three, four seconds?), it stage-rolled directly into a Roger Rabbit pop-the-eyeballs-and-reel-them-back-in-with-a-giant-fishing-rod/unroll-the-tongue-like-a-red-carpet/pull-out-the-elastic-waistband-and-check-out-the-machinery/hubba-hubba/*brrrooowwwwwwlllllll!!!!*/pull-the-oversize-slot-machine-handle—*leering wolf! leering wolf! leering wolf!*—JACKPOT!/sort of thing.

And then, again—fear.

Moments before, skepticism and objectivity had been in conflict. Now, each instinct had dropped to the curb, downcast, toes digging at the ground, defeated. The power of speech itself was in danger. I felt a need to test my voice, to see if I could use it, control it, to see if it might crack or be caught in the upwind of hyperventilation, to see if my tongue was in fact turned to wood.

"Hey."

That was the best I could do.

Gina stepped forward. She introduced herself. I suppose she introduced me, as well, or, most likely, introduced *us*, as in we, me-and-her, a married couple, the couple who own this house, the couple who ostensibly have taken on this burden in some large, overt, highly ambitious, semiartistic expression of The American Family. My lovely wife, pregnant and, in so many ways, so much smarter and more capable than me.

(A threesome? Was there a potential threesome fantasy here? No. No way. Wait—just give it a second . . . no. That's just wrong.)

She returned the hello, kind of a willowy and earthy voice—her name was Carrie—but she was distracted, looking over the house with her artificial eyes.

"What's behind those?" she asked, pointing to the bank of casement windows above us.

"It's a summer bedroom," Gina answered. "Like an upstairs sunroom."

"And some closets," I added, finding a need to assert myself in whatever way I could. The oddness of that row of closets had a flip side here—what appeared to be a contiguous row of one room's windows actually spanned the summer bedroom and continued past the bisecting wall to the final window, the one at the end of the long closet corridor, the one that had given René chills. It was something of a false front. The window drawing so much attention was isolated by the architecture; on the inside it was private and removed, a tiny haven at the end of a strange corridor, but there was no indication of that from the outside.

"Hmmm. Interesting," she said. "That's something I'd like to check out."

We began the tour, such a familiar process by now, allowing me to regain myself as we told of previous damage now neutralized or repaired or otherwise changed and yet retaining its stubborn hints in the yellowed woodwork and the stains in the still-unfinished floors. As a stand-up comic comes to know when to expect laughter, I'd come to know where the drama was in this, my story, and to place the details just so—wait until they've taken in the full measure of the living room before taking them back to a time not so long ago—*imagine that you can't walk through this room, just paths through piles of junk, and there, rising out of it like some icon of a lost civilization, a harp. A harp!*

And so on. But Carrie was different. She was attentive, but she wasn't responding the way they usually responded. She didn't ask about *The Money Pit.* She was distracted. In the dining room, as I began telling the usually can't-miss tale of all our furniture being stacked in there, sealed behind plastic, an entire household in waiting, she raised a hand, paused, then curled it at the wrist, carving a half-moon in my monologue.

"I'm getting a denseness in the energy here," she said. "Female, probably someone who used to live here, probably someone who's no longer alive . . ."

"Do you know how long ago?" Gina asked.

"No. It's not that strong. Just a—denseness. A vibration. Someone who comes to visit."

We continued. She was all business, hardly any small talk, and hard to get a read on. Upstairs, passing through the big hallway, she complimented the rug.

Butterflies batted their wings; my tongue reknotted itself.

She's into me, man. Me and my rug.

I didn't allow the truth to invade my delusion: the truth that the rug was a cheap fake Persian that was constantly skating around the floor under the feet of my child, and that Gina had picked it up at a yard sale, and also of course that I *had* a child, and a wife, and another child on the way.

I held all that truth at bay so I could bask for a moment in my lie: She thinks that I have good taste. She thinks that I am cool.

I opened the door to the master bedroom. Carrie entered, then Gina.

The room remained in a frozen state, stopped after the ceiling had been repaired. Even with the progress of restoration, I still felt a distinct romance for the house at rest, not remade, but decadent, a portrait of where it was when its decline suddenly stopped, the way you sometimes see waves frozen on Lake Erie in the wintertime, stopped in icy midcurl halfway through their crash.

At the far corner was the door into the corridor of closets, the one with the window that had immediately captured Carrie's interest and where René claimed to have felt a ghost. I opened it and allowed Carrie to enter.

She stood, nodding slightly. She stepped forward, toward the window. Then back, as though trying to frame a camera lens. She was concentrating, almost in a trance, and she hovered there a long time, finally speaking without really facing us, her eyes nearly closed.

"I have a strong impression of someone standing there looking out the window. What I can see—I can get an image of a woman who looks to be . . . late thirties to early forties. Loose curls in her hair, strawberry blond to reddish, almost. Reminds me of Lucille Ball. Just standing, looking out, sad and lonely. I don't feel that she's standing here right now, but psychically I can see that image."

Is there more?

She paused for a long time, focusing. Her voice softened.

"Okay. Seems to be better working from the floor up. Black shoes. Long dress, but not real fancy. Pleated. Puffy; not overly puffy, but two layers of a ruffle down here . . ."

Her fingers slashed toward her calf.

"She appears to be taller than me, on the slender side. The neck on her dress is scooped. The sleeves are—not real tailored; they're not tight, they're loose. What strikes me more so than anything else is the curls in her hair, for some reason. Her hair has curls in it, but her

curls are not brushed out. It's like, almost like what it would look like when you took rollers out of your hair or something."

We asked if she could sense a name. She paused again, a long time.

"There are two things that I'm getting. Something with an *F*, and the name 'Anna.' But I don't feel Anna is the first name. It might be a nickname or a middle name. And something with the letter *F*."

I paused from scribbling in my notebook. She cautioned that there was nothing more, and she didn't believe in speculating beyond the information that she was able to gather. In fact we were the ones doing the speculating, mentally scanning through the tidbits of information we had regarding the previous occupants, trying to narrow the possibilities of who this woman could have been. Or was. Or is. This woman. Anna. Maybe.

Carrie wanted to go back to the dining room, to compare the "denseness in the energy." We returned there. She nodded in agreement with herself—something similar, female.

Gina asked her if she could go one more place—around the corner, into the back servants' staircase off the butler's pantry. This was not on the agenda. I didn't know what Gina was after. I followed them into the darkly cramped passage.

Carrie walked halfway up, back down a few steps, then up to the top, then down again, stopping on the sixth stair.

"Right here . . . ," she said. "The same energy as the other places . . . why do you ask?"

Gina began sheepishly.

"One day, it was shortly after we moved in, in the middle of the day I was walking down the steps. I had a baby in my arms, and sex was the last thing on my mind, but I had this overwhelming—this *rush*—that two people were having sex at some time on those stairs . . ."

My eyes grew wide.

" . . . two people who shouldn't have been having sex."

A hot blush crept up my neck.

"Maybe the man who lived here or something. And I haven't had it since, but I did have it once, and it was profound; it was strong."

Carrie nodded, connecting.

"You should definitely trust that. It's something that you're tuning into from the past. It's called, like, retrocognition or something. Intense emotion gets recorded into the atmosphere. Do you have psychic abilities?"

I wanted to disappear. My wife, who I assumed had no knowledge of my hyperactive fantasy vis-à-vis the psychic, was discussing sex—with the psychic—while I stood taking notes. You can't do this. You can't have a fantasy this way, being dragged into some tangent that could, if you'd been given the time and creative space to outline and refine your fantasy, could actually have been an excellent addition, a sexy backstory. But only if you had come up with it yourself. Gina had pierced my imagination, not only deflating it, but also exposing it, rendering me even more useless than when I was inside its bubble.

We chatted outside after the tour was complete, learning a little more about Carrie, how she had realized as a child that she had psychic ability, that she saw and felt things others did not see and feel, and how at times this had frightened her until she grew into her ability and understood it. She was more scientific than I'd expected, more skeptical, it seemed, than the type of people who draw on psychics for help. She came from a Native American background, deeply spiritual. She was a minister in the Order of Melchizedek. A reverend.

Also, she was an accomplished belly dancer.

I'd had a scrap of paper with a name and a phone number on my desk for months—someone who knew the family of the original owners. But I hadn't followed up. After Carrie's visit, I began making phone calls in search of a slender woman with wavy hair, possibly named Anna and probably dead.

And this is how I began to find my way backward into those other lives whose stories were draped across my own, whose stories I had wondered about for so long. One phone call led to another, the account growing with help from the friends and family of the original owners.

The house we owned on North Portage Path was built in 1913 by a local attorney named Frank Theiss as a wedding gift for his daughter. Theiss came from a prominent family; a road in a neighboring township was named for them. Frank Theiss was one of Akron's new breed of industrial aristocracy, serving simultaneously as treasurer and assistant secretary of the upstart Miller Rubber Company and vice president of the prosperous American Sewer Company. He lived in a showplace mansion at the intersection of Portage Path and Market Street, the city's main thoroughfare. He and his wife planned on having only one child, which they did—a son named Floyd. But he died in childhood of typhoid fever. They tried again and had a daughter. They named her Ruth.

From his rear windows, just 350 yards away, Frank could have seen the house where Ruth and her soon-to-be husband, William Rabe, an inspector for the B.F. Goodrich tire company, would begin their lives together. He could watch its construction; he could see tangible evidence of his family's next generation taking shape. This part of town was being settled by the newly minted tire-industry elite. In 1916, Ruth and William's next-door neighbor was Winfred E. Fouse, one of the founders of General Tire. The year before, a mile north, Goodyear founder F. A. Seiberling had moved his family into the Stan Hywet estate, whose approximately $4-million construction cost would rival Bill Gates's $53-million Lake Washington mansion in contemporary dollars. Portage Path was transforming quickly from the ancient Indian trail, from which its named derived, to a millionaires' row.

The proximity to Frank Theiss's mansion finally explained why this house was located where it was, suspended between the estates in the semidistance and those at the center of town. He wanted his daughter to be close.

The Rabes lived in the house until 1922, when they moved to Winter Haven, Florida. The family was growing; they had five children. Ruth's presence remained in Akron, however, in the form of a lavish, life-size portrait, an oil painting that hung above the landing of the formal staircase at her father's mansion. Portraying Ruth as a

young woman, shortly before her marriage, it remained there, holding her place in the memory.

Around 1930, during a family outing in Winter Haven, a boating accident dumped several passengers into the water. In the ensuing scramble for safety, William Rabe helped others get back into the boat. He was clinging to the boat's side when Roshell, the family's African-American nanny, looked at him and asked, "Bill? Are you all right?"

"I don't think so," he said, and slipped back into the water. He died of a heart attack.

Ruth remained in Florida until 1942, when her father died and she returned to Akron to settle his estate. She moved into his mansion, where the portrait of her as a young woman still hung in the staircase and where she could gaze from the upper windows toward the home where her marriage had begun, a gaze at whose very center would be the window that framed a "denseness in the energy."

Ruth died in 1965. More than thirty years later, I contacted her daughter, Mary Clause, by telephone. I asked her to describe her mother. The similarity to Carrie's image was impossible to dismiss. Ruth was about five foot seven and quite slender. She always wore a dress. She had reddish brown hair, curly, though not quite as curly or light as Carrie had described. "But you know," Mrs. Clause continued, "my mother touched up her hair."

She was certainly sad and lonely after her husband died, and again after the death of her father.

But what of those names—Anna and something with an *F*? They were not connecting. Not until Mrs. Clause told me Ruth's parents' names.

Addie and Frank.

Ruth would have been forty-six when she moved back into her parents' house—about the age Carrie described. She would have been sad. Returning to Akron after many years away, she would certainly have been thinking about the house that had been her wedding present.

In a follow-up interview, I described this to Carrie. She confirmed that a spirit often will take on the appearance it had at a significant

time in its life. She confirmed too that restoration work can stir up spirits. And also that a spirit can come and go, paying visits. Carrie didn't want to push any connections, but she did agree that the similarity of the names, the similarity of appearance, and the sad events of Ruth's life all pointed strongly toward the possibility of her having a presence in the house.

In the years following Ruth Rabe's death, the house she and William had shared began its slow decline. Her father's mansion fared no better. After Ruth moved out, she rented it for a while; later it sat vacant and was vandalized. Eventually, with Akron itself in decline, there was no one to keep up such a large and opulent estate. The house was razed and replaced with a bank branch.

Shortly before demolition, a relative of the Theiss family went into the vacant house and found Ruth's portrait, still hanging in the landing, slashed to ribbons.

I don't know if our house has a ghost. But it does have a ghost story, and like all ghost stories, it provides a connection to the living. Not long after the psychic's visit and the new revelations about the first family to occupy this house, I was working in the master bedroom. It was cold and I was feeling melancholy; for some reason, I thought if I tried, I might connect with the ghost of Ruth Rabe. I went to the end of the row of closets and sat in the dark for a very long time, feeling nothing except the frigid floor through the seat of my pants.

Instead, I found what I always found when I stopped: a dread compulsion to get up and go again, to get back to work.

Who were Ruth and William? I finally understood. They were people like me and Gina, young, in love, with a family ahead of them and some idea of where their lives might go, an idea that would reveal itself as weak and unreliable, hammered into shape by the forces of circumstance and misfortune. They were people like us, holding on to hope.

home

I paced slowly along the driveway, considering the wisteria. I stepped back, taking it in from a slight vantage, and—yes—the shaggy, monstrous parasite revealed itself as just the right choice. It was May. The baby was coming. I would kill the wisteria.

Winter had been odd—winter is always odd in Akron—with a long, temperate stretch that allowed me to frame the garage roof. A week before Christmas, the temperature was close to seventy degrees and I was crawling across that rusty I beam in a T-shirt, aware at every moment that a blizzard could blow in from nowhere, nowhere being Lake Erie. I had scavenged the materials from Chris's family's barn in southern Ohio, the same barn I'd threatened to move here and convert into a house. With my dad and Louis, we'd removed a section of the hayloft, gathering joists and worn flooring on a trailer that we pulled back to Akron. The load smelled strongly of livestock. The beams were 150-year-old oak, rough sawn, far too stubborn and dense to accept a nail. I had to predrill every hole and even then I burned through a dozen drill bits and bent a nail every ten feet or so.

With the framing in place, I pulled across the top a big green plastic tarp that rattled in the wind.

The warmth didn't last. Our skin turned papery and tight as Ohio crept back into the winter. The heating bills returned with their reproachful monthly accounting. The wind sliced in at side angles to the glass, breathing itself into our lives. The cold infused the wooden floors and seeped into everything. All of our molecules shrank. Our days were colorless as sparrows. We found the few spots in the house where we could feel comfortable, most notably a radiator along the kitchen wall that Gina sat on all winter as though it were a nest.

We ate our meals on the hand-me-down table in a bare dining room scrubbed dull. I finished the master bedroom and we moved in. With the door closed and the right mind-set, we were able to imagine, in the fresh wallpaper and the restored fireplace and the faint whiff of new paint, what life here still could hold. A year before, this house was an orgy of possibilities; now they were meted out in drams. Possibility was compressed by probability.

Gina and I took our coffee each morning sidled up close to each other, backsides against the radiator, her robe belted above the meteoroid of her midsection. Evan ranged through back staircases and unfinished rooms, raw cheeked and heedless, a child allowed to roller-skate full speed across 450 square feet of living room, with only the Gilligan's Island furniture to dodge.

When the three of us curled on that couch at night under the perpetual dimness of the wall sconces, with our feet off the frigid floor and a blanket collecting our warmth, we could allow ourselves to feel settled, or as settled as we might feel in a life charted on consequences. Restlessness and romance—those things were enough to get us here, but not enough to carry us through. I wish I knew more, but I don't.

A job offer had come, in the only other place I've ever wanted to live—New York City, a place as mythical and unthinkable as

this—but entertaining it was moot. We had made a choice. This was home.

We threw open the doors for New Year's Eve, to celebrate our first year and to force the issue of the house as a gathering place, ready or not. We put candles in the fireplaces, hearths whose disrepair could handle no larger flame. We threw a tablecloth across our ramshackle dining table. We swept the unfinished floors and tacked pictures over drywall patches. We taped up a piece of wallpaper in the solarium, to show people plans for some future day.

Gina spent the whole day cooking, the way she had imagined for more than a year. Despite the blue-gray porch paint under her feet, and despite cantankerous cupboard doors that often popped open on their own, and despite the fact that we'd realized too late the sink was slightly off center from the windows above it, she felt complete here, correct in a way that was more real than romantic.

Her apron conformed to the growing urgency of pregnancy. She stirred sauce all afternoon, steaming the windows, a big pot bubbling with sausages and fresh basil and garlic from the local Italian shop. She made sandwiches and chopped vegetables, prepared bowls of snacks and plates of cookies, her banquet filling the butler's pantry with a pastiche of old-country incongruity.

I hauled a hodgepodge of scavenged chairs from the billiards room where we stored them, lining them along the wall of the dining room, a gallery of curb-find rogues. We unlatched the heavy brass handle on the front door, finally able to accept visitors here at the entrance where they belonged.

And Gina and I found ourselves together at midnight, in a raucous swirl at the center of the grand sunken living room, arms across each other's shoulders, eye to eye, underneath a ceiling whose attempted repair only emphasized the extent of its imperfection. We had arrived here by accident and on purpose and by accident and on purpose, a

perpetually mysterious machinery. We did belong here. That was still true. But we belonged here in far different ways than we might have imagined that day when we looked up into the condemned chandelier.

We kissed amid wishes for another year.

A nd so I stood in the driveway five months later, pondering the wisteria and the question of whether to attack from above or below. With the long Memorial Day weekend ahead, I would take care of this. Then I would stop and be ready for the baby to come.

Although I'd hacked away the foliage that grew into the attic, the heavy vine still convoluted one wall of the house, clinging to the corner with the panache and tenacity of Kong. Its tendrils clenched into the gaps where the mortar had decayed between the bricks. It sent long runners down the length of the wooden half-timbers, creeping behind them with an obstinate hold, in some cases heaving them outward. Already this spring, it had sneaked tender green shoots back into the attic gaps. It covered the south wall so thickly that the moisture it held there had rotted and discolored the wood; it had consumed the brownness from the surface, sucking color like a vampire. Its main stems were as thick as a man's arm, sinuous and twisted, like the elephantine ropes I'd seen on ore boats on the Cuyahoga. There, on the corner nearest the driveway, it was the first thing we'd seen the first time we'd approached this place, and it still carried its wild-headed attitude of natural dominance. It provided its own definition of this house, a house I finally regarded, for better or for worse and regardless of the squirrels, as ours.

I began at the ground, lying on my side with a handsaw, hacking through the main stems. The pulp stiffened and grabbed at the blade halfway through, tightening with fibrous concern, slowing the progress, but I jammed forward with the coarse teeth, too experienced now in the art of resistance to give in. Once they were disconnected from their roots, I took one of the vines in my hands and began to walk backward with it, leaning and yanking, playing tug-

of-war against my house. When it would give no more, I jerked at it hard. The leaves shook and a cascading length of them pulled loose. I tossed it into a leafy, tangled loop of disconnectedness and went forward for another, pulling this way and that, fighting the thing strand by strand. It left as much of itself clinging to the wall as it surrendered to me and I climbed up after the tendrils, digging with my fingers into the gaps where mortar should have been but instead was dogged woody vine.

Evan came out to watch me. Something about me on a ladder always seemed to draw his attention. He stood in the shade in the yard on the other side of the driveway. Toddlers never sit when they are spectators. Invariably they stand. Something in their legs gives them the impulse to participate, even as their consciousness refuses to explain this. They watch, imagining imitation, and bouncing imperceptibly to its rhythm. In this regard, at least, I was an excellent father. I was forever providing a live image of something a small boy might wish to try himself, something involving a hammer or a saw or an act of suspension ten feet in the air or something generally dangerous or violent or related to wet paint.

I had been afraid of him at first, and afraid to admit this, so our arrival at the place we were now had been tentative and stretched out through impossibly long nights alone, nights that, if nothing else, had allowed me the space to try to understand who I was to him and who he was to me, all the while unraveling something that was parallel to this, usually something concerning plaster and lath or wires and switches, things to keep the fingers busy. Whatever it is about human males that elevates us from the beasts, whatever it is that gives us the capability of insight and emotional depth, that thing that elevates us also makes our lives really, really messy. It's not that men are not capable of internally working out their emotions. It's that we *are*.

I wanted to tell Evan all this. I wanted to tell it to him on a Thursday night, with just the two of us at the dinner table. I wanted to explain to him the family illness which, at that very moment, would have me thinking about building us a proper dining table, preferably

306] David Giffels

from the wood of a tree I'd climbed as a child, because that's the true way to build a dining table, and that this undertaking would require my hands, and his hands, and his grandfather's hands, as well as a lot of explaining to people who couldn't understand why we didn't just go buy a table at the furniture store like normal people.

"Hey, chief," I said, hanging from one rail of my uncertain ladder.

"Hi, Daddy," he said, squinting into the sky.

"Whatcha doin'?"

"Nothin'."

And so on. He'd learned language; I'd learned to communicate with him in the diluted conversation of young men. Six months before, he stood on the first rung of my stepladder as I pried up ravaged bedroom floorboards. Recognizing a telltale sideways nervousness, I asked, "Hey, Evan—you wanna go pee-pee in the potty?" He said yes and he stopped wearing a diaper that day. Just like that. Easiest potty training in human history, accomplished with a minimum of words, barely an interruption in the day's demolition.

Now he watched as I dropped foliage from the wall, scratching at brick and digging in the spaces between timbers.

When I climbed down, satisfied I'd removed all I could, I turned my attention to the ground. I bent at the waist and took hold of the remainder of one of the vines that had rooted themselves there, intricately twined into a large bed of pachysandra and English ivy, competing creepers embroiled in acid-loving sectarian struggle. I tugged hard and the strand ripped a jag up through the soil, then stopped hard, sending a jolt into my elbows. I yanked once, then again, harder, but all I succeeded in doing was pulling the outer layer from the root, leaving me with a slippery yellow grip.

When I turned to look for my shovel, Evan was wandering back up the driveway, his interest waning in something that was absorbing me with increasing intensity. I retrieved the shovel and scratched down to where the root kept its grip. It split off there into two directions. I drove the shovel blade into it, severing it. I chose one and gave it a yank. It came up for a distance, then stopped hard. I

dug down to it and discovered another fork. I picked up the shovel, chopped into it and pulled. It stopped hard at another fork. This is the exponent of a hard life. I already knew better than to try for an easy solution. I'd have to follow these roots down into the ground, pulling them sinew by sinew until there was nothing left to take.

For three days I did this. My abdomen ached from the constant upward pulling. My hands grew raw; despite Gina's constant insistence, I refused to wear work gloves, believing my palms were better served by exposure and eventual callusing, which is stubbornness for its own sake, but that should be obvious by now. I was sunburned and irritated from the constant friction of vegetation. The pachysandra was decimated, patchy and upturned, ripped through with endless abstract lines where I'd chased the roots through their geometry. These roots, it seemed to me, possessed unnecessary vehemence.

I'd seen pictures of wisteria climbing the sides of castle ruins in Europe, and now I understood that these roots had a monarchy even deeper than their hosts.

What fear had been bred into this plant that would lead to such depth of perseverance? What in the DNA suggested it could be plucked too easily and therefore must send out an infinite network of roots, must never rest nor give up its hold?

Was it the Tudor curse: "Thou shalt get no heirs"?

Or stubbornness for its own sake?

I also understood that, after wisteria and pachysandra and English ivy, the fourth vine I hadn't been able to pin down was, as I had feared, poison ivy. By the time I returned to work—a week before the baby's due date—the tender skin of my inner forearms and kneecaps and my right earlobe was prickled with a rash rising into ugly yellow blisters.

And so these final days in which I had intended to rest with the satisfaction of a job completed, a small thing set right, were instead characterized by the distance Gina and I kept from each other, fearing the potential of my itch and the implications it might have on the baby connected to her bloodstream.

After all this we slept as far from each other as the boundaries of the

bed would allow and I lay awake crusted with calamine and wrapped in gauze, blinking in the dark and thinking about the ceiling.

She arrives with a rasp, crumpled and annoyed, punctual—this is the Industrial Midwest; to be on time here means to be early. She is early, by five days; we are slightly unready. She is offered to me and I take her, my sleeves carefully covering the dying rash I thought would be gone by the time she came.

I peel back her miniature stocking cap. The planer's curl of her hair is wet. Her fontanelle is concerned. Her lids are silver. Her lips are thin. I weigh her in the balance of my forearm and bring her close to smell the carnal perfume.

We have named her Lia, the name we have been holding on to for so long that it has become burnished, like a worry stone.

The light here in the hospital room flushes out whatever the face might wish to conceal, so when I look at Gina, whom I have been looking at all afternoon, our sweaty hands locked, urging this baby downward and outward, I see now that this is all she ever wanted and that she thinks I am a fool for wanting more.

I am a fool for wanting more.

The tiny body is wrapped tightly in a thin blanket, forcing her straight and stiff. This is not the newborn's natural shape. The newborn's natural shape is the shape of a question mark, formed by the space she has occupied forever until now. You can never take this shape away from her. She will find it in her sleep.

I am afraid, and this is what I wanted, this has been my secret all along. I wanted fear. I wanted never to stop being afraid. I wanted warm fear that I could lift from the blankets, that I could hold in my arms, that would share my restlessness as we sit rocking in the night, taking turns breathing, inventing her lullaby.

We bring her home, carrying her in a padded baby container from the garage whose roof is a temporary tarp that turns the sunlight green and warm. We carry her up the back steps, a corner of which

has tumbled loose, revealing a gnawed tunnel in which I found old bones. And through the back door, whose outside remains weathered and cracked; whose inside is repaired and repainted, glossy and white, making this the threshold of Oz, monochrome to Technicolor.

And across the painted floor into a hallway half filled with the forty-watt glow of an obstinate bulb and up through my swinging spot to the oak landing whose foot-worn bicolor finish carries the impression of an old runner, removed. And up past the church windows, reflectors of nonsensical soliloquies—*my people! my people!*—and to the top of the stairs, a closed door, closed because parts of this house must be kept from the other parts—this is necessary; this is how we live now; this is what we understand; this is what we share; we know no other way . . .

. . . and into a room where secrets linger in the walls.

This is where she will live. This is what it means to be a family; this is what it means to be home. To be complete in a place that will always be unfinished.

postscript

Y ou're not really going to ask, are you?
(Sigh.)
No. It's not finished. We have not sold it. I have not died.
Ten years have passed and I could show you evidence of progress—
a living room done once and done again, finally stripped of its gaudy
misguided wallpaper and soda fountain green woodwork. And con-
versely, I could show you a billiards room that has not been touched
since the night my brother and I tore down the ceiling. I could show
you a house that in its every detail proves my father's adage.

I could tell you the story of the night we hosted a tour by the local
preservation society, an event preceded by weeks of harried prepara-
tion and self-congratulatory preening and last-minute quick fixes, and
how the telephone rang at exactly the moment the tour was to begin
with the news that my aunt had just been killed in a car accident.
And then the doorbell rang. And how, as we did our best to carry on
with the show, one of the visitors detoured into the master bathroom,
locked the door, and took a prodigious dump.

Or how I broke my ankle one summer and rigged up scaffolding so I could continue to scrape and reglaze windows from a seated position, filling the leg cast with six weeks' worth of paint chips and grit.

Or how, a day before this writing, I heard some new scratching in the wall.

The broad, literal answer is that we live in a house that now looks and feels something like normal, but whose maintenance and continuing restoration represent their own illogical and hugely consuming lifestyle, and therefore is not normal at all, which pretty much describes every American family I've ever observed.

But the real answer is less tangible and completely fluid.

That answer exists in the din of the wedding receptions and funeral gatherings, the milestone birthdays and anniversary celebrations, the First Communions and Thanksgivings and Christmas parties and family dinners and sleepovers that have found a home here. It's in the aromatic vats of pasta Gina made for a house full of New York firemen who visited Akron after the September 11 tragedy. It's in the mourning of a third miscarriage, in 2002, and in the breathless advance of our two children who grow and thrive here. It's in the deep scar where one of the house's doors took off the end of our daughter's finger and it's in the sidelong way they've learned to negotiate bicycles and basketballs around a buckled and potholed driveway whose repair is beyond our means.

It is, in other words, on the opposite side of the universe of epics and anecdotes.

It's in the most mundane truths: that life goes on, that plans are for fools, that children grow up too fast.

I had always thought I might someday try to find Mrs. Radner and invite her back to see the house that had been so much a part of her life. She died in 2006 before I had the chance. Steve Braun died that same year. He never got to see the changes, either. Our friend Danny continued his weekly visits with loaves of banana bread until his death in 2000.

The Orange Dutch Colonial was demolished in 2006.

I still have not seen *The Money Pit*.

—February 2008

acknowledgments

This book would not exist without the talent, spirit, and commitment of Daniel Greenberg, David Highfill, and Seale Ballenger; and the generous support of everyone at Levine Greenberg Literary Agency and William Morrow.

The following people provided indispensable editing, criticism, encouragement, and illumination throughout the process of writing. They are listed in descending order of height: Dr. Thomas J. Dukes, Chuck Klosterman, Bob Ethington, Eric Nuzum, Michael Weinreb, and Gina Giffels.

For similar reasons, I am indebted to these people, arranged by hair color, fairest to darkest (approx.): Louis Giffels, Connie Schultz, Dr. Mark Auburn, Jimmy Morris (DJ 1 Auxy), Chris Eck, John Gladden, and Jason Fagone.

The following institutions and their staffs provided information, inspiration, insulation, and scrap paper: the Special Collections Division of the Akron-Summit County Public Library, the *Akron Beacon Journal* archives, M–80/the Puglia Collective, the Lime Spider, West

Hill Hardware, Akron Paint, Square Records, Revival Resale, and, alas, the Double Olive.

Virginia and Lee McAlester's *A Field Guide to American Houses* was a vital resource. So too was the audio companionship of: Jeff Buckley, Houseguest, the Constantines, the Black Keys, Bishop Allen, Sigur Rós, Imperial Teen, Goodmorning Valentine, and Bottom of the Hudson.

I am grateful to the *Akron Beacon Journal* for the gift of meaningful employment and the generosity of a long leave of absence in a spell when there were few bodies to spare.

I owe immeasurable gratitude to my parents, Thomas and Donna Giffels, the entire Giffels family, the Hall family, and to all those who came and helped whenever I needed an extra set of hands or someone to talk sense.

More than anyone else in the whole wide world, I thank Gina, Evan, and Lia, for their love, patience, constancy, and light, gifts I try to return every day forever.

This book is in honor of Samuel Carr Greenberg.